Nineteenth Century
Dutch Watercolors
and Drawings

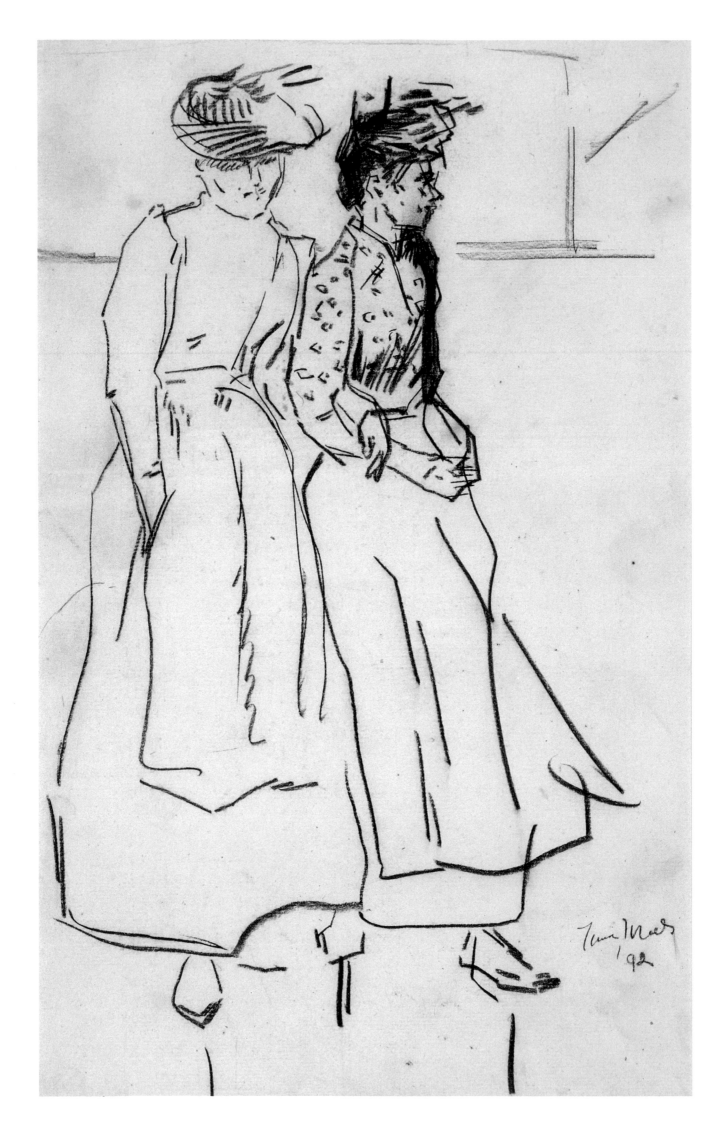

Nineteenth Century
Dutch Watercolors and Drawings

FROM THE

MUSEUM BOIJMANS VAN BEUNINGEN, ROTTERDAM

Saskia de Bodt and Manfred Sellink

With contributions by

Robert-Jan te Rijdt and Evert van Uitert

ART SERVICES INTERNATIONAL
ALEXANDRIA, VIRGINIA
1998

Nineteenth-Century Dutch Watercolors and Drawings from the Museum Boijmans Van Beuningen, Rotterdam

This exhibition is organized and circulated by Art Services International, Alexandria, Virginia.

PARTICIPATING MUSEUMS
Frick Art Museum, Pittsburgh
Columbia Museum of Art, South Carolina
Grand Rapids Art Museum, Michigan

Library of Congress Cataloging-in-Publications Data
Museum Boijmans Van Beuningen (Rotterdam, Netherlands)
 Nineteenth century Dutch watercolors and drawings from the Museum Boijmans Van Beuningen, Rotterdam/ Saskia de Bodt and Manfred Sellink: with contributions by Robert-Jan to Rijdt and Evert van Uitert.
 p. cm.
 Catalog of an exhibition held at the Frick Art Museum, Pittsburgh, Sept. 5-Nov. 1, 1998, the Columbia Museum of Art, Columbia, South Carolina, Jan. 16-Mar. 21, 1999, and the Grand Rapids Art Museum, Michigan, Apr. 11-Aug. 8, 1999.
 Includes bibliographical references and index.
 ISBN 0-88397-129-1
 1. Watercolor painting, Dutch--Exhibitions.
2. Watercolor painting--19th century--Netherlands--Exhibitions. 3. Watercolor painting--Netherlands--Rotterdam--Exhibitions. 4. Drawing, Dutch--Exhibitions.
5. Drawing--19th century--Netherlands--Exhibitions.
6. Drawing--Netherlands--Rotterdam--Exhibitions.
7. Museum Boijmans Van Beuningen (Rotterdam, Netherlands)--Exhibitions. I. Bodt, Saskia de. II. Sellink, Manfred. III. Frick Art Museum (Pittsburgh, Pa.)
IV. Columbia Museum of Art. V. Grand Rapids Art Museum. VI. Title.
ND1967.M87 1998
759.9492 ' 074492385--dc21 98-20287
 CIP

Cover: Wijnandus Johannes Josephus Nuyen, *Canal with Old Houses.* Museum Boijmans Van Beuningen, Rotterdam (cat. 27)

Frontispiece: Isaac Israëls, *Two Servant Girls from Amsterdam.* Museum Boijmans Van Beuningen, Rotterdam (cat. 77)

Edited by Jane Sweeney
Designed by Judy Oser, Oser Design
Printed by South China Printing Company, Ltd., Hong Kong
Printed in Hong Kong

Photo Credits
Studio Tom Haartsen, Oudekerk aan de Amstel, all photographs from the collection of the Boijmans Van Beuningen Museum and De Bodt essay, figs. 2 and 4, cat. 23, fig. 1, cat. 24, fig. 1, cat. 26, fig. 1, cat. 57, fig. 2, cat. 65, figs. 1 and 2, cat. 73, fig. 3; Amsterdams Historisch Museum, Te Rijdt essay, fig. 1; Audiovisueel Centrum Vrije Universiteit, Amsterdam, cat. 47, fig. 1; Rijksmuseum Stichting, Amsterdam, Te Rijdt essay, figs. 2, 4, and 5, De Bodt essay, fig. 3, cat. 8, fig. 1, cat. 16, fig. 1, cat. 20, fig. 2, cat. 37, fig. 2, cat. 47, figs. 2 and 3, cat. 73, fig. 2; Stedelijk Museum, Amsterdam, cat. 25, fig. 2, cat. 35, fig. 1; Sotheby's, Amsterdam, cat. 48, fig. 2; Vincent van Gogh Museum, Amsterdam, Van Uitert essay, figs. 2, 4, and 6, cat. 53, fig. 1; Saskia de Bodt, Buren, De Bodt essay, fig. 1; A. Dingjan, The Hague, cat. 57, fig. 1; Gemeentemuseum, The Hague, cat. 48, fig. 1, cat. 63, fig. 1; Teylers Museum, Haarlem, cat. 30, fig. 1; Jan Stoel Fotografie, Haren, De Bodt essay, figs. 5-10, cat. 42, fig. 1; Prentenkabinet der Rijksuniversiteit Leiden, Te Rijdt essay, fig. 1, cat. 27, fig. 1; Kröller-Müller Museum, Otterlo, Van Uitert essay, figs. 3 and 5, cat. 48, fig. 3; Degens Foto en Dia BV, Rotterdam, cat. 32, fig. 1; A. Frequin, Rotterdam, cat. 21, fig. 1, cat. 30, fig. 2, cat. 37, fig. 2; Gemeentelijke Archiefdienst Rotterdam, cat. 25, fig. 1; Maritiem Museum "Prins Hendrik," Rotterdam, cat. 13, fig. 1; Universiteitsbibliotheek, Utrecht, De Bodt essay, fig. 11; V.d.S. Collection, cat. 20, fig. 1.

CONTENTS

ACKNOWLEDGMENTS

The exceptional level of mastery achieved in the media of drawing and watercolor in nineteenth-century Holland has never before been highlighted in the United States in a major exhibition. It is thus with great pride that Art Services International presents *Nineteenth-Century Dutch Watercolors and Drawings from the Museum Boijmans Van Beuningen,* this decade's third cooperative venture with that institution. The exhibition surveys the evolution in Holland from the taste for finished, highly detailed presentation drawings to an appreciation for fleeting sketches that reveal the very moment of inspiration. The spectacular sheets in this exhibition highlight this phenomenon.

With gratitude we recognize Chris Dercon, Director of the Museum Boijmans Van Beuningen, Rotterdam, for his institution's ongoing collaboration and generous loan. It has been a great pleasure to work again with Manfred Sellink, Chief Curator, Department of Prints and Drawings in the Museum Boijmans Van Beuningen, who has skillfully led this project from the outset and, along with Saskia de Bodt, former Curator at the museum and Assistant Professor at the University of Utrecht, has made the selection of the works of art for the tour. It is also our pleasure to recognize our valued colleague A. W. F. M. Meij, Chief Curator of Drawings, for his continued support. We are grateful to Maartje de Haan, Assistant Curator at the museum, for her able and cheerful assistance in the preparation of the loans and catalogue text and Robert-Jan te Rijdt, Evert van Uitert, and Saskia de Bodt for the sensitive and thorough scholarship documented in this publication. Working with all of these professionals has been a great pleasure, and we thank them for their dedication to this project.

It is our privilege that His Excellency J. M. Voss, Ambassador of the Netherlands, has agreed to serve as Honorary Patron of this consummate Dutch project. His commitment to the exhibition has been gratifying. In addition, Madelein A. J. de Planque, Counselor for Press, Public, and Cultural Affairs at the Royal Netherlands Embassy in Washington, has been a welcome ally and partner in the overall promotion of this enterprise.

Most deserving of acclaim in bringing these superb works of art to public attention is the participation of our partners in the exhibition. We extend our special thanks to the museums that will be hosts of the tour and especially to DeCourcy E. McIntosh, Executive Director, and Sheena Wagstaff, Director of Collections, Exhibitions, and Education, Frick Art Museum, Pittsburgh; Salvatore G. Cilella, Jr., Director, and William B. Bodine, Jr., Chief Curator, Columbia Museum of Art, South Carolina; and Celeste M. Adams, Director, and Henry Luttikhuizen, Guest Curator, Grand Rapids Art Museum, Michigan. Working with these valued colleagues to expand the appreciation of Holland's treasures has been a truly satisfying experience.

Jane Sweeney, Judy Oser, and South China Printing Company, Ltd., are responsible for the sensitive editing, design, and printing of this catalogue. We are delighted to recognize their individual efforts in the production of this handsome volume.

Finally, it is a pleasure to credit the staff of Art Services International for skillfully pooling their expertise in the realization of this project—Douglas Shawn, Donna Elliott, Sheryl Kreischer, Linda Vitello, Kerri Spitler, Catherine Bade, Sally Thomas, and William McDonald. We thank them for their ongoing dedication.

Lynn K. Rogerson
Director

Joseph W. Saunders
Chief Executive Officer
Art Services International

FOREWORD

It is my pleasure to introduce a selection of nineteenth-century Dutch drawings from the Museum Boijmans Van Beuningen, Rotterdam, to the American public. The print room of the museum has a long-standing tradition of presenting treasures from its collection to art lovers all over the world.

In cooperation with Art Services International we have had the honor of offering several exhibitions in the United States in the last decade, including *From Pisanello to Cézanne,* a selection of our master drawings in 1990 91, a group of prints by Wenceslaus Hollar in 1994, and more than ninety drawings from our collection of nineteenth-century French drawings. Now from the more than 15,000 nineteenth-century Dutch drawings at the Boijmans Museum we present eighty of the most beautiful drawings of the major Dutch artists of that century, from the early Dutch romantics and the works of the so-called Italianates, who worked in a traditional style and subject (artists such as Josephus Knip and Hendrik Voogd) to our famous artists in the second half of the nineteeth century of the so-called Hague school who were also popular with American collectors: Willem Roelofs, Jozef Israëls, the Maris brothers Jacob, Matthijs, and Willem, and the world-famous artists Johan Barthold Jongkind and Vincent van Gogh.

The present exhibition was first shown in 1994–95 in the Boijmans Van Beuningen Museum in Rotterdam. Extensive projects of this nature are only realized with the help of a number of people. I would like to thank Saskia de Bodt, Assistant Professor, University of Utrecht, who initiated this project, authored one of the three essays, and was scholarly editor of this catalogue, and Manfred Sellink, Chief Curator, Department of Prints and Drawings, who wrote the *Introduction* and with Dr. De Bodt was responsible for the selection of the drawings and compilation of the catalogue. Furthermore I thank Robert-Jan te Rijdt, Curator of Drawings, Department of Prints and Drawings of the Rijksmuseum, Amsterdam, and Evert van Uitert, Professor of Modern Art, University of Amsterdam, for their interesting essays. I extend gratitude also to the many authors of the catalogue entries whose names are to be found in the Note to the Reader. Maartje de Haan, Assistant Curator, Department of Prints and Drawings, was responsible for the organization of this project. She could not have done this job without the enthusiastic assistance of Margreet Wafelbakker, Curatorial Assistant, Department of Prints and Drawings, and Simone de Ruyter, intern from the University of Utrecht. The Chief Curator of Drawings Bram Meij was as always a great support. Furthermore I would like to thank Wendie Shaffer who took care of the English translations in the Rotterdam edition of the catalogues and Ruth Koenig who provided additional translations for this new edition.

Finally I would like to thank Lynn K. Rogerson and Joseph W. Saunders, Directors of Art Services International, for realizing this project in the United States of America.

Chris Dercon
Director
Museum Boijmans Van Beuningen, Rotterdam

INTRODUCTION
Manfred Sellink

Among the fifteen thousand or so drawings that make up the print room collection at the Museum Boijmans Van Beuningen is a rich assortment of Dutch drawings from the nineteenth century, mostly unknown by the public and largely unexplored by art historians. Although the history of the print room has recently been excellently documented and inventoried, it is natural in the light of this exhibition that some attention be paid to the origin of this part of the collection.[1] There is a striking difference between the provenance of works from the first half of the century, when traditionalism combined with the heyday of Dutch romanticism, and drawings from the period after 1850, when the so-called Hague school and the Amsterdam impressionists came to the fore.

The Boijmans Collection

The major portion of the drawings from the first half of the century was assembled by two people who left their collections to the Rotterdam museum, the Utrecht lawyer Frans Jacob Otto Boijmans (1767-1847) and the Rotterdam collector Hubertus Michiel Montauban van Swijndregt (1841-1929).[2] F. J. O. Boijmans' collection forms the basis of this museum. After considerable negotiation, the city of Rotterdam accepted the donation of the large collection of drawings and paintings from the Utrecht art enthusiast. There is some uncertainty as to the exact number of drawings contained in Boijmans' legacy. While one source reported that there were eight to ten thousand drawings in the collection, another source suggests that there were no more than three thousand pieces.[3] Arie Johannes Lamme, the first director of the Boijmans Museum, was given the task of separating the chaff from the wheat in this collection. The "Boijmans waste," as the later director Haverkorn van Rijsewijk cynically called it, was finally sold in two auctions. What this sale actually contained, at least "3,592 pieces, 55 art books and 88 folders with prints," will unfortunately never be known.[4] Only 2,962 sheets survived this sifting as documented in the first catalogue of drawings published three years after the museum was opened to the public in 1849.

Almost half of the drawings from the original collection as it was catalogued in 1852 fall under the heading of modern Dutch, German, and Flemish schools, containing the work of artists from 1700 to Boijmans' day.[5] Although little is known of the donor's preferences and collecting methods, it would seem that he had a lively interest in the work of Dutch masters of his time. It is known that he was acquainted with the painter of sea- and riverscapes Johannes Christiaan Schotel (1787-1838, see cats. 12 and 13) and owned twenty-six drawings by Schotel. Other masters who were exceptionally well represented in Boijmans' collection are Pieter Gerardus

van Os (1776-1839, cat. 7), Jan van Ravenswaay (1789-1869), James de Rijk (1806-82), Andreas Schelfhout (1787-1870, cats. 14-15), and Jacob van Strij (1756-1815, cat. 4).

The exceptionally large number of landscapes, cityscapes, and riverscapes in the Boijmans collection is striking. The almost complete absence of portraits, figure studies, and compositional sketches, and to a lesser extent drawn genre pieces, is so remarkable that it may be assumed that it indicates a clear personal preference and predilection in which the collector was not alone. Furthermore, to all appearances it would seem that in his old age Boijmans no longer could, or wanted to, follow the latest developments in art, even in the genres he loved. Of the younger artists who were then working in a looser style, such as Petrus Molijn (1819-49), Wijnand Nuyen (1813-39, cats. 26 and 27), and James Tavenraat (1809-81), only one drawing by Nuyen was present in the collection. Finally, it is worth noting that the nineteenth-century Italianates who could boast considerable popularity were scantily represented. There was not a single drawing by Josephus Knip (1777-1847, cats. 9-11) in the Boijmans collection and only two by Abraham Teerlink (1777-1857, cat. 8) and Hendrik Voogd (1768-1839, cat. 5).

In the night between February 15 and 16, 1864, a catastrophic fire ravaged the museum. Though almost the entire paintings collection went up in flames, nearly half of the portfolios of drawings were saved.[6] Apart from the German and Flemish works, drawings of all the foreign masters were destroyed by the fire. Of the northern European artists, the folders containing work of artists with surnames beginning with *C* through *S* were rescued. Because of their favorable position in the alphabet, more than ninety percent of the sheets made after 1700 were saved. Thus it can justifiably be said that of all the subcategories in the print room, the drawings from the eighteenth and nineteenth centuries most clearly carry the stamp of the original Boijmans collection.

After the Fire

Except for small donations, coincidental purchases, and, in some cases, pieces whose provenances can no longer be traced, there were hardly any additions to the early nineteenth-century collection after 1864. Although Boijmans had been an active collector of work by living masters, the young and somewhat impecunious museum did not follow his lead. Apart from a few incidental donations of more recent works, the museum acquired pieces from the sixteenth to the early nineteenth centuries, and these only on an extremely modest scale. In 1863 it even had been laid down in the museum's statutes that neither the director nor the museum board were to concern themselves with the purchase of contempo-

rary art. The collection of contemporary art was put into the care of the board of the Rotterdam Academy of Fine and Applied Arts. The later director and chronicler of the Boijmans collection, Haverkorn van Rijsewijk, recounts with understandable sarcasm how this group succeeded time and again, because of its dilettantism, lack of finances, mutual squabbling, and, above all, conservative attitudes, in buying the wrong works for exorbitant prices.[7]

The early directors of the museum themselves do not appear to have been very interested in collecting contemporary art. After the fire in 1864, this was certainly so; following this calamity the director A. J. Lamme and later his son and successor D. A. Lamme were occupied in trying to restore the dramatic losses sustained in the collection of old masters.[8] After the insurance payments had been exhausted, the museum again faced hard times. The annual budget was spent on acquiring older art, while the generosity of Rotterdam citizens was relied upon for more recent works. The donations from this source, however, were usually eighteenth- and early nineteenth-century works and scornfully described by Haverkorn as "a whole heap of drawings . . . the regrettable thing is that this stuff is added to by the over enthusiastic folk who also wish to present something to the museum."[9]

Before his appointment as director of Amsterdam's Rijksmuseum, F. D. O. Obreen was director of Boijmans Museum from 1879 to 1883. Lamme father and son had held the post as an honorary position while they ran the family business of buying and selling art, and Obreen simultaneously held the post of adjunct librarian-archivist for the local council. The esteem that the Rotterdam council felt at that time for the museum is evident in the fact that Obreen as director was granted permission to leave the archives at three in the afternoon in order to carry out his obligations as museum director until closing time one hour later, at four o'clock.

Haverkorn van Rijsewijk: A Dedicated Museum Director

Pieter Haverkorn van Rijsewijk, director of the museum from 1883 to 1908, changed the direction of the museum's collecting, concentrating mainly on building an important collection of contemporary art. In this area, Haverkorn made a few daring though often extremely expensive purchases for the collection of prints and drawings. His friendships with leading Dutch artists also induced many of them to donate works on paper to the collection of the print room.

In a highly personal account, published in 1909 shortly after he retired as museum director, Haverkorn described the history of the museum from its foundation to the close of his tenure.[10] Despite his frequently highly outspoken and not entirely unprejudiced remarks about certain people and works of art, the book reads easily and offers an important historical overview of the first sixty years of the museum's existence. Most striking is the zeal with which Haverkorn went about the task of building up a good collection of contemporary art.

Haverkorn, an ambitious man, succeeded in pushing through various changes in the organization of the museum. The most interesting in this context is his attempt to build a collection of prints and drawings by major contemporary Dutch artists. Sometimes he bought sheets using money from the annual budget, an example being the beautiful watercolor by Willem Witsen showing a view of Rotterdam's Leuvehaven (cat. 69). Although Haverkorn twice managed to obtain a sizable increase in the annual acquisitions fund, it was clear that other financial sources had to be tapped. Thus in 1895, with extra support from the city council, the museum bought eight drawings by the eminent Rotterdam artist Charles Rochussen. One of these is *Music Festival in Rotterdam July 15, 1854* (cat. 28). Appeals were also made for funds outside the city of Rotterdam. Haverkorn greatly admired the work of Matthijs Maris and managed to acquire a drawing by him in 1906, the chalk drawing of the head of a girl that was to go down in history with the title "Ecstasy" (cat. 47). This interesting but at the time highly overrated sheet cost the exceptionally large amount of six thousand guilders, making it one of the costliest acquisitions in the history of Rotterdam's print room. For half of the amount Haverkorn applied to the Rembrandt Society, which gave an interest-free loan, incidentally supporting for the first time in their history the purchase of a work by a living master.[11]

In those days the word "drawings" meant both line drawings as well as detailed watercolors and gouaches, which had the same impact as paintings. The enthusiasm with which Haverkorn collected was clearly driven by didactic notions. More than for aesthetic reasons, the director of the Boijmans Museum found the importance of a collection of painters' studies to lie in the insight they offered into an artist's working processes. In order to raise the standard of the collection, Haverkorn appealed to the generosity of many leading artists. Finally in 1898 the Boijmans Museum managed, largely thanks to Haverkorn's amiable manner of dealing with the foremost artists of the Hague school, to acquire at least 150 drawings that these artists donated to the museum.[12] In this exhibition works by Paul Gabriël, Josef and Isaac Israëls, Willem Maris, Albert Neuhuys, and Hendrik Johannes Weissenbruch all bear witness to the success of this campaign.

Haverkorn was not equally appreciative of all contemporary art. There are noticeably fewer works by the younger generation of artists who were active in Amsterdam from the mid 1880s (Breitner, Witsen, Van Looy, Veth) than by the older painters of the Hague school. There is a noteworthy letter written by the painter Breitner in 1899, in reaction to Haverkorn's request for drawings, indicating that the two were not on the best of terms: "How can a museum that does not own any work by me, have the audacity to ask me to donate studies I have made. I have absolutely no intention of giving that museum—or indeed any other such—work of mine, except for reasonable payment."[13] It appears that Haverkorn had no affinity whatsoever with symbolism and the more decorative schools of art that developed in the final decade of the century. It is only thanks to the friendship between the two that some works by Jan Toorop were acquired when Haverkorn was director. The most typical examples by Toorop (*Aurore, De Werkstaking, Godsvertrouwen,* and see cats. 64 and 65) were acquired later. No rep-

resentative work by such important artists as Theo van Hoytema and Thorn Prikker was acquired during Haverkorn's time, while by Verster there is only the atypical *Decorative Gourds* (cat. 71), which was presented by the Rotterdam Art Circle.

Dirk Hannema and the Montauban van Swijndregt Collection

After the departure of Haverkorn, the Boijmans Museum went into something of a decline. The new director, Frederik Schmidt-Degener, who held office from 1908 to 1921, was unable, because of restricted finances, to expand the museum's collection. Also, he had a preference for the old masters rather than contemporary works. With Dirk Hannema as director from 1922 to 1945, a basis was gradually laid for the international reputation that the museum was to build up in the postwar years. All of the existing departmental collections were added to, while the museum gained a sizable decorative arts section. The print room in particular profited greatly from the efforts of Hannema and his assistant, J. G. van Gelder. Through their efforts, a large part of the famous collection of old masters from Franz Koenigs was finally acquired for the museum in 1940, and thus the foundations were laid for the great reputation the print collection attained during the postwar period.[14]

Significantly less spectacular but very interesting in this context is the fact that in 1929 Hannema managed to secure the legacy of H. M. Montauban van Swijndregt for the museum. This legacy enriched the collection of eighteenth- and early nineteenth-century drawings by almost four hundred pieces. Even more so than Boijmans, Montauban van Swijndregt, an art enthusiast from a well-to-do family of artists and merchants, had a clear predilection for the work of the eighteenth century. His collection was also more evenly compiled. With the exception of his father and grandfather who both painted, no artist in the collection is represented by more than three or four drawings. Unfortunately perhaps, Montauban van Swijndregt was no less preoccupied with landscapes and cityscapes than Boijmans, which further increased this emphasis in the collection. The most noteworthy addition to the collection is certainly the lovely gouaches by Josephus Knip, several of which can be seen in this exhibition (cats. 9-11).[15]

Thanks to his excellent connections with wealthy Rotterdam collectors, Hannema also managed to steer smaller though not less interesting donations toward the museum. The art historian Knoef, for instance, donated a group of drawings by the above-mentioned Knip, while the descendants of Johannes Tavenraat enriched the collection with a particularly interesting sheet containing a handwritten autobiographical text on the verso. As for the second half of the nineteenth century, of great importance was the gift from the Rotterdam collector J. P. van der Schilden in 1925. The legacy from this leading local figure made a notable contribution to the paintings and drawings by artists of the Hague school. In the present exhibition his gift is evidenced by attractive sheets by Bosboom, Jacob Maris, Mauve, and Weissenbruch. There is also a quartet of drawings by Breit-

ner, Josef Israëls, Willem Roelofs, and W. B. Tholen of exceptional quality from the collection of A. J. Domela Nieuwenhuis, brother of the famous Dutch nineteenth-century Socialist politician. The collection was expensive because it contained a somewhat overrated number of old-master prints and a collection, unique in the Netherlands, of German romantic drawings, but it also turned out to hold several unexpectedly beautiful pieces from the nineteenth century.[16]

Despite this, nineteenth-century drawings were not actively collected by Hannema. Other areas of collection, more important ones for the print room, were rightly given more attention. At the same time, interest in this period on the part of art historians, both from the museum and the university, was particularly restricted.

After the Second World War

In the postwar period little changed in the pattern of museum collecting. Interest in Dutch nineteenth-century art in general had declined considerably and, as a result, for many years the collection was only added to by the occasional incidental offering. Furthermore, from the late 1950s the museum concentrated its efforts on acquiring contemporary art, which led to considerable neglect of nearly all sections of the print room. This policy gradually changed in the course of the 1970s. The limited budget available for acquiring new works made it increasingly difficult to raise funds to meet the sharp increases in the prices of old drawings and to obtain sheets that can compete with the masterworks already present from the Koenigs collection. However regrettable this may be, the scarcity of funds resulted in buying being directed toward lesser known and less expensive areas. In combination with a growing interest in Dutch nineteenth century art from museum specialists and universities, this again led to active collecting in this field.

Regarding the first half of the century, we have tried to fill up the gaps in the collection in an intelligent way. Good examples of Teerlink's (cat. 8) and Voogd's (cat. 5) Italian periods were acquired over the years, as well as an impressive prizewinning landscape by Hendrik Hoogers (1747-1814) who until recently was not represented in the collection. We also succeeded in adding typical examples of figure studies by Nicolaas Muys (1740-1808) and Wybrand Hendriks (1744-1831, cats. 1-3) to the very small number of such drawings in the collection. Of later generations important works by such artists as Jongkind, Thorn Prikker, and Toorop illustrate how it was possible to strengthen the collection at essential points during the last decades. Even the most recent acquisitions show that it is always possible to add to the collection, however good it may be, in a positive manner. In 1995, for instance, the museum was able to acquire an important group of five drawings from a private collector. Noteworthy among these are the comparatively rare detailed drawings by Jacob van Looy (cat. 57) and Eduard Karsen (cat. 68) as well as Willem Witsen's exceptionally beautiful sunny watercolor of the harbor in Dordrecht (*Voorstraathaven*, cat. 70). Let us hope that such acquisitions will continue.

1. See the extensive history by Ger Luijten, a curator with the print room at that time, in Luijten 1990, 6-16. An extensive overview of the collection of drawings from the nineteenth century is to be found in De Bodt/Sellink 1994 and De Bodt/Sellink 1995. For a more brief survey of the collection of paintings from this period, see Jansen 1987 (1800 to 1850) and De Bodt 1988 (1850 to 1900).

2. Not taken into account in this essay is a recent important loan of a vast collection of Dutch nineteenth-century drawings, mainly from the period up to 1875, from the Foundation Cornelis Ploos van Amstel-Knoef. In 1997 this foundation placed a collection of more than six thousand drawings and sketchbooks on long-term loan to the Boijmans Van Beuningen Museum. The nature of this collection, with its emphasis on studies and sketches, per-fectly supplements the print room's emphasis on finished draw-ings. Anticipating a detailed scholarly inventory that will be drawn up in the near future, no works from the Foundation Ploos van Amstel-Knoef have been included in this exhibition. Exhibitions and publications on the collection are scheduled from the year 2000 onward.

3. Luijten 1990, 6-7.

4. See Haverkorn van Rijsewijk 1909, 74-76.

5. See Lamme 1852, 36-62.

6. See in particular Haverkorn van Rijsewijk's cynical report of this disaster: Haverkorn van Rijsewijk 1909, 110-20.

7. Haverkorn van Rijsewijk 1909, 172-208. The board of the academy was given the sum of five hundred guilders to spend at the triennial Exhibition of Living Masters (held alternately in Amsterdam, Rotterdam, and The Hague). In turn the board of the academy delegated this task to a selection committee.

8. It was initially planned only to replace the Dutch old masters that had been destroyed in the fire. Occasionally exceptions were made. For example, Lamme bought works from the romantic school by Dutch artists such as Koekkoek, Nuyen, and Molijn. Most striking is the acquisition of two history pieces by Ary Scheffer, which cost the museum the huge amount of 21,232 guilders, almost one-seventh of the total insurance claim the museum received. Perhaps worth noting is the fact that the then-director, A. J. Lamme, was a first cousin of the painter Scheffer, who had died in France in 1858. Compare Haverkorn van Rijsewijk 1909, 149-50.

9. Haverkorn van Rijsewijk 1909, 166.

10. On Haverkorn as a museum director in general, see Saskia de Bodt's essay in De Vries 1996, 46-82.

11. Haverkorn van Rijsewijk 1909, 335-36, and Stroo 1992, 2. The Rembrandt Society lent the sum of three thousand guilders, to be repaid in three annual installments. The other half of the total was raised by gifts from seventy-one Rotterdammers.

12. Compare the introduction by Saskia de Bodt: "Quelque chose de diabolique: Sketches, Scribbles, and Watercolors" and Haverkorn van Rijsewijk 1909, 344-49.

13. Letter from Breitner to Haverkorn van Rijsewijk, November 8, 1899, in the Rijksprentenkabinet, Rijksmuseum, Amsterdam. Additionally painful is the fact that the art dealer E. J. van Wisse-lingh had in 1898 unsuccessfully tried to sell a painting by Breit-ner to the Boijmans Museum at a reduced price; Bergsma 1994, 58. I thank Maartje de Haan for this information.

14. Luijten 1990, 8-12. In July 1999, on the occasion of the 150th anniversary of the Boijmans Museum, an elaborate study on twelve of the most important private collectors whose collec-tions have enriched the museum will be published. This will include chapters on Boijmans and Koenigs. On Hannema see the recent and unfortunately not all too satisfactory biography, Mosler 1995.

15. Compare the catalogue of drawings from the Montauban van Swijndregt legacy, Drost 1944. In 1987 there was a small exhibi-tion in the museum dedicated to the Montauban van Swijndregt collection, which was accompanied by a brochure written by Jacqueline Burgers.

16. Compare Luijten 1990, 8-9 and 15, note 29.

Dutch Drawings in the First Half of the Nineteenth Century

Robert-Jan te Rijdt

Dutch Sources on Draftsmanship, c. 1780-1850

Before about 1850 few Dutch artists revealed their inner thoughts about what drove them to paint and draw. In the meager written sources—letters, diaries, and autobiographical writings—Dutch artists almost always limited themselves to factual observations. More profound feelings, such as the motivation behind a work, the choice of subject, the decision to place certain details in a scene, the ideas that the work was intended to communicate, and stylistic and aesthetic choices are subjects about which little is known. Not until the second half of the century are there a large number of intimate communications to friends and colleagues regarding what inspired an artist, the desire to excel, comments on artistic struggles, vain efforts, and rare triumphs. The best-known example is the unique series of letters written by Vincent van Gogh to his brother Theo. And also from the circle of the Marises, the Weissenbruchs, Breitner, Israëls, and others from the years 1850 to 1900 are many thoughtful discussions about the struggles of artists.

In a very few cases, accounts of a less summary and reserved nature have survived from the early period. One of the best examples is a letter of 1807 in which Abraham Teerlink tells his friend and colleague Arnold Lamme about his stay in Paris. "I am at present extremely busy making a copy in oils of the most beautiful landscape that I have ever seen by Hobbema. Before I began this project I was making a lot of life studies or I would work in my room—for I am, thank God, entirely free and not under anyone's supervision."[1] The tone of this letter, however, forms a sharp contrast to the emotional outpourings of many artists later in the nineteenth century, of which almost any random example reveals a difference. The painter of church interiors Johannes Bosboom wrote to a colleague in 1865 in connection with a stay in the country: "When lodging in the Utrecht countryside I had the opportunity to grow more kindly disposed to the stables, the various parts of the farm, and so forth. I made sketches that later ripened into drawings, and Van Rappard wanted to have them all. Other collectors shared his opinion and in this manner the churches got somewhat pushed into the background. But that doesn't mean I've forgotten about them—far from it!"[2] Unfortunately only the examples that have been preserved through time can be compared, and these are few. Presumably a great number of artists' letters and writings have simply been lost.

Artists' writings on the subject of art have always had a didactic purpose and were therefore—certainly in the early days —written in as general and neutral a fashion as possible. The artist was not chiefly concerned with his or her own work. Classical art, drawings of nude models, and generally accepted ideals, particularly when this concerned the choice of subject and the representation of ideal beauty, were the major themes. In by far the majority of cases there is only a slight reference to the Dutch artist's daily practice. Since almost all of these accounts were written in connection with awards being offered by academies, they are chiefly concerned with painted history pieces. On a topic such as landscape, for example, after the publication of the book *Het groot schilderboek* by Gerard de Lairesse in 1707, there were only a few references to be found in artists' handbooks. These practically oriented books dealt chiefly with such topics as perspective or the preparation of colors and paint. An insignificant book for young landscape artists appeared in 1823 by E. Maaskamp, after which it was not until 1841 that B. C. Koekkoek filled the gap with his important but fragmentarily presented recommendations and theories titled *Herinneringen en mededeelingen van eenen landschapschilder* (Recollections and recommendations of a landscape artist).

An appreciation of drawing as an independent branch of art and the rise of the professional drawings collector began to grow in the eighteenth century. During this period writings about drawing tended to champion one theme, "drawing as the mother of the arts." It was emphasized how extremely useful it was to be able to draw well, essential for all forms of art, for scientific work, and especially for the skilled crafts. Particular interest was given to this topic as the Netherlands was experiencing a period of economic malaise at the end of the eighteenth century. What was needed was an industrial revival, and a massive program for teaching drawing was seen as an important condition for the economic revolution. After all, it was argued, drawing was universally applied in decorating houses: from wallpapers and decorations on fabrics, from painted pottery and porcelain (at that time largely imported) to the most insignificant suppliers such as confectioners making sweets for the Saint Nicolaas festival, everyone needed to know how to draw. Furthermore, learning to draw was for the middle class a way of educating "good" taste, which would in turn be interpreted in a preference for tasteful industrial products. Thus the summons to rebuff the economic decline from the years 1770 to 1800 was usually accompanied by an appeal to take drawing lessons. The result was that tuition-free drawing schools were established for young people. There, side by side, sat the artists of the future with tomorrow's craftspeople, the masons, carpenters, cabinetmakers, metalworkers, and tailors.[3] The drawings that students made during their lessons—copies from prints and from the drawings of others, drawings of classical statues and at last of nude models—are not discussed in this essay.

Half a century later people emphasized quite different values in draftsmanship. The Protestant minister and art lover K. N. Meppen, writing in 1846, had the following to say: "She [art] teaches us to observe beauty. She trains our taste. She offers us a pure and noble delight that inclines us toward all that is good."[4] The draftsman learns to observe more carefully all that man and nature have created. The chief aim of the artist is to perceive beautiful shapes, to idealize them, and to represent them. Draftsmanship trains the taste whereby it becomes possible to make a true and worthy realization of the beautiful. By studying nature the artist is prevented from allowing distasteful artistic approaches to taint his or her imagination. "Only what is beautiful is also true," and in one glance the trained draftsman becomes able to distinguish the artificial from the natural, the false from the true, and the truly beautiful from the apparently beautiful. Finally, it was understood that the "the hours dedicated to Art are hours of immeasurable delight." Above all, "True art ennobles the heart because it enkindles, nourishes, and strengthens a love for what is truly beautiful, which is so closely allied to what is morally good."

Scarcely anything is known about the ideas of eighteenth- and early nineteenth-century artists and collectors concerning different types of drawings and drawing styles as they are distinguished and evaluated today. One great exception is formed by the timber merchant, artist, and avid collector Cornelis Ploos van Amstel (1726-98). He wrote a short article in 1772, on the occasion of an auction of drawings, in which he defended making sketches. At the time, and this was to last well into the nineteenth century, by far the favorite type of drawings in collectors' circles were the finished drawings that were made with great attention to detail and preferably colored. However, argued Ploos, the quick sketch shows the direct thoughts of an artist. It is an unforced style that makes it possible, as he put it, to permit "the fire of his imagination with more freedom and strength to shine through in its valiant and vigorous outlines." It was impossible to achieve this in the carefully controlled drawings that were specially made for collectors, which are in fact paintings on paper. In making these detailed drawings the artist was forced to subdue "the abundance of genius" to the laws of accuracy and precision of production. However, it is possible to discover in sketches "the Spirit of Artists as if they were close to us, manifesting itself, as it were, with a kind of freedom and common nature, through which the lover of art may be led to reflective judgments, yea even to new discoveries concerning art."[5]

In voicing this opinion Ploos aligned himself with an international company of art lovers that included Denis Diderot and Joshua Reynolds. Although Ploos published other articles in which he advocated aesthetics and the appreciation of drawing, it cannot be sufficiently regretted that he never wrote his promised essay on the art of drawing. He announced that it would be "a short description of the drawing styles" and an examination of Dutch drawing "according to the types and tastes that exist."

One may assume that a great many artists and collectors toward the end of the eighteenth century considered different types of drawings, different styles, and collecting drawings. Such topics were often discussed at the meetings of cultural societies, sometimes at the home of a collector. At these gatherings drawings and prints would be passed from hand to hand and appraised (fig. 1). The selection of works was almost always based on a theme or a particular artist. Puffing quietly on pipes and sipping port, the group would listen to a talk from one of their members, usually a well-known collector or artist, after which they would converse while looking at the prints and drawings.[6] Such meetings remained highly popular until well into the nineteenth century and are still to be found occasionally even today.

Different Types of Drawings: The Selection Process

There are far more types of drawings than is the case with paintings. For example, a drawing might be made as a sketch for an artwork, but the term also covers all the stages from sketch to finished work. The way in which an artist works determines the number of sketches made during the production of a painting. Paintings are almost without exception works that the artist considers finished and worthy of public showing. Collectors evaluate paintings on grounds of subject matter, composition, execution, size, and condition. Unfinished paintings or the sketches and studies in oils that were sold in studio auctions quickly went out of circulation, presumably neglected and lost or destroyed by other artists. This was not the case for drawings in the nineteenth century. During the eighteenth century, with its pronounced preference for highly detailed drawings, people apparently had no scruples about converting a seventeenth-century sketch into a "finished" sheet.[7]

The study of old auction catalogues is a constant reminder of how enormous is the percentage of drawings that have been lost over the years. For example, there are today about thirty watercolors by Aert Schouman illustrating flowers, plants, and fruits, while at his death in 1792 there were at least 268 pieces in his estate. Of the 168 figure drawings by Pieter Gerardus van Os, which in the auction of his estate in 1839 went to various bidders, there is today not one in a Dutch museum or a large private collection. Adriaan de Lelie was highly proficient in producing life drawings for his countless genre scenes; at one time all of his studies were assembled in about eight portfolios and auctioned with the estate of his far-from-successful painter son. Where these drawings are today is a mystery.

The drawings just mentioned had passed through two selection procedures. The first was that of the artists themselves. They had the opportunity to sort through and destroy work and in this way affect the idea that posterity would have of their oeuvre. The preservation of work is also affected by incidental circumstances such as whether one was the kind of person who liked keeping records or simply liked keeping things, or by an accidental fire, or by settling abroad. For example, in 1807 when he was thirty-one years old, Abraham Teerlink went to Rome on an educational trip. He stayed in Italy and married an Italian woman. When he died his Italian relatives inherited the studio estate so that today there is scarcely any of his work in the Netherlands. The family, inheritors, or pupils of an artist, however great his reputation, were in a position to decide what they

were going to do with his or her work: what they kept, what they auctioned, what they destroyed. The auction of the estate of an artist did not necessarily mean that every drawing was put up for sale. This is demonstrated in the sale in 1802 of the studio estate of the Amsterdam painter and draftsman Jacobus Buys, the catalogue of which only contains his more finished drawings. Apparently the sketches and preliminary studies were not auctioned, and today there exist only a few sketches by Buys.

Sometimes an artist's estate, or much of it, remained for a long time in the family. In such cases, circumstances also played an important role. Relatives, especially distant relatives inheriting a studio estate, were not necessarily people who appreciated drawings. Until well into the nineteenth century no museums specialized in protecting the sketches and drawings of artists in the way that print rooms do today. Despite this, the almost complete estates of David Pierre Giottino Humbert de Superville, Alexander VerHuell, Ary Scheffer, and Paul Tetar van Elven ended up in the nineteenth century in museums in Leiden, Arnhem, Dordrecht, and Delft. Such collections provide a greater understanding of the work of these draftsmen (and of their pupils, who are sometimes included in the collections) than do the "representative" works in their oeuvres, that is, what they sold to collectors. Nor is it a coincidence that only recently have the studio estates come on the market of several artists whose drawings are now easily accessible, for example Josephus Augustus Knip and Hendrik Voogd (fig. 2).

Documentation of studio work that was still intact was very important, since this established who was the creator. For example, toward the ends of their lives Henriette Ronner-Knip, Johannes Bosboom, Barend Cornelis Koekkoek, and Willem Roelofs signed a great deal of their previous work that was in their studios. After an artist died his or her work could be given an authenticated stamp from a studio or an estate, sometimes a stamped signature of the artist. This would usually be supervised by the executor of the will or by one of the artist's children. This was very common in France in the second half of the nineteenth century and was the case for the estates of drawings by Chasseriau, Corot, Courbet, David, Delacroix, Doré, Manet, Millet, Rodin, and Jongkind. In the Netherlands there was less enthusiasm for documentation, and less interest was shown in drawings and sketches from a studio estate. In the nineteenth century the only cases where a certified stamp was given were for work by Matthias Ignatius van Bree, Johan Daniel Koelman, and Anton Mauve. The relatively small number of sketchbooks from the eighteenth and nineteenth centuries that have survived is presumably attributable to this lack of interest. The sixteen sketchbooks dating from 1845 to 1870 by the relatively insignificant draftsman Jan Diederik Kruseman, Jr., until recently owned by his family, tell us more than the thirty sketchbooks by the fanatical sketchbook draftsman Johannes Tavenraat, from roughly the same period, also until recently owned by his family and now largely by the Rijksprentenkabinet in Amsterdam.

Once an artist's work was put on the market by family and inheritors, the next selection was made by collectors. They had the final decision about what drawings would be saved. Collectors made a more

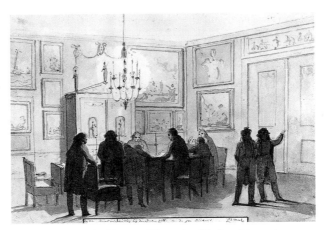

Fig. 1. Christiaan Andriessen, *Discussing Works of Art at the House of Mr. Goll*, c. 1808. Stedelijk Museum Amsterdam

Fig. 2. Hendrik Voogd, *Aqua Claudia*, c. 1810. Rijksprentenkabinet, Rijksmuseum, Amsterdam

conscious choice but were swayed by factors such as current fashion. In this way collectors have determined to a great extent the picture that later generations have of the art of the past. Collectors would document and look after their possessions in relation to the amount they had paid for drawings and other work. Unwanted types of drawings and objects would be rejected by the serious art lovers, whereby they would come into another circuit where they were less appreciated and cared for and become doomed to partial or total oblivion. In practice this applied to sketches and documentary drawings, which were less valued in their day than they are now. There was a gradual disappearance of paintings and drawings that depicted topics that became unfashionable, such as nineteenth-century scenes representing piety and other themes that came to be judged as over-sentimental. In catalogues for exhibitions and auctions and in illustrations reproduced between the years 1835 and 1860, there is a superfluity of old men or women at prayer and of hermits and saints, of which very little appears to have survived.

There are a great number of artists by whom a substantial painted oeuvre has remained but few or no sketches connected with these works. No drawings are preserved from several seventeenth-century artists, the most notable being Johannes Vermeer and Jan Steen. It was not as common to produce drawings for collectors then as in the eighteenth and

nineteenth centuries. Yet there is a large number of drawings by Rembrandt, who had an active group of pupils trying to equal his style of drawing. After his death Rembrandt's drawings were immediately collected and preserved with great care by his students. There are also countless painters from the years 1780 to 1850 whose studio drawings are only fragmentarily preserved. Some examples are the prolific portrait and genre painters Adriaan de Lelie, Jan Ekels, Jr., Charles Howard Hodges, Jan Adam Kruseman, Jean Augustin Daiwaille, and Petrus van Schendel. Various draftsmen are represented in the collection of the Boijmans Museum with finished drawings or watercolors of whom the study material and compositional sketches appear to have been lost, for example Jacobus Abels, Wybrand Hendriks, Hendrik Hoogers, Bartholomeus van Hove, Jan van Ravenswaay, James de Rijk, Martinus Schouman, Gilles Smak Gregoor, and Wouter Verschuur.[8] Nicolaas Muys is known for a large series of figure studies for his paintings and watercolors, all from the same book that has been taken apart. There are no compositional sketches or other studies by him. For most draftsmen and painters in the eighteenth and first half of the nineteenth centuries there exist detailed drawings made for collectors and figure studies by a large number of them, but compositional sketches and detail studies by only a very few. Far more drawings of this sort by artists from outside the Netherlands have been preserved.

A Brief Overview of Various Genres

In the second half of the eighteenth century and the first decades of the nineteenth there was a marked growth of interest in drawings among collectors.[9] Furthermore, during the first half of the nineteenth century there was a gradual increase in the number of artists in Holland.[10] The demand from this market was not only for art of the Golden Age but also for work by contemporary artists. Although the variety of genres being produced in drawings decreased at the beginning of the nineteenth century, there are unfortunately no precise statistics about this. Roughly speaking, it can be said that draftsmen tended to concentrate more on Dutch landscapes, cattle pieces, and "modern" scenes, which offered tableaus from contemporary life, than on other forms. The tendency to produce work for collectors was born partly out of necessity. Many of the skilled crafts that were practiced by young or less gifted painters no longer existed, and artists had to look for other sources of income. They turned to giving private lessons in drawing and supplying "small-time" collectors.

Landscapes

Remarkably few works in oils have survived by the artists who between 1780 and 1820 depicted the Dutch landscape. In contrast, countless drawings and watercolors exist by the artists who are generally listed as eighteenth-century and who lived and worked mainly in Haarlem and Amsterdam. They include Egbert van Drielst, Jan Hulswit, Pieter Barbiers, Hermanus van Brussel, Carel Lodewijk Hansen,

Fig. 3. Gerrit Jan Michaelis, *Wooded Landscape*. Boijmans Van Beuningen Museum, Rotterdam

and Hermanus Fock. This generation of artists produced relatively few paintings; furthermore, many of these are presently in circulation as seventeenth-century work. Although each succeeding generation that, in the nineteenth century, chose to paint landscapes claimed to have found the true means of portraying the beauty of nature, this can truly be said of this early group. Before them, making drawings of landscapes was an occupation that, as far as can be known, largely took place in the studio. The landscape artists who began working around 1780 and who had trained in the workshops making painted wall hangings set out in the summertime into the countryside and made spontaneous impressions of nature. A considerable number of these drawings have been preserved, but there is nothing of the sort from the generation that preceded them. During the winter months these life sketches would be worked out as carefully compiled compositions, sometimes in two or three copies, and this was entirely in accordance with tradition. Their great examples were Hobbema and Ruisdael, particularly in the manner of painting, the composition, and choice of motifs. These detailed drawings that went to collectors around 1780 were of a style that was less schematic than most seventeenth-century drawings. Both inspiration and motifs were sought in the dunes near Haarlem and in the still-unspoiled countryside of the province of Drenthe.[11] There were also artists working independently. One of the most important of these was Jacob Ernst Marcus, who died at an early age. His unexpectedly spontaneous landscapes were mostly made in the dunes and the region of Twente, in the northeast Netherlands.

Another important group of landscape artists worked around 1780 to 1820 in Dordrecht. There, Jacob van Strij made his sometimes quite literal imita-

tions of the landscape paintings with cattle by Albert Cuyp, the famous seventeenth-century painter, and his fellow townsman. Van Strij also developed a style in other types of landscape, such as winter landscapes or landscapes with farmhouses, using a predominance of heavy contours based on Cuyp's artistic vocabulary and on that of Anthonie van Borssum. Van Strij had many pupils and followers including Johannes van Lexmond, Gilles Smak Gregoor, and Abraham Teerlink, but it is not clear whether they imitated him or looked directly at the work of Albert Cuyp. Van Strij made many copies of works by Cuyp, but very little is known about the work of his pupils in this respect.

The next influential generation of landscape artists worked in Amsterdam. The drawing style of members of this group was very similar and determined the way landscape drawings looked for the years roughly between 1810 and 1830. They were Albertus Brondgeest, Hendrik Gerrit ten Cate, Daniel Kerkhoff, Gerrit Lamberts, Gerrit Jan Michaelis (fig. 3), Cornelis Sibille Roos, Abraham Johannes Ruytenschildt, Cornelis Steffelaar, and Pieter George Westenberg. Some of them should be classified as highly competent amateurs, since they also had other jobs; for example, Brondgeest and Roos were both organizers of art auctions. With the exception of Kerkhoff all of these artists were born between about 1780 and 1800. Their landscapes were less lively and more serene than those of their predecessors. The work of earlier artists contains the active play of curving tree trunks and branches, but this group had a preference for the rhythm of the straight lines of birch and beech trees. Their compositions are dominated by horizontal and vertical lines, while the previous generation were fond of using diagonals. The style of drawing also changed: in place of fairly emphatic contours in black chalk came lightly applied areas of wash in silvery gray, soft brown, or pale watercolor tones. This delicate manner of working is modeled on an idea then current in connection with drawings by Ruisdael and his pupils. There also was a striking predilection for compositions in which the trunks of trees were cut off, as it were, by the upper edge of the picture.

Some of the artists in this group were highly active as topographical draftsmen. In search of inspiration they would often choose the province of Gelderland, where great favorites were the small city of Rhenen and its surroundings and places just across the German border such as Kleve and Bentheim. Düsseldorf too, where there was a fine and accessible collection of old-master works, became a popular place to visit.

After this group of draftsmen and painters, the center of landscape art until the end of the nineteenth century was no longer Amsterdam but, after a brief intermezzo in the Gooi district south of Amsterdam that was largely the province of cattle painters, The Hague. There, in the early decades of the nineteenth century, Simon Andreas Krausz had kept the art of landscape painting alive. He worked in a highly independent manner and was alternately praised and vilified. There was also Andreas Schelfhout, a self-taught artist who had learned his skills in the workshop of a theater-set painter and who as early as 1820 was a highly regarded landscape painter working in the Amsterdam style. He taught a group of pupils in The Hague who went on to practice various disciplines. Two of them, the highly gifted Wijnand Nuyen and Antonie Waldorp, made a study trip through France and Germany in 1833. They found new ways of expression in the French romantic work of Eugène Isabey, Théodore Gudin, and Eugène Lepoittevin. They already knew something of this style of drawing from prints they had seen, particularly lithographs. When they were in Paris they were able to study the French use of color and brushstroke. In about 1836 Nuyen again visited the northern coast of France, the mecca not only for French artists but also for a number of British romantic landscape artists such as Samuel Prout and Richard Parkes Bonington.

When these new techniques were applied to traditional Dutch themes, the result, certainly around 1830-40, met with far from universal approval. In the early years, Dutch art critics were most suspicious. However, following the premature death of Nuyen, his new style was soon accepted and was regarded by contemporaries as romantic. The Dutch romantic movement was a variation on a European theme rather than the product of a romantic attitude of mind, although incidental artists such as Albertus van Beest and Johannes Hilverdink sometimes approached very close.[12] Romanticism is to be seen above all in The Hague where it flourished because of the work of Schelfhout, who enthusiastically embraced the style of his former pupils. This movement continued via Schelfhout's many subsequent pupils and followers. The result was a vast series of summer and winter landscapes, cityscapes, and waterscapes, of which the drawing and colors were at first regarded as far too loose and unnatural. A contemporary critic complained that these artists could never have been distinguished from one another were it not for the signatures on their work. Their style was somewhat syrupy, placing great emphasis on downward curving lines, for example washing hanging out a window, the outline of windmills, or the backs of figures. This style of painting was perpetuated by members of the Pulchri Studio that was founded in 1847, its members generally having been born between 1810 and 1820.[13] It remained in fashion until about 1860 when the unaffected painting methods of the French Barbizon school became widely known in the Netherlands. The artists who in the second half of the nineteenth century were to have great influence as the painters and draftsmen of realistic Dutch landscape scenes were trained at the close of the romantic tradition: Willem Roelofs, Johan Barthold Jongkind, Matthijs and Jacob Maris, and Jan and Hendrik Johannes Weissenbruch.

As for traveling abroad in order to gain inspiration, the example of Nuyen and Waldorp who went to Brittany and Normandy was not imitated by many Dutch artists. Indeed, it is clear from the work of the

Fig. 4. Petrus Johannes Schotel, *Coast at Boulogne*, 1829. Rijksprentenkabinet, Rijksmuseum, Amsterdam

Fig. 5. Wijnand Nuyen, *Coast in Brittany*, 1837. Private Collection

seascape painter Johannes Christiaan Schotel and his son and pupil Petrus Johannes Schotel that it was not enough simply to visit the district where new developments were taking place; the artist also had to be truly open to new ideas. There are two watercolors drawn from life by P. J. Schotel in 1829 at Boulogne-sur-Mer of which one has an exceptional tone that is unusual in Schotel's work but is probably entirely attributable to the setting (fig. 4). The contrast in emotional content with a similar work by Nuyen, showing a rocky cliff in the same region, is striking (fig. 5).

In search of inspiration from foreign landscapes, many Dutch artists during the years 1820-30 settled for a trip through the highly picturesque valley of the Maas. Later it became fashionable to visit the more majestic Rhine valley and its intimate branches such as the rivers Ruhr and Ahr. Switzerland also became a favorite place to visit. Barend Cornelis Koekkoek pursued his love of the hilly German landscape, finally settling in Kleve in 1836. His school of painters not only attracted Dutch artists such as Johannes Tavenraat and Willem Bodeman as students, but also meant that many Dutch artists would stop off at Kleve on their travels to Germany and farther away. However, the Dutch artists adopted very little from their host land, either from the Nazarenes or German romantics.

During the first half of the nineteenth century Britain was scarcely visited by Dutch artists. Therefore the influence of outstanding British watercolor artists on Dutch artists was nil, with the exception of Charles Rochussen in about 1848-50. British and German drawings were rarely interesting to Dutch collectors at this time, although French drawings were popular.

Cattle Pieces

There were few specialists in painting cattle in the eighteenth century with the exception of Jan van Gool, now better known as an artists' biographer. Toward the close of the century, the genre's popularity began to blossom. At this time many artists turned to this subject because of a revival of interest in seventeenth-century history and the growth of landscape art. Lauded above all was the painter Paulus Potter. There were also followers of the work of Cuyp, Berchem, Adriaan van de Velde, Dujardin, and Van der Does. Cuyp had his devotees in Dordrecht with Jacob van Strij and his pupils, and elements of the other artists can be found in the work of Jan Kobell (fig. 6), Pieter Gerardus van Os, and Wouter Johannes van Troostwijk. The remarkably lightly painted work by the latter is often cited as the earliest example of a fresh observation of Dutch nature. Van Troostwijk was fed up with the endless comparison made by art critics between the work of his time and that of the seventeenth century and reputedly had the following to say: "I much admire Potter, Du Jardin and Van de Velde; but I pursue the simple beauties of nature on my own. If you wish to compare my work, compare it with what I made when I was younger; or preferably, compare it with the beauty of nature."[14]

Like the landscape artists, the Amsterdam painters of cattle pieces settled in a favorite village or frequented one. They chose Hilversum and the nearby 's-Graveland. Best known of this group was Pieter Gerardus van Os, but also important were two artists who were natives of Hilversum, Jan van Ravenswaay and James de Rijk. The landscape around Hilversum was varied, having woods and meadows filled with cows as well as heathery turf where a great many sheep were kept. These painters of cattle pieces were joined for shorter or longer peri-

Fig. 6. Jan Kobell, *Landscape with Cattle*. Boijmans Van Beuningen Museum, Rotterdam

ods by many landscapists, so that in the years 1815-30 the small village of Hilversum always had at least fifteen artists among its population.

In The Hague too cattle pieces flourished together with landscapes, thanks to such artists as Simon Andreas Krausz, Hendrikus van de Sande Bakhuyzen, and the influential Simon van den Berg who was also one of the teachers at the academy in the city.

Scenes from Contemporary Life

There was a fairly clear development in landscape and some other styles, but in the case of what is termed "modern" genre, that is scenes from contemporary life, this development is not as visible. Aside from many preliminary drawings for book illustrations, the genre style was not practiced by many draftsmen at the end of the eighteenth century. Themes were borrowed almost exclusively from the seventeenth century, although contemporary dress and often the posture of people in the drawings gave them an unmistakably different appearance. In most cases the persons represented are of the lower classes, whose work clothes differ less from those of the past than do more fashionable garments. The clothing style depicted combines both contemporary elements and garments of a bygone age.

In about 1780-1800 there were good genre painters and draftsmen at work in various cities, including Amsterdam, Haarlem, The Hague, and Dordrecht. Most of them produced paintings, detailed drawings, and watercolors. Here, just as in other types of painting, there are exceptions. For example, no genre drawings by the productive genre painter Adriaan de Lelie are known to exist, and there are no genre paintings by such artists as Jacobus Perkois.

The influence of drawing societies small, often informal groups where artists practiced life drawing from clothed models—was undoubtedly important. There are various examples from different cities of painted and drawn genre scenes with figures that are directly copied from these model studies. Examples can be found in the work of Jacob Ernst Marcus and Abraham van Strij and their pupils. There are also many examples in which this may be assumed because of the great similarity in the figure types, although such a connection cannot yet be proven. In this category is the work of Jan Ekels, Johannes Huibert Prins, and Cornelis Kruseman. Until well into the nineteenth century a strong affinity existed between life studies made at the drawing societies and genre scenes. This is particularly true between 1820 and 1840 among Utrecht artists such as Pieter Christoffel Wonder, Jan Lodewijk Jonxis, George Gilles Haanen, and Willem Albertus Haanebrink, and after about 1850 among artists in The Hague such as Jan Weissenbruch and Jacob Maris.[15] Figure studies made in drawing societies were not only used in genre scenes; they frequently appear as staffage in landscapes and cityscapes.

As well as preliminary drawings and studies for painted genre scenes and life studies, many watercolors and drawings were made specifically for collectors. Certainly until about 1835, many drawings that are best described as detailed life studies are actually genre scenes containing one or two figures based on

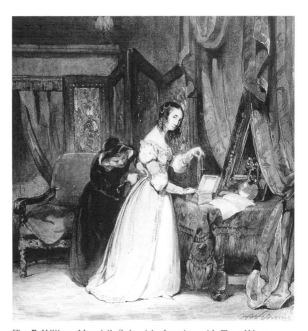

Fig. 7. Willem Hendrik Schmidt, *Interior with Two Women*. Boijmans Van Beuningen Museum, Rotterdam

studies made at a drawing school or society, which were then transformed into pieces that appear to be drawn from life by the addition of various attributes and a detailed background. Such drawings were made especially by Abraham van Strij, Gijsbertus Johannes van der Berg, and Pieter Christoffel Wonder and his followers.

More ambitious compositions were made in many styles and types. In about 1800 there was a pronounced imitation of Adriaen van Ostade's genre pieces in Haarlem and Leiden. Pictures of people in elegant contemporary company were made in Amsterdam by Jan Ekels and Johannes Jacobus Lauwers, in The Hague by Johannes Hari and Louis Moritz, and in Rotterdam by Nicolaas Muys and Dirk and Jan Anthonie Langendijk. In almost all of this work a lightly veiled neoclassicism can be detected. Certainly more provincial but equally ambitious is the work of the Dordrecht draftsmen of the period 1815-25 such as Pieter Fontijn, George Adam Schmidt, and Michiel Versteegh, who freed themselves from the scenes of old Dutch life that were the specialty of Abraham van Strij.

In this work the draftsmen were only concerned with drawing, as it were, paintings on paper, with emphasis on contour. After about 1840 this was much less the case, when genre scenes acquired a romantic mood. In the drawings of Ary Scheffer, Reinier Craeyvanger, Petrus Marius Molijn, Willem Hendrik Schmidt (fig. 7), George Gillis Haanen, and many others, the loose brushstroke removes their work stylistically from their paintings far more than was so with the previous generation. The influence of the Belgian genre painters and draftsmen such as Ferdinand de Braekeleer, Jean Baptiste Madou, and Charles van Beveren can not be overstated here.

The number of genre scenes, particularly small-size ones made for collectors, seems to have increased around 1830. The subjects became anecdotal or sentimental. The illustration of literary themes never became very popular in the Nether-

lands as it did in both France and Germany. The preference in the Netherlands was to quote and paraphrase the seventeenth-century painters using the idiom of genre. Around 1850-60 such artists as Lambertus Johannes Hansen, Hubertus van Hove, Johannes A. B. Stroebel, and many others expressed in painting and drawing their veneration for their famous predecessors from the Dutch Golden Age such as Pieter de Hoogh and Nicolaes Maes. The costumes and attributes of the figures in their pieces are sometimes difficult to date precisely. Far less ambiguous is the work, also from this period, of David Bles, Herman F. C. ten Kate, Henricus Engelbert Reijntjes, Charles Rochussen, and somewhat later Alexander Hugo Bakker Korff. They took great pains to set their work in the seventeenth or eighteenth century, and it can be classified with the group discussed below, namely historical genre.

Still Lifes and Seascapes

In the late eighteenth century there was a slight increase in the number of draftsmen specializing in flower and fruit still lifes and in seascapes. Watercolor still lifes by a large number of professional artists, including Jan van Os, Willem van Leen, Gerard van Spaendonck, Anthonie Oberman, Gerardus J. J. van Os, Arnoldus Bloemers, and Albertus Jonas Brandt were inspired by the example of the famous eighteenth-century flower painter Jan van Huysum. Detail studies by most of them exist of flowers or fruit, but there are scarcely any compositional sketches for their paintings and watercolors except in the case of Van Leen. Furthermore, many others attempted this style including amateur ladies and gentlemen of the nineteenth century. A great many of their watercolors have been lost because they were framed and hung on the wall, whereby they were subjected to sunlight and faded. The still life with objects, in contrast to those produced in France and despite the many breakfast and banquet still lifes from the greatly admired and imitated seventeenth century, was scarcely produced in the Netherlands until well into the nineteenth century.

The seascape remained the prerogative of a limited number of very active artists who both drew and painted. Johannes Christiaan Schotel, who worked until 1838 and enjoyed great international renown, was the source to which many of his contemporaries turned when painting their own seascapes, with either calm, choppy, rough, or stormy waters, the four possibilities then available. Occasionally there would be a shipwreck scene, but this was always in the distance so that the artist did not have to portray the gruesome details. Around 1835 the seascape was embraced by more avant-garde artists. Wijnand Nuyen, Andreas Schelfhout, Antonie Waldorp, Louis Meijer, Frans Arnold Breuhaus de Groot, and Albertus van Beest (fig. 8) not only applied the romantic idiom but even introduced from time to time a wholly romantic subject. They painted shipwrecks close by, with panic-stricken faces of the drowning. Gradually, too, the seascape presented more imagined seventeenth-century ships and situations. With regard to Schotel and his conservative followers this was a new phenomenon that fitted closely with the rise of the historical genre scene.

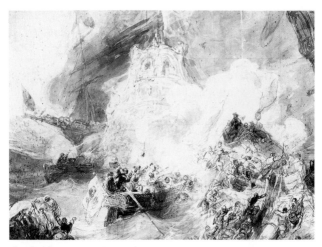

Fig. 8. Albertus van Beest, *Seventeenth-Century Sea Battle*, c. 1850. Private Collection

Other Genres

The increase in production of the types of work just described—landscape, cattle pieces, genre, still lifes, and seascapes, together with the new historical genre scenes from Dutch history (leaving aside a consideration of book illustrations and historical prints)—can be seen as a compensation for a number of genres that were disappearing. The art of painted wall hangings vanished entirely and with it a large number of preliminary sketches and presentation drawings for clients. In the wake of this the Arcadian landscape had lasted the eighteenth century as a collectors' item, outstanding artists in this genre being Juriaan Andriessen and Jean Grandjean. But after about 1815-20 mythological subjects were out of favor; by that date they had become special topics reserved for art exhibitions and competitions. Gone too was what had once been a large market, designs for book title pages and drawings for book illustrations in, for example, Bibles and classical, topographical, scholarly, and historical works. Demand remained only for novels, almanacs, and magazine illustrations, and this was met by a select number of artists.

For many eighteenth-century artists a major source of employment was documentary topography, and this remained possible. The market for prints showing scenes from large cities remained lively. There was now only a handful of specialized artists in this genre who, although they were highly active, restricted themselves to a particular region of the country. Portraits of country seats or castles remained popular, particularly by Petrus Josephus Lutgers, although by this time it was generally the owners of the houses rather than collectors of topographical pieces who wanted the work. Topographical drawings of the countryside including representations of villages and hamlets, which had been a very important subject in the years 1730-80, disappeared almost entirely from the repertoire of professional topographical draftsmen.

For many artists there was a shift in topic. Instead of recording specific buildings or cityscapes with lively anecdotal staffage, they took up drawings that captured a certain atmosphere but were based on topographical facts. Jacob van Strij in Dordrecht, Wybrand Hendriks in Haarlem, together with Gerrit Lamberts, Pieter George Westenberg, Daniel Kerkhoff (fig. 9), and contemporaries in Amsterdam often selected picturesque spots on the city's edge. Careful

notations by these artists make clear that their interest was strictly documentary. In the case of Lamberts this is quite clear: he owned a large collection of drawings of Amsterdam arranged so that the viewer could enjoy a number of walks through the city. Most draftsmen from about 1790 to 1820 were also landscape artists. Apart from the seventeenth-century sources of inspiration already discussed for Amsterdam draftsmen, there was the series of 245 large drawings of castles by Roeland Roghman. In these drawings there was a contrast between the solid structure of the buildings and the woodland setting. In 1800 the series became separated, and the drawings became dispersed among many collectors.

The pupils of the Amsterdam group, who were working at the same time as a number of traditional and otherwise unremarkable cityscape draftsmen, were in turn to provide a new outlook. They chose to return to the historic city center in combination with lively street scenes. Their cityscapes are more about depicting atmosphere, with the subject being the street, than portraits of streets or buildings. In their work they took full advantage of the by-then accepted romantic style of draftsmanship. In Amsterdam, Kasparus Karsen took lessons from his uncle P. G. Westenberg and from H. G. ten Cate. He in turn, together with Ten Cate, was the teacher of Cornelis Springer. Karsen's work is largely of tranquil city views, while Springer enlivened this genre and brought it to hitherto unknown heights of popularity in the 1850s. A comparable development took place in The Hague. Here, Bartholomeus Johannes van Hove was the master who was to train such artists as Johannes Bosboom, Lambertus Hardenberg (fig. 10), Samuel Verveer, Charles Leickert, and Petrus Gerardus Vertin.

New types of painting included such genres as the Italian landscape, the historical genre, and the animal piece. Since 1779 the Italian landscape had been drawn from life by Dutch artists. In that year, Jean Grandjean, sponsored by two wealthy patrons, traveled to southern Europe. He died there two years later, but the example had been set. Others followed:

Fig. 10. Lambertus Hardenberg, *View of a City*, c. 1835. Boijmans Van Beuningen Museum, Rotterdam

Daniel Dupré took Grandjean's work in Rome under his wing and about five years later, in 1790, returned with large quantities of study drawings. By far the most important Dutchman to visit Italy at this time set out in 1789. This was David Pierre Giottino Humbert de Superville, whose astonishing name seems to have sprung largely from his own invention. After adventurous wanderings he returned to the Netherlands in 1802. As artist and art historian he was a solitary figure, but he was the only neoclassical draftsman in the Netherlands of international standing. Because of his position as keeper of the print collection of Leiden University he did not as an artist have to make any concessions to the taste of the public.

In 1808 King Louis Bonaparte of the Netherlands set up a Prix de Rome competition, modeled on the French custom. Even when the French were no longer in power in the Netherlands, this award was still granted, and a regular stream of Dutch artists made use of it. Some of them, breaking the competition regulations, settled permanently in the Eternal City; examples are Voogd and Teerlink. Those who went back to Holland did not always turn out to be major artists, and their time in Italy did not deeply influence their work. From 1825 on the Italian style became popular in the Netherlands especially through the influence of Cornelis Kruseman and the imported taste for southern genre scenes with pretty shepherdesses or the troubadour from Savoy with his guitar and sunburned face.

The historical genre was a new variation on the contemporary genre scene. Several artists worked in this style in the late eighteenth century, such as Jacob Buys and Johannes Huibert Prins. They made pictures of non-specific, imagined scenes or events, giving them a specific historical setting. In scenes made in the nineteenth century the central figures portrayed usually came from the lower classes. There are endless paintings showing soldiers in their guardrooms or the interiors of poor homes and taverns with merry drinkers and women of dubious virtue. The paintings of merchants and their families, so associated with the flourishing Dutch Golden Age, portrayed in their comfortable homes or in their "offices," hardly appear in the imagined history pieces. However, there was a definite preference for anecdotal scenes set in the sixteenth or seventeenth century. In the second half of the nineteenth century it also became popular to portray eighteenth-century

Fig. 9. Daniel Kerkhoff, *Oude Gracht, Haarlem*. Boijmans Van Beuningen Museum, Rotterdam

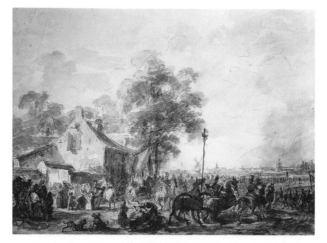

Fig. 11. Jan Willem Pieneman, *Troops Marching*, c. 1832. Prentenkabinet der Rijksuniversiteit Leiden

scenes. The name of David Bles is inseparably connected with such work. The historical genre pieces tended to be paintings but were also very popular as drawings, such as the work of Reinier Craeyvanger, Willem Hendrik Schmidt (see fig. 7), and Johan Coenraad Hamburger. There must have been mutual influence and interaction between Dutch and Belgian artists such as Jean Baptiste Madou and Ferdinand de Braekeleer, who even after the official separation of the two countries in 1831 continued to work for many collectors and art dealers from the northern Netherlands.

Finally, there is the animal piece that in many ways resembles the genre scene and should not be confused with the cattle piece. The preferred subject of the animal piece was dogs or cats, often in an anecdotal scene. In the nineteenth century there was an unabashed delight in moralizing scenes and anecdotal pictures, such as the tableau of the dog family cowering in dread while they watch mistress Pussy eating from their dish. In the second half of the nineteenth century this genre was eminently presented by Henriette Ronner-Knip (cats) and Otto Eerelman (dogs). Drawings and paintings with horses as the subject, so popular in other countries, were rare in the Netherlands. Wouterus Verschuur, Sr., Anthonie Oberman, and Gijsbertus Craeyvanger sometimes approached the British taste, while that curious romantic Karel Frederik Bombled occasionally equaled the heights of French tragedy with his portrayals of horses wounded or killed in battle.

The contemporary military piece experienced two important, if brief, periods of glory after Dirk Langendijk. These periods were not surprisingly associated with Dutch military successes. The heroic part played by the Dutch Prince Willem, the future King Willem I, at the battles of Quatre-Bras and Waterloo against the French in 1815 and the valiant struggle during the Belgian Revolt of 1830, with the Ten-Day Campaign of the following year, were inspiring topics for artistic work. It was mainly paintings and prints that were produced, but a considerable number of preparatory studies, for example by Jan Willem (fig. 11) and Nicolaas Pieneman and Louis Moritz, have survived. This work has an undeniable élan—it almost seems as if the artists were more inspired, feeling that they were engaged in a momentous topic and making what for a master is the most important genre, a history piece.

Portraits

Portraits are of two main types in the category of drawings. The formal portrait was almost always commissioned by a client and intended as a public picture. It portrayed the sitter as he or she would like to be seen, with attributes symbolizing his or her social position and career. This type of portrait was almost always in paint or pastels, although in both the sixteenth and seventeenth centuries, particularly by Jacques de Gheyn, Hendrik Goltzius, and Cornelis Visscher, drawn portraits were popular.

The other type of portrait, equally interesting, is the informal picture that certainly before 1880 was almost always a drawing. It was not intended as a showpiece and usually recorded a member of the family, a good friend, perhaps an (artist) acquaintance of the draftsman, or a striking face that had captured the artist's attention. Together with preliminary sketches for paintings and engraved portraits, these were virtually the only drawn portraits from the late eighteenth century. In the course of the 1830s a change took place. In imitation of portraiture abroad, drawings and, slightly later, watercolors of family members, inspired respectively by the portrait drawings of Ingres and by portrait miniatures, gained great popularity in Dutch Biedermeier interiors. These fairly inexpensive and small pictures replaced the highly popular pastels of the eighteenth century that were made by traveling artists such as Rienk Jelgerhuis, which in most cases could only have offered a vague resemblance to the sitter. Portraitists who were highly skilled in their work in pencil were Henricus Wilhelmus Couwenburg (fig. 12) and Johan Coenraad Hamburger; for watercolor portraits there were Jean Chrétien Valois and Louis Chantal. A large number of local artists whose names are now almost forgotten drew both types of portrait with a somewhat deadly but dedicated devotion. Many famous artists also made the occasional portrait drawing on commission. Often they made preliminary studies for portrait prints of famous people. These were in general the portrait drawings that finally found their way into drawings collections.

Fig. 12. Henricus Wilhelmus Couwenberg, *Portrait of Susanna C. B. J. van Erven Dorens*. Private Collection

Developments in Drawing Techniques

Artists were able to present new outlooks not only via their choice of subject matter and method of drawing; they could also make a conscious decision to use different materials than those that had so far been applied or they could experiment with new techniques using well-tried materials. And the availability of new materials for drawing influenced the possibilities for expression. This was the case in the early nineteenth century.

Until about 1780 a draftsman made his own watercolor paints based on his experience combined with generally accepted recipes. Thus the artists' biographer Van der Willigen reports an unusual use of color, which incidentally did not appeal to him, attributed to Jacob van Liender, that this draftsman-cum-apothecary made from the juices of rare plants.[16] In 1781 the London-based company of Greeves patented watercolors in dried blocks, and boxes of watercolor paints came onto the market similar to the paintboxes known today. This made it much easier for artists to color their work from life or, as happened chiefly in Britain, to paint outdoors in watercolor. In the art of painting too, the first decades of the nineteenth century saw similar developments, and many types of ready-made paints became available. The chronology of this is not yet clear, but it is known that in about 1840 people set off to paint from life, armed with easel, palette, and artist's box of equipment.[17]

It was customary for techniques to become fashionable within groups of artists and later fall into disuse. For example, the painters of cattle pieces who settled in Holland's Gooi district around 1815-25 preferred to use a characteristic light brown ink. Others, such as B. C. Koekkoek, chose the combination of brown pen and light gray washes that was particularly used in the seventeenth century in a group of Italianate landscapes by Jan Hackaert. Koekkoek, however, used this technique in a slightly less schematic manner than Hackaert. The method of preparing paper with alum, that is treating the surface of the paper so that a drawing in red chalk would show up better, was perfected in about 1815 by Cornelis Kruseman. Stumping on a detailed black chalk black drawing was hardly practiced in the eighteenth century but was used in the nineteenth to achieve a more even balance between light and dark than was possible with hatching. An entirely new technique was the charcoal wash, used for example by Springer but also found in the work of Johan Conrad Greive and Johannes Hilverdink.

Accents of light were introduced by removing some paint with the wooden part of the paintbrush. There was literal scratching in the drawing, especially after the romantics—Nuyen, Schelfhout, and others—adopted this daring and imaginative technique in their watercolors, thus imitating British and French artists. The scratches made in this way were particularly effective in winter scenes for depicting an icy surface. The drawing cards that came on the market in about 1835 were eminently suited to this scratch technique. They had a thin shiny layer in white or a pale color, and highlights could be made by scratching this away. Drawing on this special cardboard was done with a fine pencil. Another novelty that indicates how much drawings were valued

as a form of art was drawing cards with a wide decorative border in relief. They were used for the countless Friendship Books, and the larger sizes were framed. It is clear that the new techniques, as well as the older ones that were revived, arose out of a need to draw more freely in detailed scenes that were intended for collectors without working too schematically. Probably even more important was the attempt to break free from the restrictive repertoire of techniques that was employed in the eighteenth century for finished drawings.

In conclusion, one general trait that distinguishes Dutch drawing of the mid-nineteenth century from that of the end of the eighteenth is the gradual disappearance of local schools with styles and characteristics recognizable for individual cities. These were largely rooted in the veneration and imitation of the seventeenth century and generally concentrated around one particular master from a city. The gradual change in attitude had several causes. One was the different system of government after the Napoleonic period with the creation in 1813 of the new Kingdom of the Netherlands. Under its constitution, not only was there a strong central government headed by a monarch having considerable powers, but the autonomy of the provinces was drastically restricted. National awareness arose as the feeling of municipal and regional loyalty decreased markedly. This inevitably affected collectors in such cities as Dordrecht and Utrecht. Collections made in the first decades of the nineteenth century largely contained the work of contemporary local artists, but a collection such as that of Willem Hendrik van Bilderbeek of Dordrecht, who died in 1918, contained only eight works by local artists, amounting to less than one tenth of the entire accumulation.

Such a development has more than one cause. Besides the decline of local loyalty, another significant factor was the dwindling quality of regional schools of artists. In the course of the nineteenth century the mobility of artists increased considerably. The big cities, Amsterdam and The Hague, exerted an enormous attraction. Local employment for artists became ever more scarce. Many of their activities, today classified as craft work such as painting wall hangings, decorating interiors and gardens, or painting fans, screens, coaches, and signboards, were no longer required; changing fashions and industrial production combined to make these practices obsolete. And even portrait painting or drawing was no longer a source of employment for local artists, since in the upper-income brackets people traveled to the studios of famous artists for their portraits, and in the larger lower-income group there were specialized portraitists who traveled from place to place, working in their clients' homes. Paintings made on easels became very much the terrain of the professional artist. This profession offered no advantages that were regionally determined, with the exception of the demand of local art collectors and the production of pictures having local interest. The temptation was great to seek inspiration among artistic colleagues and to hobnob in a few artistic centers. In order to acquire "brand familiarity" and to sell one's work, Dutch artists were dependent from 1808 onward on the annual exhibitions of work by Living Masters, held alternately in Amsterdam and The

Hague. With the passage of time this type of art exhibition came to be held sometimes incidentally, sometimes regularly, in many places including Rotterdam, Utrecht, 's-Hertogenbosch, and Groningen. It is clear, were it only from the names of the participating artists in this last-mentioned category of shows, that these other Dutch cities had far less prestige in the world of the visual arts.

It would be absurd to imagine that all Dutch artists went to live in Amsterdam or The Hague. There were many reasons, family ties among others, to settle elsewhere. Another circumstance that promoted the development of a more uniform Dutch style than had previously been the case was that mutual contact between artists became far more intensive because of the artists' societies and the activities these organized. Furthermore, after about 1845 artists from different cities turned their footsteps in the same direction in search of inspiration: to the countryside, in companionship with fellow artists, and in consideration of each others' work. Artists' colonies developed and settled for longer or shorter periods in one place. Spending the summer months together in cities or villages became a habit. Kleve, Oosterbeek, Brussels, the Dutch Lake District, Scheveningen, and Laren were places that in the second half of the nineteenth century became the favorite haunts of Dutch artists.

This overview of Dutch draftsmanship from the late eighteenth to the mid-nineteenth century has been compiled in the absence of written sources by the artists. Drawings themselves and contemporary documents such as auction catalogues, biographies, and minutes from artists' societies have been important sources in this inquiry. Above all the works themselves, in their delightful detail, in their fascinating variety, have yielded the insights found in these observations.

1. Letter from Abraham Teerlink to Arnold Lamme, October 15, 1807; Rijksprentenkabinet Amsterdam, inv.no. RP-D-1992-1.
2. Letter from Johannes Bosboom to the painter, later merchant Johan Diederik Kruseman, Jr., dated May 6[-10], 1865; cited in Jeltes 1910, 14.
3. Knolle 1986-87, 293; and, for example, Van de Kasteele 1810, esp. 12-24. Also see Martens 1994.
4. Meppen 1848.
5. See Knolle 1984, 45, for the complete text by Ploos van Amstel on the appreciation for making sketches. Appreciation of the sketch also appears, albeit somewhat en passant, in Adriaan van der Willigen's biography of Jacob Cats, who died in 1799. "Many of his drawings are worked out in great detail, indeed in some cases one may speak of exaggeration and the masterly treatment suffers while the piece, as it is called, becomes ponderous. The latter is often the case with his colored Drawings, which is why his more schematic or less finished work is generally preferred by true art lovers." Translated from Van Eijnden/Van der Willigen 1816-40, 2:312. There is a nasty dig here in the distinction made between the cognoscenti in the realm of drawings and the ignorant. The former are not deceived by outward show and quantities of detail.
6. A good idea can be gained of the subjects discussed at artists' societies by consulting the list of weekly meetings held by the society Concordia et Libertate, especially in the years 1796-1806 (see Van Hattum 1983, 21-31).
7. See Broos 1989.
8. Sketches and sketchbooks of several of these artists, especially Jan van Ravensway, have been rediscovered in the important collection of the Foundation Cornelis Ploos van Amstel-Knoef, now on long term loan to the Boijmans Van Beuningen Museum. (See Sellink, note 2).
9. I now offer a bird's-eye view of the development of all the different types, whereby I mention the major artists in each area. They are only listed in the categories that apply to their major activities and this overview does not do justice to the other areas in which good artists sometimes worked with astonishing success. For an overview of Dutch art from the period c. 1800-50, with (possibly too much) emphasis on its relation to the seventeenth century, see Jansen 1986.
10. Hoogenboom 1993, esp. 73-74 and 88-106.
11. Niemeijer 1977.
12. Compare Van Tilborgh 1984.
13. On the founders of the Pulchri Studio see De Bodt 1990, 43.
14. Cited by G. Jansen in Chong 1988, 232.
15. See Hoogenboom 1982.
16. Van Eijnden/Van der Willigen 1816-1840, 4:164.
17. Compare the title page of Koekkoek 1841. In Cornelis Kruseman's reports of his visit to Italy, the painter regularly mentions artists painting in plein-air. See Elink Sterk 1826, 101, 104, and 130.

"QUELQUE CHOSE DE DIABOLIQUE": SKETCHES, SCRIBBLES, AND WATERCOLORS

Saskia de Bodt

The second half of the nineteenth century saw a change in the general appreciation for drawings in the Netherlands as well as in other countries. Large detailed drawings, pastels, and watercolors by contemporary masters, which had been considered collectors' items since the seventeenth century, remained popular. However, from the middle of the century on there was an increasingly large group of people who enjoyed sketches and rough drawings. By about 1860 the fascination with this type of art, also among artists, had become a veritable craze.

Not surprisingly, this was connected with general developments of the time in the visual arts. For example, with the increasing tendency of artists to make studies from nature, the character of sketching also changed. No longer were detailed academic studies taken as the starting point for a painting. There was an increasing use of quick impressions that served as reminders for the larger salon pieces that were worked out in the quiet of the artist's studio. This happened on a large scale with the painters of the Hague school, who were deeply devoted to the concept of the free brushstroke. The process was strengthened by the publication of interviews that appeared regularly through the 1890s in the new magazine *Elsevier's Geïllustreerd Maandschrift* (Elsevier's illustrated monthly), written about the avant-garde painters of the 1850s and 1860s who in the meantime had grown somewhat gray-haired. There are forceful descriptions of the walls of artists' studios, by the painters Gabriël and Weissenbruch and others, that tell of endless sketches and sheets of paper covered with impressions drawn from nature that the masters could not bear to part with. Simple line drawings and careful charcoal sketches, repeated in prints, decorate the margins of this type of publication and provided the signature in more ways than one, of the artist.

The first symptoms of the sketching fever may be found as early as 1841, described with a certain amazement by the artist and writer B. C. Koekkoek in his *Recollections and Revelations of a Landscape Artist*. Koekkoek, a figure of some influence, tells how he saw a fellow artist working on a landscape painting and adding the staffage with the help of his sketchbook. This book was "full of quick sketches of figures, animals, various groups, all kinds of compositions."[1] The sketches, amplified with notes and suggestions about colors to be used, had, wrote Koekkoek, been made in all kinds of places at all kinds of times. The artist "always had the book with him, indeed was often holding it." Koekkoek was very enthusiastic about this habit of constant sketching. However, it appeared in his sequel to *Recollections and Revelations* that this praise was not so much on account of his own need to take impressions fresh from the oven, as it were; rather, it was primarily because of Koekkoek's attitude toward emptiness combined with his sense of duty: he felt that an artist should never let slip an opportunity to work. In later passages there is a far more dogmatic approach to studies from nature from this no-longer-so-young painter: "Nature is the perfect picture, that is why we should make as many studies of her as possible. The works of man are imperfect. Unwittingly, people accept the not-beautiful together with the beautiful. But in Nature we cannot err. In her, everything is true—and truth should always be the hallowed goal of the artist."[2]

Forty years later, when working in The Hague and influenced by the Hague school, Vincent van Gogh put into words what he felt about landscape painting for the artists of his day: all that counts is "the honest, the naive, the truthful aspects of a landscape."[3] "I know old lithographs by Jules Dupré, either by himself or by some of his ilk. They possess such energy and such love. And yet they are made in so free and spirited a manner!" Like the French writer Théophile Thoré in his open letter to Théodore Rousseau, the grand master of the French school of painters at Barbizon,[4] Van Gogh stressed that it is essential for landscape painters from their earliest days to love "the hedges, the fields, the farmlands, the woodlands . . . and the rain and the storm." And as a footnote to his observation that the imitators of the Hague school are too superficial and tend to be somewhat decadent, Van Gogh concludes as follows: "An absolute reproduction of Nature is also not the aim—rather, it is to know Nature so well that what people make is fresh and true, which unfortunately many now lack."

A similar longing for continual observation of nature as was voiced by Koekkoek's colleague, and to which Koekkoek himself reacted on a certain boat trip along the river Rhine as recorded in his *Recollections*, can also later be found in the work of the seascape painter Hendrik Willem Mesdag. When, after studying in Brussels, he settled in The Hague in 1869, he reported to a Belgian friend that, weather permitting, he would take daily walks by the sea in order to study it in all its moods.[5] It also appears from Mesdag's sketchbooks that in 1880, from the day on which he signed the contract to paint a panorama (May 1, 1880) he sat sketching, perched upon Seinpost dune, recording the scene around him with each changing hour so that he could bring together all the various aspects of that exciting vista and reproduce them in his painting (fig. 1).[6] With mathematical precision and the help of a glass cylinder, Mesdag finally transferred his many impressions onto the giant canvas for his panorama.

The influential landscape artist Willem Roelofs, who settled in Brussels, contended that artists when making a painting from a study should continually recall as distinctly as possible the impression of the moment. "It is extremely difficult, when making a

painting from a study, to copy this really accurately. It is all too easy to make something different—said to be better—and in doing so to lose the faithful copy. A good outdoor study contains the breath of Nature, which should neither be neglected nor destroyed. Such a study should be used as a complete source, not just half or one-third copied."[7] At the same time, being a realistic scholar, Roelofs saw the danger of exaggeration: "If it is really possible to improve something, then do so, but otherwise it is to be recommended that the study be followed assiduously, like a guide."

Among the generation of painters known as the Tachtigers (from the 1880s) it became fashionable to make snapshot sketches. The painter George Breitner always had his sketchbook in his pocket, ready to jot down anything that caught his attention. This medium was even quicker and more effective for him than photography, which he took up around 1890.[8]

The passion for making quick sketches was clearly connected with the mood of the times and was not only a habit of artists. Witness the notebooks of a nineteenth-century literary figure such as the Dutch writer Marcellus Emants:[9] "For my work I look for something that is strongly individual—distinctly different," he once said to the Rotterdam writer and journalist M. J. Brusse.[10] "I keep notebooks full of jottings, whole collections of conversations, with stories, things I have heard or experienced." Emants called this habit "making sketches from nature." The notes, which he continued to make throughout his life, vary in length from a few lines to a full page in an exercise book.

These literary sketches, however, never came to be as highly regarded as the drawing sketches. The drawing sketches of Breitnēr, for example, were often more valued than the resulting painting because they were seen as capturing the essence of the artist's motivation. This, too, was connected with a changing style and particularly with general ideas about "what is an artist." The more personal a work was, the better. Breitner, for example, was free to decide when a work was finished.

Earlier in the nineteenth century such a choice had not been available. An illustration, clear and at the same time lamentable, of the position granted to studies and sketches in the creative process is the article published in 1865 in the journal *Nederland-sche Spectator*. It was written on the occasion of an auction of work by the old and ailing seascape painter Louis Meijer.[11] The article criticizes Meijer because, having sold all his oil paintings at a previous auction for several thousand guilders, he then tried to get rid of his sketches. It asks, "How is it possible that someone who is truly an artist can bear to get rid of his sketches, which represent his whole life and career as an artist?" The author, who remained anonymous, drew the dire conclusion: "The man for whom art is a garment, that has served its purpose, and can be shed and disposed of, has never truly been an artist." What emerges from this discussion is that studies and rough sketches, not only worked-out drawings, in the mid-1860s had a certain value as independent works of art, since auctions would not have been held were there not a potential market.

The importance of rough sketches in an artist's development was emphasized later in the century by the Boijmans Museum director Pieter Haverkorn van Rijsewijk, who in 1898 tried to acquire for the museum as much of this work as possible from the artists he so greatly admired. Haverkorn quoted an old Dutch verse: "If you would know a poet's rhyme/In his land you must spend some time" to add weight to his argument in the book he wrote about the museum, *Het Museum Boymans* (1909), a lively work although not entirely free from whiffs of megalomania.[12] "It is also true for artists, and the land where you can learn their rhymes is not far away, it usually lies in their studio portfolios. There, with a few lines and colors, they recorded what they saw, what took their fancy, what roused their imagination—that is where you see the artist most clearly and most vividly." And the literary-minded Haverkorn who, before he took up art had been a Protestant minister, made the comparison between an art collection containing sketches and an autobiography. "If one manages to obtain sketches made in

Fig. 1. H. W. Mesdag, *Sketch for the Panorama Mesdag*. Panorama Mesdag, The Hague

Fig. 2. H. W. Mesdag, *Sailboat near the Shore*. Museum Boijmans Van Beuningen, Rotterdam

various periods of the artist's life—an impossibility in the case of paintings—then every collection becomes an autobiography, better than any biography made by a different person. It becomes this chiefly because it provides the opportunity to compare the first efforts with the finished work." In October 1898 Haverkorn managed to obtain for his museum 119 studies from fifteen artists.[13] Later, more sketches were added by living masters (fig. 2).

It was not only rough sketches but also watercolors that the artists of the Hague school used as mnemonic devices for paintings. Thus in 1871 the artist Johannes Bosboom stated when he submitted his work for the exhibition of Brussels watercolor painters that, were one of his watercolors, *'t Regthuis*, to be sold, he wished to have it back for a fortnight in order to paint a copy of it.[14]

The transition from the stage in which the drawing or rough sketch was seen purely as a preliminary study to that in which it was valued as an independent work of art belongs to the most important developments in the art of drawing in the second half of the nineteenth century. In one way or another, these developments are connected with the predilection for the loose brushstroke, as is exemplified in the forming of Mesdag's private collection. Most of the almost 350 Dutch works now in the collection of the national Mesdag Museum in The Hague, which was built up between about 1870 and 1900, could be described as studies.[15] The same holds for the non-Dutch pieces in this collection.

That the artists themselves valued work on paper very highly appears clearly in the period following that of the Hague and Amsterdam schools. The symbolists and neo-impressionists made their most revolutionary work in pen, chalk, watercolor, gouache, or pastel. The fragility of the medium did not detract from the finesse of the representation and the status of the work of art as such. Thus, for example, all the pioneering symbolist work by Jan Toorop (*De Tuin der Weeën, Fatalisme, Les Rôdeurs, De Sphinx, Aurore*) was produced on paper in pen, colored chalk, or watercolor. Also, the most interesting work of Johan Thorn Prikker, such as *De Graflegging* and many of his neo-impressionist landscapes, was done on paper.

The drawing developed as a work of art in its own right partly because of public demand. In particular watercolors were widely popular from the middle of the nineteenth century. When in the beginning of the 1880s Van Gogh was looking for a means to make his living with art, he was told by the Hague artist Anton Mauve that he should master the art of painting watercolors, the reason being that watercolors always fetched a good price at the art dealer Tersteeg.

Things were partly stimulated by the artists themselves who, in midstream as it were, began to take more initiative to promote their work on paper and especially to present it in public. As early as 1860 the artists' society in Amsterdam, Arti et Amicitiae, organized an exhibition of drawings on the occasion of a visit from King Willem III, who was known to be interested in art. The press underlined the importance of the show. The art journal *Kunstkronijk* gave a vivid description of how until the time of that exhibition "everything painted in oils was hung in the place of honor in the large rooms and with full lighting" while in contrast "everything done in spattery watercolor or smudgy chalk was hidden away in small, deserted rooms off distant corridors" where only a few stray beams of light could reach them.[16] Although today this kind of dimly lit presentation is strictly required from a conservator's point of view, in those days interests lay elsewhere. The *Kunstkronijk* went on to say: "The supreme importance of the oil painting has gone; we announce equal opportunity for watercolor, chalk and charcoal, and etchings. The huge fashionable salons where formerly not a chalk squiggle was to be found—far less a charcoal stroke—now rejoice in drawings, etchings and lithographs, and the full clear light of day. The art lovers are surrounded by them like fully opened blossoms in the sunlight, and they stream toward the viewer along the rays of light that are pregnant with beauty."

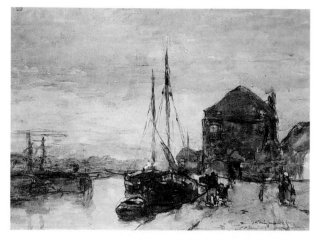

Fig. 3. J. H. Weissenbruch, *View of a City with Ships (Haarlem)*. Rijksmuseum, Amsterdam

This flowerful initiative for an exhibition of drawings was repeated if not annually, at least at frequent intervals, by the society Arti.[17] In the city of The Hague, Arti's rival the Pulchri Studio was somewhat slower in its promotion of drawings via exhibitions. However, the organization of the Hague artists was ultimately more effective, since a close-knit society developed out of the members of Pulchri, known as the Hollandsche Teekenmaatschappij, or Dutch Drawing Society. It was partly through this society that the Dutch market for watercolors was promoted.

The development of watercolor painting in the Netherlands is as follows. It is a technique that is most closely related to that of painting. This particular manner of painting, which requires quick reactions and short but concentrated bouts of working, played an important part in the stylistic development of Dutch art in the years between 1850 and 1880.

The technique of watercolor was considered difficult, more so than painting in oils since the transparency of the medium does not permit overpainting or correcting. Artists regularly complained about this. The famous Dutch-English painter Lawrence Alma-Tadema wrote in 1872 to the secretary of the Brussels Society for Watercolor Painters that his offering for the society's collection was a bit of a failure, after his criticized attempts to reproduce marble succeeded in looking only slightly less like blue cheese: "Isn't it astonishing how difficult it is to produce a watercolor? Never mind. I'll try again."[18] And the Dutch painter Gerard Bilders expressed his tale of woe thus: "I have again these latter days harrowed my soul attempting to paint watercolors." He wrote this in 1863 to the man of letters Jan Kneppelhout and continued, "Ah well, I am convinced that Dante never drew with watercolors for otherwise he would have described some poor wretched painter in his Hell, doomed for all eternity to paint watercolors without ever improving and making generous use of a wet sponge. What a gloomy outlook!"[19]

The fruitless attempts by Vincent van Gogh in this area are to be read in his letters during the months that he worked under the shadow of the artist Mauve. "Mauve has shown me a new way to paint, namely in watercolor. Well, I'm very busy trying to learn this, and spend my time making a wash to cover up what I've just botched—in short, searching and struggling . . . *l'exécution d'une aquarelle a quelque chose de diabolique* [there's something devilish about attempting a watercolor]."[20] Within six months Van Gogh had given up the whole thing because he had discovered, with the support of the artist Weissenbruch, that the medium of expression best suited to him at that moment was drawing. Sometime later he announced that he found painting in oils "more manly" than watercolors because they contained "more poetry."[21]

Important considerations when painting in watercolor, besides skill and accuracy, are the materials used. The different tones in a watercolor are created by applying various layers of watercolor to paper. White areas and details are not painted over. The paper should not be allowed to yellow with age since this would alter the effect of painted drawing. In his handbook published in 1919 offering practical tips for fellow painters, *De practijk van het schilderen . . .* , Willem E. Roelofs, Jr., using the vague practices of his father's colleagues as horrifying examples, advising "Use good paper—it is more expensive but never forget that besides being an artist you are in every sense a businessman. . . . Of course it sounds very much like a great artist to proclaim: 'I don't care what happens to my work,' but in fact you don't have the right to say this, and most certainly the artist should never try consciously to deceive his fellows."[22] Roelofs provided the somber story of the artist Weissenbruch:

When he made his watercolor on that piece of wallpaper, [he] did not foresee the consequences. On the thin washed parts of his watercolor, where the paper contributed to the tone, there the paper has turned yellow, and ultimately brown, because of the effect of light on it. In the places where bodycolor plays a part in creating the tone, the yellow effect only appeared later. So what remains from all the relationships of color tone in a watercolor like this, especially a Weissenbruch, where in the first place contrasts of tone are of major importance and where the drawing, the composition and the sense of form only play a subsidiary role? What is left of all that beauty created by Weissenbruch, grand master of Dutch watercolor painters? Nothing, absolutely nothing.

And furthermore, the paint which was used to print the wallpaper has begun to appear through Weissenbruch's work, which certainly does not contribute to the beauty of the overall effect. The end of this story of the wallpaper painting is that a work of art has been lost as such, and in terms of money it becomes totally devoid of value. This watercolor is kept in Amsterdam's Rijksmuseum as a horrifying warning for all (fig. 3).[23]

However, even when an artist used good paper, such as that of the Whatman company, a watercolor could easily go wrong. The main problem, clearly instanced in the work of Van Gogh, is that of transparency. A watercolor painting must have only thinly applied paint while maintaining a fresh and strong look, as Van Gogh himself put it. The more the artist wishes to add layers, the greater is the danger that

the paint becomes thick. Van Gogh's experiments, one reads, tended to be heavy, thick, muddy, black, and deathlike.

The younger Roelofs took a somewhat suppler approach. Because, despite the rather late appearance of his book, he still placed at center stage the watercolor artists of the Hague school, it is interesting to look more closely at his description of watercolor painting. He distinguished three different methods of watercolor painting, all of which received his seal of approval:

1. The old-fashioned manner, which is still followed by the Italians and English, that is the pure washed drawing. In these paintings the white paper is of great importance and remains completely uncolored in those places where the artist wants white, while the other colors are achieved by applying very thin washes on top of each other until the desired tone is obtained.
2. The different tones are obtained by dabbing off with a sponge or brush the paint that has already been applied to the paper or partially removing it, which produces a tone with a different effect than the color as first applied since the paint is no longer on the paper but has still left an effect.
3. The use of white as bodycolor mixed together with other colors.

Roelofs went on to say how the Dutch watercolor painters use a mixture of the above methods with the result, as he described it, that they achieve a richness of tone and expression that far excels that of watercolorists from other countries in whose work the paper plays a greater role. Criticism leveled at the Dutch painters in, for example, the Belgian press concentrated to a great extent on the impurity, that is, the mixed nature, of their technique.[24]

Until the mid 1870s the very first Dutch watercolor painters such as Johannes Bosboom, Josef Israëls, and J. H. Weissenbruch relied mainly on private contacts for the sale of their work on paper. The well-known collectors of drawings (in the nineteenth century watercolors, pastels, and gouaches fell in the category "drawings") around the mid century were J. Wittering, C. J. Fodor, J. de Vos Jacobszoon, and C. A. Crommelin in Amsterdam, P. Verloren van Themaat, Baron C. A. Ridder van Rappard, and Baron M. C. Boellaard in Utrecht, Baron De Jonge van Ellemeet in Oostkapelle, W. N. Lantsheer in The Hague, and P. van der Dussen Beeftinck in Rotterdam. Many painters, among them Laurens Hanedoes, Andreas Schelfhout, Nicolaas Pieneman, Louis Meijer, and Pieter Stortenbeker, owned sizable portfolios containing drawings by other artists.

In the third quarter of the nineteenth century, exhibitions of drawings were rarely held. What artists' societies such as Arti or Pulchri and many other local groups in the Netherlands did organize were the so-called art viewings. These were evening gatherings of select groups of art fanciers and artists at which people sat together at long tables studying drawings from a particular collection. All the collectors mentioned

Fig. 4. E. Verveer, *Discussing Art*. Pulchri Studio, The Hague

above at one time or another showed their works at such an evening organized by Pulchri Studio. In a drawing by Charles Rochussen he illustrated the participants at such a gathering, passing the works from hand to hand.[25] Sometimes a collection of a private individual would be on the program, while at other times an art dealer provided the material for a viewing and the pieces would also be for sale. At designated times a portfolio containing a selection of drawings by working masters would travel around the country. Pulchri, for example, would lend out portfolios for a season that would be studied in local cultural societies in such places as Groningen in the far north of the Netherlands or Middelburg on the southwest coast.[26] Not until the close of the 1870s did the aim of these art viewings change at Pulchri Studio. Then people no longer sat at long tables, but walked around the room while the sheets of drawings were displayed on lecterns or, after 1877, hung on the walls so that people could see them more easily. A caricature by Elchanon Verveer, kept by Pulchri Studio, shows that the drawings were mounted in passe-partouts but not framed (fig. 4). This method of presenting the pieces, together with the short length of an art viewing (at most one day), were the main differences with the art exhibitions of the time.

Until the Dutch Drawing Society (Hollandsche Teekenmaatschappij) was founded in The Hague in 1876, Dutch artists who wanted to exhibit their drawings, watercolors, and pieces of this nature had to do so outside Holland. An active part in the growth of interest within the Netherlands was played by the Belgian Society of Watercolor Painters, set up in Brussels in 1856 and modeled after the elite English Watercolor Society, which was founded in 1804.[27] The Belgian group was an active organization that from the beginning was most welcoming to foreign artists. Thanks to the fact, among other things, that the Dutch artist Willem Roelofs, Sr., was one of the founding members, a number of key figures in Dutch

Fig. 5. Album presented to H. W. Mesdag and his wife S. Mesdag-van Houten. Groninger Museum

Aan

den Heer H.W.Mesdag

en Mevrouw

S.Mesdag-v.Houten

ter gelegenheid van hunne
Zilveren-Bruiloft aangeboden
door de leden der Holland-
sche Teeken Maatschappij.

25 April 1881.

Dit Album is dva my ge
lchicke on 8 9 ca Hole ter Ste de...

Fig. 6. Title page of Mesdag album.

art were soon made honorary members. After a trial period such artists as Bosboom, Israëls, Jacob and Willem Maris, as well as J. W. van Borsselen, Anton Mauve, David Bles, Christoffel Bisschop, and finally Weissenbruch enjoyed great popularity as draftsmen in the Belgian capital in the 1860s and 1870s. There the Dutch works hung, between drawings by compatriots who at that time were living in Belgium such as Roelofs, Gabriël, Henriette Ronner, Jan de Haas, Willem de Famars Testas, and later the Oyens brothers. Around the mid 1860s the share of Belgium's northern neighbors in the annual exhibition of watercolors was so large that the press made a point of saying that the number of Belgian entries hardly exceeded the Dutch ones.[28] And in 1882 the Belgian poet Emile Verhaeren wrote of the Dutch at the Brussels watercolor exhibition: "*Les maîtres hollandais tiennent la corde*" (the Dutch masters top the bill).[29]

The Dutch watercolorists were appreciated in Belgium above all for their realistic work, for the attractive sober tone as well as the intimacy and sensitivity they expressed. Around 1870, however, Belgian critics began to make cautious comments about the technique. The Dutch painters were guilty above all for their use of gouache and bodycolor so that, in the eyes of the Belgians, they destroyed the characteristic delicacy of the watercolor. And although Willem Roelofs, Jr., could in his handbook of 1919 accept any conceivable method of achieving an effective watercolor, his father in 1882 clearly felt it necessary, in reaction to an article by the Dutch man of letters Carel Vosmaer, to defend himself fiercely against the allegation that he used bodycolor in his watercolors.[30] During the 1880s in particular the use of bodycolor was a recurrent charge. In 1886, for example, the avant-garde Belgian newspaper *L'Art Moderne* complained about the *facture cotoneuse* (looking like a worn-out piece of cotton) of the Dutch, a far from complimentary expression especially in connection with watercolor.

The Belgian society was already twenty years old when the Dutch variation was created in The Hague. One of the reasons for this late undertaking may have been the huge success of the art viewings in the Netherlands. The founder members of the Dutch Drawing Society were J. van de Sande Bakhuizen, his sister Geraldine, C. Bisschop, Mrs. Bisschop-Swift, D. Bles, B. J. Blommers, J. Bosboom, G. Henkes, J. Israëls, J. Maris, W. Maris, A. Mauve, H. W. Mesdag, P. Sadee, and P. Stortenbeker. Immediately after the first meeting the following were admitted as ordinary members: H. J. (J. H.) Weissenbruch, W. C. Nakken, J. W. van Borsselen, A. Artz, A. Neuhuys, C. Stortenbeker, E. Verveer, and J. Weissenbruch together with fourteen artists who were living abroad.

Within two years the Dutch Drawing Society, to judge from the critics, was a resounding success. The promoter of the Hague school, J. van Santen Kolff, wrote, under the epigraph of the Dutch classical scholar Allard Pierson, "Criticism is Admiration" in 1878 in the *Nederlandsche Spectator* that the drawing society clearly excelled the pretentious exhibitions of Living Masters as far as artistic quality was con-

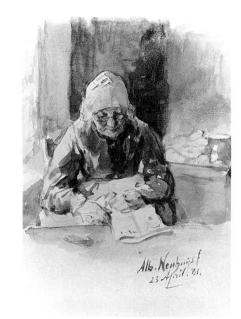

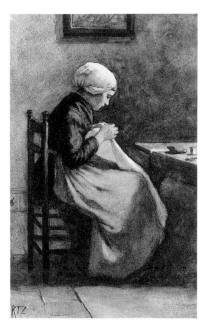

Fig. 7. A. Mauve, *The Shepherdess* (drawing in Mesdag album). Groninger Museum

Fig. 8. A. Neuhuys, *Woman Reading the Newspaper* (drawing in Mesdag album). Groninger Museum

Fig. 9. D. A. C. Artz, *The Seamstress* (drawing in Mesdag album). Groninger Museum

cerned. And although Bosboom criticized Kolff for "exclusiveness,"[31] he himself, along with Josef Israëls, J. H. Weissenbruch, H. W. Mesdag, and not to forget Jacob Maris ("the monarch of the previous exhibition"), was highly praised.[32] Entirely in agreement with his restricted but consistent attitude toward the art of painting, Van Santen Kolff used the exhibitions of the Dutch Drawing Society as an additional means of promoting art that was typically Dutch, like that of the Hague school.

In her book on Dutch nineteenth-century art, the critic and painter "Miss" Marius showed the connection between the founding of the Dutch Drawing Society and the so-called "address" of 1876 in which thirty-two painters signed a protest against the jury selected by the king to choose the awards for the triennial exhibitions.[33] As a result, the "old-fashioned" artists, friends of the king, one of whom was Herman ten Kate, held an alternative exhibition in 1882 in the Gothic Hall of Noordeinde Palace in The Hague, running parallel with the annual exhibition of the society. The alternative group called themselves the Royal Society of Watercolor Painters. This experiment, because of the "fiasco" as Marius describes it in her book, was not repeated.

The Dutch Drawing Society must have been a very sociable group, which is not surprising in that most of the members came from the equally friendly circles of Pulchri Studio, famed for its artists' festivities.[34] Like the artists from Pulchri, members of the drawing society presented attractive joint gifts at personal celebrations held by the draftsmen. In the art museum in the city of Groningen there is a copy of the album that was presented to the untiring founder of the society, Mesdag, and his wife Sientje on the occasion of their silver wedding in April 1881 (figs. 5-

6). The beautifully produced folder was kept by a niece of the Mesdags, Barbara van Houten, herself a draftswoman and the first curator of the Mesdag Museum in The Hague. It contains watercolors and drawings by everyone who at that time was a member of the society (see figs. 7-11). They are not of the most ideal size (they are rather small) but they do provide a good cross-section of the society in 1881. An album like this is all the more interesting because it is so difficult, simply based on catalogues or reviews, to identify work exhibited at the Dutch Drawing Society, since the titles given to pieces were so general. For example, of the thirty-three watercolors exhibited by J. H. Weissenbruch in the first ten years of the society's existence, from 1876 until 1885, in the catalogue it is only stated for ten of the works what place they illustrate, and then often vaguely, such as "Near Schiedam." Many pieces by others are titled simply "Edge of the Woods" or "Evening" or "Cityscape" and altogether only serve to strengthen the suspicion that it would be impossible to reconstruct an exhibition of the drawing society.

From a business angle, the Dutch Drawing Society was a success. Sometimes almost one third of the pieces exhibited were sold.[35] Furthermore, the society was so rich that in the 1880s it could afford to lend the Pulchri Studio five thousand guilders when the studio wanted to buy premises on the Princegracht canal in The Hague where they could set up an art showroom.[36] It is also noteworthy that from 1881 onward the art dealer Tersteeg was accountant for the society, whereby a direct business link between the society, and the world of the art dealer, although not openly stated, was certainly suggested.

The modern approach of the Pulchri artists who held the reins in the Dutch Drawing Society was

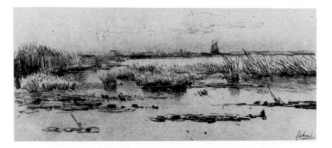

Fig. 10. P. Gabriël, *Landscape* (drawing in Mesdag album).
Groninger Museum

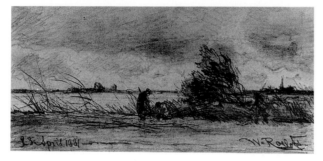

Fig. 11. W. Roelofs, *Landscape* (drawing in Mesdag album).
Groninger Museum

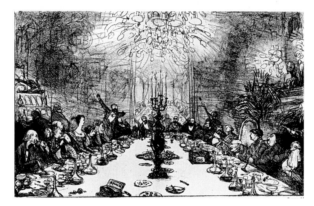

Fig. 12. Rusticus (M. Bauer), *Banquet at the Dutch Drawing
Society*. Universiteitsbibliotheek Utrecht

increasingly criticized from the 1890s by the group
connected with the rival Hague Art Circle. In 1886 the
art critic Jan Veth wrote that the level of the exhibi-
tions was already diminishing. "When the older artists
stop caring, this society must see to it that it gains the
support and strength of the young members," were
his outspoken words in one of the first reviews he
wrote."Where are they?" he asked, "why are Breitner,
Tholen, and Witsen not members? Why not De Zwart

and Van der Maarel? One hears strange murmurings
in answer to these questions. And Miss Schwartze is
accepted?"[37]

The critic "G.," who can be identified as G. H.
Marius,[38] declared in 1892 that what was missing was
the "earlier *joie de vivre*" and complained that the
members "sat snoozing on the sofa of indifference."[39]
Followers of the art journal *De Kroniek* (The Chroni-
cle) made great fun of the drawing society. A fine
example is the lampoon by the Dutch cartoonist Rus-
ticus (Marius Bauer) entitled *The Banquet of the
Dutch Drawing Society* and subtitled in elegant
rhyming quasi French-Dutch. The joke lies, among
other things, in the description of the champagne,
where the Dutch word *plas* is used, a word that
means either a puddle of water or of urine (fig. 12).
In his cartoon Bauer drew a table lavishly set with
carafes of wine. Seated at the table are artistic figures,
half skin and bones, eating their fill, together with fig-
ures of decided corpulence including such recogniz-
able characters as Mrs. Mesdag and Willem Maris and
Mesdag himself, who is shown as the epitome of the
bourgeois. Beside the cash register, dripping with pre-
cious metal and holding a fat cigar, is the resplendent
figure of the not entirely non-commercially minded
chairman of the group, the painter Josef Israëls.

In his annihilating review of the following year's
exhibition (in 1897), Jan Veth drew up the balance,
saying, "Your days of glory are over." He pointed iron-
ically at the old Mesdag and Israëls and continued,
even though these old masters "still hold forth with
the spell-binding words of their melodramatic
speeches, not all the waters of the sea can wash away
the fact that the far-famed Hague Round Table has
declined in numbers and weakened in social anima-
tion, and that neither friend nor foe will ever again be
struck at your exhibitions by the optimistic strength of
a vigorous creative force."[40] And Veth proceeded to
suggest the means by which the drawing society
could rejuvenate itself. With his customary self-
confidence he asserted that the art of watercolor
painting had passed its peak in Holland, and it was
now important to follow the latest developments in
contemporary art. These, said Veth, lay in the realm
of etching and lithography and also in decorative
drawing in general.[41] Thus Jan Veth heralded the
breakthrough of the *Nieuwe Kunst* (compare Art Nou-
veau) in Holland. In this style what mattered was not
so much a moment captured in a sketch, guided by
the feelings and drawn with a personal touch, which
was the ideal of the artists of mood and impression;
rather, what counted was precision of line.

1. Koekkoek 1841, 14-15. On draftsmanship in the first half of the century, compare Robert-Jan te Rijdt's essay in this catalogue, "Dutch Drawings in the First Half of the Nineteenth Century."
2. Koekkoek 1841, 231.
3. Vincent van Gogh to Theo van Gogh, The Hague, [c. 3-5] December, 1882. Van Gogh 1990, 754.
4. Thoré-Burger 1893, "Salon de 1844," 4:6.
5. De Bodt 1981(1); De Bodt 1985.
6. De Bodt 1981(2).
7. Jeltes 1911, 91. Compare De Bodt 1995(1).
8. Tineke de Ruiter, "Foto's als schetsboek en geheugensteun" (Photographs as sketchbook and mnemonic), in Bergsma 1994, 190-91, and Veen 1997.
9. Emants 1985.
10. Emants 1985, 7, n. 5.
11. See Nederlandsche Spectator 1865, 130-31.
12. Haverkorn van Rijsewijk 1909, 344ff. See also Saskia de Bodt, "Pieter Haverkorn van Rijsewijk als museumdirecteur," in De Vries 1996, 44-86.
13. Cf. Haverkorn van Rijsewijk 1909, 345: "The artists were: M. A. J. Bauer, Theoph. de Bock, Isaac and Josef Israëls, P. de Josselin de Jong, Jacob Maris, Willem Maris, H. W. Mesdag, Mrs. S. Mesdag-van Houten, Albert Neuhuys, Baron C. N. Storm van 's-Gravesande, W. B. Tholen, J. H. Toorop, and J. H. Weissenbruch."
14. Johannes Bosboom to Henri Hymans, The Hague, April 17, 1871. Archive of the Koninklijk Museum voor Schone Kunsten, Antwerp. I thank Dorine Cardyn-Oomen for this information.
15. Cf. Van Schendel 1975 and Leeman 1996.
16. "The exhibition in Amsterdam's Arti et Amicitiae" [translated], in Kunstkronijk 1861, 21ff.
17. Cf. Heij 1989, 142-49.
18. Lawrence Alma-Tadema to Henri Hymans, London, August 6, 1872. Archive of the Koninklijk Museum voor Schone Kunsten, Antwerp. I thank Dorine Cardyn-Oomen for this information.
19. Gerard Bilders to Jan Kneppelhout, Amsterdam, December 20, 1863, in Bilders 1876.
20. Vincent van Gogh to Theo van Gogh, The Hague, [c. 12-16] January 1882. Van Gogh 1990, 491.
21. Vincent van Gogh to Theo van Gogh, The Hague, August 13, 1882. Van Gogh 1990, 653.
22. Roelofs 1919, 46.
23. Roelofs 1919, 46-47.
24. Roelofs 1919, 47-48.
25. Charles Rochussen, *Art Viewing at the Artists' Society Arti et Amicitiae*, watercolor over chalk, 225 x 29i0 mm (8 3/4 x 11 1/4 in.). Museum Boijmans Van Beuningen, Rotterdam, inv. MB516.
26. Cf. Van Delft 1980, 157-58; see also De Bodt 1990, 31-33.
27. For the Belgian Society of Watercolor Painters (Société Belge des Aquarellistes) see the relevant paragraph in De Bodt 1995 (1) and De Bodt 1995 (2), 85ff.
28. For example, "H" 1865, 70.
29. Verhaeren 1882, 58. I thank Fabrice van de Kerckhove for this information.
30. Cf. De Bodt 1995(1), section on the Société Belge des Aquarellistes.
31. Johannes Bosboom to Jan Kruseman, January 1879. Jeltes 1910, 93-94.
32. Van Santen Kolff 1878, 262-63, 267-69, 275-77.
33. Marius 1920, 187.
34. The best descriptions of this are by H. E. van Gelder, in Van Gelder 1947.
35. Cf. Richard Bionda, "De afzet van eigentijdse kunst in Nederland" (The market for contemporary art in the Netherlands), in Bionda 1991, 56.
36. See the annual reports of the Pulchri Studio for the years 1886 and 1887 to 1894-95.
37. [Trans.] "On the exhibition of the Dutch Drawing Society and a little over Alma-Tadema" [1886], in Veth 1905, 1-5. Therese Schwartze painted mainly society portraits for a fee and was not considered to be an avant-garde artist.
38. This identification is based on style and can be verified by the handwritten explanation in an archive for old newspaper cuttings titled "Jozef Israëls en de Nederlandsche Spectator," to be found in the National Institute for Art History (RKD), The Hague.
39. "G." 1893, 317. The following year, however, the same critic sounded a far more positive note.
40. "De Hollandsche Teekenmaatschappij" (The Dutch Drawing Society), [1897], in Veth 1905, 153.
41. Ibid., 156.

Blots and Lines: Dutch Draftsmanship c. 1870-1910

Evert van Uitert

Fig. 1. G. H. Breitner, *Plaster*. Boijmans Van Beuningen Museum, Rotterdam

The art of the Dutch Golden Age was a source of amazement and inspiration to artists in the centuries to follow. It still cast its shadow in the nineteenth century.[1] There is, however, a marked difference in its interpretation between the beginning and end of that century. The change that took place in the 1870s and 1880s may be described as a shift away from carefully wrought works of art toward a more fluently executed and sketchy looking product. Generally speaking, formats became larger. A similar but converse stylistic development, from rough to fine, had taken place in the latter half of the seventeenth century.

Nineteenth-century artists thus not only had plenty of exemplars to choose from, but also gradually shrugged off the influence of the Old Masters. A remark made by Vincent van Gogh (1853-90) in 1882 reflects the new situation. "Rembrandt & Ruysdael are sublime, for us as well as for their contemporaries, but there is something in the moderns that seems to us more personal and intimate." (250 [218] July 21, 1882)[2]

Moreover, the painters of the Hague school, who played a part in conveying this more intimate impression, saw the work of their seventeenth-century Dutch forbears through the eyes of French painters who in turn had been inspired by the Dutch artists of the seventeenth century. This primarily is true of the realistic landscape art of the school of Barbizon. The work of the Barbizon painters, whose heyday was in the 1860s, was generously represented by examples of superb quality in the collection of the Hague school painter Hendrik Willem Mesdag (1831-1915).[3]

Painters of the People

Among the admirers of these modern French painters were Vincent van Gogh and George Hendrik Breitner (1857-1923, cats. 59-62). Not surprisingly they enjoyed a predilection for French literature, a preference they shared with most young painters of their day. In 1882 Van Gogh lent some books to Breitner, who was being treated for venereal disease in a hospital. One of these books was Jules Michelet's aptly titled *L'Amour*. It opened up an entirely new, unknown world, wrote Breitner. In that same letter of 1882 Breitner declared his credo, which would be Van Gogh's, too, in his Hague period. "I, for myself shall paint people in the streets and in their houses, the houses and streets that they have built, and above all, their lives. *Le peintre du peuple* is what I shall try to be, or rather already am, because I want to be."[4] This new program implied that Breitner, and by the same token Van Gogh too, wanted first and foremost to be a figure painter. But realistic painters no longer resorted to history books for the subjects of their figural paintings. Dutch history had to step aside for "A market a quayside a river. A band of soldiers under a glowing sun or in the snow," as Breitner

wrote.[5] Together, he and Van Gogh went out to draw in the streets of The Hague.[6] There are watercolors of soup being distributed to the needy, a socially engaged theme that was surely inspired by pictures in the new illustrated magazines such as *Graphic*, *The Illustrated London News*, and the French *L'Illustration*. These gave generous coverage to the wretched conditions that prevailed in the expanding cities.[7]

Illustrated descriptions of cities were another source, for example *London: A Pilgrimage*, written by Blanchard Jerrold and illustrated by Gustave Doré. Published in 1872, the book contained many prints depicting hard labor, homelessness, and charity.[8] Van Gogh was an enthusiastic collector of such prints and even had the ambition to become an illustrator himself at first.[9]

With their moralizing tenor these prints actually descended from an old genre, the topographical atlas, in which town views, trades, types, and city life in general were recorded.[10] Because the character of cities was undergoing such radical change in the course of the nineteenth century, this old repertory of images was given a new expressive charge. The figures, often grouped together anonymously, assumed heroic features, thereby shaping the artistic image of the modern age and more particularly life in the big city.

The Modern

The artists who struck out in new directions in the 1880s derived many of their ideas about "the modern" from *Manette Salomon* (1866), a novel about artists by Edmond and Jules de Goncourt, a second edition of which had appeared in 1875. Both Van Gogh and Breitner referred to this novel and to the ideas propounded in it. The Goncourts described the Parisian art life of the fifties, referring to its beginnings in the romantic generation of 1830. They contrasted the academic artist with the anti-bourgeois *bohémien* and the modern realist. Referring to a remark of the romantic painter Théodore Géricault, they described the French Academy at Rome, where winners of academic prizes could study under strict supervision, as "*une cuisine bourgeoise.*" The modern painter in the novel, Coriolis, advocates individualism and the new in life and art. What counted most, he said, was the artist's personality—or temperament, as people were fond of saying in those days. It was the maker's personal vision that was needed in the modern work of art, a vision conveyed by both the choice of subject matter and the personal rendering.

Opposition to Coriolis comes from the painter Chassagnol who, prompted by Coriolis' rapid sketch of *Un Souvenir de la rue*, launches a vigorous attack against his notions.[11] Coriolis has too much temperament, according to his conservative opponent, who regrets the "burial" of beauty. Coriolis has thrown in

his lot with ugliness and vulgarity and that, says Chassagnol, is the fault of the new religion, realism.[12]

Coriolis tried to render his modern street scenes in a line "*qui donnerait juste la vie, serrerait de tout près l'individu, la particularité, une ligne vivante, humaine, intime.*" As an example the Goncourts cite the artist Gavarni, whom Van Gogh and Breitner would later mention with respect.[13] In addition, the authors place a copy of *L'Illustration* in Chassagnol's hand as a reference to the new, vulgar iconography.

Realism, according to its advocates, was however meant to be more than "*la bêtise du daguerrotype*" or "*la charletanerie du laid*"; it sought expressive, contemporary images, executed in a personal style. In this dual undertaking modernity emerges in both the choice of subject matter and in style, photography being condemned as an unintelligent, mechanical art. Although a gifted photographer, Breitner is likely to have subscribed to most of the Goncourts' views. Photography was simply a device—Breitner did not exhibit his photographs—for recording "*la caricature physiologique de notre temps.*" And that characteristic trait was depicted "*par puissance du dessin,*" to quote Edmond and Jules de Goncourt once again.[14]

From his letters Van Gogh emerges as a fervent supporter of the new realism. "But realism—*unwanted* then [in the romantic period] is now demanded, and there is a greater need than ever for that realism, which has character and a serious sentiment."[15] A correct, academic drawing impeded that serious sentiment, according to Van Gogh.

Beyond Academic Drawing

Breitner, like most artists, had received a substantial part of his training at the academy of art. Drawings he did during that period from life and plaster casts have been preserved; they are in an entirely traditional vein (fig. 1).[16] Breitner obtained his teaching diploma and taught drawing for a while without much success.

His virtuoso watercolor technique soon attracted the attention of his colleagues in The Hague. These drawings (in his letters Breitner often referred to drawings when he meant watercolors) were rapidly executed and sold well. They were circulated in portfolios in the principal cities so that

they could be brought to the attention of artists and amateurs. Watercolors in general owed their success partly to a weak art market. The technique was not only faster but also much cheaper than painting in oils, as well as being less cumbersome to use in the countryside or in the streets.

Town and Country in Perspective

Younger Dutch artists who wanted to work in a freer manner and hoped to make a name for themselves with watercolors were likely to have been inspired by their compatriot Johan Barthold Jongkind (1819-91, cats. 32-34), who worked in France and was famous in French avant-garde circles. Jongkind's work clearly reflects the nineteenth-century stylistic development. He started off in a painstakingly accurate style. His more freely rendered view of Paris with a boat in the Seine is a wash drawing in the well-tried tradition of the precise topographic drawing rather than a free impression (cat. 33). The figures are of secondary importance. Later landscapes and town views show a hand gradually less restrained and ultimately nervous, as if the artist's temperament had finally emerged. His drawing style, in other words, became increasingly fluent and painterly. In 1862 Baudelaire observed that a series of etchings by Jongkind were "curious abbreviations" of his paintings, sketches "*que sauront lire tous les amateurs habitués à déchiffrer l'âme d'un artiste dans ses plus rapides gribouillages.*"[17]

The same might be said of the masters of the Hague school, first and foremost painters of subdued landscapes.[18] The town drawn by Jacob Maris (1837-99, cat. 43) melts away into a fine haze. The town cannot be identified, nor does its identity seem to be relevant. This is a far cry from the documentary drawings of the eighteenth and early nineteenth centuries. So is the view of red-tiled roofs in a watercolor by Willem Tholen (1860-1931, cat. 66), a muted image blurred in distant mists, while in the foreground the rooftops wing their way toward the background. Vincent van Gogh had a similar feeling for the expressive value of perspective. He demonstrated it in the painstakingly drawn view from the attic window of his studio at The Hague, uniting the outskirts of the city, work, and countryside (fig. 2).[19]

Fig. 2. Vincent van Gogh, *Carpenter's Yard and Laundry*. Museum Kröller-Müller, Otterlo

Fig. 3. Vincent van Gogh, *Walking Peasant*. Museum Kröller-Müller, Otterlo

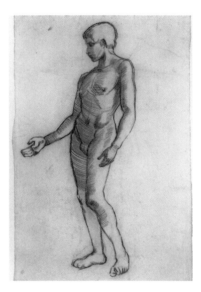

Fig. 4. Vincent van Gogh, *Nude Youth Standing*. Vincent van Gogh Museum, Amsterdam

Receding lines also occur in Van Gogh's views of towns, a late example being his drawing of Arles on the bank of the Rhône (cat. 54). Again, a comparison with Jongkind's view of the Seine serves to illustrate the revolutionary developments in nineteenth-century drawing, in which topography plays such an important role.

Breitner later turned his interest toward Amsterdam. Sometimes that interest was purely documentary: he preserved, notably as a photographer, images of the city's disappearing monuments. His paintings and watercolors show an Amsterdam under gray skies, with melting snow or mysterious gaslight. He photographed and sketched people and horses in the streets and squares.[20] Again, Breitner was not the only artist to work in this renewed tradition. In the exhibition is a drawing of a deserted house by Eduard Karsen (1860-1941, cat. 68) that should be regarded as a self-portrait. Willem Witsen (1860-1923, cats. 69 and 70), another specialist in the modern topographic genre, wielded an equally gifted brush and camera. Witsen repeatedly photographed his friends, thus becoming a chronicler of artistic life. Isaac Israëls (1865-1934, cats. 77-79) worked in this tradition too, although people are in the foreground in his work. His Amsterdam maids are in the spirit of Breitner's sketches, although Israëls' draftsmanship is more slipshod (cats. 77 and 78). The fluently drawn pastel (cat. 78) is an impression of a maidservant and the surroundings of the canal along which she is walking.[21]

Breitner had found it hard to shrug off his academic training in drawing, and so it was only natural for him to develop a painterly style in a watercolor technique no longer based on line but on the effect of blots. However, in his sketches of figures—Breitner was not a master of the large, autonomous drawing—the long contours do betray his academic training. Like Isaac Israëls and other modern artists, though, he sometimes broke up the contour into short sections in order to achieve a more "impressionistic" effect. His delineation is also angular at times, shading and accents creating a more restless effect.

Vincent van Gogh and Contour

Breitner's colleague at The Hague, Vincent van Gogh, scarcely had any formal training in art. In 1881 the aspiring artist went to Brussels to find out what was going on there. He sought contact with artists and students at the academy there, including the Dutchman Anthon van Rappard (1858-92). Van Gogh embarked on a more or less academic program of his own and studied anatomy and physiognomy. He had already begun to copy prints. His letters to Van Rappard are a reliable source of information about his ideas and experiments. In 1881 he wrote to his friend, "What I am trying to say is this: Rappard, I believe that when you work at the academy, you try to become more and more of a realist."[22] Vincent compared the academy to a mistress. True love was supposed to be devoted to "nature or reality." His comparison came from the book that he would lend Breitner a little later, Michelet's *L'Amour*.

Van Gogh's quarrel with his teacher at the academy in Antwerp is reported in detail in the letters he wrote to his brother Theo. In 1886 he went to Paris, and it was not long before he was drawing and painting from life and from plaster casts at an independent art school there. Life drawing was essential for a figure painter.[23] When Breitner settled in Amsterdam he went back to the academy to attend life-drawing classes. And in 1890, in the last stage of his odyssey, at Auvers, Van Gogh studied the academic drawing models of Bargues.

Nevertheless, the nude had played out its dominant role. Modern, realistic artists were now paying attention to costume, fashion, and the clothes worn in various walks of life, for that was what determined the contemporary character. In 1885, for example, when he was working in the Brabant countryside, Van Gogh wrote: "But the fact is that peasants and laborers are not nudes, nor does one need to imagine them in the nude. The more that people begin to do workers' and peasants' figures, the better I shall like it."[24] And Vincent van Gogh and many of his fellow artists collected costumes, fishermen's clothing, peasants's smocks, and the like.[25]

Having read about how Eugène Delacroix (1798-1863) and other artists drew, Vincent developed his own ideas about drawing, which meant rendering the modeling of a figure in a manner contrary to academic teaching.

Van Gogh's first observations on the unorthodox drawing style of Delacroix date from the autumn of 1885. He linked that style with that of Jozef Israëls, Anton Mauve (1838-88, cats. 44-46), and the Maris brothers (cats. 43, 47-48, 51). Delacroix was of the opinion that an artist should not proceed from the outline but from "the middle [of the masses, the cores]."[26] In his conflict with Siebert, his teacher at the Antwerp academy, Van Gogh would often repeat and paraphrase the "*ne pas prendre par le contour, mais prendre par les milieux.*" Closed contours, he said, counteracted a figure's plastic effect, turning it into a flat, rigid doll.[27] Vincent not only wrote extensively on the subject, but also endeavored to employ the method in his Brabant drawings. An extreme example is his drawing of a peasant (fig. 3).[28] The body is modeled with curving lines running under and over the outlines. The same principle can be observed in countless other figure drawings and even in academic nudes (fig. 4).[29] Here the encircling hatching models the figure; the ground is left white.

The Transition to Symbolism

Vincent van Gogh was undoubtedly the most remarkable of Dutch draftsmen to work in a variety of techniques and styles. Fairly soon after his death, reproductions of his drawings were appearing in avant-garde journals to illustrate fragments of letters; they were also shown in exhibitions. The late, lively drawings were particularly appreciated by the following generation of modernists. The influence of Van Gogh's drawing style is quite evident in the work of Henry van de Velde (1863-1957) and Johan Thorn Prikker (1868-1932). These two artists drew landscapes in colorful, rhythmic arrangements of dashes.

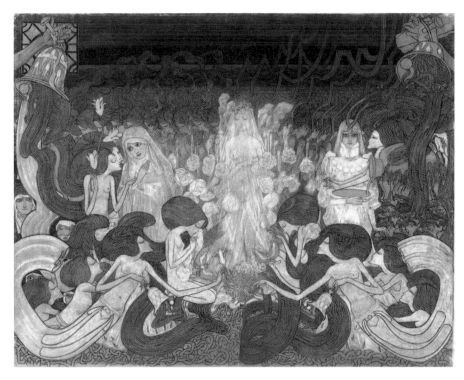

They recall Van Gogh's late pen and brush drawings and some of his paintings executed with a swirling brushstroke that Van Gogh said was based on popular wood engravings.

Vincent van Gogh was one of the sources of inspiration for Dutch symbolism. The significance for drawing of this brand of symbolism is demonstrated by the catalogue cover designed by Jan Toorop (1858-1928) for an exhibition of modern art at The Hague. No sign of realism here; in Toorop's allegorical representation, modern art is personified by a valiant knight on horseback who, having overcome various obstacles, is about to pass through the gate leading into The Hague. The design is related to a "vignette" drawn by Georges Lemmen (1865-1916) for the Belgian magazine *L'Art Moderne*. It shows a field being plowed and freed of thorn bushes so that modern art may flourish under a Van Goghian sun. The new element, however, is the abstract pattern of lines that Toorop introduced to underline the "literary" meaning. This was one of the innovative aspects of symbolism. The line was paramount, being best suited to the expression of the spiritual character of art. For that reason drawing was deemed more important than painting.[30] Thorn Prikker objected to oil painting because it had "too much matter"—paint and frame—and showed "too much how it was done."[31] And that is another noteworthy principle, for symbolism vehemently opposed the foregoing realistic and materialistic art. Spirit, not matter, was the important thing.

In his letters Johan Thorn Prikker frequently berated the older generation. Marius Bauer (cat. 80) was his particular *bête noire*.[32] He made an exception in the case of Maris (1839-1917, cats. 47 and 48), whose brides and other female figures were thought to possess a spiritual element. It is hence not surprising that Pieter Haverkorn van Rijsewijk, director of the Boijmans Museum in Rotterdam, paid a handsome sum for the drawing *Ecstasy* in 1906, which he had ordered from Maris in 1894, at the heyday of symbolism. The dreamy mood in Matthijs Maris' late work is evoked not by abstract lines but by their absence. Conversely, the symbolist Thorn Prikker advocated drawing on white or in a pinch tinted paper and a construction of merely a few dark penciled or chalked lines. "Pure linear art, then, without shading, without color."[33]

The Decorative Line of Symbolism

Dutch symbolism reached its climax in a series of large drawings made by Jan Toorop between 1892 and 1897, the uncontested masterpiece of which is *The Three Brides* of 1893 (fig. 5).[34] Although the artist supplied various interpretations for the representation, the message is clear enough.[35] The eyes of the bride in the middle are cast down. Her nudity, embodying heavenly love, shimmers through her veil. She must choose between chaste love, symbolized by a nun on her right, and unchaste, worldly love on her left. The whole is placed in a Christian context. The bride in the middle wears a crown of thorns, and the drawing is closed off on both the right and left sides with Christ's pierced hand on a fragment of the cross and with large bells. The aerial spirits in the foreground also hold bells. These bells emit visible waves of sound. The women in the background bear candles from which curls of smoke ascend. On the "good," left-hand side of the drawing, their character is more charming than on the right. As on the catalogue cover of 1892 these lines of sound and scent reinforce the meaning of the representation. The lines themselves have become signifiers. The draftsman and critic Jan Veth, a friend of the artist, was of the same opinion and expressed it in lofty, lyrical prose. The function of these lines was no longer to define form and representation, they were as abstract as music.[36] The arrangement of these non-imitative lines in "sheaves" has a strongly decorative effect. It is hard to express their meaning in words, although Thorn Prikker did write of his intention to

explain his "lines of unrest, of force, or of holiness" to the people.[37] He never did, though.

Jan Toorop and Thorn Prikker did not cling to this abstract aspect for long; the odd marriage between depiction and linear ornament was short-lived. By 1900 Toorop had already renounced linear abstraction cast adrift from the representation. The birth of abstract art in the Netherlands had to wait until after 1910 for Mondrian and a few of his contemporaries to make their purely abstract contribution.[38] Henry van de Velde and Thorn Prikker found a completely different solution: they abandoned drawing and painting in favor of architecture and the applied arts. Politically on the left, they condemned easel painting as capitalist and commercial. For Toorop the relationship between form, content, and conviction was more complex, as is demonstrated by two drawings in the exhibition.

In *The Strike* of 1899, pregnantly subtitled "Thirst for Justice," Toorop shows the socially engaged aspect of his character (cat. 64). The rising working class, personified by a red-shirted laborer with a spade, cries for social justice. Like many avant-garde artists at the turn of the century, Toorop supported the workers' cause without actually being a socialist. In keeping with that cause is the realistic style used by Toorop in every element of the drawing. However, the proportions are not right, and the surface is crowded. A number of details, such as the tools and the large hand, immediately catch the eye. All this enhances the expressive value of the realistic representation.

Faith in God of 1907 is much more finely drawn (cat. 65); only by relating the upward-looking peasant to the church tower and to the title might one arrive at a symbolic interpretation. Abstract lines or expressive deformations are totally absent. Toorop's realism is painfully precise, a far cry from the realism of artists like Breitner or Willem de Zwart (1862-1931, cat. 72). The style of the head, the white hair and beard drawn in fine lines, harks back to a source in the fifteenth and sixteenth centuries, and this could be regarded as a sign of conservatism.

Graceful, decorative lines, inspired by oriental art, are to be found in the drawings of a number of artists around 1900. Van Gogh had collected Japanese prints and in Paris had even painted two copies after prints. Toorop's oriental background, having spent his youth in Indonesia, inevitably cropped up in discussions about his symbolic art. Thorn Prikker was enthusiastic about photographs sent by his friend Henri Borel from China.

Stylization, decorative infills, and fine details are also to be seen in the beautifully colored drawings of gourds by Floris Verster (1861-1927, cat. 71) and in the varied oeuvre of Theo van Hoytema (1863-1917, cat. 73), whose graceful swimming swans exploit the decorative character to the full. The drawing is built up with a host of lines and virtually flat areas of color. There is no shading, in keeping with Thorn Prikker's "rule." The swans swim under a branch of laburnum,

Fig. 6. Vincent van Gogh, *Wooded Landscape*. Vincent van Gogh Museum, Amsterdam

irises grow on the bank; it is tempting to seek deeper meanings here, swans and flowers demand interpretation. In this case, though, any underlying meaning would seem to be far-fetched. Theo van Hoytema was simply an animal painter, well-known for his drawings in two books, *How the Birds Were Given a King* and *The Ugly Duckling*. Hoytema, a *bohémien*, used the stately swan as his personal symbol on labels and invoices, and once said: "I have never been able to draw figures. With a few exceptions, I find all people villains or idiots."[39]

Although Hoytema and his wife Tine, the daughter of an impoverished farm laborer, fought like cat and dog, he was devoted to her. We know this from an eye-witness account, but also from the dedication "*het vrouwtje*" (the little woman) under a tranquil drawing of Heeze, a rural village in the province of Noord-Brabant, in autumn (cat. 75). The foreground is a decorative patchwork; black crows set accents and winding tracks on the land create depth. One is reminded of Vincent van Gogh's late drawings (fig. 6).[40] Hoytema might be said to have produced a Van Gogh drawing come to rest. His drawings and prints show signs of the various influences in play around 1900: Van Gogh's drawings, the decorative element, and Japanese art. These influences did not make themselves felt to the same extent. The powerful, spontaneously executed cockerel (cat. 74) is drawn on a blank sheet of paper, giving the drawing a decorative character and, together with the monogram constructed from the initials *TvH*, contributing to the Japanese effect.

Drawings from the beginning of the twentieth century but still in the symbolist vein often retain that same tranquil character. On the other hand there is Suze Robertson (1855-1922, cat. 58) with her robust, expressive drawings. The modernism that became current after 1910 is expressionist in character and a little later cubist and abstract. The era of experiment had dawned with a vengeance.

1. Haskell 1976; Rosen and Zerner 1984, 183-202; Van Tilborgh 1986; De Leeuw 1983, "Introduction," 16-22; Van Grijzenhout 1992, especially chapters 5 and 6.
2. Van Gogh 1958.
3. Leeman 1996.
4. Hefting 1970, 59-68; Breitner 1970, letter no. 24, March 28, 1882, 30; Bergsma 1994.
5. Breitner 1970, 31, letter no. 24 of March 28, 1882. Breitner preceded the statement quoted here with the remark: "I wanted to paint History and so I shall paint History in its broadest sense." In May 1882 Van Gogh wrote of Mauve's prejudiced attitude toward English art: "Over and over again Mauve says, 'This is literary art,' but all the while he forgets that English writers like Dickens and Eliot and Currer Bell (Brönte), and of the French, for instance, Balzac, are so astonishingly '*plastic*,' if I may use the expression, that their work is just as powerful as, for instance, a drawing by Herkomer or Fildes or Israel." Van Gogh 1958, R8 of May 28, 1882.
6. Van Gogh 1958, letter no. 174 of February 13, 1882.
7. Breitner 1970; Treuherz 1987.
8. "The other day I saw a complete set of Doré's pictures of London. I tell you it is superb, and noble in sentiment—for instance that room in The Night Shelter for Beggars—I think you have it, or else you will be able to get it." Van Gogh 1958, letter to Anthon van Rappard (R13), September 18 or 19, 1882.
9. Paris 1972; Pickvance 1974/75.
10. The term "atlas" was first used in the sixteenth century by the publisher Mercator and later by Joan Blaeu. An atlas was supposed to contain maps and pictures of cities, countries, peoples, traditions, and customs all over the world. An atlas could be a book of maps or a collection of prints including maps. In the nineteenth century a learned society such as Het Koninklijk Oudheidkundig Genoteschap (the Dutch archeological society) also compiled an atlas. Gerlagh 1995, also published in *Leids Kunsthistorisch Jaarboek* 10:199-220.
11. The relevant passage is in chapter 106 of Edmond and Jules de Goncourt, *Manette Salomon*, quoted from the photographic reprint (1993) of the 1896 edition with a foreword by Thierry Paquot, 321-25. See also Hubert Juin's introduction to the edition in *Fins de siècle* (Paris, n.d.).
12. See Nochlin 1971, with an excellent bibliography.
13. Van Uitert 1993, 129-45. Breitner called Gavarni "that colossal artist." Both Van Gogh and Breitner had read the Goncourts' monograph on Gavarni.
14. See Scharf 1974, 127-42; Veen 1997.
15. Van Gogh 1958.
16. G. H. Breitner, *Plaster*, black chalk, The Boijmans Van Beuningen Museum, Rotterdam, inv. no. MB 836.
17. "At the same publisher's M. Jongkind, that charming and unaffected Dutch painter, has placed several plates in which he has enshrined the secret of his memories and reveries—as calm as the banks of the great rivers and the horizons of his noble country; curious abbreviations of his painting, sketches which will be intelligible to any amateur used to deciphering an artist's soul in his most rapid *scribbles*." Baudelaire 1965, 220-21.
18. See De Leeuw 1983.
19. Vincent van Gogh, *Carpenter's Yard and Laundry*, drawing, Museum Kröller-Müller, Otterlo. In the summer of 1882 Van Gogh practiced with a perspective frame, making several drawings and watercolors of the view from his attic window (F939). On July 23, 1882, he wrote about this type of landscape that these were landscapes with complicated perspectives, the drawing very difficult, but that was the very reason for their truly Dutch character and sentiment. Van Gogh 1958.
20. Veen 1997, 30-60.
21. As the nineteenth century drew to a close, artists evinced a renewed interest in the pastel technique. The best-known practitioners were Edgar Degas and Odilon Redon, the latter of whom was early appreciated in the Netherlands. Van Gogh, too, worked in pastel. See also Monnier 1985.
22. Van Gogh 1958, R4 Etten, September 12, 1881. In letter R5 of November 21, Vincent wrote about his friend's academic training, pointing out the danger of falling into routine. "A man, who, like you, is working at the academy cannot help feeling more or less out of his element when, instead of knowing, This or that is my task for today, he is forced to improvise, or rather to *create*, his task every day anew." Later, in R7 of December 30, 1881, he referred to the technical skill that Van Rappard hoped to acquire at the academy in Brussels. His hopes, wrote Vincent, were bound to be dashed. "But I have already told you so several times, and I won't repeat it. I won't hear another syllable about the whole academy, nor will I say another syllable about it—it really isn't worth the trouble."
23. In a long letter Van Gogh held forth on his preference for figure drawing. He also wanted to draw nude studies. "Not exactly academic poses. But I would, for example, be tremendously pleased to have a nude model for a digger or a seamstress. From the front, from the back, from the side. To learn to see and sense the shape properly through the clothes and to have an idea of the movements." Van Gogh 1958, letter no. 182, March 14-18, 1882.
24. Van Gogh 1958, letter no. 418, July 1885.
25. Van Uitert 1987, 14-46.
26. Van Gogh quotes an article by Gigoux reporting a conversation in Delacroix's studio. "'Tenez, mon ami,' Delacroix said, 'C'est très beau, mais c'est pris par la ligne, et les anciens prenaient par les milieux (par les masses, par noyaux)!' [Look here, my friend, it is very beautiful, but it is started from lines, and the ancients started from the central things (the masses, the *nuclei*]. And he adds 'Look here a moment' and draws a number of ovals on a piece of paper . . . and he *pulls these ovals together* by means of little lines, hardly anything at all, and out of this he creates a rearing horse full of life and movement. . . . Now I ask you, isn't this a *superb truth*? But . . . does one learn it from the plaster-of-Paris artists or at the drawing academy? I think *not*! If it were taught *in this way*, I should be pleased to be an enthusiastic admirer of the academy, but I know only too well that such is not the case." Van Gogh 1958, letter no. R58, September 1885.
27. Van Gogh 1958, letter no. 452, c. mid-February 1886.
28. Vincent van Gogh, *Walking Peasant*, drawing, Museum Kröller-Müller, Otterlo (F. 1330, recto).
29. Vincent van Gogh, *Nude Youth Standing*, drawing, Vincent van Gogh Museum, Amsterdam (F. 1364b, recto).
30. Gerards 1994.
31. Thorn Prikker 1980, 69, letter no. 2, October 1892. In his letters Thorn Prikker frequently writes about lines, and even wanted to produce a brochure on the subject. "I wanted to tell people about the impression certain lines make on me, to show them that an ordinary line affects me quite differently from a wildly curving one . . . I now believe that carrying on in this manner is the best way for me to explain my lines of unrest, of force, or of holiness, to people." He had already thought up a title for his brochure, of which nothing ever came: "Auto-Contemplatie." Letter no. 5, December 5-9, 1892, 86.
32. Thorn Prikker 1980, 95, letter no. 7, January 22-28, 1893: "I don't like Bauer's work any more. Once, in the past, I thought that it was beautiful and good, but I've changed my mind. All I can see in his work is a hopeless muddle of smeary paint."
33. Thorn Prikker 1980, 136, letter no. 14 of July 1, 1893.
34. Jan Toorop, *The Three Brides*, drawing, Kröller-Müller Museum, Otterlo.
35. Gerards 1989, 1, 2-17.
36. Music is often associated with color, but the melodic line is found more often in symbolism. One of the artists who compared art and music was James McNeill Whistler, who was held in high esteem in symbolist circles. Many of his ideas derive from Delacroix and Baudelaire's writings about Delacroix. Mras 1966. See also Lockspeiser 1973.
37. See note 31.
38. Blotkamp 1978.
39. Timmerman 1983. Timmerman was on friendly terms with several artists, including Jan Toorop, and wrote a beautifully perceptive portrait of Theo van Hoytema, 229-39.
40. Vincent van Gogh, *Wooded Landscape*, drawing. Vincent van Gogh Museum, Amsterdam (F. 1640).

Notes to the Reader

Dimensions are sheet sizes, height before width, expressed in millimeters followed by inches in parentheses.

Authors of Entries

MdB-S	Mariette den Bieman-Smithuis
RB	Richard Bionda
MB	Madeleine Bisschoff
SdB	Saskia de Bodt
IG	Inemie Gerards
MdH	Maartje de Haan
JK	Jeroen Kapelle
JKK	Joke Klein Kranenberg
FK	Fransje Kuyvenhoven
CM	Caspar Martens
AM	A. W. F. M. Meij
MN	Michiel Nijhoff
RJtR	Robert-Jan te Rijdt
MS	Manfred Sellink
EvU	Evert van Uitert
CW	Chris Will

CATALOGUE

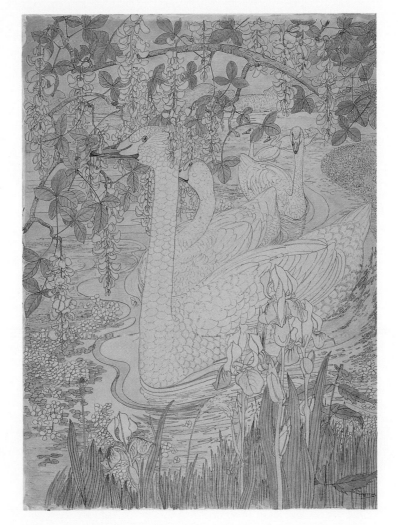

WYBRAND HENDRIKS

Amsterdam 1744–1831 Haarlem

1 Head of a Young Roe

c. 1821

Watercolor over pencil, 239 x 298 mm (9 1/2 x 11 3/4 in.)

Signed lower left in pencil: *W. Hendriks*; verso, signed upper left in pencil: *W. Hendriks*

Watermark: VI (cut off)

Inv. MB 463

Provenance: D. Seldenthuis, Rotterdam; his legacy, 1943

Literature: Van Borssum Buisman 1972, 36, no. 113

After training at the Amsterdam Academy of Art from 1765 to 1777, Wybrand Hendriks worked in a wallpaper factory. In 1786 he was appointed *kastelein* (superintendent) of the Teylers Foundation, the art collection in Haarlem. With a brief interruption he was also director of the Haarlem Academy of Drawing from 1782 until it closed in 1796. Hendriks was a versatile and virtuoso draftsman who retained a penchant for the seventeenth century. Besides interiors, landscapes, and peasant scenes (see cats. 2 and 3) he painted flower still lifes and animal portraits.

Among the works of art in Wybrand Hendriks' estate, auctioned in 1832, was a portfolio containing "68 pieces with drawings colored in with watercolor by W. Hendriks. . . . Also living and dead game, poultry, flowers etc."[1] Of these sixty-eight pieces and all other similar watercolors that Hendriks sold or gave away before his death, a small number are still in the possession of Dutch public collections. In Haarlem's Teylers Museum there are eight animal drawings, and the Rijksprentenkabinet in Amsterdam owns one. In the Boijmans van Beuningen Museum's print room is a flower still life and the present work.

This watercolor, which is known as *Head of a Chamois* in the museum catalogues, is in fact a picture of the head of a young deer. Many of Hendrik's

animal drawings bear the inscription *ad vivum* (drawn from life). Some of his drawings are of living animals, such as the lovely sheep and ram heads in the Teylers Museum, whereas others are of dead animals.[2] Hendriks clearly drew the wild boar in the Teylers Museum and the buck in the Rijksprentenkabinet after a hunting trip.[3] That Hendriks was involved with hunting is also apparent from a drawing of a dead fox and hare with a hunter and his dog in the Gemeentearchief Haarlem. According to the inscription on the back of that drawing, it is "a red fox—shot in the dunes . . . on 28 December 1821—by Mr. Springer."[4]

The Boijmans van Beuningen roe was probably drawn from a living subject, as the shadow on the back of the animal suggests it is standing upright and the eyes and nose appear alive and shining.
MN

1. Auction Amsterdam (De Vries/Roos), February 27–29, 1832, 22–23, portfolio B, nos. 1–68.
2. Compare Menalda 1995, 75–76.
3. Niemeijer says of the buck, "In this case, to all appearances, this is a dead animal lying flat on the ground with lifeless eyes." Niemeijer 1990–91, 62.
4. Hendriks has used the name red fox, which is wrong in this case: the fox in the drawing has a white brush, while a red fox has a black one.

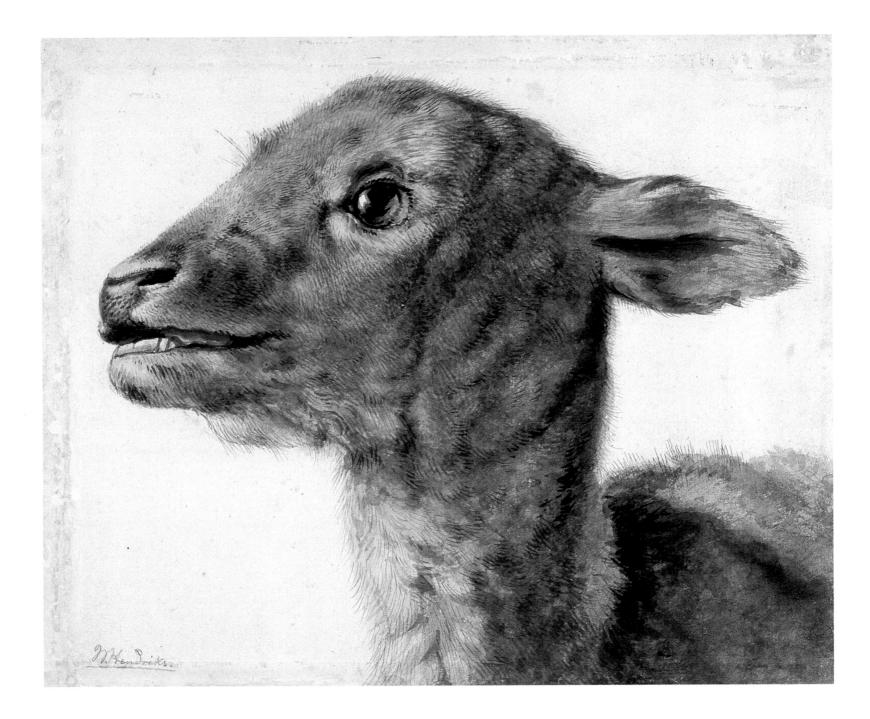

WYBRAND HENDRIKS

Amsterdam 1744–1831 Haarlem

2 Interior of a Barn with a Cut-open Pig

Watercolor over pencil, 305 x 272 mm (12 x 10 3/4 in.)

Verso signed lower left in pencil: *W:Hendriks inv. et Fecit*

Inv. MvS 123

Provenance: H. M. Montauban van Swijndregt, Rotterdam; his legacy, 1929

Literature: Drost 1944, 30, no. 123; Van Borssum Buisman 1972, 36, no. 110; Jansen 1986, 42, fig. 33

Between 1783 and 1786, Wybrand Hendriks stayed alternately in the rural region of the Veluwe (in the villages of Ede and Nijkerk) and in Amsterdam. In Gelderland, as J. Immerzeel has pointed out, he made "many studies and drawings."[1] It is tempting but incorrect to consider the undated watercolor *Interior of a Barn with a Cut-open Pig* and the much larger *Two Farmers in a Tavern* (cat. 3) as sketches of daily life in the Veluwe, for the drawings that he made during the Gelderland period are very different in character. They are usually sketches and studies of landscapes or barns such as the drawing *Country Track with Barn* in the Rijksprentenkabinet.[2] Furthermore, these sheets are often marked with the date, the location, and the note *ad vivum* (from life). The two exhibited watercolors were undoubtedly made in the quiet of the studio. The note in pencil on the back of cat. 2, *W:Hendriks inv. et Fecit* (meaning "Wybrand Hendriks invented and executed this composition"), indicates that it is an imaginary scene.

The drawing shows an interior in which a man is butchering a pig. The woman behind him, judging from the basket standing beside her, is making sausage. Another woman, carrying firewood, can be seen coming toward the viewer through a door opening onto a courtyard. Paraphernalia associated with slaughter is lying all around including buckets, tubs, and a large cooking pan containing blood. The watercolor has little of the spontaneous character usually associated with this medium; the details have been very carefully reproduced, and attention has been paid to the illumination of the objects in the gloomy interior.

This drawing was recently used to illustrate the reintroduction of a motif used by seventeenth-century painters such as Rembrandt (1606–69), Barend Fabritius (1650–72), and Adriaen van Ostade (1610–84).[3] Hendriks frequently copied seventeenth-century paintings. The Teylers Museum in Haarlem possesses a number of large watercolors after militia paintings by Frans Hals (1584–1666). Paintings after Jan Steen (1626–79), Jan Weenix (1640–1719), and Van Ostade are also known to exist. However, the Rotterdam drawing *Interior of a Barn* is not a copy but rather an elaboration of a seventeenth-century painting. Thematically it resembles Van Ostade, whereas in mood and style it is closer to the interiors of Pieter de Hoogh (1629–84). It also appears, from the wording of the auction catalogue of Hendriks' estate, that Van Ostade served as a model for Hendriks' work, for the catalogue reads: "an interior with farm folk after a famous painting by A. van Ostade."[4]

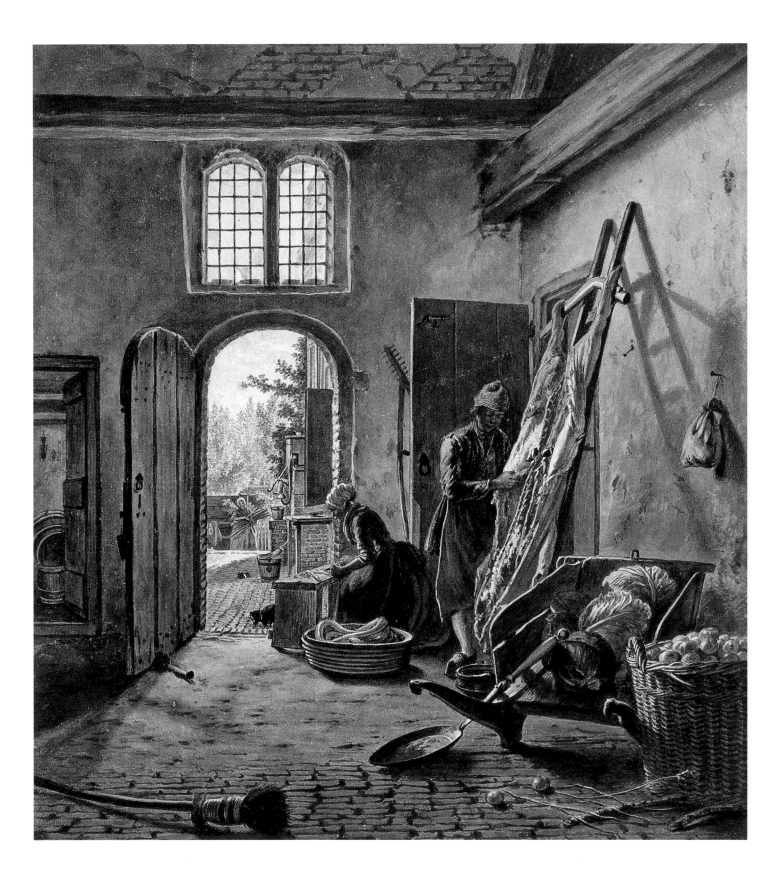

45

WYBRAND HENDRIKS

Amsterdam 1744–1831 Haarlem

3 Two Farmers in a Tavern

Pen and brown ink, watercolor over black chalk, 165 x 147 mm (6 1/2 x 5 3/4 in.)

Signed upper left in pen and black ink on the plaque on the wall: *W: Hendriks pinx*; above it the inscription: *VXIII III*; verso inscribed lower center in later handwriting in pencil: *Hendriks*

Inv. MB 462

Provenance: F. J. O. Boijmans, Utrecht; his legacy, 1847 (L.1857)

Literature: Lamme 1852, 43, no. 1418; Lamme 1869, 38, no. 1785

The previous reference to Van Ostade probably does not allude to the drawing of two farmers (cat. 3) shown here, although Hendriks certainly was indebted to Van Ostade in one of the figures. Striking differences are evident in the representation of the seated and standing figures. The seated figure, who is drinking and smoking, is more lively and more directly painted, which gives him the impression of being painted from life. The use of watercolor has given him a more three-dimensional head and body in comparison to the violinist, who seems flatter, looking as if Hendriks has drawn outlines in ink and filled them in with paint. This last figure was clearly influenced by the work of Van Ostade. Hendriks composed such figures based on his predecessor's violinists. There is, for instance, a watercolor by Hendriks after Van Ostade in Haarlem's Teylers Museum in which the posture of the violinist in the middle of a group of dancing farmers strongly resembles the player pictured here.[5] Van Ostade's *Fiddler* in the Hermitage Museum in Saint Petersburg bears a strong resemblance to Hendriks' violinist; even the expression on the man's face is similar.[6] The figure in this painting is an amalgam of a number of figures by Van Ostade, and, like the drawing, is a combination of copied and imagined elements.[7]

MN

1. Immerzeel 1842–43, 2:31.
2. Inv. 1968:42.
3. Jansen 1986, loc. cit.
4. Auction Amsterdam (De Vries/Roos), February 27–29, 1832, 21, portfolio A, no. 9.
5. Teylers Museum, Haarlem, inv. W. 51. The violinist can be seen here on the right of center, next to the door. Copied from a painting by Van Ostade, see Hofstede de Groot 1907–28, 3: no. 798.
6. Hofstede de Groot 1907-28, 3: no. 107. The painting was part of the Gerrit Braamcamp collection in Amsterdam. This renowned private collection was accessible to those who were interested. On the viewing day before the auction in July 1771, 20,000 people went to see the collection. See Bille 1961, 1:68 and 2:38–38a and 110. Hendriks could certainly have seen the painting himself.
7. Hendriks often made variations on the work of painters from the Golden Age and made compilations of existing works. See Plomp 1993.

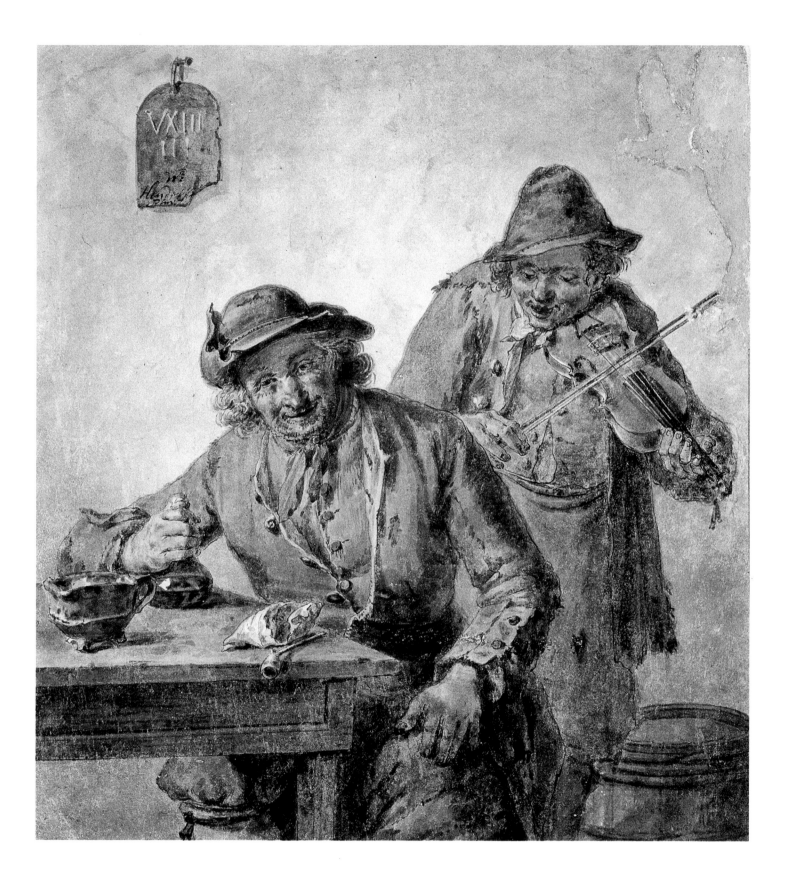

JACOB VAN STRIJ

Dordrecht 1756–1815 Dordrecht

4 Landscape with Horseman and Milkmaid

Brush and brown and red ink, watercolor, 331 x 482 mm (13 x 19 in.)

Signed on the gate right in brush and brown ink: *J. van Strij*; verso, lower right in pencil in later handwriting: *J v Strij*

Watermark: D & C Blauw IV (cut off, Heawood 3268, countermark)

Inv. MvS 309

Provenance: H. M. Montauban van Swijndregt, Rotterdam: his legacy, 1929

Literature: Drost 1944, 62, no. 309; Bol 1956, 13, no. 95

Jacob van Strij came from a Dordrecht family of painters. It was quite customary in his time for sons to follow the professions of their fathers. In this way, skills were passed from generation to generation, and the business stayed in the family. The father of Jacob van Strij ran a prosperous business in interior decoration in which both Jacob and his elder brother Abraham (1753–1826) were active. Wall hangings painted by Abraham and Jacob van Strij made for a dwelling in Dordrecht are now in The Hague's Gemeentemuseum. The two brothers worked in a very similar style on the wall hangings they produced before 1800, but afterward each developed in his own way. Abraham was a painter in the broadest sense of the word, decorating objects ranging from banners to coaches, while his brother Jacob concentrated on the traditional aspects of the artist's trade and produced wall hangings, paintings, and drawings. In public and private collections there are a great many drawings and paintings by Jacob Van Strij, including a good number of copies and works made in his style.

After several years in his father's business, Jacob went to Antwerp. There studied with the history painter Andreas Lens (1739–1822), whose heroic classical style did not arouse the pupil's enthusiasm. The biographer Immerzeel says with reference to these years: "He chiefly trained himself by accurate observation of nature and by studying the great models of former times."[1] The work of Albert Cuyp (1620–91), Dordrecht's most famous painter, had an especially large influence on the artistic development of Jacob van Strij. Cuyp's use of color and his compositions with cattle and water were effortlessly integrated into Van Strij's work. Partly because he also painted copies after work by Cuyp, Van Strij was for a long time labeled the great Cuyp imitator: "he often followed him [Cuyp] in his choice of subjects and manner of composition and was so skilful a copier of the master that it needed a trained eye to distinguish one of his copies from the original."[2]

Van Strij's paintings are realistic, with occasional romantic moments; it is as if he saw reality through the eyes of his predecessors. In his drawings and sketches he was less bound by the visual tradition of the masters of the seventeenth century. The drawings appear fresh and unmannered and are often freer and looser in execution; in particular, the flat watery landscape with the country estates in the region around Dordrecht is clearly recognizable.

The sheet *Landscape with Horseman and Milkmaid* is a delightful work, partly because of its charming subject, partly because of the immediacy of the style and the sparkling use of color. The milkmaid with her shining polished pails, lifted straight from paintings by Cuyp, is the very paragon of Dutch cleanliness.[3] A characteristic of Jacob van Strij's work is the sense of serene tranquility that predominates in the scene. On this subject the art historian Laurens J. Bol remarked: "The Van Strij brothers must have experienced a peaceful, calm atmosphere in those well-kept Dordrecht houses, sparkling with cleanliness, and read it in the shining water of the rivers and canals around the island where they lived."[4]

Along with the praise that Van Strij received for his work from an early age, there was also criticism. His somewhat harsh use of color that was not always true to nature was remarked upon by his contemporaries. "I saw two landscapes by the Dordrecht painter J. van Strij," wrote the art critic B., "both of them attractively composed but not, in my opinion, resembling Nature—at least, I never observed such a color green in the shadows of trees, nor did I ever perceive earth of such a nature."[5] In the Rotterdam sheet the somewhat unusual bluish-gray hue of the cow bears witness to this eccentric use of color.

Van Strij, besides painting landscapes with (and sometimes without) cattle and winterscapes, also made a few self-portraits.

MB

1. Immerzeel 1842–43, 3:119.
2. Van Eijnden/Van der Willigen 1816–40, 2:414.
3. Compare Cuyp's paintings *Milking Scene* (National Gallery of Ireland, Dublin) and *The Milkmaid* from 1646 (Duke of Sutherland collection).
4. Bol 1956, 4.
5. B. 1818, 284.

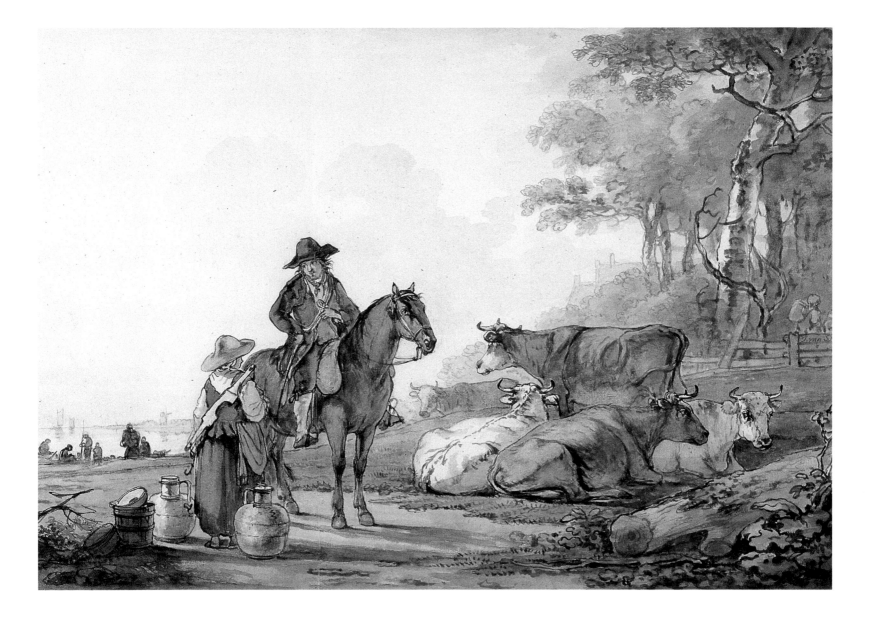

HENDRIK VOOGD

Amsterdam 1768–1839 Rome

5 Terni Waterfall near Civita Castellana

1789

Watercolor over pencil, 590 x 470 mm (23 3/8 x 18 1/2 in.)

Verso, signed lower left, dated and inscribed on the reverse in pen and black ink: *Civita Castellana H. Voogd Roma 1789*

Watermark: fleur-de-lis; countermark: D & C Blauw (Heawood no. 1828, after 1746)

Inv. MB 1993/T1

Provenance: A. Van der Willigen, Sr. and Jr., The Hague; their auction, sixth section, The Hague February 23–24, 1875, in lot 318–21; A. W. M. Mensing, Amsterdam; his auction, Amsterdam (F. Muller), October 26, 1937, lot 211; auction Utrecht (Van Huffel), February 14–15, 1966, lot 503; H. van Leeuwen, Amerongen; his auction, Amsterdam (Christie's), November 24, 1992, lot 435

Literature: De Leeuw 1984, 206–7, no. 153

One of the recent acquisitions of the Boijmans Van Beuningen Museum is a large watercolor by the Dutch landscape and animal painter Hendrik Voogd. The work shows an Italian landscape near Civita Castellana, a village about fifty miles north of Rome. In the early nineteenth century it was a highly popular resort for artists because of its picturesque craggy rock formations and the tributaries of the river Tiber streaming wildly past.

Hendrik Voogd made this drawing in 1789, one year after his arrival in Rome. He was one of the first to return to the habit of artists' visits to Italy. In Amsterdam he had completed training as painter, among other things making wall hangings under Juriaan Andriessen.[1] Lacking Dutch colleagues in Rome he joined a group of artists including the German landscape painters Johann Christian Reinhart (1761–1847) and Johann Martin von Rohden (1778–1868) and the French painter Didier Boguet (1755–1839). During his first years in Rome Voogd sent his large watercolor drawings and paintings to the Netherlands, where the art collector Dirk Versteegh was his zealous salesman. In the years after 1800 Voogd built up his own circle of clients, consisting of Italians and foreign tourists who, especially after the French occupation, came streaming back to Rome. Voogd was fairly well known as a landscape painter. In about 1800 he had already earned the appellation "the Dutch Claude Lorrain," and in 1808 he appears to have been running his own drawing academy for well-to-do foreigners. When in 1816 he was elected to membership in the Accademia San Luca, in itself a tremendous honor for a non-Italian, he was not required to submit a work of art to demonstrate his competence. Apart from a brief visit to Holland around 1828, Voogd spent the rest of his life in Rome. He died there in 1839, largely forgotten by the artistic world, and was buried in the Protestant cemetery near the Cestius Pyramid.

Voogd left an oeuvre of about four hundred drawings. His black chalk studies with topographical and landscape motifs (of which the *Landscape near Tivoli*, bought by the Boijmans van Beuningen Museum in 1980, is a fine example) and his sketches of trees, mountains, and rocky cliffs, together with many animal studies, are the best known.[2] He also made several etchings and about twenty-three lithographs. Apart from his graphic work approximately seventy oil paintings by him are known. He appears to have made only three watercolors in color, two dated 1789 and one that is undated and unfinished; the Boijmans landscape is one of the dated sheets. The other (now in the Teylers Museum, Haarlem) shows a river view in the Narni district, also near Civita Castellana.

The Rotterdam drawing is a good example of Voogd's early work. It is a carefully composed landscape drawing in cool colors, in which the immen-

sity of nature is emphasized by a minute human figure with a dog. In its composition the sheet is related to work by Jacob Philip Hackert (1737–1807) who in the 1770s had a great influence on landscape painters.

Voogd's working method usually followed a fixed pattern. He made a sketch, a fairly detailed preliminary study, and then the final work as either a painting, a lithograph, or a drawing with washes, sometimes with staffage such as cattle, sometimes with motifs from nature, and for these he would make separate studies. It is not certain whether the work here should be connected with Voogd's oil painting *A Group of Cliffs near Civita Castellana*, which he sent to the Netherlands in 1789 to be sold and is known only from the literature.

However, there is considerable information about the Rotterdam drawing. It was first signaled in 1875 in the catalogue of the Dutch art enthusiast Adriaan van der Willigen who had visited Voogd in 1805 in Rome and had the following to say of him: "Among the landscape painters a prominent place is occupied by our Amsterdammer Hendrik Voogd . . . since his work is greatly in demand and exported to other places I did not have the pleasure of admiring a great deal of it. . . . He had with him little more than a few sketches and studies, which indeed I most whole-heartedly admired."[3] It would appear from this citation that Van der Willigen did not buy the drawing from Voogd on his visit to Rome, but later on his return to Holland. It is probable that, in the 1875 auction catalogue of Van der Willigen's estate, the landscape Civita Castellana was referred to.[4]

In the diary recounting his travels in Italy, Van der Willigen made denigrating remarks about the countryside around Civita Castellana, in sharp contrast to his enthusiastic words about the artist Voogd. He wrote: "So far I have seen very few strong and attractive straight trees in Italy, which detracts from the beauty of a countryside that is otherwise often quite pleasing. Various painters and draftsmen have then taken the liberty of adding trees to their scenes of the Italian countryside, thereby misleading us in a pleasant way; making the places to appear more charming than in fact they are."[5]

FK

1. Private funding enabled Voogd to make this journey. From the collector Dirk Versteegh (1751–1839) he received at least 2,400 guilders for the study trip. Bredius 1936, 111–18.
2. Inv. MB 1980/T 1.
3. Cited from Van der Willigen 1811–13.
4. "H. Voogd Vues aux environs de Rome. Aquarelle et sépia"; auction A. van der Willigen, Sr. and Jr., part 6, The Hague February 23/24 1875, lot 318–21. This refers to four watercolors and pen drawings by Voogd, which are described in the auction catalogue as being extremely large and do not fit into portfolios of the average dimensions.
5. Cited from Van der Willigen 1811–13.

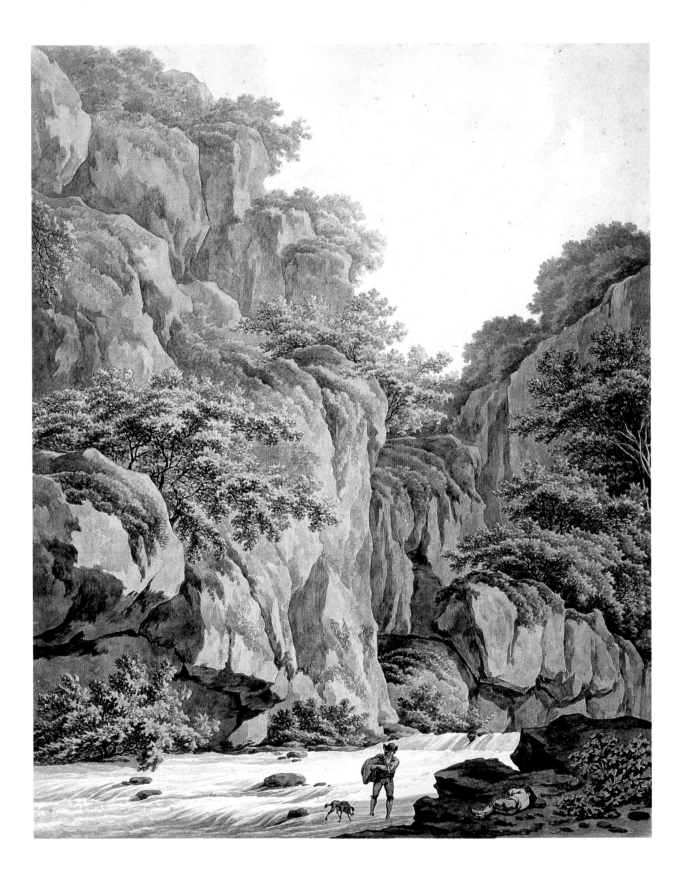

MARTINUS SCHOUMAN

Dordrecht 1770–1848 Breda

6 *Ships on the Zuiderzee*

1805

Watercolor over pencil, 325 x 434 mm (12 3/4 x 17 1/8 in.)

Verso, below in pen and black ink: *door. M.Schouman. getekend, na het orginele Schilderij. van L. Bakhuijsen. hoog 18 en breed 25. duim berustende. in het Cabinet van de Heer. Van Zwieten te Rotterdam in Jaar. 1805* [drawn by M. Schouman after the original painting by L. Bakhuysen . . .]

Inv. MvS 287

Provenance: H. M. Montauban van Swijndregt, Rotterdam: his legacy, 1929

Literature: Drost 1944, 59, no. 287

Martinus Schouman, born in Dordrecht, showed great artistic talent at an early age. In his native town he studied with Michiel Versteegh (1756–1843) who was known for his landscapes and interiors by candlelight. After a year and a half Schouman quit Versteegh's studio and around 1788 went to The Hague to work with his great-uncle, the famous painter Aert Schouman (1710–92). This uncle, also originally from Dordrecht, was a well-known painter of wallpapers, of the so-called *grauwtjes* (paintings using various tones of gray), portraits, and genre pieces. However, he was most renowned for his watercolors of birds, mammals, and topographical views.[1] Three years later Martinus decided it was time to return to Dordrecht where he could devote himself to painting river- and seascapes. His work was greatly admired by contemporaries, and even the Dutch king Louis Bonaparte bought one of his seascapes in 1808.[2]

Like many of his contemporaries, Schouman was a great admirer of the masters of the Dutch Golden Age. He would make meticulous copies of the great seascapes of the past by such artists as Willem van de Velde the Younger (1633–1707) and Ludolf Bakhuysen (1630–1708); indeed, he owned one by Bakhuysen.[3] The drawing shown here, *Ships on the Zuiderzee*, is apparently a copy of a so-far unknown painting by Bakhuysen.[4] A huge man-of-war is shown towing two sloops. On the flat stern of the large ship can be seen the coat of arms of the city of Amsterdam, with a lion rampant on either side. This suggests that the ship was probably the most important vessel of the Amsterdam Admiralty. Unfortunately it is not possible to identify the ship from the coat of arms since there were several admiralty ships named *Amsterdam* in service during Bakhuysen's lifetime.[5]

The two large ships, one at the extreme left and one at the extreme right, are regular line service ships. In front of the one on the right sails a fishing boat. The presence of the fishing boats, together with the fact that a ship of the line would never sail on the open seas with two sloops in tow and the characteristic movement of the waves, suggests that this painting shows the Zuiderzee (today's IJsselmeer). The tower in the background on the right may belong to one of the harbor towns such as Enkhuizen, which still can be seen today.[6] Bakhuysen frequently painted this type of scene.

The original painting by Bakhuysen was, according to the inscription, in 1805 in the Van Zwieten collection in Rotterdam. Unfortunately nothing is known about this collection nor about the present whereabouts of the work.[7] Schouman first made a painstaking copy in pencil and then applied the watercolor layer by layer in an attempt to correspond as closely as possible with the original. As a result the drawing loses some of the transparency that it so characteristic of watercolor. Schouman applied this opaque technique far less in his work that was not based on other paintings, instead suggesting the composition with a few strokes of color on the paper.

Schouman had a small number of pupils, the best known of whom was Johannes Christiaan Schotel (1787–1838, see cats. 12 and 13). Schotel attended the studio of his older colleague in about 1808 and learned above all the art of painting water and skies, which was Schouman's area of expertise.[8] Before long Schotel was regarded as a better painter of seascapes than his teacher and usually received higher praise by critics. Yet although his pupil excelled him, Schouman was still highly regarded as a teacher: "Yes, he trained masters! That sea, that womb of waves. On yonder shattered shipwreck you see his pupil's work. Render due praise to Schotel for that and say: In the pupil's hands lives creative power, no less than in the master's."[9]

MdH

1. See chiefly Bol 1991.
2. Bergvelt 1984(2), 121.
3. Schouman bought this work in 1812 from D. Weiland of Rotterdam. See: Hofstede de Groot 1907–28, 7:284, no. 175. The painting is now owned by Amsterdam's Rijksmuseum, inv. A 11; Van Thiel 1976, 97.
4. Hofstede de Groot, op. cit., did not describe this particular painting nor was it to be found in the photographic documentation in the Rijksbureau voor Kunsthistorische Documentatie in The Hague.
5. The drawings of types of ships by Willem van de Velde (1633–1707) did not reveal a comparable ship's stern bearing the coat of arms of the city of Amsterdam, nor can this be identified from the Vreugdenhils list of Dutch men-of-war from the period 1572 to 1950; compare Vreugdenhil 1936–55.
6. This information was given by Ronald Prud'homme van Reine of the print room in Amsterdam's Maritime Museum.
7. So far nothing is known about this Rotterdam collector. We wish to thank the Rotterdam Municipal Archives for their help.
8. Compare De Groot 1989, 73.
9. These lines by the preacher and poet Dr. B. F. Tydeman were recited in 1824 during the celebrations marking the fiftieth anniversary of the Dordrecht society Pictura. The speech is published in Schotel 1840, 46.

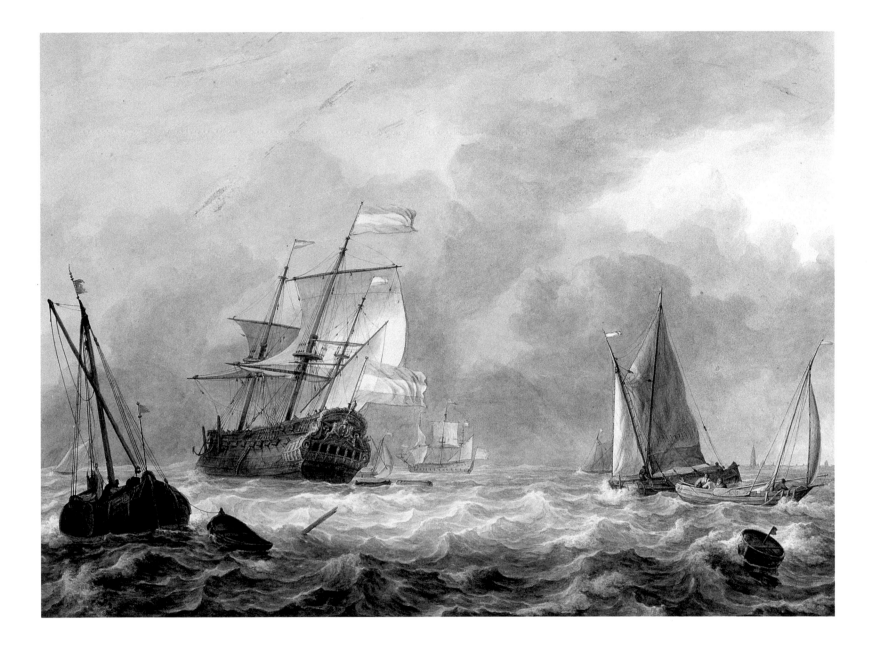

53

PIETER GERARDUS VAN OS

The Hague 1776–1839 The Hague

7 *Cows at a Riverside*

c. 1808

Watercolor over black chalk, 270 x 395 mm (10 5/8 x 15 1/2 in.)

Signed lower left with pen and black ink: *P. G. Van Os.f.*; verso: unclear sketch in pencil in center

Inv. MvS 242

Provenance: H. M. Montauban van Swijndregt, Rotterdam; his legacy, 1929

Literature: Drost 1944, 51, no. 242

Pieter Gerardus van Os was the oldest son of the gifted still-life painter Jan van Os (1744–1808). His brother Georgius Jacobus Johannes (1782–1861) and his sister Maria Margaretha (1780–1862) followed in their father's footsteps and painted still lifes in contrast to Pieter Gerardus, who at the age of fourteen had already made clear his preference for animals. He made a copy of the famous stag by Paulus Potter (1625–54), a work that at that time was accessible to the general public in the Prince Willem V Gallery in The Hague. Having enjoyed a number of years at The Hague drawing academy, Van Os set up in Amsterdam as a miniaturist.[1] However, he had so little success in this field that he soon returned to his first love, painting animals in the style of the seventeenth-century masters. As examples he had not only Potter, but also Nicolaes Berchem's (1620–83) popular landscapes with disporting shepherds and shepherdesses.

Van Os was successful with his animal pieces, and in 1808 he won the Louis Napoleon Prize for the best landscape and the gold medal from the drawing department at the Felix Meritis artists' society, a prize he shared with his friend, the landscape painter Wouter van Troostwijk (1782–1810).[2] Contemporaries exuberantly praised Van Os; in response to a landscape with trees and grazing animals, one critic wrote: "In this piece the artist displays such strength in the treatment and accuracy in his imitation of nature that, having excelled himself, he could be considered as maintaining the reputation of the entire school of Dutch painting in this subject."[3]

P. G. van Os was the father as well as the teacher of the animal painter P. F. van Os (1808–92), who significantly influenced developments in Dutch art in the second half of the nineteenth century. In his Haarlem studio P. G. van Os trained, among others, Paul Gabriel (1828–1903, compare cat. 42) and Anton Mauve (1838–88, compare cats. 44–46).[4]

MdH

1. Niemeijer 1961.
2. Knoef 1943, 255–57.
3. B. 1818, 346–47.
4. De Bodt 1997(2), 18ff.

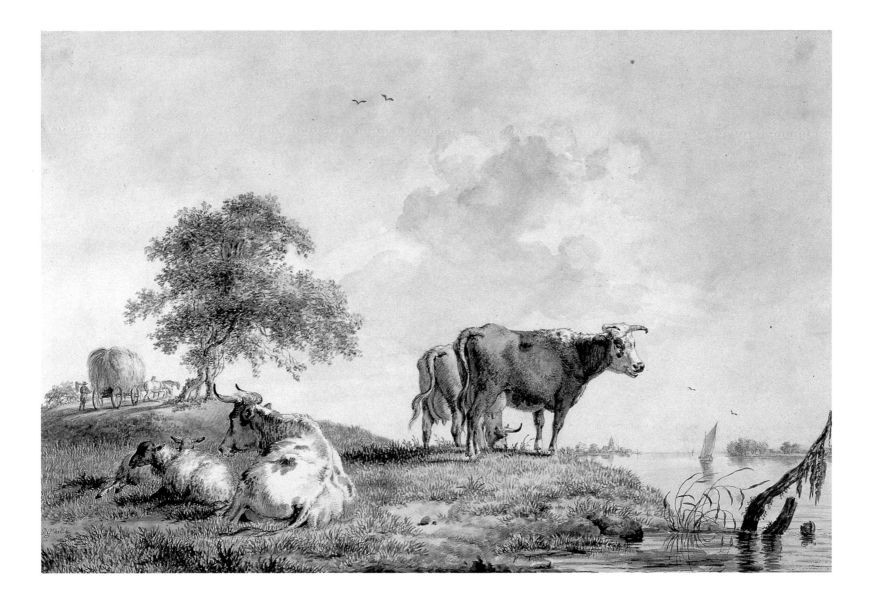

ABRAHAM TEERLINK

Dordrecht 1776–1857 Rome

8 *Bridge at Bagni di Lucca*

1830s–1840s

Black chalk with pencil, white highlights, on blue paper, 460 x 662 mm (18 1/8 x 26 in.)

Signed lower right in black chalk: *A Teerlink f*; inscribed above left in black chalk: *Ponte di Calavorno Strada di Bagna Diretto Luchese*; four pinholes in the corners

Watermark: coat of arms with oblique bar, crowned with fleur-de-lis; countermark: P M (compare Heawood 150–159)

Inv. MB 1986/T1

Provenance: Legatees of Teerlink, Rome; G. J. Hoogewerff, Rome; J. A. van Dongen, Amsterdam, acquired in 1964; acquired from the art dealer Ch. Roelofsz, Amsterdam 1986

Literature: Meij 1993

Fig. 1. Abraham Teerlink, *Bagni calde di Lucca*. Rijksmuseum, Rijksprentenkabinet, Amsterdam

Abraham Teerlink occupied an important place among the Dutch painters active in Rome around 1800. He arrived there in 1810 and stayed until his death in 1857.

During his years in the Netherlands, Teerlink studied painting and drawing with Arie Lamme (1748–1801) and Michiel Versteegh (1756–1843) in his native town of Dordrecht. In 1807 he was granted a scholarship by King Louis Bonaparte enabling him to study at the Louvre in Paris under Jacques-Louis David (1748–1825), where he copied paintings by the old masters. Later, on the same scholarship, he traveled to Rome to complete his training. In the same year that he arrived in Italy, France absorbed the kingdom of the Netherlands and the state of Rome, and Teerlink felt relieved of his obligation to return to Holland. He therefore remained living and working in Rome and over the years established a prominent position for himself in the Dutch artists' colony there.

The professor of Dutch language and literature Jan Wap (1806–80), who visited Teerlink several times in Rome in 1837, described him as a man in his sixties with a very youthful appearance. His home was a gathering place for the cultured Roman world as well as foreign visitors. Wap added that life clearly suited Teerlink admirably in Rome and that he had "built himself up an independent fortune."[1]

The landscape by Teerlink shown here is a typical example of the neoclassical style of drawing that was popular in Rome in the first decades of the eighteenth century. Teerlink's inscription indicates exactly the place the drawing represents, the Ponte di Calavorno crossing the Sérchio river. The valley through which the river runs is called La Garfagnana. The road on the other side of the bridge is, according to Teerlink's inscription, the Strada di Bagna, named after the highly sophisticated bathing resort Bagni di Lucca, which lies about twenty-five kilometers north of the town of Lucca. In the first half of the nineteenth century in particular, the place was crowded with visitors from abroad such as the British poets Byron and Shelley and the German Heine. It was patronized by painters, writers, and poets and clearly by Teerlink, who made many drawings of these surroundings (fig. 1).[2]

In October 1836 Teerlink, who had meantime changed his given name of Abraham to Alessandro, married the little-known painter Anna Muschi. On the occasion of their marriage Anna's uncle, Patrizio Muschi, wrote a small verse for the couple, which tells more about Teerlink. The penultimate couplet makes a reference to Teerlink's great admiration for the Scottish poet and dramatist James Thompson (1700–48).[3] The latter wrote a work between 1726 and 1730 titled *The Seasons*, which describes the countryside and the landscape changing with the year. It was Thompson's most famous work and was published in many languages; Patrizio Muschi himself made a translation into Italian in 1826.[4] During the eighteenth century *The Seasons* influenced artists in many disciplines. For example, the composer Josef Haydn, inspired by the work, wrote his famous oratorio of the same name. And later, in the romantic period, there was lively interest in Thompson's work. Although Teerlink continued to paint in a neoclassical manner until the end of his life, a few lines from Thompson's poem bring out a romantic mood in his picture:

> Welcome, ye Shades! ye bowery Thickets, hail!
> Ye lofty Pines! venerable Oaks!
> Ye Ashes wild, resounding o'er the Sheep!
> Delicious is your Shelter to the Soul!
> As to the hunted Heart the sallying Spring
> Or Stream full-flowing, that his swelling Sides
> Laves, as he floats along the herbag'd Brink.[5]

It would seem reasonable to date Teerlink's drawing of the bridge of Calavorno to the 1830s or 1840s. Teerlink died in Rome at the age of eighty and was buried in the church of San Carlo al Corso.

AM

1. Wap 1839, 75–76.
2. *Bagni calde di Lucca*, black chalk, reworked in pencil, heightened with white, 460 x 642 mm (18 1/8 x 25 1/4 in.), signed lower left in black chalk: *A. Teerlink f.* and below this in pen and brown ink: *no 29* and *Bagni calde di Lucca*; inv. 1964:68, Rijksmuseum, Rijksprentenkabinet, Amsterdam.
3. An example of this sonnet, in printed form, is in the Koninklijke Bibliotheek, The Hague; see Meij 1993, 90, ill. 4.
4. See Thompson 1826.
5. See Thompson 1981, 82.

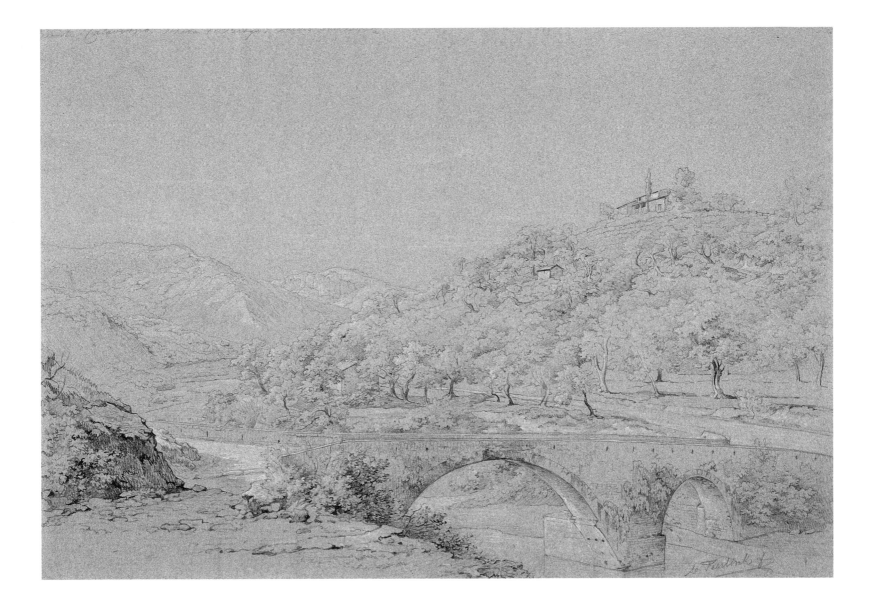

JOSEPHUS AUGUSTUS KNIP

Tilburg 1777–1847 Berlicum

9 *Cloud Study*

after 1809

Watercolor over pencil, 282 x 420 mm (11 x 16 1/2 in.)

Inscribed in pencil at lower center: *2 Schitter Ligt.*; in pencil in the center of the clouds: *2*

Watermark: Van der Ley (Heawood 3733, countermark)

Inv. MB 471

Provenance: Gift of J. Knoef, Amsterdam 1938

Literature: Bergvelt 1975, 31, no. 23; Esmeyer 1977; Bergvelt 1984(1), 174, no. 86

Although Josephus Augustus Knip was the son of a painter and had been fond of drawing and handicrafts since his childhood, the course of his training in draftsmanship did not run smoothly. As he himself said, his talent was not sufficiently stimulated. "Although I had shown an aptitude for drawing since I was a boy, there was no opportunity to nurture that aptitude properly."[1] Nor did he gain much benefit from the tutelage he received at a school of drawing in 's-Hertogenbosch. In spite of this, when his father went blind in 1796, Josephus was compelled to take up painting to support the family. Like his father, he specialized in painting wallpaper.

On April 1, 1801, Knip set off on foot to Paris to try his luck as a painter. He was reasonably successful, married the wealthy French painter Pauline Rifer de Courcelles (1781–1851) in 1807, and when his father died in 1808 felt free from all worries about his family. At the urging of his fellow townsman, the flower painter Gerard van Spaendonck (1746–1822), and with the support of the French painters Jacques-Louis David (1748–1825) and François Gérard (1770–1837), he applied to King Louis Bonaparte for a grant.[2] In order to stimulate the arts in the Netherlands, the king had installed the Prix de Rome, which enabled young artists to spend two years in Paris and two years in Rome and take lessons from famous artists.[3] Knip's application was successful, and he was able to have thorough training in art for the first time: "I was thirty-one years old at the time, had never had a master nor ever done any copying, and boldly began to assemble a portfolio of life drawings."[4]

During the period that he was a *pensionnaire* (scholarship student), Knip built up a portfolio of drawings. On his return from Italy he brought with him a collection of at least 570 studies of landscapes and clouds, buildings and ruins, nudes and staffage figures, animals and plants as well as drawings of farm machinery and various other vehicles. These portfolios were a source he was to draw on for the rest of his working life. He used the so-called jigsaw-puzzle method to compose his paintings, putting different drawings together to form a single complete work.[5] Although Knip wrote that he had assembled this collection of drawings between the ages of thirty-two and thirty-seven, which corresponds with his time in France and Italy, he stated elsewhere that he later continued to add to this portfolio from time to time.[6] In any case they are subjects that could be used in many landscape compositions. It is not possible to tell exactly when the study shown here was made.

Knip made a number of drawings of plants and trees that he sometimes transferred in their entirety into a final piece. The cloud studies, seven of which are known, could also have been used in later compositions.[7] In landscape studies he nearly always left the sky untouched, only adding the clouds to the final, fully worked-out drawing. Thus the clouds also have to be seen as independent elements of a composition for which Knip made a number of separate studies.[8]

Knip often made notes on his drawings, which varied from a single indication of the location to detailed instructions for the application of color. He sometimes used numbers to indicate specific shades of color. His intention was obviously to use this information in a complete work later on. Knip has written a figure "2" in the middle of the Boijmans Van Beuningen cloud study that refers to the word *schitterligt* (brilliant light) on the drawing. He obviously wanted to create a radiant contrast with the dark clouds at the center. Another cloud study, which has very detailed numbering, has two different explanations for the number 2: on the recto is written "2 is very clear and brilliant yellow-red" and on the verso is "2 soft yellow."[9] From this it would appear that his system of color coding had no fixed meaning.

Research into Knip's seven cloud studies, including the one shown here, has made a connection between Knip's method of noting details and painters' handbooks of the sixteenth to nineteenth centuries. Because light is always changing in the landscape and thereby affecting colors to be painted, artists were advised in these handbooks to make quick, short notes on the colors needed so that they could be worked out later in the studio. Looked at in this way, it might seem that Knip conscientiously followed their advice, particularly in the cloud studies, where the changing light itself became the subject of the drawings.[10] However, a complicating factor is that Knip has marked a diverse range of subjects such as animal studies and the interior of a cattle stall, while of the seven cloud studies, notes on three of them were incomplete. There is therefore no reason to attach a particular meaning to the numbers written on a cloud study, since Knip used a method of numbering details throughout his work as a whole.[11] Whether or not Knip had adopted this method from one of the painting handbooks, it certainly corresponds with his aim "to build up a portfolio of life studies" that he could later use.

JKK

1. Knip 1840 (2).
2. Knip 1840 (1).
3. See Van Luttervelt 1984, 561–72, and Bergvelt 1984(1) and (2).
4. Knip 1840 (2).
5. Bergvelt 1976, 11–73.
6. Compare Knip 1840(2) and Knip 1819.
7. For an analysis of the enormous scientifically oriented interest in clouds among artists at this time, see Busch 1994.
8. Bergvelt 1977, 115.
9. Amsterdam, Ploos van Amstel-Knoef Foundation, inv. 60. Pen and gray ink, 272 x 345 mm. Compare also the sheet in the Rijksprentenkabinet, see Sillevis 1985, no. 28.
10. In connection with this, see in particular Esmeyer 1977.
11. Compare Bergvelt 1977, 68.

JOSEPHUS AUGUSTUS KNIP

Tilburg 1777–1847 Berlicum

10 Ruins of the Aqueduct Julia and the Porta San Lorenzo

after 1809

Watercolor over pencil, 352 x 505 mm (13 7/8 x 19 7/8 in.)

Inscribed lower left in pencil: *Porte St. Laurent*; four pinholes in the corners

Inv. MB 1982/T21

Provenance: Acquired from H. Stokking, Amsterdam 1982

Literature: Rotterdam 1982, 22

As was the case for many artists who undertook the journey to Italy, the remains of ancient Rome were a favorite subject of Knip's. He called them "Delightful Ruins" and was certainly not the first to find grandeur in the weather-beaten architecture of a lost past. Knip loved to draw partially collapsed, overgrown arches. He recorded every nuance of color brought to life by the sun on the crumbling stone. He often chose popular subjects such as the Colosseum or the Basilica of Maxentius, but sometimes drew ruins that were less often the subject of drawings, as is the case here.

The main subject here is not the *Porte Saint Laurent* as the inscription suggests. The name refers to the gate with the towers in the background on the left of the drawing. This ancient gateway was built by Caesar Augustus in the year 5 B.C. and was originally called Porta Tiburtina. Since the Middle Ages it was also known as the Porta San Lorenzo after the nearby Basilica of San Lorenzo *fuori le mure*. The arches in the foreground that occupy most of the space on the page are part of the aqueduct Julia, which was built by Agrippa in 33 B.C. The Porta Tiburtina carried the Aqua Julia over the Via Tiburtina. By the time Knip was in Rome, the remains of this junction had already long disappeared and only a few arches of Aqua Julia remained. Nowadays the Porta Tiburtina and the ruins of the Aqua Julia are separated by the yard of the train station Termini.

In a watercolor of S. Maria Maggiore, Knip once again drew the arches of the Aqua Julia, this time seen from the other side.[1]

JKK

1. Amsterdam, Prof. Dr. I. Q. van Regteren Altena Collection, inv. 22. Inscribed: *Ste Marie Majeure à Roma*.

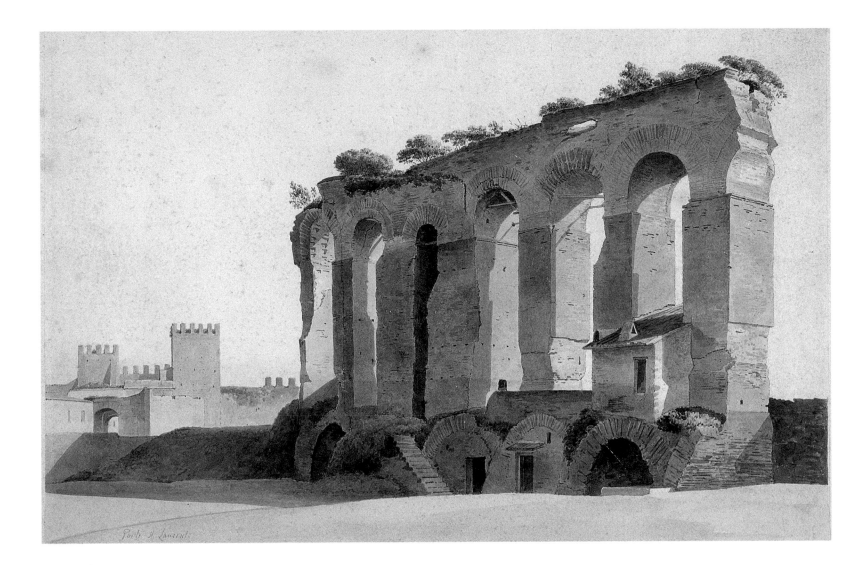

Porte S. Laurent.

61

JOSEPHUS AUGUSTUS KNIP

Tilburg 1777–1847 Berlicum

11 Monte Mario

after 1809

Watercolor over pencil, 329 x 475 mm (13 x 18 3/4 in.)

Inscribed lower left in pencil: *Mont Mario.*

Watermark: J. Honig & Zoonen (Heawood 3344)

Inv. MB 559

Provenance: Unknown, acquired in 1940

Through a row of five pine trees Knip shows us Monte Mario, lying just outside Rome and north of the Vatican. A building, presumably the Villa Mellini, stands on the hillside named after its fifteenth-century owner, Mario Mellini. It is not clear what the building in the foreground represents. The drawing is unfinished: there is the beginning of a reflection of the pine trees, which suggests a river, but this is not developed.

The two pines farthest left in this watercolor also appear in a painting now to be found in the Kunstmuseum, Düsseldorf.[1] This work was probably made by Knip after his return from Italy, with the help of portfolio sketches. The trees are not identical, but it seems likely that the drawing of Monte Mario served as a preliminary study. Knowing Knip's working method, one may assume there was also a model for the central pine tree in this painting. In the painting the connection with Monte Mario is not noticeable at all, and the shrubbery at the base of the tree trunks is also an addition. Although Knip paid great attention to the careful study of natural detail, it presumably did not mean that he avoided personal invention. Here he was completely at one with the classical theory of art, which held that the artist should take as his basis the study of perceivable reality but should in fact improve nature by combining her most beautiful elements in one picture.

There is another drawing by Knip of Monte Mario, on the lower half of a sheet of paper, with a view of the Vatican above. Placed beside each other, these form an extended panorama.[2] However, the viewer's perspective in this drawing is much farther away and also higher, so that a broader view is provided across the valley in front of Monte Mario than is here the case.

JKK

1. Inv. 4432; see Andree 1968, 52.
2. Amsterdam, Prof. Dr. I. Q. van Regteren Altena Collection, inv. 1, pencil and watercolor, 367 x 510 mm (14 1/2 x 20 in.), inscribed: *Palais du Vatican* and *Mont Mario*. See Bergvelt 1977, 95, no. 39.

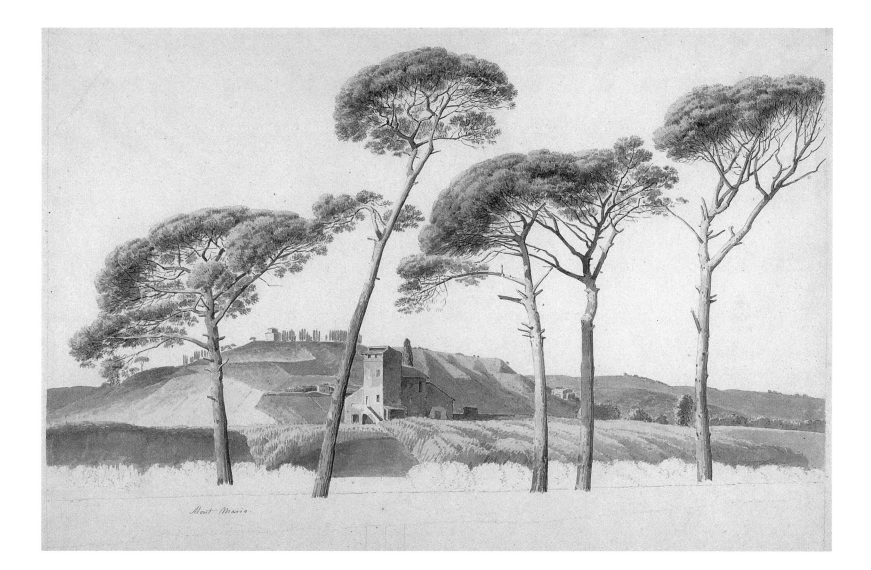

Mont Mario

JOHANNES CHRISTIAAN SCHOTEL

Dordrecht 1787–1838 Dordrecht

12 River View

Pen and brown ink, watercolor over pencil, 335 x 478 mm (13 1/8 x 18 7/8 in.)

Signed lower center and dated in pen and black ink: *J:C:Schotel 18[15?]*

Inv. MB 476

Provenance: F. J. O. Boijmans, Utrecht; his legacy, 1847 (L.1857)

Literature: Lamme 1852 56, no. 1814; Lamme 1869, 51, no. 2187; De Groot 1989, 138, no. 45

Johannes Christiaan Schotel was born on November 11, 1787, in Dordrecht, the son of a well-to-do manufacturer of sewing silks and cottons. Although the young Johannes enjoyed watching boats pass by and toyed with the idea of becoming a sailor, he conformed to the wishes of his father and took over the family business.

As a boy Schotel took drawing lessons from Adrianus Meulemans (1763–1835), an artist who was "no shining light" and who "failed to impart a thorough basic knowledge of the art of drawing."[1] In 1808 therefore, Schotel decided to study with Martinus Schouman (1770–1848, see cat. 6), who was the leading seascape painter of his time in Dordrecht. Under this master, Schotel learned not only drawing, but also painting in oils. In 1805 this businessman, who spent almost all his spare time as a draftsman, became a member of the drawing society Pictura, where he came in contact with the work of Abraham (1753–1826) and Jacob van Strij (1756–1815, compare cat. 4), who both taught at Pictura.[2]

As well as training in draftsmanship, Schotel studied such seventeenth-century seascape artists as Ludolf Bakhuysen (1631–1708) and Willem van de Velde the Younger (1633–1707). To begin with the young artist worked in a manner similar to theirs, and later developed his own, somewhat looser style. From about 1809, when an economic depression made Schotel's business almost bankrupt, his chief source of income became drawing and painting.[3] There was never a shortage of commissions for or interest in Schotel's work. Both King Willem I of the Netherlands and Tsar Nicholas I of Russia bought his

work. In the Netherlands and abroad he won various prizes for his paintings. In his native town of Dordrecht there was considerable interest among members of the town council, and in other places too, where his clients included members of officialdom, art collectors, and business people.

Two drawings of Schotel's in the Boijmans Museum, both featuring a state yacht sailing out of a harbor, are virtually identical in composition. The exhibited work, showing meticulous detail, is painted in watercolor[4] and is intended to be an independent work. Indeed, it was probably sold as such. The other is a drawing in pen that was presumably the design for the watercolor and probably also for an as-yet unknown painting. Schotel often used the same compositions in paintings and in drawings, a method adopted by many artists of his time.

CM

1. See the biography "Mijn vader J. C. Schotel," written by the artist's son P. J. Schotel. This manuscript is kept in the Schotel family archives, Gemeentelijke Archiefdienst (Municipal Records) Dordrecht, and published in De Groot 1989, 71–74.
2. On October 2, 1805, Schotel became a member of the society Teekengenootschap Pictura, founded in 1774. See De Groot 1989, 29.
3. The economic slump was largely a result of the economic blockade of Britain during the wars into which the Dutch were dragged when they were under French rule during the years 1795–1813. This policy had disastrous effects on the export trade in Holland.
4. Johannes Christiaan Schotel, *River View*, pen and brown ink over pencil; 313 x 485 mm (12 3/8 x 19 1/8 in.); verso, inscribed lower right in pen and brown ink: *No: N:711, No. 7a grooter*; watermark: fleur-de-lis. Museum Boijmans Van Beuningen, Rotterdam, inv. MB 477; gift of D. Duuring, Amsterdam 1867.

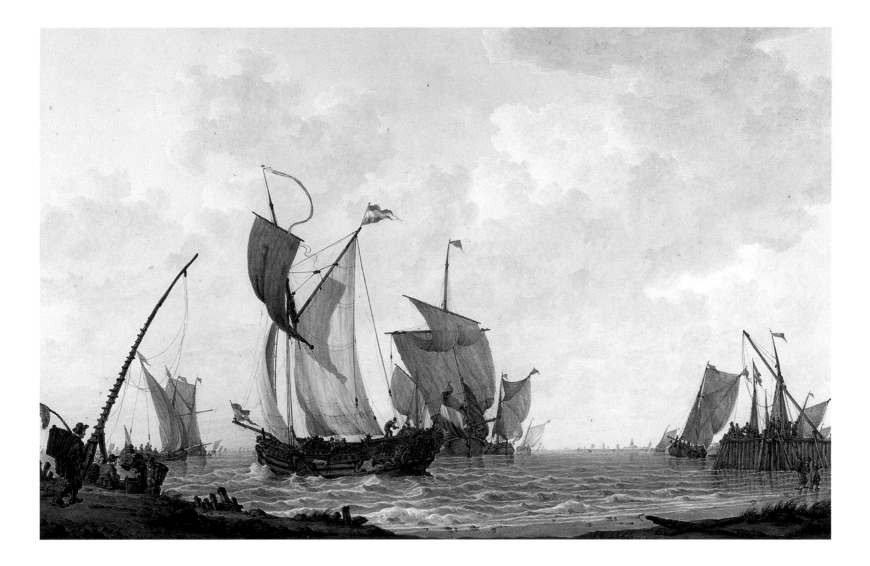

JOHANNES CHRISTIAAN SCHOTEL

Dordrecht 1787–1838 Dordrecht

13 Storm at Sea

c. 1829

Brush and black ink, gray washes over pencil, 630 x 905 mm (24 3/4 x 35 5/8 in.)

Inscribed lower right in pen and brown ink: *N 87*; upper right in pencil: *N 87.*; below center in pen and black ink: *a 161*

Inv. MB 556

Provenance: Gift of G. Duuring, Amsterdam 1867

Literature: Lamme 1869, 51, no. 2183; De Groot 1989, 143, no. 81

Fig. 1. Johannes Christiaan Schotel, *View of a Lighthouse in Stormy Weather*. Museum Boijmans Van Beuningen, Rotterdam

Johannes Christiaan Schotel was a meticulous man, which is confirmed by his list of the paintings he had made during the years 1817 to 1838. He noted 208 works, each provided with a reference number, mentioning subject, buyer, and the price for which it was sold.[1] The major biographer of the painter, his son Dr. G. D. J. Schotel, also mentions two other inventories that his father made. One is a book containing notes on the paintings, and the other is a list of 274 large detailed drawings that he made for collectors. There was yet another list of sketches by J. C. Schotel that was drawn up by his son Petrus Johannes, who like his father was a painter of seascapes. This is probably the basis of a regrettably incomplete list of sketches for the artist's paintings.[2]

The two lists that have been preserved would be of purely documentary historical interest were it not for the fact that they enable us to link numbered preparatory sketches with the paintings. The systematic-minded artist and his sons made a note on a great many of the sketches about the painting that was based on these preliminary drawings. This admirable procedure curiously enough escaped the notice of the compilers of the Schotel monograph and its accompanying exhibition.

The large drawing exhibited here reveals several interesting points. It shows a small sailboat passing a tower and approaching the coast in a strong wind. The painting based upon this drawing (fig. 1) can be found in Schotel's inventory under number 87 titled "View of a lighthouse in stormy weather."[3] It was painted in 1829 and sold for 800 guilders to the Amsterdam collector Abraham Jacob Saportas. The drawing bears the inscription "N 87" twice, above right in pencil and lower right in brown ink. Comparing it with other preliminary sketches of which the later paintings are also known, it would seem that the numbers written in pen are generally the original ones.[4] The Rotterdam drawing also has a second number: "a 161." This refers to the list of sketches on which paintings were based. In this list the sheet, with a reference to the painting owned by Saportas, is described as "A view of a lighthouse and harbor where a boat is entering in stormy weather, drawn in Indian Ink with a brilliant effect." The method of numbering with a small "a" is used on other preliminary drawings for paintings.[5]

It seems likely that a number of paintings may be identified by studying these numbers on the preliminary drawings. In this way the year in which works were made may be established, together with the first buyer and the price paid for the painting.[6]

RJtR

1. These notes, in the Gemeentearchief (City Records) Dordrecht (archive Schotel inv. 60), are printed in De Groot 1989. There are 215 numbers in the list, one of which refers to the restoration of an old painting while six refer to paintings by other artists in which Schotel painted the staffage (figures and ships).
2. In the archive from G. D. J. Schotel (Gemeentearchief [City Records] Dordrecht, inv. 74–24). The list contains, with a few omissions, the numbers 81–239. The references by G. D. J. Schotel in his book *Leven van den zeeschilder J. C. Schotel* (Biography of J. C. Schotel, painter of seascapes), which are detailed allusions to preliminary sketches for paintings, are based on the auction catalogue of the estate of J. C. Schotel, held in Dordrecht on 29 April 1839 and successive days.
3. Oil on canvas, 71 x 95 cm (28 x 37 3/8 in.). Museum Boijmans van Beuningen, inv. 1794 (on loan to the Prins Hendrik Maritime Museum, Rotterdam, inv. P. 728).
4. See two drawings in the Teylers Museum, Haarlem (inv. Z 39 and Z 40), respectively for the paintings 57 and 92; the numbers are written in brown ink on the front of the drawings. This has not always been done consistently: on inv. Z 37, a variation on Z 39, there is only the reference in pencil "N 57," which indicates the painting (I thank Marjolein Menalda for this information). Written on a drawing in the Dordrechts Museum (inv. DM 989 T 902) is the number "38" (referring to the painting) also written in pencil (I thank Peter Schoon for this information). Schotel kept the design sketches for his paintings rather than a series of sketches made from his paintings before they left his studio (compare De Groot 1989, 75 and 121). That he did so is clear from both the Haarlem and the Dordrecht drawings, which, as far as what is depicted is concerned, differ somewhat from the final painted versions that are in both cases in the same museum. The incorrect assumption is based on the introduction to the auction catalogue of Schotel's estate, which states: "At the beginning of his career as an artist he took the habit of making a sketch of each of his drawings which he would keep; by all the orders that he received later he retained this habit and in this way the majority of this collection was created." G. D. J. Schotel in his biography refers explicitly to the mentioned drawings, now in Dutch museums, as "the" sketches.
5. These numbers were probably added by P. J. Schotel. They show inconsistencies: for example, on one drawing in Dordrecht (inv. DM 989 T 903) there is the reference "a 140," referring to the list of sketches, but no reference to the painting number 50 for which it is a direct preliminary sketch.
6. It is now possible to identify a drawing in the Boijmans Van Beuningen Museum (inv. MB 575), on the basis of the "N 80" written on it in brown ink, as the picture painted by Schotel in 1828 and sold to the art dealer Lamme for 300 guilders. A drawing in the Teylers Museum (inv. Z 41) was intended, according to the "N 172" written on it in brown ink, for the painting of 1836 that was sold to the Amsterdam art dealer Brondgeest for 900 guilders. It appears incontrovertibly from the number "a 244" also on this sketch that the list here given in note 2 above must be incomplete. There are unfortunately also a large number of sketches with, or so it would appear, numbers also penciled in by Schotel that, in view of the subject, cannot possibly refer to the list of paintings. Some of these presumably refer to the lost list of detailed drawings.

It appears that the son P. J. Schotel, like his father, began to keep a record of his work, as is confirmed by a drawing that came into the hands of the Amsterdam art dealer B. Houthakker (catalogue 1971, no. 51, illus.). This sketch bears the numbering "N 1.S" and "N.10.T" above right, evidently referring to a list of paintings and drawings.

ANDREAS SCHELFHOUT

The Hague 1787–1870 The Hague

14 *View of the French Coast*

c. 1833

Watercolor over pencil, 140 x 194 mm (5 1/2 x 7 3/8 in.)

Signed lower left in pen and gray ink: *A. Schelfhout f*; verso, lower right in later handwriting in pencil: *A. Schelfhout*

Watermark: J WHATMAN (cut off, Heawood 3457–3462)

Inv. MB 481

Provenance: F. J. O. Boijmans, Utrecht; his legacy, 1847 (L.1857)

Literature: Lamme 1852, 55, no. 1798; Lamme 1869, 51, no. 2167

Andreas Schelfhout was born on February 16, 1787, in The Hague, the son of Jean Baptiste Schelfhout, a frame maker from Ghent, and Cornelia van Hove of The Hague.[1] Andreas spent four years as apprentice to the set painter Joannes Breckenheimer, Jr. (1772–1856). As a result of learning from a theater painter who was under pressure to produce results as quickly as possible and with a minimum of equipment, Schelfhout's work reveals great spontaneity. For him and his contemporaries the paintings of seventeenth-century Dutch landscape artists were an important source of inspiration. Between the years 1817 and 1869 Schelfhout submitted work almost every year to the exhibitions of Living Masters. These were held alternately in The Hague and Amsterdam. Schelfhout became extremely well known and his work fetched high prices. He had many pupils, the best of whom included his son-in-law Wijnand Nuyen (1813–39, see cats. 26 and 27), Charles Henri Joseph Leickert (1816–1907), and Johan Barthold Jongkind (1819–91, see cats. 32–34).

Schelfhout was in touch with a great many painters from Holland and abroad, partly because he traveled widely, partly because many came to visit him in The Hague. He would then introduce his pupils to these artists.[2] Curiously enough, the same thing also happened to him. When, around 1830, he was having a depressed period and felt that all the colors he used where faded and uninteresting, his former pupil Wijnand Nuyen recommended that he take a holiday and go to France, exactly as Schelfhout had recommended to Nuyen. So in 1833 Schelfhout went to the north coast of France where he painted the craggy cliffs and relaxed in bathing resorts such as Boulogne, Dieppe, and Calais.[3] The exhibited watercolor must have been made somewhere around there. The landscape was new to Schelfhout and, combined with light that was completely different from that in Holland, it changed the tone of his work. Although the Rotterdam watercolor is minutely drawn, it would seem that Schelfhout's painting style became looser and less precise, influenced by the French painters Eugène Isabey (1803–86) and Théodore Gudin (1802–80). Based on the watercolors he made on this trip, Schelfhout continued to paint French coastal scenes long after his return to The Hague. In 1861, almost thirty years after the visit, Schelfhout exhibited a painting with this subject.[4]

JK

1. Cornelia van Hove was the daughter of the frame maker Andreas van Hove and the aunt of the artist and set painter Bart van Hove, both from The Hague. See Van Gelder 1950.
2. For example, he sent Wijnand Nuyen in 1830 to France to study under the French artist Eugène Isabey. In 1846, when Isabey visited The Hague, Schelfhout sent his pupil Jongkind back to France with him. Besides French visitors, colleagues from Belgium and Germany also came to see him, especially from the so-called Düsseldorf school, some of whom settled in Holland for a time. Also see Robert-Jan te Rijdt's essay in this catalogue.
3. See the journal *Kunstkronijk* from 1871, 40. Presumably Schelfhout visited Dieppe at the suggestion of Isabey, who lived there for a time. Nuyen had earlier visited the town, and Jongkind was to go there later with Isabey. Schelfhout traveled farther west through Normandy and Brittany.
4. See the journal *Kunstkronijk* from 1861, 41–42. The painting titled *French Coast in Showery Weather* was shown in the 1860 exhibition of the Academy of Fine Art in Rotterdam. In making this type of picture Schelfhout may have used, besides his own drawings, those by French colleagues. He owned eleven lithographs by Isabey, for instance.

ANDREAS SCHELFHOUT

The Hague 1787–1870 The Hague

15 Winter Landscape with a House and Windmill on a Waterway

Watercolor over pencil, 160 x 210 mm (6 1/4 x 8 1/4 in.)

Signed lower left in pen and brown ink: *A Schelfhout f.*; verso, lower right in pencil and a later handwriting: *A Schelfhout*

Inv. MvS 278

Provenance: H. M. Montauban van Swijndregt, Rotterdam: his legacy, 1929

Literature: Drost 1944, 57, no. 278

"Your winter challenges your spring with fruitful days; all Holland holds you dear, all Europe sings your praise." These were the lines written for Andreas Schelfhout and signed by 225 artists on a richly decorated parchment scroll, which they presented him on his seventy-fifth birthday.[1] It was clear that his winter and ice scenes were highly regarded. Among art critics he was even described as "the Claude Lorrain of the winterscape."[2] Once Schelfhout had established his reputation as a painter of Dutch winter scenes, he repeated his successful formula continuously, adding slight variations. The compositions of his paintings are fairly stereotypical: half of the sky is dark, the other half clear. Often the ground rises on one side, with houses, windmills, and groups of trees, while on the other side is a low horizon with a road, a waterway, or open country. Because of their great similarity, many of his drawn or painted winter scenes are difficult to date.

The exhibited watercolor is one of the many variations. Based on sketches that he had made sometimes years before, Schelfhout carefully composed these watercolors and paintings, in which elements, such as the tower mill and the skaters beside a sleigh, are to be seen time after time. The swift working method of the highly successful Schelfhout aroused the jealousy of other painters, in particular the young artists of the informal group of painters in The Hague. Malicious stories went around about Schelfhout's way of working: it was said that when he stayed in the Amsterdam hotel De Zon he would even use the water in the jug in order to produce more high-speed watercolors.[3]

There was much criticism of Schelfhout because of his vast productivity and because he so often repeated his subject matter, but it cannot be denied that his work always retained a high degree of craftsmanship. Several of his pupils working in the same style, artists such as Nicolaas Johannes Roosenboom (1805–80), Charles Leickert (1816–1907), and Lodewijk Kleyn (1817–97), soon began to produce dull and monotonous pieces. Unlike them, Schelfhout knew how to capture and hold the viewer's attention. In the watercolor here the ice is freezing cold and the old house is utterly convincing in its detail, as are the figures of the skaters.

JK

1. Kramm 1857–64, 4:1471.
2. The publication *Kunstkronijk* 1850, 63.
3. See Marius 1920, 73–74. It was the painters of the Hague school in particular who were critical of Schelfhout's rapid painting methods. As they saw it, a serious painter went out into the countryside and did not have an easy life in his studio. The painter Johannes Bosboom, a great admirer of Schelfhout, tells of his compulsive manner of working: ". . . came to fetch Schelfhout at an appointed time to go for a walk and the painter had a little blue paint left on his palette and said it was a pity not to use it up, so he'd just paint a bit more sky." Cited in Marius 1917, 73. However, Marius constantly twists Bosboom's laudatory remarks about Schelfhout and creates the impression that Bosboom was extremely critical of the old master. Compare Bosboom 1917.

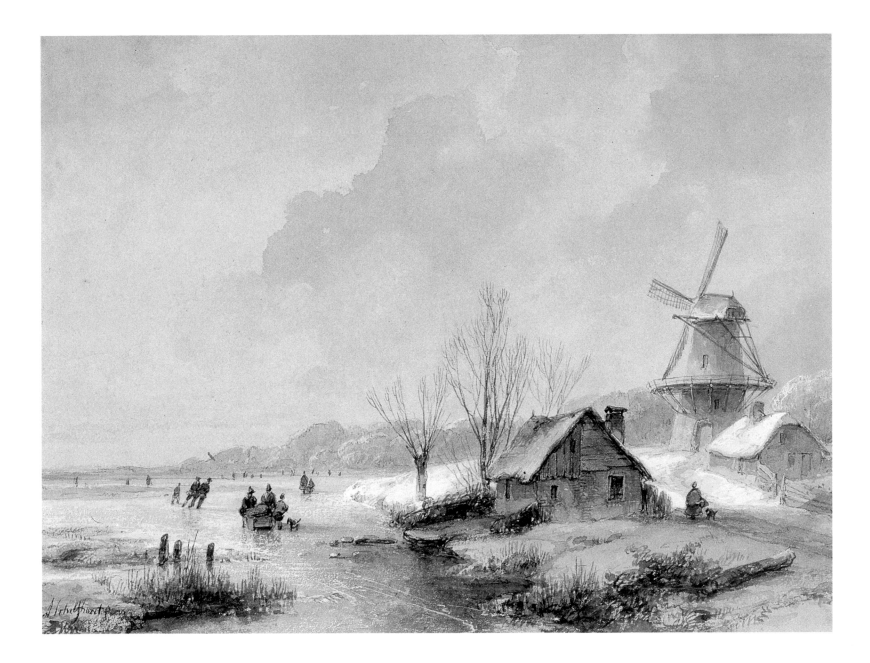

ALBERTUS JONAS BRANDT

Amsterdam 1788–1821 Amsterdam

16 *Four Plums*

c. 1813–18

Watercolor over pencil, 213 x 200 mm (8 3/8 x 7 7/8 in.)

Inv. MB 455

Provenance: F. J. O. Boijmans, Utrecht; his legacy 1847 (L.1857)

Literature: Lamme 1852, 38, no. 1255; Lamme 1869, 34, no. 1661; Ihle 1960, no. 4

Fig. 1. Albertus Jonas Brandt, *Flower Still Life*. Rijksmuseum, Amsterdam

Albertus Jonas Brandt worked in his father's bookshop and the adjoining bookbinder's until he was twenty years old. In his spare time, with his father's permission, he studied drawing with the flower painter Jan Evert Morel (1769–1808). After Morel's death, Brandt went to classes given by the famous still-life painter Georgius J. J. van Os (1782–1861). Around 1812 Van Os went to Paris where, for a time, he painted decorations for the famous Sèvres porcelain factory.[1]

In 1813 Brandt, deciding to try his luck as an independent artist, held his debut exhibition at the biennial showing of contemporary masters in Amsterdam. It was a great success. He exhibited a large watercolor still life (fig. 1) after a painting by Jan van Huysum (1682–1749).[2] The work was received with much admiration: "No less superb was a flower piece in watercolor after Van Huysum; executed in a way which equals the painting, so that I must admit never having seen watercolor used as powerfully as in this case," remarked one critic.[3] Jan van Huysum, who even in his lifetime was called the "phoenix of all flower painters," was also celebrated in the nineteenth century.[4] His paintings are characterized by precision, accuracy, and his enormous technical ability.

Fig. 2. Albertus Jonas Brandt, *Flowers in a Terracotta Vase*. Rijksmuseum, Amsterdam

Van Huysum's work had a strong influence on Brandt, who borrowed many elements from his predecessor for his own compositions, as one of his flower still lifes demonstrates (fig. 2).[5] That Brandt was possessed with the desire for perfection can be clearly seen in the fruit shown here; he endeavored to depict his "models" with as much realism as possible, not the ideal perfection of the fruit or flower. In his various fruit and flower studies he shows the mildew on an oak leaf,[6] a withered nasturtium leaf,[7] and even a small brown patch on one of the plums (cat. 16). Brandt's skill is especially revealed in these paintings of fruit. He could reproduce the velvety bloom on the skin of the deep-red shiny plums and achieved the same effect on the white grapes (cat. 17).

ALBERTUS JONAS BRANDT

Amsterdam 1788–1821 Amsterdam

17 Bunch of White Grapes

c. 1813-18

Watercolor over pencil, 212 x 200 mm (8 3/8 x 7 7/8 in.)

Inv. MB 456

Provenance: F. J. O. Boijmans, Utrecht; his legacy, 1847 (L.1857)

Literature: Lamme 1852, 38, no. 1253; Lamme 1869, 34, no. 1659; Ihle 1960, no. 7

Indeed, grapes are often used as a subject where the painter can show his skill in reproducing light, shadow, and half-tones. An artist could demonstrate his technique by painting this fruit.[8] In this picture of grapes Brandt provides an exceptional example of his artistry. He shows the fruit in all their translucency, with a great variety of yellow-green tints. He did this by building up very thin layers of paint. Since such layers rapidly lose their translucency, it is extremely difficult to preserve the transparent quality of watercolor when using this technique.

Brandt painted his flowers and fruit in minute detail but paid less attention to the background. At most he suggests how the subject is positioned with the use of shadow. In the drawing of the bunch of grapes it is obvious that something else was lying against the right-hand side of the grapes, but the artist apparently did not think it important enough to develop. He was clearly more concerned with the fruit.

These drawings were preliminary studies. Like most flower and fruit painters, Brandt did not paint his bouquets from life but composed them, using preparatory studies that gave him the freedom to combine flowers and fruit from different seasons in a single still life. The real fruit was not usually available at the time of painting, which explains why the preparatory studies had to be so detailed.

Brandt enjoyed great success with his work, receiving in 1816 and 1818 medals of honor from the Maatschappij Felix Meritis, an Amsterdam society for the fine arts, for the best still life. The reviews remained favorable, though some thought Brandt was a greater draftsman than painter.[9] In 1818, a wasting disease began to undermine his strength, and he died three years later at the age of thirty-three. His early death was deeply mourned, and his drawings fetched high prices when his estate was put up for auction in 1821.

MdH

1. Van Eijnden/Van der Willigen 1816–40, 3:249. Brandt's biography was also described by these authors at great length; idem, 3:286–87.
2. *Flower Still Life* (1723), Rijksmuseum, Amsterdam, inv. A 188. See Van Thiel 1976, 294.
3. B. 1813, 302.
4. For Van Huysum and his reputation in the eighteenth and nineteenth centuries, see Grant 1954, Segal 1982, 60–63, and Van Boven 1988, 18, 41–43.
5. *Flowers in a Terracotta Vase* (unfinished at the artist's death in 1821), Rijksmuseum, Amsterdam, inv. A 1013. See Van Thiel 1976, 141.
6. Albertus Jonas Brandt, *Sprig of Oak Leaves*, watercolor over pencil, 273 x 313 mm (10 3/4 x 12 3/8 in.), signed lower right in pencil: *A. J. Brandt*, verso: inscribed lower right in pencil in later handwriting: *Bladeren v.d. eik, aangetast door Meeldauwschimmel*; watermark: OL (cut off). Museum Boijmans Van Beuningen, Rotterdam, inv. MB 458; provenance: F. J. O. Boijmans, Utrecht; his legacy, 1847 (L.1857).
7. Albertus Jonas Brandt, *Spray of Nasturtiums*, watercolor over pencil, 193 x 259 mm (7 5/8 x 10 1/4 in.), signed lower right in pen and brown ink: *J:A: Brandt;* verso: inscribed lower right in pencil in a later handwriting: *O. I. kers (Tropeolum Majus)*. Museum Boijmans Van Beuningen, Rotterdam, inv. MB 457, provenance: F. J. O. Boijmans, Utrecht; his legacy, 1847 (L.1857).
8. Compare Hecht 1980, 32.
9. De Vries 1816, 778.

PIETER GEORGE WESTENBERG

Nijmegen 1791–1873 Brummen

18 A Shabby Interior

Pen and brown ink and gray washes over pencil, 279 x 235 mm (11 x 9 1/4 in.)

Verso, signed in pen and brown ink lower left: *P. G. Westenberg*

Inv. MvS 388

Provenance: D. Vis Blokhuyzen, Rotterdam, his auction in 1872[1]; H. M. Montauban van Swijndregt, Rotterdam; his legacy, 1929

Literature: Drost 1944, 74, no. 388

Pieter George Westenberg was born in 1791 in Nijmegen. At the age of seventeen he studied painting in Amsterdam with Jan Hulswit (1766–1822), who was known as a wallpaper painter and is particularly famous for his paintings and drawings. Westenberg was mainly known for his landscapes and cityscapes. In 1816 he traveled through the Dutch provinces of Gelderland and Overijssel to Bentheim in Germany. The following year he traveled farther into Germany where he painted several landscapes of the Rhineland area. However, Dutch cityscapes still held the greatest fascination for him. He made his debut in 1814 at the exhibition of contemporary masters in The Hague. There he showed a cityscape of Rhenen that was well received.[2] Westenberg moved to Haarlem in 1836 where, two years later, he was appointed director of the Kabinet van Moderne Kunst (Cabinet of Modern Art) in the museum Paviljoen Welgelegen.[3] Twenty years later he left this post and, with his family, set off for what was then the Dutch East Indies. There he was appointed to the elevated position of Junior Keeper-of-the-Seal of the city of Batavia, now known as Jakarta.

Until his departure for the Far East in 1857, Westenberg was represented at almost every exhibition of Living Masters. His work was repeatedly acclaimed. In 1816 the well-known art critic Jeronimo de Vries, having seen one of Westenberg's cityscapes of Delft, proclaimed him as the new Vermeer: "His *Cityscape of Delft*, his *View of the City Ramparts in Winter*, *The Landscape of Bentheim*, but above all the first of these, reveal a superior talent. He is absolute master of his brush and promises in time to become the new Vermeer."[4] Like most of his contemporaries, Westenberg was a great admirer of the artists of the Golden Age. He regularly painted and drew in their styles.[5]

The Rotterdam drawing is typical of seventeenth-century views inspired by the Delft artist Johannes Vermeer (1632–75) and by Pieter de Hoogh (1629–84), who had also worked in that city. The open door grants a view inside a simple household where a mother is seated with her children. In contrast to the tidy, prosperous interiors of Vermeer and De Hoogh, Westenberg shows us a romantic interior exuding poverty, with crooked shelves, crumbling plaster, and cracking walls. Even the barrel on the left of the drawing, which once stood upright, is shown tilted to one side. The drawing is immediate and was done in pen and gray washes whereby the artist was not distracted by the need for accurate reproduction of detail. Delightful as this drawing is, Westenberg's fame is not a result of this type of genre scene. He acquired a considerable reputation with his evocative cityscapes that in turn were to influence Hendrik Gerrit ten Cate (1803–56, see cat. 22) and Kaspar Karsen (1810–96, see cat. 25).

MdH

1. This drawing is probably from D. Vis Blokhuyzen's collection, which was auctioned April 29, 1872, as lot 436 and not as lot 365 as is stated in Drost 1944, loc. cit.
2. Van Eijnden/Van der Willigen 1816–40, 3:298.
3. In 1838, contemporary works of art from the Mauritshuis and the (then) Rijksmuseum were assembled in a separate museum, the Paviljoen Welgelegen in Haarlem. When the artists died, their paintings were returned to the Mauritshuis or the Rijksmuseum. See Bergvelt 1984(2).
4. De Vries 1816, 773. In 1818 the same critic wrote in laudatory terms: "Westenberg has art under his thumb; may he learn ever to apply a natural simplicity, taught by her, the infallible and true teacher, that in the days to come he may be the equal of Delft's Vermeer. He has a rare talent." De Vries 1818, 713.
5. Compare Jansen 1986, 174–75.

ARY SCHEFFER

Dordrecht 1795–1858 Argenteuil

19 Female Nude

Black chalk heightened with white chalk, 575 x 382 mm (22 5/8 x 15 in.)

Lower right, various numbers in chalk; verso, inscribed lower right in pencil: *Ary Scheffer.*

Watermark: C . . [illegible]F and a bunch of grapes

Inv. MB 533

Provenance: Gift of A. J. Lamme, Rotterdam 1889

Literature: Ewals 1987, 361

The career of Ary Scheffer is marked by two extremes: he was renowned and he was reviled. This artist, who was only Dutch in name, having lived and worked in France from the age of fifteen, was one of the most influential painters in Paris in the 1830s and 1840s. There, together with famous artists such as Eugène Delacroix (1798–1863), he was seen as a major spokesmen of the French romantic style. Criticism against him began during his lifetime. His work submitted for the 1846 Salon, the major exhibition of living masters held in Paris, was viciously castigated by the young poet and art critic Charles Baudelaire. This marked the beginning of a rapidly downhill course as far as Scheffer's reputation as a painter was concerned. It started in France and continued in the Netherlands. The painter, who died in 1858 in his country house in Argenteuil, did not live to see the worst. Scarcely ten years after his death, he was no more than a footnote in the history of the romantic painters. Despite recent attempts to alter this, it looks as if Ary Scheffer will be remembered more for his dramatic reversal of fame than for the beauty of his works of art.[1]

Ary Scheffer's father was a portrait painter from Germany, Johann Bernhard Scheffer, and when his son was only thirteen he sent him to the drawing school in Amsterdam.[2] There and also during his further studies in Lille and Paris, Ary, like most young artists of the day, learned to draw from classical sculpture and from nudes. In the Dordrechts Museum there are many sheets of such studies by him.[3] Scheffer's drawings reveal him as a talented but seldom great draftsman, whose sketches were usually made in preparation for paintings.

It is difficult to determine when the Rotterdam study of a nude was made.[4] There are sheets containing similar drawings from Scheffer's student years,

that is, the first two decades of the nineteenth century, but these are of lesser quality and demonstrate quite a different technique. Despite a certain imperfection in the drawing of the body, for example the curious shortening of the raised left arm and the over-small feet, the exhibited drawing has a painterly quality comparable with the master's more mature work.[5] This work has a great deal of stumping, by which the sharp chalk lines are softened with a special leather smudging tool. All the folds in the skin and the curves of the back and shoulders are treated in this way. This technique, together with the stumped white chalk around the body, brings an almost ethereal character to this female nude.

MS

1. For Scheffer's biography, see Ewals 1987. For the painter's reputation, evidenced by his submissions to the Paris Salons, see Ewals 1980, 7–25, and Ewals 1995.
2. For information about Johann Bernhard Scheffer and the family ties between the Scheffers and the Lamme family, of which the first two directors of the Boijmans Museum were members, see Sellink 1993 and De Geest 1989, 13–33, which I had overlooked at the time.
3. Ewals 1987, 211. From the estate of Ary Scheffer's daughter Cornelia Marjolin-Scheffer, an important part of the painter's studio estate came into the hands of the Dordrechts Museum in 1899. See also the exhibition catalogue Ewals 1980, which provides an overview of this collection.
4. Although the drawing is neither signed nor dated there is scarcely any doubt as to its attribution. The sheet was the gift of the art dealer and critic Arie Johannes Lamme (1812–1900) in 1889. He was the first director of the Boijmans Museum and a first cousin of Ary Scheffer's. The two maintained an intensive correspondence. See also note 2.
5. Although totally different in subject matter, the Rotterdam sheet can be compared with *The Holy Women Returning to the Grave of Christ*, a preliminary study dated 1847. This study uses the same technique, black and white chalk with stumping, and is drawn on identical dark paper. See Ewals 1980, 116–17. Probably the study of a nude shown here was a preliminary study for a painting that was either never made or has been lost.

CORNELIS KRUSEMAN

Amsterdam 1797–1857 Lisse

20 Three Studies of an Old Man

1817

Red and black chalk, 286 x 371 mm (11 1/4 x 14 5/8 in.)

Signed and dated above left in black chalk: *C Kruseman f 1817*

Inv. MB 488

Provenance: F. J. O. Boijmans, Utrecht; his legacy, 1847 (L.1857)

Literature: Lamme 1852, 47, no. 1562; Lamme 1869, 42, no. 1922

Fig. 1. Cornelis Kruseman, *Studies of Heads and Hands*. V.d.S. Collection, Rotterdam

Fig. 2. Cornelis Kruseman, *Peasant Family in an Interior.* Rijksmuseum, Amsterdam

Even as a boy, the Amsterdam pharmacist's son Cornelis Kruseman showed marked signs of talent as a painter and draftsman. He studied life drawing at the Amsterdam drawing academy under Jean Augustin Daiwaille (1786–1850) and won first prize for this in 1814 at the age of sixteen.[1] Young artists practiced life drawing of both nude and clothed models at the art academies and at the then-fashionable drawing societies.[2]

In the print room at Rotterdam is a sheet[3] with five studies of heads, three of them of the same old man, and between them are six studies of hands. Kruseman prepared the paper by first lightly sanding it and then preparing it with a fine layer of alum and drew on this using very finely sharpened red chalk. Although the sheet is not signed or dated, there is a comparable sheet signed 1816 in a private collection (fig. 1)[4] that suggests Kruseman drew the Rotterdam

sheet in the same year. The second sheet uses the same technique and shows identical studies of the old, balding man, and the model for the head of the boy is also the same. Kruseman apparently often used the expressive man as a model. He is also to be seen in the drawing on exhibition here (cat. 20). The date in the upper right of this drawing is difficult to decipher, but is probably 1817. That was the year in which the artist completed *Peasant Family in an Interior*, now in Amsterdam's Rijksmuseum (fig. 2).[5] The same old man can be found on the right in this painting.

There are more sheets from this period in which Kruseman has drawn one or two models from different points of view, in combination with detail studies of hands. These attractive sketches reveal how even at a young age Kruseman was virtually a fully qualified draftsman. It is likely that he considered these drawings not simply as study material, but as works complete in themselves, which he planned to sell. The careful dating and signing would support this theory.

Kruseman's work won great acclaim from an early stage, and as early as 1817 some of his contemporaries, such as Louis Henry de Fontenay (1800–52) and Douwe de Hoop (1800–30), studied under him.[6] But the young Kruseman felt that his apprenticeship was far from finished and decided at the age of twenty-four to travel abroad in order to learn more. His ultimate goal was Italy, where he stayed for several years. Back in the Netherlands he was very successful with his genre pieces and biblical scenes, in which Italian country folk play a leading role.

MdH

1. Van Eijnden/Van der Willigen 1816–40, 3:308.
2. Te Rijdt 1994.
3. Cornelis Kruseman, *Studies of Heads and Hands*, red chalk on prepared paper, 191 x 304 mm (7 1/2 x 12 in.); verso, inscribed lower left in pen and black ink: *No 82.z*. Museum Boijmans Van Beuningen, Rotterdam, inv. MB 1941/T7; gift of J. H. J. Mellaart, The Hague 1941.
4. V.d.S. Collection. This, too, is a study sheet with hands and heads, in red chalk, of approximately the same size as the Rotterdam sheet, 195 x 289 mm. See Hannema 1961, no. 89.
5. Inv. A 1067; see Van Thiel 1976, 328.
6. Knoef 1947, 19.

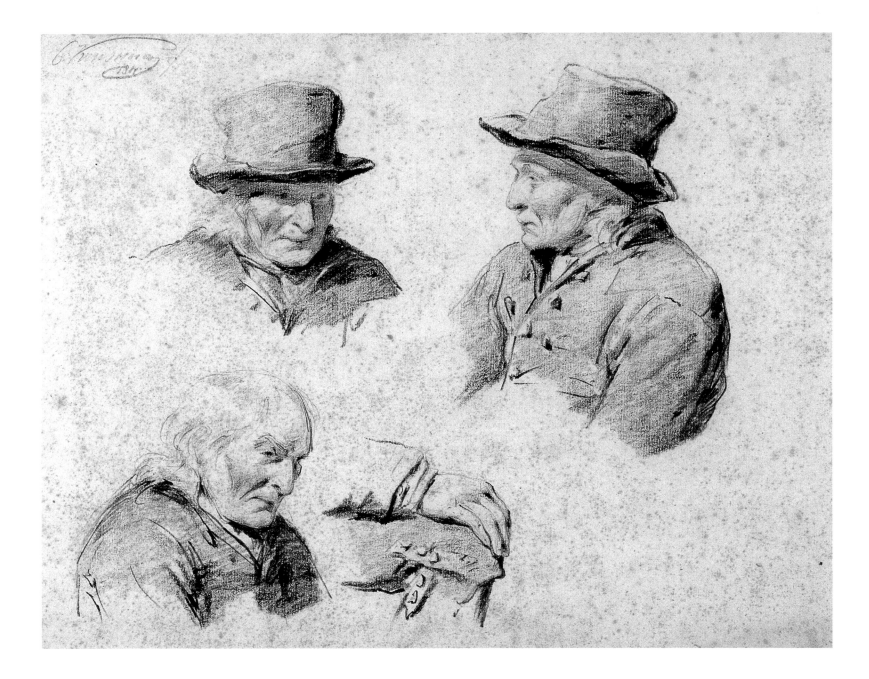

JACOBUS THEODORUS ABELS

Amsterdam 1803–1866 Abcoude

21 *River in the Evening*

c. 1836–66

Pen and brown ink, watercolor,
body color over pencil, 354 x 496
mm (13 7/8 x 19 1/2 in.)

Signed lower right in pen and
black ink: *JTA[in ligature]bels
f[eci]t*

Inv. MvS 1

Provenance: H. M. Montauban van
Swijndregt, Rotterdam; his legacy,
1929

Literature: Drost 1944, 5, no. 1

Fig. 1. Jacobus Theodorus Abels, *Land-
scape by Moonlight*. Museum Boijmans
Van Beuningen, Rotterdam

Almost nothing is known about Abels' parents or
childhood. He was born in Amsterdam where he
began his career with Jan van Ravenswaay
(1789–1869), a painter of cattle pieces. In 1826 Abels
went on an educational trip to Germany.[1] He proba-
bly made the drawing *Mountainscape*[2] on this trip, a
sheet that shows a typical landscape view of the
Rhine near either Koblenz or Heidelberg.

After his trip to Germany, Abels established him-
self in The Hague where, early in his career, he
painted mainly summer landscapes. He became
friendly with the painter Pieter Gerardus van Os
(1776–1839, see cat. 7), with whom he painted a
number of pictures and whose daughter he married.
Abels painted the landscapes, and Van Os, the
famous animal painter, supplied the staffage.

Around 1830, Abels moved to Arnhem where he
lived until a year before his death. At this time he
painted mainly evocative evening scenes of rivers
and cities or night scenes lit by the moon. The gifted
painter of moonlit landscapes Aert van der Neer
(1603/04–77) was a major source of inspiration.
Abels made countless paintings in the style of this
master of the Golden Age of Dutch painting and was
reasonably successful with them. One reviewer was
not entirely enthusiastic, writing "Still, the paintings
of J. T. Abels did not please us as much as those by
him which we have seen previously. Number 3 how-
ever, a moonlit scene, possessed good color effects."[3]

The exhibited sheet is a typical example of a
riverscape in the style of Aert van der Neer. The com-
position with the fishing boat in the foreground, the
trees and houses on the riverbank, and the tower of a
church, town hall, or castle in the distance appears
more than once in the same way in riverscapes by
Van der Neer.[4] Although the landscape in Abels'
drawing appears too bright for a night scene, the
cool, blue light clearly comes from the moon that is
hidden behind the farm on the left of the drawing.
Abels frequently used a concealed moon. This can
be seen in the painting *Landscape by Moonlight* also
in the Boijmans Van Beuningen Museum (fig. 1).[5]
After 1836, Abels continued to make use of the same
subject matter and painted these popular evening
and night landscape scenes until his death.

MdH

1. Jansen 1986, 81.
2. Jacobus Theodorus Abels, *Mountainscape*, pen and brown ink,
 watercolor over pencil, 186 x 248 mm; signed lower left in pen
 and brown ink: *JTA[in ligature] f[eci]t*. Museum Boijmans Van
 Beuningen, Rotterdam, inv. MB 443, provenance: F. J. O. Boij-
 mans, Utrecht; his legacy, 1847 (L.1857).
3. X. 1835, 332–33.
4. See especially Bachmann 1982.
5. Inv. 1000, see Ebbinge Wubben 1963, 13, and Jansen 1986,
 81–82, no. 1. It is noteworthy that this painting also came from
 the Montauban van Swijndregt collection.

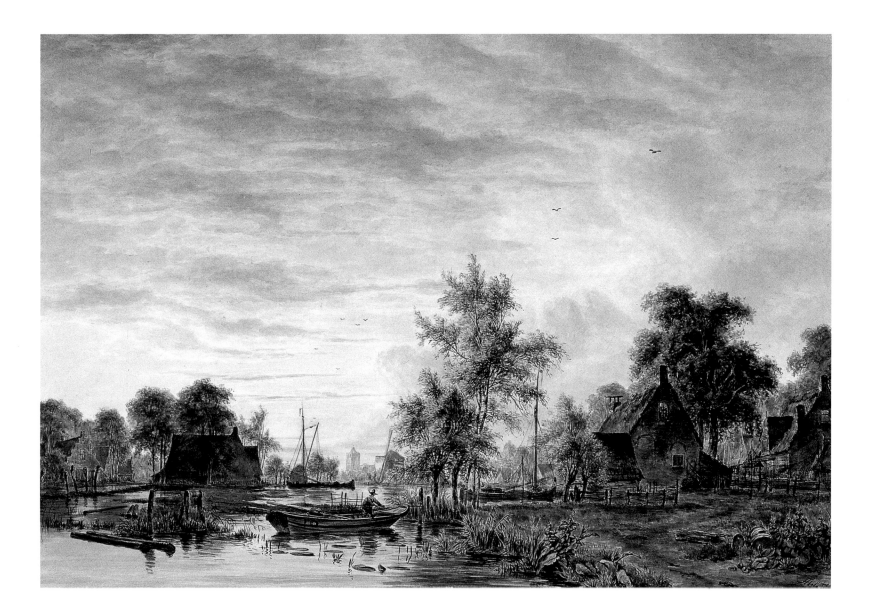

HENDRIK GERRIT TEN CATE

Amsterdam 1803–1856 Amsterdam

22 Winter View with Rollers

1848

Pen and brown ink, watercolor over pencil, 191 x 265 mm (7 1/2 x 10 1/2 in.)

Signed and dated lower left in pen and brown ink: *H G ten Cate fec 1848*

Watermark: D & C Blauw (Heawood 3267, countermark)

Inv. MvS 391

Provenance: P. G. J. Hoog van ter Aar, Rotterdam; H. M. Montauban van Swijndregt, Rotterdam; his legacy, 1929

Literature: Drost 1944, 13, no. 39

Hendrik Gerrit ten Cate was a pupil of Pieter George Westenberg (1791–1873, see cat. 18). Like other young artists of the time, he began by working exclusively in the manner of his teacher and, like his teacher, gained a reputation as a painter of cityscapes. The young artist brought his own special quality to the scenes, particularly to night views of villages and cities glistening in the moonlight. Ten Cate became extremely well known for his scenes of village fetes and town fairs by night. The artist's biographer, J. Immerzeel, described in lyrical terms how the painter captured these scenes with a "nimble and playful" brush: "The still, silvery nocturnal sky contrasts with the varied lights of the tents and stalls, whose reddish appearance combines with the countless, entertainingly drawn, and tiny flickering images, reflecting as it were through the crowd and lending a poetic atmosphere to the whole scene."[1] It therefore not surprising that Ten Cate won a gold medal of honor in the Felix Meritis society competition for paintings on exactly this subject.[2]

Ten Cate was a versatile artist. Besides his popular cityscapes at night, he painted and drew still lifes, portraits, and landscapes.[3] It is not known where Ten Cate drew this unmistakably Dutch landscape entitled *Winter View with Rollers*, but it may be based on a sketch of the watery polders north of Amsterdam. A feature of this landscape that has nowadays all but disappeared is the rollers that can be seen in this win-

ter view. The slope running diagonally downward with the large double wheel at the top was used to pull up small boats so that they could be lowered into the water at a different level on the other side. This relatively simple device allows different water levels to be traversed without locks.

Ten Cate has captured the wide open space of the polders with their low horizons and the gray-blue background almost dissolving into a cloudy sky with the soft red glow of the setting sun. This is a traditional composition of a sort that goes back to icy scenes by the painters of the seventeenth century. By combining effective use of watercolor with livelier accents in pen and brown ink in the foreground, Ten Cate has captured the Dutch winter in an impressive manner while remaining within the conventions of a traditional genre.

MS

1. Immerzeel 1842–43, 1:130. For an appreciation of Ten Cate, see also the obituary in the *Kunstkronijk* from 1857, 134.
2. Kramm 1857–64, 1:223. The Museum Boijmans Van Beuningen has a typical example of this genre by Ten Cate: *Village Fair in the Evening*, inv. 1119. See Ebbinge Wubben 1963, 30.
3. For a list of paintings by Ten Cate in public collections, see Wright 1980, 73. There are drawings in the Boijmans Van Beuningen Museum (twenty-five sheets among which are a number of winter scenes), Rijksprentenkabinet (Amsterdam), Teylers Museum (Haarlem), and the Rijksmuseum Kröller-Müller (Otterlo). See also Sillevis 1985, nos. 13–14.

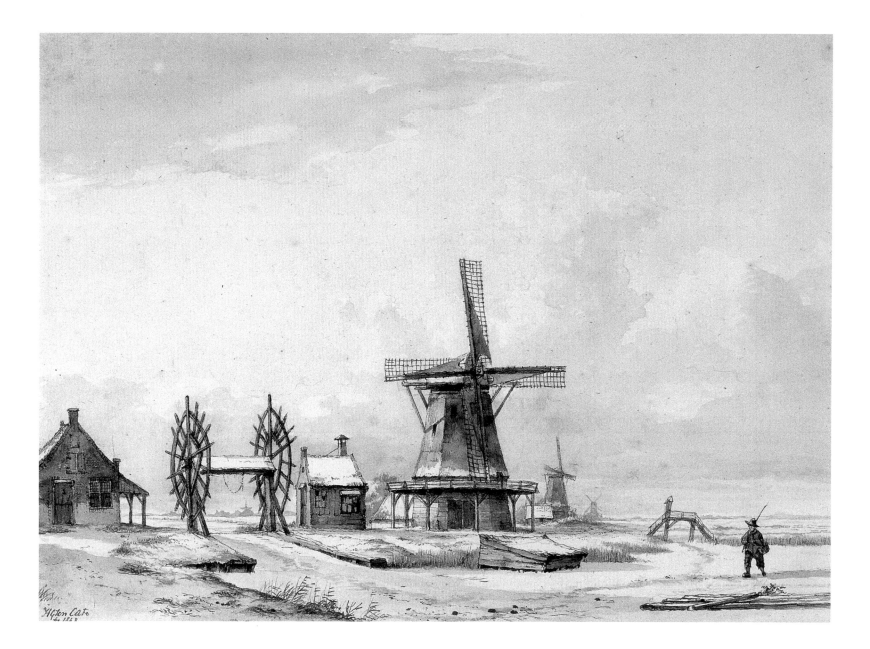

BAREND CORNELIS KOEKKOEK

Middelburg 1803–1862 Kleve

23 *Brigands in the Mountains*

1830

Pen with brown ink, gray washes over pencil, 228 x 311 mm (9 x 12 1/4 in.)

Signed and dated lower right in pen and brown ink: *B. C. Koekkoek. 1830*

Watermark: J WHATMAN (Heawood 3457–3462)

Inv. MB 489

Provenance: Unknown

Fig. 1. Barend Cornelis Koekkoek, *Mountain Landscape with Dancing Soldiers and Girls.* Museum Boijmans Van Beuningen, Rotterdam

Barend Cornelis Koekkoek is the best-known member of a large family of artists active over several generations; like their father Hermanus Koekkoek (1778–1851), Barend and his three brothers were professional painters as were their children and grandchildren.[1] Barend received his first lessons in painting at home until 1816, when he attended classes at the academy of drawing directed by Abraham Krayestein (1793–1855) in his native town of Middelburg. Koekkoek went on to study at the recently opened Royal Academy of Art in Amsterdam under Jean Augustin Daiwaille (1786–1850), his most important teacher.[2] After his studies Koekkoek remained on friendly terms with Daiwaille, collaborating with him on a series of lithographs entitled *Landscape Studies.* In 1833 Koekkoek married the painter Elise Thérèse Daiwaille (1814–81), a daughter of his teacher. After a few changes of domicile the couple settled in Kleve, just over the German border, where the artist founded his own school in 1841. By the time he died in 1862, Koekkoek's fame had spread all over Europe; he was known as the "prince of landscape painters."

During the summer of 1830 Koekkoek traveled through Brabant, the Rhineland, and the Harz Mountains in central Germany. The exhibited drawing was made on the final section of this trip. In the drawing are five robbers, one of whom is wearing the uniform of a Dutch soldier, being pursued by mounted soldiers. Earlier on this trip, in Brabant, Koekkoek had made a study of Dutch soldiers. He drew technically similar genre pieces showing a Dutch military camp and a village fair.[3] While on his journey through the Harz Mountains he probably also drew another sheet in the Boijmans Van Beuningen Museum, *Mountain Landscape with Dancing Soldiers and Girls* (fig. 1), a type of anecdotal drawing quite uncommon for Koekkoek. The drawings are of roughly the same size and use the same technique, pen and brown ink over pencil, covered with gray ink washes. This meticulous method of drawing was common at the time. However, there are few such painstakingly worked-out drawings by Barend Cornelis Koekkoek.

In the auction catalogue of Koekkoek's studio in 1862 no more than six drawings of this type are listed, while more than 108 sketches by him were auctioned at the time.[4] Among Koekkoek's landscape drawings were also topographical sheets.

When in 1845 King Willem II of the Netherlands visited the Grand Duchy of Luxembourg and other countries, Barend Koekkoek was part of his entourage. The painter accompanied the court on various pleasure outings in the district and made a great many sketches of the "most beautiful scenes and views" in the king's private grounds.[5] Later, based on these sketches, Koekkoek made nine paintings of the landscape in Luxembourg, all of which were bought by Willem II. When, after the king's death in 1850, his successor Willem III found himself in financial straits, he sold all the landscape paintings.[6]

JK

1. His father Johannes Hermanus Koekkoek (1778–1851) and his brother Hermanus (1815–82) both painted seascapes, beach scenes, and river views; his brother Johannes (1811–68) was a well-known lithographer. Marinus Adrianus Koekkoek (1807–68), Barend's pupil, also painted wooded landscapes with cattle. In addition, Barend Cornelis Koekkoek and his three younger brothers had children and grandchildren who painted. B. C. Koekkoek's two daughters Adèle (1839–19) and Maria Louise (1840–1910) were "merely" amateurs. For more about this family of painters, see Nollert 1994.
2. From 1822 to 1826 Barend attended classes at the Royal Academy in Amsterdam, where one of the teachers was the celebrated history painter Jan Willem Pieneman. De Werd 1983, 78. For biographical data see especially Nollert 1997.
3. Boijmans Van Beuningen Museum, Rotterdam, inv. MvS 176. The drawings of a village fair and an army encampment are presently in respectively the Städtisches Museum Haus Koekkoek, Kleve (inv. 431/862) and in an unknown private collection.
4. Auction Amsterdam (De Vries/Roos/Engelberts), December 9, 1862, 7–8, lot 1–108.
5. "Maandelijks overzigt der kunstberigten" (Monthly overview of art news), *Kunstkronijk* VII (1846), 76. The Städtisches Museum Haus Koekkoek owns a sketchbook of this trip. On the title page is written in pencil: "In het jaar 1845 met de Koning van Holland naar Luxemburg geweest" (In the year 1845 [I] went with the King of Holland to Luxembourg). See De Werd 1983, 17.
6. Kramm 1857–64, 3:896. Auction The Hague, August 12–18, 1850, lot 55–63.

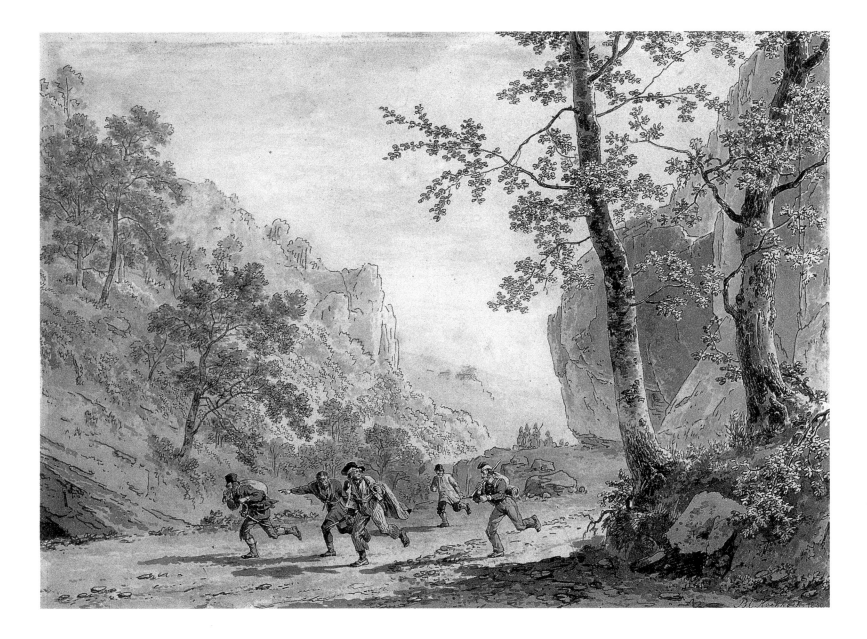

BAREND CORNELIS KOEKKOEK

Middelburg 1803–1862 Kleve

24 *Cascading Mountain Stream*

1838

Black chalk, brush and black ink, highlighted with white, 207 x 278 mm (8 1/8 x 10 7/8 in.)

Signed and dated lower left in black chalk: *BCK. [in ligature] 1838.*

Inv. MB 494

Provenance: Gift of J. J. Tavenraat, Rotterdam 1931

Fig. 1. Barend Cornelis Koekkoek, *Mountain Stream*. Museum Boijmans Van Beuningen, Rotterdam

Around 1838 Koekkoek made a journey from Düsseldorf to the town of Limburg on the river Lahn in central Germany. On the way he came across a small stream near Düsseldorf that greatly appealed to him. He described it in his book *Herinneringen en mededeelingen van eenen landschapschilder* (Memories and messages from a landscape painter) as follows: "Presently the rush of a waterfall reaches your ear and touches your soul. It becomes impossible to resist hastening toward the source of the noise, and while descending gently a little way through shrubs and bushes, the noise grows stronger. Then, between bushes growing wildly through each other, your eyes discover the source of the noise gushing forth from cracks in the rocky ground, a silvery sheen. 'There is the waterfall!' you cry out in delight. You stand on the bank of the most picturesque mountain stream as it cascades with its crystalline spray from the four or five small waterfalls into the Dussel Stream."[1]

It is impossible to find out exactly where Koekkoek made this drawing of a mountain cascade. Quite possibly it was made at the location described above. However, it is clear that Koekkoek was fascinated by the subject of the drawing since four almost identical studies of this waterfall have survived. The print room at the Museum Boijmans Van Beuningen owns a second drawing of the stream (fig. 1), and two more are known to be in a private collection.[2] All these drawings are on colored paper and are signed and dated *BCK[monogrammed] 1838*. Koekkoek only used this type of signature on drawn studies.[3] In contrast to his drawings of rock formations, he did not work out his drawings of waterfalls as separate oil sketches, but integrated the motif into the background of countless landscapes and woodland scenes.

JK

1. Koekkoek 1841, 36–37.
2. Museum Boijmans Van Beuningen, inv. MB 574, and a pair of drawings from the collection of H. Jüngeling, Schipluiden. All sheets are executed in black chalk on colored paper and highlighted in white.
3. Koekkoek recorded this himself in J. Immerzeel's questionnaire, which was compiled for the artists' lexicon published in 1841. See De Werd 1983, 6.

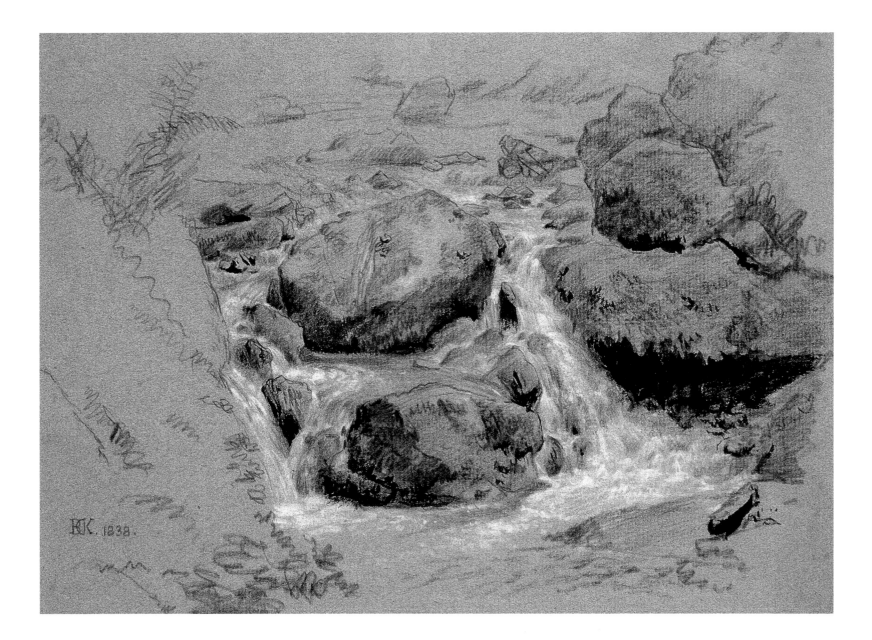

KASPARUS KARSEN

Amsterdam 1810–1896 Biebcrich

25 Saint Laurence Church in Rotterdam

Pen with brown and black ink, brown and gray washes over pencil, 260 x 350 mm (10 1/4 x 13 3/4 in.)

Verso, signed lower left in pen and black ink: *K Karsen*

Inv. MvS 158

Provenance: H. M. Montauban van Swijndregt, Rotterdam; his legacy, 1929

Literature: Drost 1944, 36, no. 158

Fig. 1. Christoffel Meyer, *Laurenskerk, Rotterdam.* Municipal Archives, Rotterdam

Fig. 2. Kasparus Karsen, *Laurenskerk, Rotterdam.* Stedelijk Museum, Amsterdam

Kaspar Karsen was born in Amsterdam on April 2, 1810, to the cabinetmaker Aalt Karssen and his wife Helena Westenberg. When the baptismal register was filled in, his name was misspelled with one "s." From that time on, this branch of the family was recorded as Karsen.[1]

He received his first painting lessons from the cityscape artist Pieter George Westenberg (1791–1873, compare cat. 18), after which Karsen studied for two years at the Royal Academy of Fine Art in Amsterdam.[2] At the same time Karsen was tutored by his older colleague Hendrik ten Cate (1803–56, see cat. 22), who was also one of Westenberg's pupils. As a result of the unfavorable economic conditions that existed for artists at that time, Karsen was obliged after completing his education to work for four years as a house decorator and painter of ornaments for the carpenter and ship's painter Dirck Vettewinkel (1787–1841).[3]

When he took up painting again in a professional capacity, he remained poverty-stricken. Despite considerable success as a painter, he still needed to supplement his income with other activities.[4] Numerous anecdotes about Kaspar Karsen have survived from which we can gather that he must have been a difficult and moody man, no doubt partly caused by his constant financial worries. The temperamental artist developed such an antagonistic relationship with his fellow painter Jan Willem Pieneman (1779–1853) that it ended in a challenge to a dual. Pieneman, however, did not turn up at the appointed hour.[5]

Kaspar Karsen was particularly good at painting cityscapes. In his work he combined imaginary buildings with parts of or complete existing buildings. He differed from other nineteenth-century painters of architecture who often painted in a more picturesque manner in that he sometimes used an unrealistically large scale that made people appear insignificant. The exhibited drawing is highly typical of Karsen's oeuvre. It shows a view of the Laurenskerk in Rotterdam as seen from what was then the waterway, Leidse Veer.[6] The fact that many of the buildings in Karsen's drawings have been positioned by him becomes apparent when one compares the Rotterdam drawing with a watercolor showing a more truthful depiction of the same view (fig. 1).[7]

This watercolor, made in 1808 by Christoffel Meyer (1776–1813), pictures the Laurenskerk from the same angle. The most striking difference is that Karsen has depicted water running from the Binnenrotte toward the viewer, whereas in reality this was a road.

This drawing by Karsen appears to be a preparatory study for a painting (fig. 2). The canvas, which was incorrectly listed as a Dordts cityscape, was donated to the Stedelijk Museum in Amsterdam shortly after Karsen's death.[8] The painting shows, more accurately than the drawing, all the architectural details of the large church, such as the small chapel on the left next to the transept. The drawing differs from the painting in many other details; for instance the rowboat on the left in front of the quay has become a sailboat in the painting.

Kaspar Karsen died at the age of eighty-six from a lung infection caught on journey home from Vienna. His most famous pupils were his son Edward Karsen (1860–1941), who belonged to the group Schilders van Tachtig (painters of the eighties), and Cornelis Springer (1817–91), who, like Kaspar Karsen, was a painter of romantic townscapes.

JK

1. Kasper Karsen spelled his Christian name in a number of ways; he used Kasper, Kaspar, or Karsper in turn. Until about 1847 he still signed work with "Karssen." After this time he consistently used one "s."
2. Karsen was a pupil at the Royal Academy from 1825 to 1827.
3. In a questionnaire compiled for J. Immerzeel's lexicon of painters, dated 1840, Karsen said of this period: "After being away from art for a little more than four years since art school, having embarrassed myself with so-called rough painting, as a result of coincidental circumstances in 1834 I exchanged the rough brush for the fine brush of the artist." For a biography of the colorful Karsen, see Bokhoven 1976 and Hammacher 1947, 16–24.
4. Karsen had to support an exceptionally large family: three marriages had brought fifteen children into the world. In order to provide sufficient income for the family, Karsen was forced to run a rather unsuccessful photographic studio with his sons to supplement his income from painting.
5. Hammacher 1947, 17.
6. The drawing was previously known as *View of Dordrecht.* With thanks to the topography department of Rotterdam's Municipal Archives.
7. Rotterdam Municipal Archive, Topographical Atlas, inv. R.I. 713(2).
8. See Heldring 1948, 38.

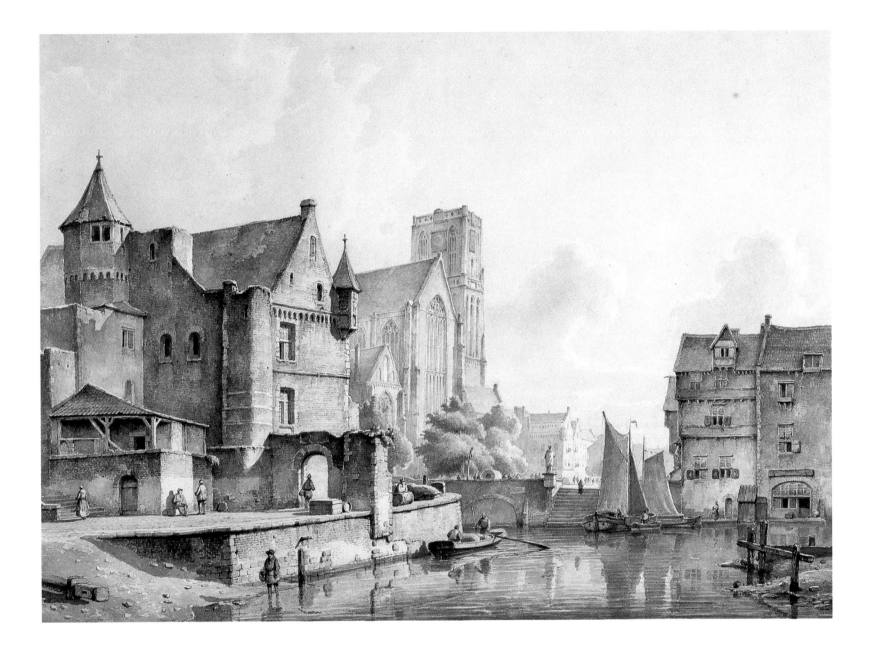

WIJNANDUS JOHANNES JOSEPHUS NUYEN

The Hague 1813–1839 The Hague

26 Ships on the Water

1836

Brush and brown and black ink, brown and gray washes over pencil, 505 x 704 mm (19 7/8 x 27 5/8 in.)

Signed lower left and dated in pen and brown ink: *WJJ Nuijen Bz 1836*; verso, inscribed lower left in pen and brown ink: *W. J. J. Nuijen*; inscribed lower right in pen and brown ink: *T24*

Inv. MB 546

Provenance: Unknown, acquired before 1869

Literature: Lamme 1869, 46, no. 2034; Scheen 1952, no. 47

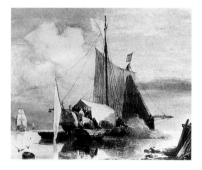

Fig. 1. Wijnand Nuyen, *Sailboat in an Estuary*. Private Collection

"The one and only true Dutch romantic artist" is the description generally given to Wijnand Nuyen because, unlike most of his Dutch contemporaries, he was strongly influenced by the French romantics.[1] Work of the French romantic school of painting has a much wilder and dramatic appearance than its Dutch counterpart, which is also seen as a more provincial variation.[2] This somewhat denigrating description is not entirely accurate, since Dutch romanticism had its own characteristics and should not really be compared with movements abroad. Dutch painters wanted to create their own reality by searching for picturesque themes and recording these in a tradition of accepted compositional patterns. French painters, in contrast, were concerned with the pursuit of spontaneity and the expression of individual feelings. Seen through the eyes of their non–Dutch colleagues, the art of painting in the 1830s and 1840s in the Netherlands must have appeared somewhat tame.

Within this context of Dutch romanticism, Nuyen holds an exceptional position. When he was only twelve years of age he began studying with Andreas Schelfhout (1787–1870, see cats. 14 and 15), the famous artist from The Hague. Between the years 1825 and 1829 Nuyen was enrolled at the drawing academy in The Hague, where Bart van Hove (1790–1880) was the principal instructor. To begin with, Nuyen painted and drew in the style of these two teachers. His talent was confirmed by the fact that in 1829, at age sixteen, he was awarded the consolation prize at an exhibition in Ghent. In the same year he won a medal at Felix Meritis, the Amsterdam artists' society, for a colored brush drawing.[3]

Meanwhile, Nuyen distanced himself more and more from the traditions of landscape art. In 1833, together with his artist friend Antonie Waldorp (1803–66), he set off for France, where they visited Paris, Brittany, and the Normandy coast. Confronted with the latest developments in French art, Nuyen's style, technique, and subjects changed dramatically. His brushstroke became looser, his palette fresher, and his themes more dramatic. Back in the Netherlands, the first reactions to this change were not wildly enthusiastic. A critic wrote about one of Nuyen's landscapes, shortly after his return from France, "We also saw that in this section [land-scapes], which ought to be based entirely upon study of nature, some artists began to stray farther and farther from the golden path . . . to the great detriment of their art in general. This was particularly noticeable in the work of a young and most promising artist [i.e., Nuyen] who tends more and more toward an undesirable romantic taste and . . . seems to prefer an easy effect lacking in truth and naturalness to a powerful and lively rendering of objects."[4] After his death, in 1839, Nuyen's painterly style was greatly admired, and connoisseurs of art often spoke of his genius.

In the exhibited work, a brush drawing made in 1836, the broad, sketchy strokes give evidence of the influence of the French artist Isabey, whose work was also to influence the slightly younger Johannes Bosboom (1817–91). Another source of inspiration in this case was the British lithographer James Duffield Harding (1798–1863), some of whose graphic works Nuyen owned. In 1834 Harding made a lithograph of fishing boats that strongly resembles this drawing in composition and theme.[6] Wijnand Nuyen used the sheet now in the Rotterdam collection in 1838 as a preliminary study of an oil painting *Sailboat in an Estuary* (fig. 1). He altered certain details; for example, in the brush drawing there is a ship and two rowboats that are not in the painting. They yielded place to a cannon firing a shot, which, with its smoke and fire, brings a threatening and dramatic character to this otherwise tranquil scene.

JK

1. Nuyen was particularly influenced by such painters as Eugène Isabey (1803–86) and Théodore Gudin (1802–80). He was also very familiar with the work of the British artist working in France, Richard Parkes Bonington (1802–28).
2. See Van Tilborgh 1984, 179–88.
3. In 1829 the society Felix Meritis announced the following competition: "A landscape showing a farmhouse, with as staffage a group of cattle being driven, the weather stormy; this to be produced as a colored drawing." The winning drawing is now in the print room of the Rijksmuseum, Amsterdam, inv. Felix Meritis 99.
4. Cited in Sillevis 1977, 12.
5. See, for example, Immerzeel 1842–43, 2:270, and Bosboom 1917, 11.
6. In the auction catalogue of Nuyen's estate dated 1839 is the following entry in the section of prints, number 20: "Harding's *Sketches at Home and Abroad*, London 1835 [. . .]." Compare Sillevis 1977, 25, no. 159.

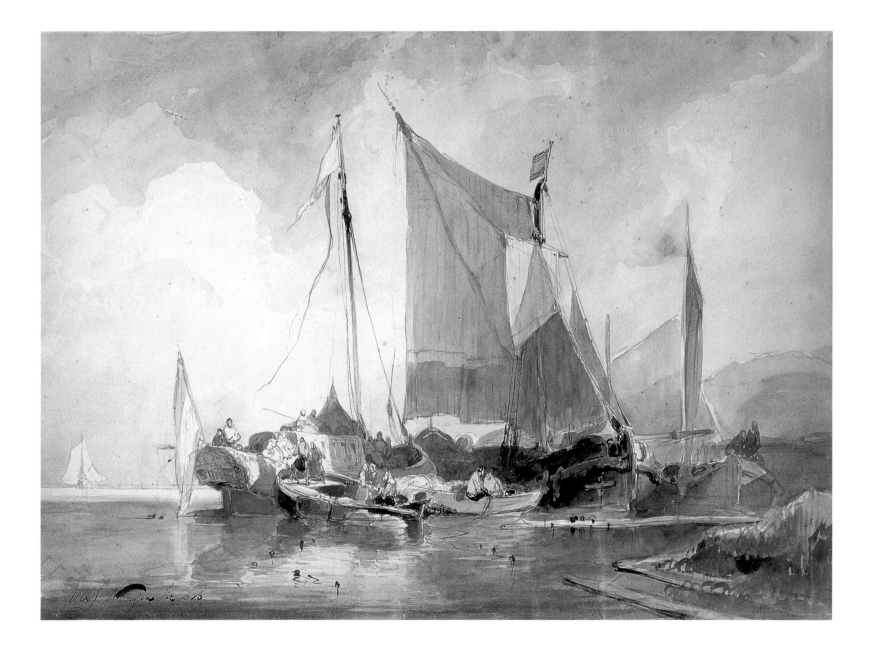

WIJNANDUS JOHANNES JOSEPHUS NUYEN

The Hague 1813–1839 The Hague

27 *Canal with Old Houses*

1838

Pen and brown ink, brown and gray washes over pencil, laid down, 282 x 362 mm (11 1/8 x 14 1/4 in.)

Signed lower left and dated in pen and brown ink: *wij Nuijen. f 38.*; verso, inscribed lower left in pencil in a later handwriting: *Gezicht te Brugge*; lower right in pencil in later handwriting: *W. J. J. Nuyen*

Inv. MB 487

Provenance: F. J. O. Boijmans, Utrecht; his legacy, 1847

Literature: Lamme 1852, 51, no. 1667; Lamme 1869, 46, no. 2034; Scheen 1952, 38, no. 54; Sillevis 1977, 114, no. 103

On several occasions Wijnand Nuyen traveled to Belgium where he sometimes visited the old city of Bruges. There, according to a note jotted on the reverse of this sheet, he made this pen drawing of a canal with old houses. The swiftly drawn lines and the clear warm light bring a different aspect to this cityscape than the often more stiffly drawn city views of his Dutch contemporaries.

Nuyen owned various collections of lithographs showing cityscapes, including work by the British draftsmen James Duffield Harding (1798–1863) and Samuel Prout (1783–1852). The latter clearly influenced Nuyen in the use of flags and draperies as a means of enlivening a street scene or the facade of a building. He has used this idea successfully in the exhibited drawing, in which a flag hangs from an attic window, adorning the bare facade.[1]

Fig. 1. Wijnand Nuyen, *Canal with Old Houses*. Print Room, Leiden University

There is an identical water-color version of Nuyen's pen drawing in the print room of the University of Leiden (fig. 1).[2] This unsigned water-color is identical down to the last detail, which suggests that it might be a copy of the sheet shown here. More recently it was proposed, probably rightly, that the drawing in Leiden is in fact by Nuyen and was probably made about the same time as the dated pen drawing, in 1838.[3]

The year 1838 was an important one for Nuyen. Not only was he exceptionally productive, but also he married the daughter of his former teacher Andreas Schelfhout (1787–1870, see cats. 14 and 15). Sadly, his marriage to Cornelia Johanna Schelfhout was to be short-lived, for only ten months later Nuyen died of tuberculosis. The following lines were engraved on his tombstone:

> Genius called Nuyen home; his life was a brief glorious breath
> His dust rests in this grave, but his name triumphs over death.[4]

JK

1. See, for example, the album Prout 1833, which contains lithographs of Flemish and French cityscapes. Prout certainly did not invent this idea. It is also recommended in a handbook for young painters published in 1827, see Maaskamp 1827.
2. Inv. A. W. 2921; also see Scheen 1952, 40, no. 62.
3. Sillevis 1977, 114, no. 102.
4. Ibid., 32. This tombstone was not placed until 1842 after various friends and artists, among whom Johannes Bosboom, Bart van Hove, Cornelis Kruseman, and Charles Rochussen had collected money for it.

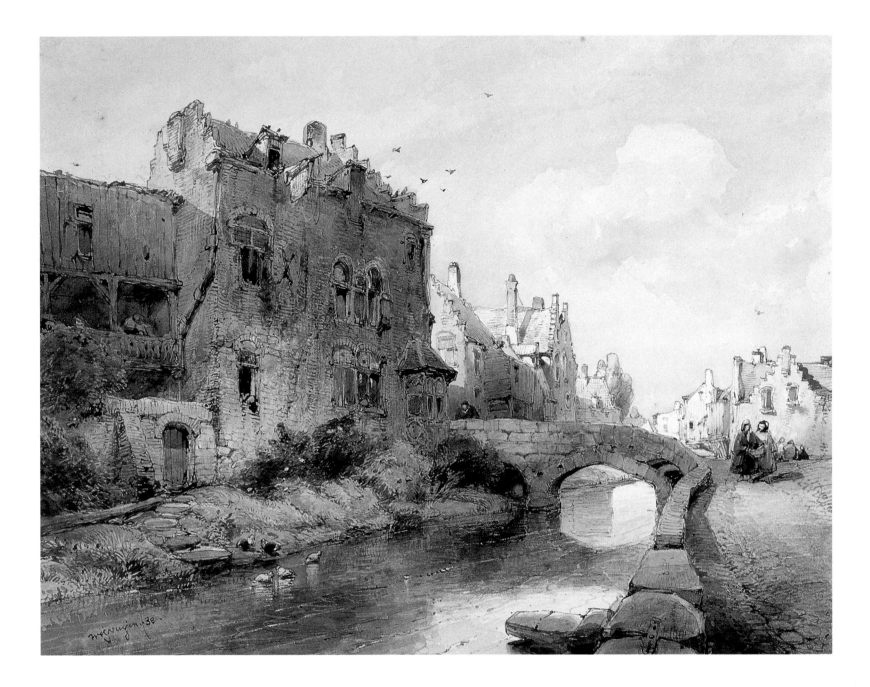

CHARLES ROCHUSSEN

Rotterdam 1814–1894 Rotterdam

28 Music Festival in Rotterdam, July 15, 1854

1854

Brush and brown ink, brown washes, accents in watercolor over pencil, 335 x 500 mm (13 1/4 x 19 5/8 in.)

Signed and dated lower right in pen and brown ink: *CR. ft– 54*; verso, inscribed lower left in pencil: *Muzykfeest d[er] M[aatschappij]. tot bevordering d[er] toonk[unst] te Rotterdam in July 1854*; inscribed lower right in pencil: *Chs Rochussen ...28 Nov 1854 te Amsterdam*

Watermark: J WHAT TURKEY 1853

Inv. MB 586

Provenance: H. A. F. A. Gobius, Rotterdam; his auction, Utrecht (J. L. Beijers), November 21–22, 1900, 39, lot 6503, acquired by the museum

Literature: Haverkorn van Rijsewijk 1909, 328

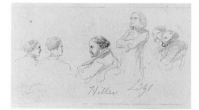

Fig. 1. Charles Rochussen, Sketch of Franz Liszt attached to verso of cat. 28. Museum Boijmans Van Beuningen, Rotterdam

Charles Rochussen came from a well-to-do and artistic Rotterdam merchant's family and grew up in the country mansion of Slot Honingen. Although his parents wished him to follow a career in business, Rochussen finally decided to follow his own inclinations and entered the world of fine art. In 1836 he left Rotterdam for The Hague to train as a painter at the studio of Wijnand Nuyen (1813–39, compare cats. 26 and 27) and his colleague Antonie Waldorp (1803–66).[1] After a number of years at the art school in The Hague and journeys through France, Germany, and Belgium, the artist moved to Amsterdam in 1849.

In the capital, where he lived until 1869, this confirmed bachelor soon became one of its most authoritative artists. With copious productivity Rochussen soon established himself, albeit somewhat controversially, as a popular painter of Dutch history scenes. The painter also turned out to be a popular chronicler of notable occasions that took place in the higher echelons of Dutch society. Until his death in 1894, Rochussen made drawings of hundreds of events that were often published as lithographic illustrations in magazines: "If there was a subject that needed illustrating—a cricket match or a rowing regatta, a historic procession, or if an old tower was restored, a company of veterans needed documenting, or whether someone had to take a glance at an exhibition or a funeral wreath needed hanging, Rochussen was always prepared and able to help us [the editors of the magazine *Eigen Haard*]. He turned out drawings with great ease that in every way betrayed a spontaneity and artistry."[2]

The Museum Boijmans Van Beuningen owns two exceptional examples of this genre along with other drawings by Rochussen. For example, in 1851 Rochussen donated a watercolor of an art viewing at the artists' society Arti et Amicitiae in Amsterdam to a lottery in aid of that society's orphans and widows fund.[3] The engraver Johannes de Mare (1806–1889) reproduced the composition in a print, which was given out as a bonus prize at the annual lottery.[4] The drawing provides a typical illustration of the activities that took place at Arti et Amicitiae of which Rochussen became a member almost immediately after it was founded, later becoming a member of the board.[5] Viewings were regularly held in the large art gallery of the society building on the Rokin. These were informal gatherings where drawings, usually

from members' own collections, were passed from hand to hand and discussed. On some of these evenings, as Rochussen's sheet shows, the spouses of the almost entirely male membership were allowed to attend.[6]

The drawing shown here was commissioned from Rochussen by the Utrecht collector Hendrik Gobius (1815–99). It records a concert that was organized on July 15, 1854, to celebrate the silver anniversary of the Society for the Promotion of Music. At the end of the performance, the composer Johannes Verhulst (1816–91), who had also conducted, was presented with a laurel wreath. Among the many members of the cultural public shown in the drawing who have since been forgotten, one person stands out in particular: on the right of the foreground, leaning against a pillar, is the renowned pianist and composer Franz Liszt, who happened to be visiting Maasstad, near Rotterdam, at the time (compare fig. 1).[7]

Both Rotterdam sheets are executed in the same watercolor technique. Rochussen quickly, and with a minimum of detailed brushwork, put the composition down on paper. The sober palette is composed mainly of gray and brown tints.

MS

1. For a recent biographical summary of Rochussen, see Bionda 1991, 258, and Halbertsma et al., 1997. For the talented Nuyen who died very young, also considered to be the only true romantic painter in the Netherlands, see De Bodt and Sellink 1994, 209–213, nos. 76–77.
2. This fragment of the obituary by the editors of the *Eigen Haard* on the occasion of Rochussen's death in 1894 is quoted from Hoenderdos 1974, 30. For a summary of Rochussen as an illustrator, see Knoef 1947, 96–117.
3. *Art Viewing at Arti et Amicitiae*, watercolor over chalk, 225 x 290 mm (8 7/8 x 11 3/8 in.); watermark: WHATMAN TURKEYMILL; inv. MB 516, provenance: Estate Charles Rochussen, Rotterdam; his auction, Amsterdam (F. Muller), February 6–7, 1895, 4, lot 24; acquired by the Rotterdam city council, together with seven other works by the artist, and donated to Museum Boijmans Van Beuningen in the same year.
4. Heij 1989, 154. For the history of Arti at this time see the essay by Margriet de Roever in Heij 1989, 12–27. For the history of the lottery for the widows and orphans fund, compare idem, 110–112.
5. See the list of board members of Arti in Heij 1989, 135–39 (supplement II).
6. Women were allowed to become artist-member from 1849 onward, compare Heij 1989, 15.
7. For the identities of the various people, see Haverkorn van Rijsewijk 1909, 328. Furthermore, Rochussen also sketched twelve individual portraits of the musicians on the same occasion on an oblong sheet of paper that was glued to the verso of the drawing (fig. 1).

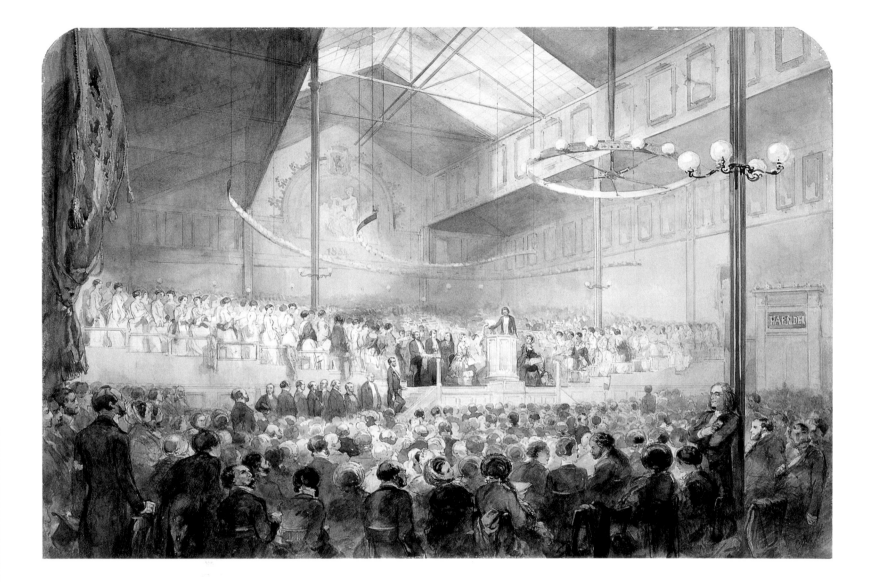

CHARLES ROCHUSSEN

Rotterdam 1814–1894 Rotterdam

29 Marciana and Aisma on the Boat between Capri and Naples

1893 illustration for Carel Vosmaer's book *Amazone* (1893)

Pen and brush and gray ink, gray-brown washes over pencil, 231 x 218 mm (9 1/8 x 8 5/8 in.)

Verso, inscribed upper center in pencil: *Wing[?] 8 c.m. breit*; lower right in pencil: *49*

Inv. MB 519

Provenance: M. Nijhoff, The Hague; gift of W. Nijhoff, The Hague 1933

Literature: Hoenderdos 1974, 31

During the autumn of 1880 the unusual novel *Amazone*, written by Carel Vosmaer (1826–88), appeared on the list of the publishing house Martinus Nijhoff. The first edition of the book, which at that time provoked a great deal of discussion, was completely sold out within five weeks. Nine editions were to follow, seven of these after the author's death.[1]

In *Amazone* Vosmaer describes how the talented painter Siwart Aisma made a long journey through Italy where he became fascinated by the culture of classical antiquity. In Paestum, in southern Italy, he meets Marciana van Buren, a young widow who was making a grand tour with her uncle and a friend. The four journeyed on together, first to Naples and then to Rome. Although Aisma and Marciana are secretly in love with each other from the beginning, they do not acknowledge it for a long time. The headstrong but distant Marciana, who is compared to the classical sculpture of the Capitoline Amazon with which Aisma was entranced, only succumbs to love after the intervention of her uncle, an older and wiser gentleman who constantly appeals to the Roman poet Horace. In fact, this simple love story occupies a rather insignificant part of the novel. Most of the time the group is seen admiring art treasures and reflecting on the intrinsic beauty of classical art.

Amazone, a book that Vosmaer himself regarded as one of his finest literary works, is worth mentioning for more than one reason. First, it was one of the earliest Dutch novels in which a contemporary artist was the leading character. Furthermore, it was a roman à clef, a novel in which real people are depicted under fictitious names. Despite the fact that Vosmaer said one should not look for portraits in the characters, various leading figures can be directly associated with the writer's circle of friends.[2] The most striking is the painter Aisma, whose character and work have a great deal in common with the Frisian-British history painter Lawrence Alma-Tadema (1836–1912). Finally, the book caused a sensation because of the archaeological precision with which the journey was described, taking the three main characters to the most important remains of classical times in Italy. Vosmaer had first traveled to Italy in 1878 with the Dutch poet Martinus Nijhoff. He became fascinated with the country, and it was the experience of this journey that inspired him to write *Amazone*. He made great use of the diaries he had kept while traveling with Nijhoff.[3]

The three editions of the book that appeared during Vosmaer's lifetime were not illustrated, despite the fact that the book lent itself perfectly to this end. Although the author himself was a skilled draftsman and illustrator besides sharing great affinities with the art of his day, there is nothing to suggest that Vosmaer had ever considered such an edition.[4] It was probably Nijhoff who, heedful of the popularity of the book written by his friend, commissioned the aged history painter Charles Rochussen to make the sixty drawings sometime between 1890 and 1892 for the fifth edition, published by Nijhoff in 1893. This collaboration was an obvious choice.[5] Rochussen not only had known Vosmaer personally, but also was an exceptionally skilled book illustrator. One may also assume that the conservative, classical ideal of beauty that appears in Vosmaer's book *Amazone* also appealed to the elderly history painter.

There was only one illustrated edition. Whether the waning popularity of Vosmaer's book or the mediocre lithographs made from Rochussen's original drawings precluded wider circulation will never be known. After being used this one time, the drawings remained the property of Nijhoff and, apart from a few that were probably lost, were finally donated to Museum Boijmans Van Beuningen in 1933 by Nijhoff's heirs. Remarkably little attention has been paid by either art or literary historians to these interesting, swiftly executed pen and brush drawings. The exhibited drawing is not representative in all aspects. More than half of the drawings are not particularly interesting, since they were copied from photographs, postcards, topographical views, and pictures of classical remains. The compositions in which Rochussen could allow his imagination free rein are the most appropriate for the book. The exhibited work illustrates this.

Shortly after meeting in Paestum, the small group journeyed on to Naples. One of the trips they made during their stay there was in a boat to the island of Capri: "Marciana remained above: she wallowed in the pleasure from the sea. Thus, wrapped in her red plaid, with Aisma she looked for a sheltered corner against the bulwarks where they sat talking. The beautiful natural setting in which people spend a day together turns hours into years of intimacy."[6]

MS

1. About *Amazone*, compare Maas 1989, 130–33, and especially Bastet 1989, 117–142.
2. ". . . do not look too hard for portraits in the characters: I deliberately avoided making them so. They are, as Beets said [referring to photographs], a nose from memory on a face of fantasy." Written in a letter to Jacques Perk, quoted from Bastet 1989, 131.
3. Compare Bastet 1989, 82–116, for a report of Vosmaer's journey in 1878.
4. For Vosmaer's view of developments in the art of the day, see Heijbroek 1989, 116–17; for Vosmaer as illustrator, see ibid., 186–202.
5. In 1892 an edition of Vosmaer's collection of short stories *Eenige schetsen* (A few sketches), illustrated by Rochussen, was published by Martinus Nijhoff; see Maas 1989, 103–6. Vosmaer had also written admiringly of Rochussen in his series of portraits of artists of the day; see Vosmaer 1881–85, n.p.; Maas 1989, 133–34; and Heijbroek 1989, 117–30. The series of undated drawings owned by the Museum Boijmans Van Beuningen is not complete when compared with the book. Apart from the illustration for the title page, the original illustrations for pages 7, 11, 122, 162, and 183 are missing.
6. Vosmaer 1893, 33.

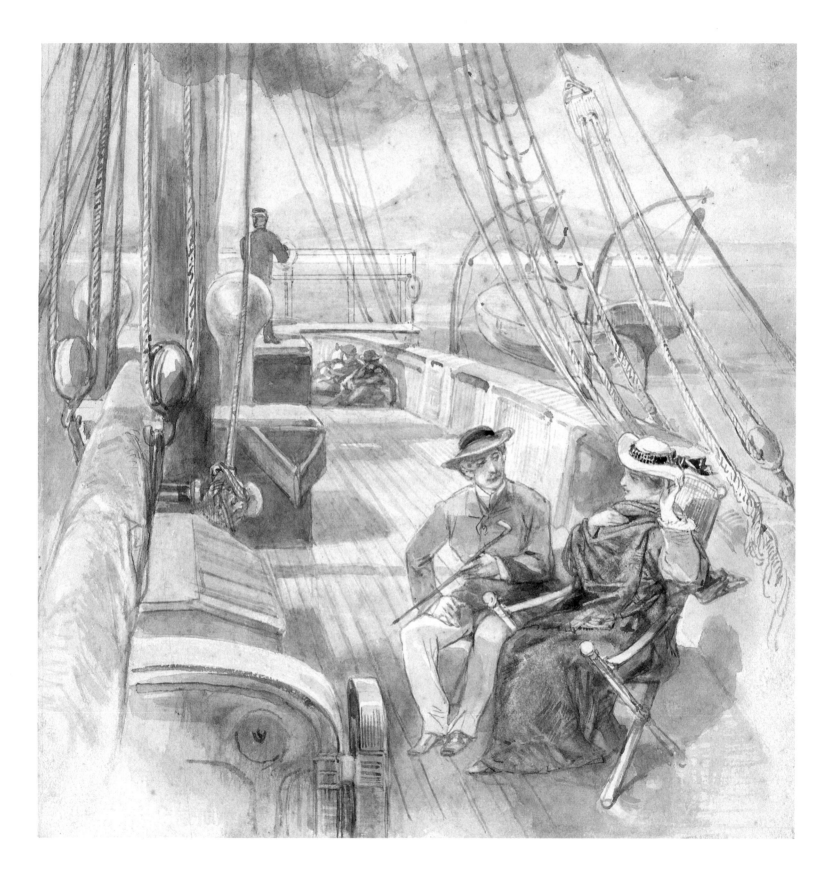

JOHANNES BOSBOOM

The Hague 1817–1891 The Hague

30 Mine Shaft in Borinage, Hainault, Belgium

1848

Black chalk, stumped, pencil, brush, and gray ink, gray washes, 383 x 543 mm (15 1/8 x 21 3/8 in.)

Inscribed and dated lower left in pencil: *Le Borinage Hainaut . . . 1848*

Inv. MB 1969/T3

Provenance: On loan from K. van der Pols, Rotterdam 1969

Literature: Zilcken 1893, 138; De Gruyter 1965, no. 10

Fig. 1. Johannes Bosboom, *Mineshaft in Borinage, Hainault*. Teylers Museum, Haarlem

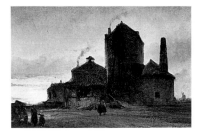

Fig. 2. Johannes Bosboom, *Mineshaft in Borinage, Hainault*, oil on canvas. Museum Boijmans Van Beuningen, Rotterdam

The erudite Johannes Bosboom first concentrated on painting cityscapes as a student under Bart van Hove (1790–1880) in The Hague. As a young man he was deeply influenced by French romanticism. After the death of the painter Wijnand Nuyen (1813–39, compare cats. 26 and 27), Bosboom was widely seen as his successor as leader of the Dutch romantics.[1] However, Bosboom developed in a different direction. His church interiors in particular, the genre in which he began to specialize in the second half of the 1830s, betray his enormous admiration for the Dutch Golden Age. In 1852 the poet S. J. van den Bergh celebrated the fact that Bosboom, as "a son of Holland's flowery fields," had not sought in a foreign school in order to find "the beauty of the fatherland."[2] Later in his career, when his work became freer and more abstract, the influence of the Golden Age became less noticeable in Bosboom's work, although it was certainly still there. His best watercolors have a Rembrandtesque intensity. The emphasis on Bosboom's function as "savior of the Dutch school of painters" together with the inseparable comparison with the old Dutch masters, a central theme in the poem by Van den Bergh, was to follow Bosboom into the grave. And the hint of religiosity of his work was mentioned in connection with his pieces for the rest of the century.

Bosboom was a great traveler, and when he could take time off from producing his highly successful church interiors he investigated other topics that caught his interest. The drawing of the mine shaft in Borinage, south of Brussels, of which there is also a watercolor (fig. 1), is undoubtedly one of Bosboom's least poetic works. It was made during one of his many visits to Belgium. After his first visit to the country in 1837, Bosboom returned repeatedly because, as he put it, he was attracted by "the overwhelming quantity of subjects to study offered by that country as well as by the tremendous amiability that I am so happy to meet there."[3] In several ways, Belgium played an important part in Bosboom's development. First, at an early date his church interiors were exhibited and received prizes in Brussels, Antwerp, and Ghent.[4] Then, in 1856, he was greatly encouraged when the Belgian Society for Watercolor Artists was founded in Brussels.[5] Almost immediately Bosboom, who from the 1830s had been one of the few serious watercolorists, received positive reactions to his work from the Belgian art world long before that happened in the Netherlands.

Bosboom often used his drawings and watercolors years after he had made them as studies for paintings or turned them into independent works. Using the drawing here, which shows a pump for a mine in Borinage, Hainault, which according to the inscription was drawn on the spot, Bosboom later made a painting that is now in the Museum Boijmans Van Beuningen (fig. 2).[6] It is not clear when the canvas was painted. In 1867 Bosboom mentioned a different study with highlights he had sketched two years previously in Chaudfontaine, Belgium. This, he said, he planned to make into a pendant for a study he had made several years before, showing a mine shaft in Borinage, which he would now finish.[7]

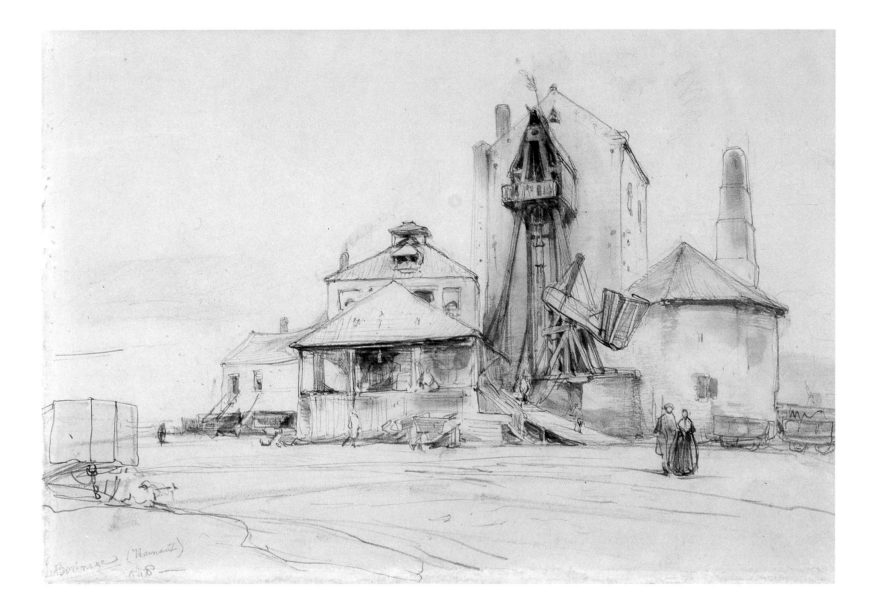

101

JOHANNES BOSBOOM

The Hague 1817–1891 The Hague

31 Farmyard Barn

Watercolor, accents in bodycolor, 398 x 567 mm (15 3/4 x 22 3/8 in.)

Signed lower right with brush and brown paint: *JBosboom*

Watermark: J[?]H&Z.

Inv. MB 545

Provenance: J. P. van der Schilden, Rotterdam; his legacy, 1925

Literature: Rotterdam 1925, 3

Toward the end of his life Bosboom said that his drawings, as opposed to his paintings, offered "a greater variety" because of their "differences in genre."[8] Undoubtedly this is thanks to his friend the collector Baron Van Rappard, who bought a great many of his drawings and watercolors. It was also from Rappard's house that in 1863 Bosboom began to draw studies of stables and farm buildings in such places as Hilversum, Nieuw Loosdrecht, and Woudenberg.[9] Despite differences in detail, the drawing here of a farm building closely resembles a watercolor in the Singer Museum, Laren, which in turn belongs to a larger series of interiors showing the same farmhouse in Loosdrecht.[10] Bosboom began making his drawings of farm buildings at a time when he was deeply depressed. He continually returned to this theme until 1867, at which time he began to feel better, and afterward made few such drawings.[11]

SdB

1. The composer Johannes Verhulst wrote to Bosboom in 1839, on the death of the painter Wijnand Nuyen: "I am deeply grieved at the death of the unforgettable Nuyen. Jan, the mantle of the young school of painters now falls upon your shoulders." Cited in Sillevis 1977, 39.
2. Van den Bergh 1852, 13–14.
3. Bosboom 1946, 37.
4. Bosboom 1946, 11–12.
5. De Bodt 1995(1), 83–93, De Bodt 1995(2), 85–103.
6. *Mine Shaft and Pumping Installation of a Mine in Borinage, Belgium*, panel, 34.5 x 51 cm (13 5/8 x 20 1/8 in.), Museum Boijmans van Beuningen, inv. 1113. Signed lower right: *J. Bosboom*. Compare Ebbinge Wubben 1963, 23.
7. Johannes Bosboom to Jan Kruseman, 30 June 1867, see Jeltes 1910, 35. See also Marius 1917, 61, and Dumas 1983, 173, where the conclusion is drawn that Bosboom implemented his "plan" in 1865.
8. Bosboom 1946, 13.
9. Marius 1917, 139–40.
10. Johannes Bosboom, *Farmhouse near Hilversum*, 1863–65, watercolor, 390 x 550 mm (15 3/8 x 21 5/8 in.), signed lower left: *JBosboom*. Singer Museum, Laren, inv. 56–1–126. Compare Kolks 1991, 42.
11. Marius 1917, 54ff.

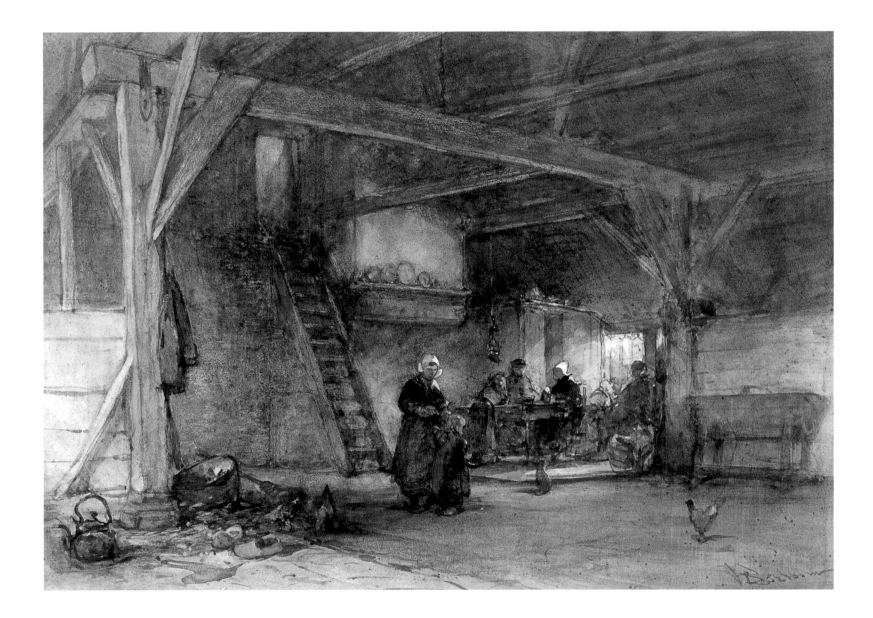

JOHAN BARTHOLD JONGKIND

Lattrop 1819–1891 La Côte-Saint-André

32 *River View in Rotterdam*

1857

Brush with brown ink, brown and gray washes over pencil, 198 x 280 mm (7 5/8 x 11 in.)

Signed and dated at lower left in brush and black ink: *JongKind 1857*; verso, center in pencil in a later handwriting: *Jonkind*

Inv. MB 515

Provenance: Gift of the art dealer Huinck & Scherjon, Amsterdam, 1935, for the opening of the new building of the Museum Boijmans Van Beuningen

Literature: Amsterdam 1932, no. 1; Rotterdam 1935, 19; Hefting 1948, no. 88; Colmjon 1950, no. 46

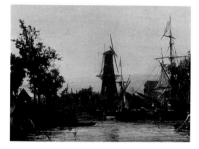

Fig. 1. Johan Barthold Jongkind, *Harbor in Rotterdam*. Courtesy Ivo Bouwman, The Hague

Although J. B. Jongkind is usually associated with French painting, his roots are in the Netherlands. His childhood was spent in Vlaardingen, near Rotterdam, and in the 1830s he studied with Andreas Schelfhout (1787–1870) (compare cats. 14 and 15) at The Hague Academy of Drawing. He made friends there with Charles Rochussen (1814–94) (compare cats. 28 and 29), like himself a proficient watercolorist, who took him to the countryside to work. In 1845 a grant enabled Jongkind to study in Paris in the studio of Eugène Isabey (1803–86). He spent the rest of his life in great poverty, alternately in Holland and France.

Between 1855 and 1860 Jongkind was again working in and around Rotterdam, following a long period in France. Among many examples of this artist's draftsmanship, the print room of the Museum Boijmans Van Beuningen owns two interesting drawings made in this period.[1]

The method used in the exhibited drawing, *River View in Rotterdam*, is closely related to the Dutch romantic school in its use of different tones of brown. This is not surprising since Jongkind was a pupil of Andreas Schelfhout (1787–1870), who was associated with the romantic school of painting. In a promi-

nent position in the background of this drawing is a tall windmill. Two three-masted ships are moored along the quay. The topography is not entirely clear. At the left is probably the Willemsplein, with De Pelikaan mill pictured right of center between the harbors of Leuvehaven and Zalmhaven. At this time there were two windmills located here, only one of which has been drawn by the artist.[2] As is often the case with Jongkind's work, he used this sketch, with some alterations, to make a painting (fig. 1) dated 1857, which turned up at an art dealer in The Hague in 1991.[3] The painting too, with the tall windmill as a central motif, expresses the same romantic mood as the drawing. Jongkind obviously wanted to introduce a certain balance to the composition by moving the large ship in the drawing to the right in the painting.

AM

1. See, for Jongkind's Rotterdam period, Meij 1978.
2. With thanks to P. Ratsma, Gemeentelijke Archiefdienst (Municipal Archives), Rotterdam.
3. Johan Barthold Jongkind, *Harbor in Rotterdam*, 1857, canvas, the art dealer Ivo Bouwman, The Hague. Illustrated in Sillevis 1991, 20, fig. 6.

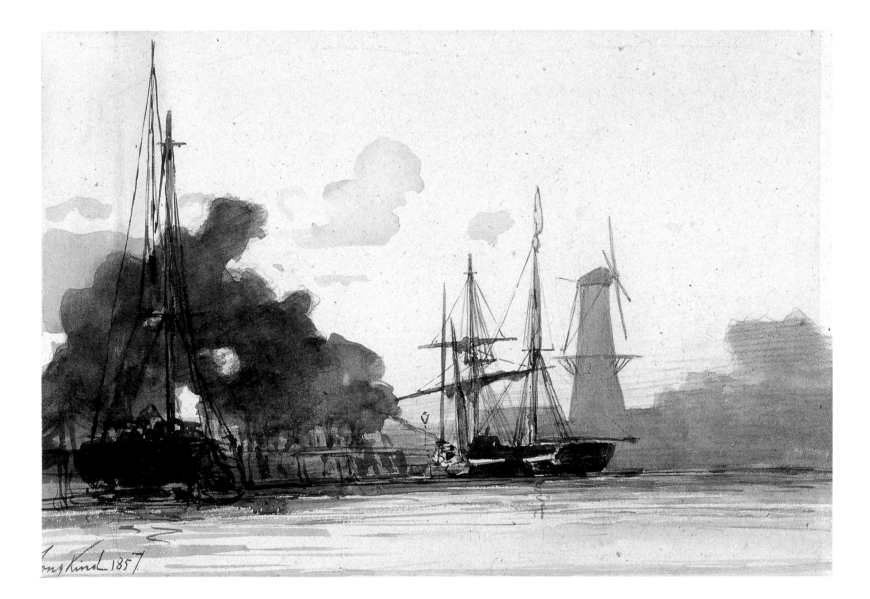

Jongkind 1857

JOHAN BARTHOLD JONGKIND

Lattrop 1819–1891 La Côte-Saint-André

33 *On the Banks of the Seine*

c. 1878

Watercolor over black chalk, 302 x 471 mm (11 7/8 x 18 1/2 in.)

Verso: *Detail of a Bateau-Lavoir*, black chalk

Inv. MB 539

Provenance: Gift of A. A. Beek, Rotterdam 1916

Literature: Rotterdam 1916, 10; Schmidt-Degener 1921, 182, no. 800; Hannema 1927, 165, no. 800; Hefting 1963, no. 53, fig. VIII; Hefting 1971(1), no. 20, fig. XI; Hefting 1971(2), no. 65; Hefting 1975, no. 145

Fig. 1. Johan Barthold Jongkind, *Bateau-Lavoir*. Private Collection

Besides views of Rotterdam (see cats. 32 and 34), the Museum Boijmans Van Beuningen owns several beautiful watercolors that Jongkind made during his years in France. This Parisian scene is a fine example. In the left foreground is a group of people fishing, and in the background a *bateau-lavoir* lies in the River Seine. In those days these boats were floating laundries, where people could do their washing on one of the lower decks and also bathe. The upper part of the boat was used to dry laundry. This boat was formerly moored behind the church of Notre Dame, close to the Pont-Neuf bridge.

There is another drawing by Jongkind, from about 1854, offering a more detailed picture of such a *bateau-lavoir* (fig. 1).[1] Clearly to be seen are the ventilation flaps by which the temperature and through currents of air could be regulated and which also kept out the rain. The flat-bottomed boats that are moored at the side of the laundry ship, as in the Rotterdam drawing, were used to transport the washing to and from the ship. It looks very much as if Jongkind used this drawing as a basis for the large watercolor in the Rotterdam collection.

The sheet is given various dates. The earliest is 1855; in this case it would have been made during Jongkind's first visit to Paris.[2] There is a handwritten note from the 1950s on the inventory card written by the then-curator, Professor Egbert Haverkamp Begemann, saying that the watercolor was made in 1868. More interesting, especially in view of the period when it was written, is the comment from the former director of Boijmans Museum, Frederik Schmidt-Degener, writing in the museum's annual report of 1916, who says in connection with the gift of this work: "[it] . . . shows a side of Jongkind's talent that is not so well known in our country. . . . This watercolor, as fresh as it is full of atmosphere, probably dates from about 1878 and gives us an impression of the confidence with which Jongkind captured an essentially fleeting moment. He shows us the banks of the river Seine in Paris, late in the day, the sky overcast. There is still a remnant of daylight, but dusk is swiftly advancing. Shadows hang already over the flat-bottomed boats and around the curious old laundry ships. Grayness spreads on the low waters and between the even blocks of houses standing high on the bank. There is a remarkable sense of completion that Jongkind has achieved with utterly sober means."[3]

In view of the loose brushstroke of this drawing, highly characteristic of Jongkind's later work, it seems that Schmidt-Degener's date is more plausible. Furthermore, the architectural style of the houses on the farther bank appears to date from the late 1870s. It is known in any case that in the winter of 1878 Jongkind, as was his custom, spent the months of November and December in Paris.

AM

1. 270 x 380 mm (10 5/8 x 15 in.), private collection. Illustrated in Hefting 1982, no. 116.
2. Hefting 1975.
3. Cited in the Annual Report, Museum Boijmans Van Beuningen, see Rotterdam 1916.

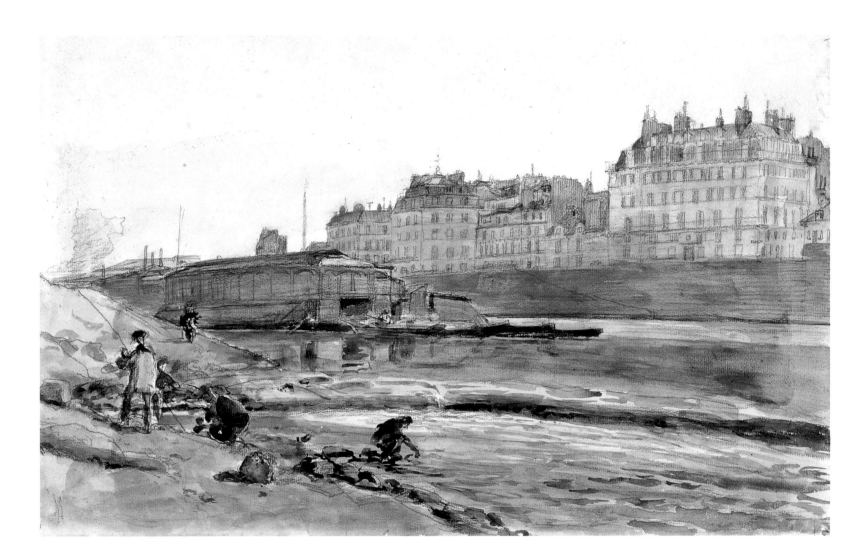

JOHAN BARTHOLD JONGKIND

Lattrop 1819–1891 La Côte-Saint-André

34 *View of the Harbor, Haringvliet*

1868

Watercolor over black chalk, accented with bodycolor, 274 x 442 mm (10 3/4 x 17 3/8 in.)

Dated lower right in black chalk: *Rotterd 16 sept 68*; verso, in the center of the sheet inscribed in pencil: *P[?] 66*

Watermark: lion rampant with the letters K[oning] & D[esjardyn], Churchill 121

Inv. MB 1977/T7

Provenance: Jongkind studio, Paris (L.1401); private collection, Paris; acquired from that art dealer Adolphe Stein, Paris 1977

Literature: Rotterdam 1977, 19; Meij 1978, 171, no. 2

During his penultimate stay in Rotterdam in 1868, Jongkind made this picture of the small harbor of Haringvliet. Between September 2 and 25 he stayed in the street called Grote Markt. One year after this, in 1869, he made his final visit to Rotterdam.[1]

Jongkind drew this picture looking from the side of the New Bridge. In the right background is the building of the shipping offices Zeekantoor, which was pulled down in 1873. This spot was unoccupied for years until it was built upon in the 1990s. The pictures reveals clearly in the center background the tower of Rotterdam's Zuiderkerk, a church that was demolished during World War II.

The drawing was made at a decisive moment in Jongkind's development. He had now freed himself entirely from the romantic way of painting in which he had been trained, chiefly by Andreas Schelfhout. This sheet illustrates Jongkind's new, spontaneous way of looking at nature, and it is precisely this manner of working that earned him his popularity in France. He was seen by his French contemporaries, the impressionists, as a pioneering figure. The French

Fig. 1. Johan Barthold Jongkind, *Rotterdam in the Moonlight*. Rijksmuseum, Amsterdam

painter Camille Pissarro (1830–1903) said of him: "Without him, we would not have been who we are."

Jongkind used this watercolor from nature, which from the studio stamp appears to have remained in his possession all his life, as a model for a work in another medium, an oil painting fifteen years later (fig. 1).[2]

AM

1. In connection with Jongkind's visits to Rotterdam and this particular drawing, see Meij 1978.
2. *Rotterdam bij maneschijn* (Rotterdam in the moonlight), oil on canvas, 34 x 46 cm (13 3/8 x 18 1/8 in.). Rijksmuseum, Amsterdam.

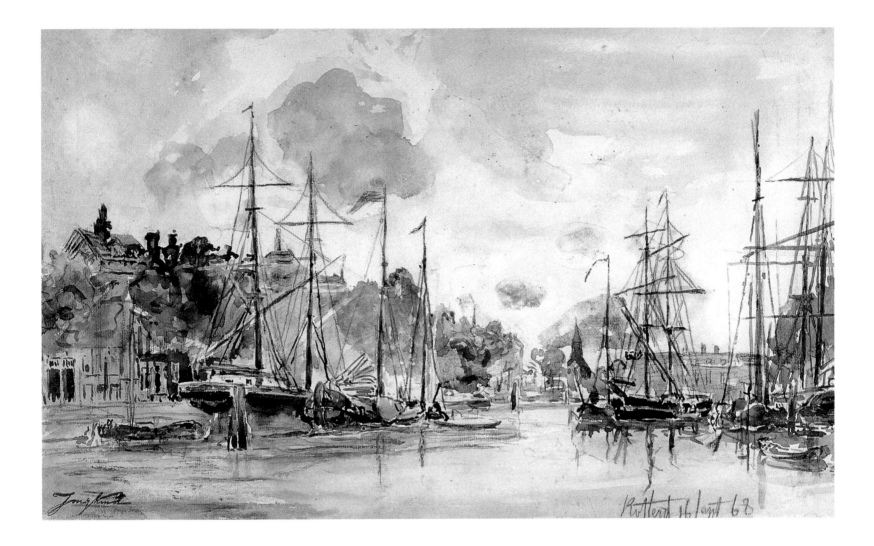

DAVID JOSEPH BLES

The Hague 1821–1899 The Hague

35 Girl in a Chair

1856

Red and black chalk, heightened with white, stomped, 250 x 184 mm (9 7/8 x 7 1/4 in.)

Signed lower right with brush and black paint: *D. Bles. f;* dated in black chalk and brush with black paint: *29.4.56*

Inv. MvS 25

Provenance: H. M. Montauban van Swijndregt, Rotterdam; his legacy, 1929

Literature: Drost 1944, 10, no. 25

Fig. 1. David Joseph Bles, *Girl in a Chair*. Fodor Museum

David Bles was a contemporary and colleague of such artists as Johannes Weissenbruch (1824–1903, see cats. 38–41), Willem Roelofs (1822–97, see cat. 36), and Johannes Bosboom (1817–91, see cats. 30 and 31), with whom he founded the Pulchri Studio.[1] He began his career in Paris where in 1841 he was introduced by his teacher, Cornelis Kruseman (1797–1857, compare cat. 20) to Robert Fleury (1797–1890), under whose guidance he copied works in the Louvre.[2]

Shortly after his return to Holland in 1843 Bles started to specialize in history paintings. Like many of his colleagues who painted in that genre, for example Kruseman, Pieter Barbiers (1798–1848), Herman (1822–91) and Mari ten Kate (1831–1910) as well as Josef Israëls (1824–1911, see cat. 37), Bles had a highly literary background. Most of his larger paintings and detailed drawings are based on literal citations, which Bles would often write out and paste onto the reverse of the work. Favorites with him, beside La Fontaine's fables, were almost always Dutch writers and poets, ranging from the seventeenth-century moralizing Jacob Cats to the contemporary Jacob van Lennep, whose book *Ferdinand Huyck* Bles also illustrated.

The name of Bles was firmly established once he had received a gold medal at the renowned Paris World Exhibition of 1855. He received considerable praise from the critics who were otherwise far from complimentary about the Dutch school. They complained that Bles' fellow Dutchmen were far too busy imitating the painters of their Golden Age and in the wrong way. "With the exception of Monsieur Bles," wrote the French critic Edmond About, "the Dutch artists would appear to be following a dismal path. All that they have inherited from their forefathers are their deficiencies."[3]

As well as large scenes based on literary subjects, Bles was also particularly fond of reproducing more intimate scenes, showing murmuring maidens, young ladies, and young mothers relaxing with their dolls, pets, or infants. In almost all cases the settings and clothing of the characters are historical. While Bles' larger pieces recall work by Jean-Baptiste Greuze (1725–1805) or William Hogarth (1697–1764), the less literary pictures clearly show the influence of Jean-Honoré Fragonard (1732–1806), who was popular throughout the first half of the nineteenth century. In the present small drawing this influence can also be seen. There are scarcely any explicit references to an earlier period; at most the girl's dress carries a suggestion of the eighteenth century. But the Louis XV chair and the footstool that goes with it were quite familiar items of furniture in the mid-nineteenth century.

In a later colored and more worked-out drawing by Bles from the collection of the nineteenth-century Amsterdammer C. J. Fodor, there is a little girl who looks quite like this one. She is half-sitting, half-lying diagonally across a chair and in fact forms part of a larger scene. The little girl in the Fodor picture is holding up her left hand (fig. 1).[4]

SdB

1. De Bodt 1990, 40.
2. Marius 1920, 84. Compare also Vosmaer 1881–85 and Ten Brink 1891.
3. About 1855, 66–68.
4. The collection of drawings from the Fodor Museum is at present in the Amsterdam Historisch Museum. For this particular drawing, see Amsterdam 1863, no. 283.

WILLEM ROELOFS

Amsterdam 1822–1897 Berchem (Antwerp)

36 Landscape with Mill by Moonlight

c. 1870

Watercolor, 249 x 355 mm (9 3/4 x 14 in.)

Signed lower left with brush and brown paint: *W. Roelofs.*

Inv. MB 508

Provenance: A. J. Domela Nieuwenhuis, Munich/Rotterdam; acquired in 1923

Literature: Hannema 1927, 171, no. 833

The landscape painter Willem Roelofs was one of the founding figures of the Hague school. Toward the end of the 1830s he studied briefly at the Academy of Drawing at The Hague, and in the summer of 1840 turned to Hendrikus van de Sande Bakhuyzen (1745–1860) for advice. Roelofs spent most of his career, forty years in all, in Belgium. Ever since the first reference work on nineteenth-century Dutch art was published by "Miss" G. H. Marius in 1903, opinion has been sharply divided on Roelofs' role in the development of art after 1850. Marius describes him as a trailblazer and an important link between the innovations of the Barbizon school of landscape painters in France and the Hague school in the Netherlands. At the same time, Marius asserts that Roelofs understood nothing of the Dutch old master landscape painters, whom the Barbizon artists actually took as their models.[1] In the course of the twentieth century, however, Willem Roelofs has slowly but surely come to be regarded, more and more on the basis of his work, as a precursor and early member of the Hague school.[2]

The ambiguity of Roelofs' role is attributable to the fact that he had left the Netherlands before romantic influences had fully crystallized there. After founding Pulchri Studio, the artists' association so crucial to the development of the Hague school, he settled in Brussels in 1846 where he was regarded as a leading artist until the 1880s.[3] It was there, influenced by realist ideas arriving from France, that he underwent a transition from a romantic vision of nature, involving grandiose effects, to more realistic representations of the world about him. "He portrays excellently the rather cold, gray, misty nature of our country," the Belgian critic Victor Joly wrote in 1857, "a country where flannel shirts flourish and Mignon would freeze in the September sun."[4] Later still, Roelofs' work was to come close to impressionism.

Along with Belgian artists such as J. B. Madou (1796–1877), Paul-Jean Clays (1819–1900), and Paul Lauters (1806–75), Willem Roelofs co-founded the

Société Belge des Aquarellistes and in so doing paved the way for a similar society in the Netherlands.[5] He also taught and advised various painters, including Paul J. C. Gabriël (1828–1903, see cat. 42), Alexander Mollinger (1836–67), who was regarded as highly promising but died at an early age, and Carel Nicolaas Storm van 's Gravesande (1841–1924).

The Boijmans Van Beuningen collection includes drawings from the more romantic as well as the more realistic periods in Roelofs' development; one of his late, fluently drawn watercolors has yet to be acquired. An ink wash landscape dating from 1845[6] conveys the drama typical of art at that time and portrays an exalted view of nature. The rather formal *Mill* produced twenty-five years later illustrates his switch to a harsher, more scientific and objective depiction of reality.

Roelofs' increasingly analytical approach was paralleled by his growing interest in the natural sciences, especially entomology. It was an interest that started in the 1860s, and he was one of Europe's first professional researchers in the study of insects.[7] The same scientific vision informs his choice of bright, sometimes harsh colors for his watercolors, colors that are opaque rather than transparent.

SdB

1. Marius 1920, 123–24 (the first edition was published in 1903); compare also De Bodt 1995(1), 172ff.
2. See Van Gelder 1947, Colmjon 1950, De Gruyter 1968–69, and Dumas 1983.
3. Compare De Bodt 1995(1), especially 95ff and 149–54; De Bodt 1995(2).
4. Victor Joly, "Salon de 1857," in Joly 1857, 368–69.
5. De Bodt 1995(1), 83–93; De Bodt 1995(2), 85–103.
6. Willem Roelofs, *Landscape with Horseman*, brush with black and brown ink, gray and brown washes, accents in white bodycolor, signed and dated lower right: *WRoelofs. fe. 45*, 257 x 253 mm (10 1/8 x 10 in.). Museum Boijmans Van Beuningen, Rotterdam, inv. MB 582, provenance F. J. O. Boijmans, Utrecht; his legacy, 1847 (L.1857).
7. Compare Saskia de Bodt, "Wetenschap of kunst? Willem Roelofs en de entomologie" (Science or art? W. R. and entomology), in De Bodt 1995(1), 113–22.

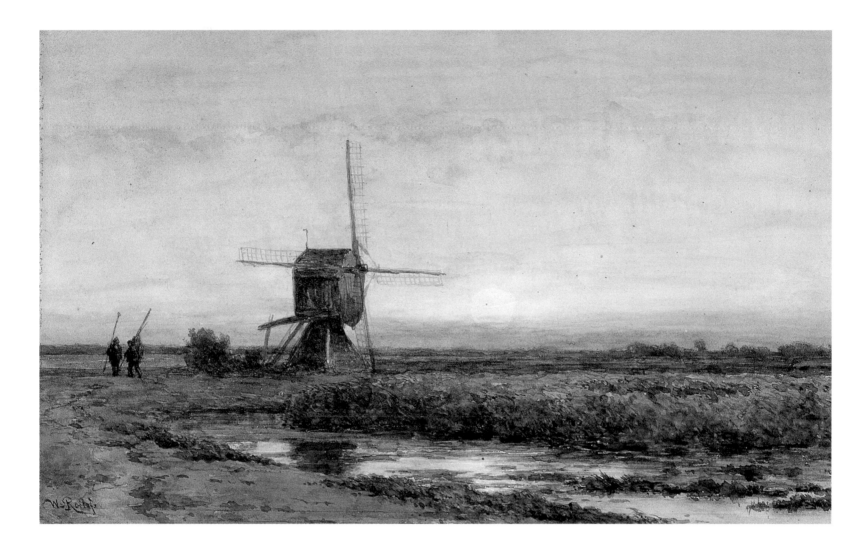

JOSEF ISRAËLS

Groningen 1824–1911 The Hague

37 Child in a Chair

c. 1872

Watercolor with accents in body-color, 432 x 312 mm (17 1/8 x 12 1/4 in.)

Signed lower right with brush and black watercolor: *.Jozef Israels.*; verso, inscribed lower center with pencil: *68 85 x 65*; inscribed lower left with pencil: *347*

Inv. MB 528

Provenance: A. J. Domela Nieuwenhuis, Munich/Rotterdam (L.356b); acquired in 1923

Literature: De Gruyter 1961(1), 22, no. 53; De Gruyter 1965, 45, no. 27; De Gruyter 1968–69, 48; Dumas 1983, 30 and 192, no. 33

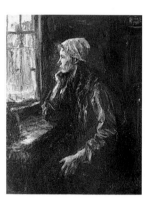

Fig. 1. Jozef Israëls, *Fisherman's Wife at the Window*, 1896. Museum Boijmans Van Beuningen, Rotterdam

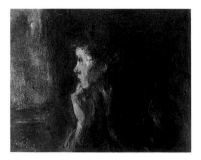

Fig. 2. Jozef Israëls, *Waiting Anxiously*. Rijksmuseum, Amsterdam

Josef Israëls has become famous above all for his paintings of the daily life of fishing folk. He said that during a short stay in the Dutch coastal resort of Zandvoort, where he went to recover from a rheumatic condition, he was struck by the beauty of the beach and the simple lives of the poor but "noble" fishing folk. The fishing genre was already important in literature and painting before 1855 in Europe and was quite popular. Although his stay in Zandvoort certainly influenced him in his choice, he also knew that the genre was commercially a good choice of subject matter.[1]

A theme he returned to many times in his work is that of the fisherman's wife waiting anxiously for the safe return of her husband. A sheet in the print room of the Museum Boijmans Van Beuningen shows a woman sitting with her head resting in her hand,[2] an attitude appearing frequently in Israëls' work. As early as 1858 he painted *After the Storm*, which pictures a woman sitting in a doorway in this position.[3] The drawing is one of the four preparatory studies, also in the print room at Rotterdam, for the painting *A Fisherman's Wife at a Window* from 1896, also in the Boijmans Museum (fig. 1).[4] The other three drawings, in black chalk and pencil, are detailed studies of the chair on which the woman is sitting, her hand resting on her dress, and a rougher sketch of a woman sitting at a table.[5] The painting *Waiting Anxiously* (fig. 2), also from 1896, which is now in Amsterdam's Rijksmuseum, is considered by some to be a preparatory study for the Rotterdam painting. Although the attitude of both women is the same, there are obvious dissimilarities that compel one to regard this painting as an independent one.[6]

The director of Boijmans Museum at that time, Pieter Haverkorn van Rijsewijk, was extremely pleased with the purchase of the painting *Fisherman's Wife at the Window*. He had wanted a piece by the famous Israëls for a long time, but the high prices asked for his work had proven a formidable obstacle. The usufruct of the Boijmans legacy and the reduction Israëls was prepared to give the museum finally made the purchase of the *Fisherman's Wife* possible in 1896.[7] Before handing it over to the museum, the painter first sent the piece to the Salon in Paris where it received a great deal of praise from both the foreign and Dutch press. "It is a woman who is still young, but life has not left her untouched. Although she is thin and shriveled, one can still see that she was once beautiful. And this is the feeling you get from the picture: a melancholic admiration for the woman's faded or fading beauty," reported the *Nieuwe Rotterdamse Courant*.[8]

Israëls had great sympathy for the fishermen's wives who lost much of their youthful bloom by the time they were thirty. Their skin was so tanned by being close to the sea and living among the dunes that the seacoast could be referred to as "Dutch Arabia" according to the Frenchman Alphonse Esquiros who published his findings of life in Holland in the magazine *Revue des deux Mondes*.[9] In 1894, Israëls

wrote in a paper on behalf of De Utrechtse Dames Vereeniging tot Verbetering van Armenzorg (the Utrecht ladies association for the amelioration of the lot of the poor): "The calloused hands of a workman are sometimes more beautiful to paint than the white hands of a lovely lady."[10] He accompanied his article with an illustration that had many things in common with the Rotterdam drawing and painting.

Child in a Chair is a watercolor, a technique that brought Israëls great fame in his day. It shows a child sitting in a wooden nursery chair on wheels and holding a piece of cloth over the edge. A gray and white cat jumps up at the material. Like the theme in the picture of the waiting fisherman's wife, Israëls painted and drew the image of a child with a cat many times.[11] The child in the nursery chair probably first appeared in the painting *Old and Young*, also known as *Army and Navy*.[12] In this painting an old fisherman is handing a tin soldier to a small child in a nursery chair. The painting is generally dated 1872. The exhibited watercolor of the child playing with the cat was probably painted at around the same time.

Israëls also made an etching of the child in the chair that bears a strong resemblance to the child in the painting *Old and Young* and the Rotterdam drawing.[13] This etching was published in the *Kunstkronijk* in 1874, along with a poem by the painter:

> In the forlorn and darkened fisher's hut
> So ancient and lone
> Where the wind shakes the roof and shudders
> the walls,
> Is there still something sweet in this home?
> Yea wait, by that hearth black with smoke and
> with soot
> That color the walls with their grime,
> And all that you spy is so old and decayed
> Sits a playing child—small but sublime.[14]

MdH

1. On Israëls as a highly successful painter in this genre, see Dekkers 1994.
2. Jozef Israëls, *Woman at a Table*, pencil, 256 x 350 mm (10 1/8 x 13 3/4 in.), verso: lower left in pencil: *No 5*. Museum Boijmans Van Beuningen, Rotterdam, inv. MB 514, gift of the artist, The Hague 1898.
3. *After the Storm*, 1858, oil on canvas, Stedelijk Museum, Amsterdam.
4. *Fisherman's Wife at the Window*, 1896, oil on canvas, Museum Boijmans Van Beuningen, inv. 1358. See Ebbinge Wubben 1963, 62.
5. Museum Boijmans Van Beuningen, inv. nos. Josef Israëls 11, 12, 13. The artist gave his four studies for the painting to the museum in 1898, when Haverkorn van Rijsewijk asked leading Dutch painters to donate studies to the museum.
6. *Waiting Anxiously*, oil on canvas, Rijksmuseum, Amsterdam, inv. A3599. See: De Gruyter 1961(1), 20, no. 28. The woman in the Amsterdam painting is only pictured to midway down her chest, whereas the Rotterdam version shows nearly her whole body. There is also no clear facial similarity between the two women. Finally, both paintings have been done in the same loose style, which implies that neither of them was a rougher oil sketch for the other.
7. De Vries 1996, 44–86.
8. Critic quoted in Haverkorn van Rijsewijk 1909, 322.
9. See Dekkers 1994, 77.
10. Drawing with caption, originally from a pamphlet published in 1894 for the benefit of De Utrechtse Dames Vereeniging tot Ver-

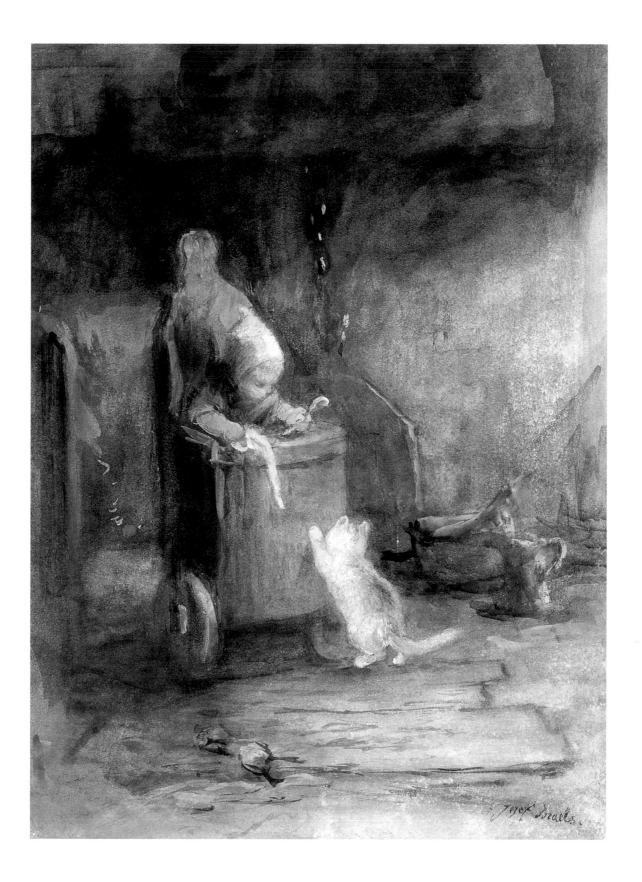

betering van Armenzorg; photographic documentation from Netherlands Institute for Art History, The Hague (RKD).

11. There are at least two other (painted) versions. See *Onze Kunst* 3 (1904), 44, and Scheen 1981, no. 486.

12. See for this painting, Dekkers 1994, 267–70, no. 16.

13. See Hubert 1909, 31, no. XIV. The child in the chair is also known as "little John" or "Johnnie"(See for instance De Gruyter 1961(1), 22, no. 53, and De Gruyter 1968–69, opposite 48). The name probably comes from Hubert's catalogue of Israëls' etchings, published in 1909, in which there was an etching of a child's head entitled "Little John"; see Hubert 1909, 34, no. XVII. This etching was published in the same catalogue as the etching of the child in the nursery chair. The similarity between the heads of the two children was probably the reason the child in the chair was also identified as "Johnnie." There is, however, no reason at all to assume that Israëls himself gave the Rotterdam watercolor such a title.

14. *Kunstkronijk* 16 (1874), 51, no. 13 under the title *A Child in a Chair Playing*; on p. 56 was the poem by Israëls. See also Dumas 1983, 192.

JOHANNES HENDRIK WEISSENBRUCH

The Hague 1824–1903 The Hague

38 Dutch Landscape

1858

Watercolor over pencil, 204 x 267 mm (8 x 10 1/2 in.)

Upper left in pencil: . . . *brug[?]*; verso: *Dune landscape with windmills*, watercolor over pencil, dated lower left in pencil: *1858*

Inv. MB 512

Provenance: Gift of the artist, The Hague 1898

Literature: Haverkorn van Rijsewijk 1909, 345–46; De Boer 1960, no. 118; De Boer 1961, no. 110; Hefting 1963, 46, no. 126

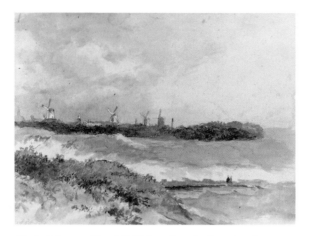

Fig. 1. Johannes Hendrik Weissenbruch, *Dune Landscape with Windmills*, verso of *Dutch Landscape*. Museum Boijmans Van Beuningen, Rotterdam

Johannes Hendrik (also Hendrik Johannes) Weissenbruch, who in the 1840s had studied as had Johannes Bosboom (1817–91, compare cats. 30 and 31) under Bart van Hove (1790–1880), began to paint in watercolors well before 1850. This technique, which was eminently suited to his broad and generous view of nature, undoubtedly contributed to his loose brushstroke. Unlike artists such as Bosboom, Charles Rochussen (1814–94, compare cats. 28 and 29), and Josef Israëls (1824–1911, compare cat. 37) who from the late 1850s showed their watercolors at the annual exhibitions in Brussels, it was not until 1867 that Weissenbruch exhibited work at a show organized by the Belgian Society of Watercolor Artists. The painter Willem Roelofs (1822–97, compare cat. 36), who was living in Brussels at that time, declared on the occasion that Weissenbruch's *Village among the Dunes* was one of the best works in the exhibition.[1] The Belgian press was enthusiastic about Weissenbruch's work. They praised not only the easy brushstrokes of his watercolors and the skill with which he characterized his topics, but, above all, his striking depiction of the sky. But it was not until the 1870s, after the founding of the Dutch Drawing Society, that Weissenbruch began exhibiting his watercolors regularly. Between 1880 and 1890 he was an active member of the society's board.[2]

The Boijmans Museum owns a representative selection of Weissenbruch's early watercolors. *Dutch*

Landscape, dated 1858, was part of the gift that Weissenbruch made to the museum in 1898 in response to the appeal of the director, Haverkorn van Rijsewijk, who aimed to acquire for the museum examples of work by all of the major Dutch artists of the day, showing them at different stages in their development.[3] This watercolor illustrates that Weissenbruch very early in his work drew windmills and waterways outdoors. He was to return throughout his life to these subjects, only making slight variations in the composition of his picture. This early landscape reveals the great indebtedness of the young artist to the Dutch seventeenth-century masters such as Van Goyen and Rembrandt.

On the reverse of this sheet, which Weissenbruch appears to have kept in his portfolio collection for much of his life, is a dated drawing from 1858 (fig. 1), a typical example of another subject very dear to Weissenbruch's heart, the dunes near The Hague. He was inspired in the desolate dunes of Dekkersduinen to produce solitary landscapes or intimate scenes showing lonely farmhouses. These, too, were subjects to which Weissenbruch constantly returned through the years.[4] He almost certainly kept this drawing in his own possession for so long because the piece of unspoiled countryside that it represents had in the meantime disappeared. Part of Dekkersduin was excavated to make room for Duinoord, a new suburb of The Hague.[5]

It is noteworthy that this sheet bears dates on both sides, since on the whole Weissenbruch rarely dated his work.[6] Quite likely the artist added the dates later, in response to Van Rijsewijk's passion for documentation. There is also a date on another sheet that Weissenbruch donated in 1898, the drawing in chalk on blue paper and showing a horseman on a towpath,[7] which strengthens the supposition that it is a preliminary study for the painting dated 1885 showing the same motif.[8] In the Bilderbeek-Lamaison Collection now in the Dordrechts Museum there is a small sketch in oil of this painting, entitled *Poldervaart bij Noorden* (Polder waterway near Noorden).[9] This, together with other towpath scenes by Weissenbruch,[10] has the dark, threatening rainy atmosphere that is so characteristic of much of his work and that of his contemporaries Anton Mauve (1838–88, cats. 44–46) and Jacob Maris (1837–99, cat. 43).

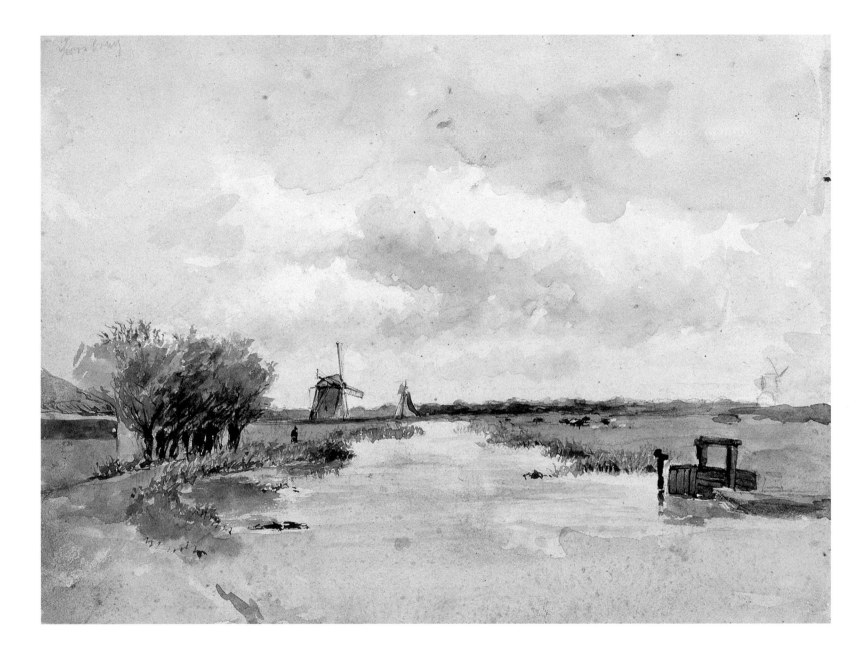

117

JOHANNES HENDRIK WEISSENBRUCH

The Hague 1824–1903 The Hague

39 *River Landscape*

after 1892

Watercolor, accents in bodycolor,
475 x 597 mm (18 3/4 x 23 1/2 in.)

Four pinholes in the corners;
signed lower right with brush and
brown paint: *J. H. Weissenbruch*

Watermark: J WHATMAN/
TURKEY MILL/ 1892

Inv. MB 553

Provenance: J. P. van der Schilden,
Rotterdam; his legacy, 1925

Literature: De Boer 1960, no. 84;
De Boer 1961, no. 78; De Gruyter
1965, 95, no. 125; Bionda 1991,
324–25, no. 166

River Landscape (cat. 39) shows very clearly the carefully balanced manner in which Weissenbruch composed his landscapes. In his own day this approach of Weissenbruch's, characterized by consistent proportions, was noted and valued, especially by his fellow artists. For example, Vincent van Gogh (1853–90, see cats. 52–56), in a letter to his brother Theo in 1883, pointed out that underlying Weissenbruch's work, just as that of the French painter Georges Michel (1763–1843), there was "a thoroughly grounded general knowledge, . . . based on accurate measurements and proportions, seen from foreground to background, and a good feel for the direction the lines follow through perspective."[11]

SdB

1. Jeltes 1925, 134.
2. See Tholen 1914.
3. Compare Manfred Sellink's introduction and Saskia de Bodt's essay "Quelque chose de diabolique; Sketches, Scribbles, and Watercolors," both in this volume; see also De Vries 1996.
4. Compare the watercolor *Near Dekkersduin* in the Hague Gemeentemuseum, inv. T 46–1939. Compare Sillevis 1988, 334–35, and Laanstra 1992, 157 (but the watercolor in the Boijmans Van Beuningen collection does not appear in this).
5. Dumas 1983, 276–77; see also De Bodt 1997(2), 42ff.
6. The monograph by Laanstra and Ooms, 1992, incorporating a catalogue of the collected works, mentions only five dated watercolors as against 124 undated.
7. Johannes Hendrik Weissenbruch, *Horseman on a Towpath*, black chalk, gray washes, on blue paper, 293 x 480 mm (10 1/2 x 18 7/8 in.); dated lower left in pencil: *1883*, verso: dated in black chalk: *1883*; watermark: *ARO* [cut off]. Museum Boijmans Van Beuningen, Rotterdam, inv. MB 504; provenance: gift of the artist, The Hague 1898.
8. Laanstra 1992, 1885–1. The work is in a private collection.
9. Dordrechts Museum, inv. B1. 100, 19.7 x 32 cm; Laanstra 1992, O/19–5.
10. Laanstra 1992 (this does not contain the watercolor from the Boijmans of *Horseman on a Towpath*) mentions two other towpath scenes: OA 40–1 (*Towpath beside the Amstel*) and OA 50–1 (*Horsemen on a Towpath near Noorden*).
11. Vincent van Gogh to Theo, 11 February 1883. Van Gogh 1990, 810.

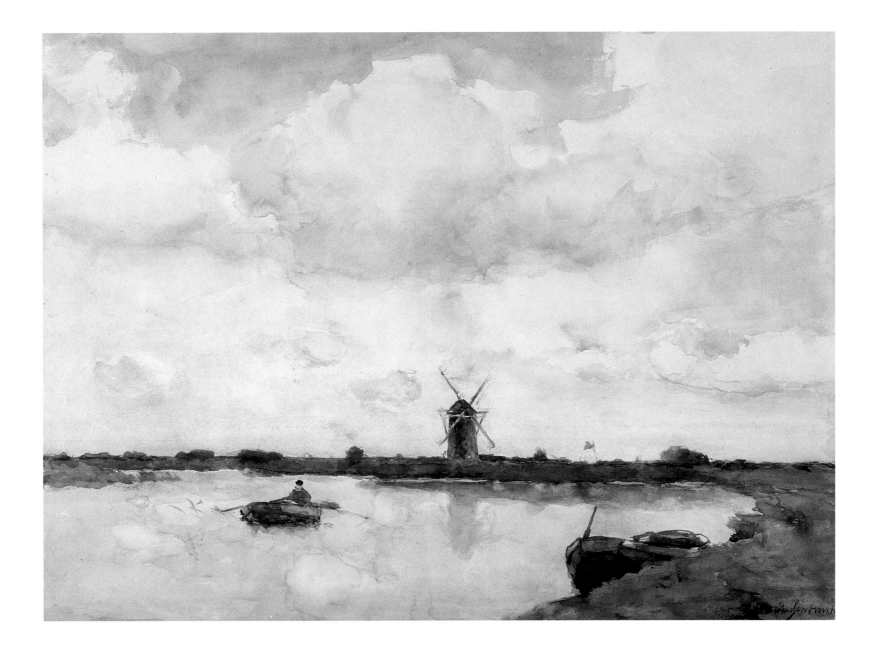

JOHANNES HENDRIK WEISSENBRUCH

The Hague 1824–1903 The Hague

40 *Polder Landscape*

1878

Watercolor, 248 x 524 mm (9 3/4 x 20 5/8 in.)

Signed and dated lower right with brush and brown paint: *J. H. Weissenbruch f 78*

Watermark: . . . AN

Inv. MB 577 (VdV 1972/T11)

Provenance: The art dealer Unger & Van Mens, Rotterdam; W. van der Vorm, Rotterdam; on loan from the Willem van der Vorm Foundation, Rotterdam 1972

Literature: Hannema 1950, no. 110; Hannema 1958, no. 84; Hannema 1962, no. 89; Hefting 1963, 46, no. 128; Giltaij 1994, 264–65, no. 90

J. H. Weissenbruch, who lived and worked his whole life in The Hague, is seen as one of the masters of the Hague school. During his lifetime there was far less written about him than the artists Mesdag (1831–1915), Mauve (1838–88, see cats. 44–46), or the Maris brothers (compare cats. 43, 47 and 48, 51). But in the course of the twentieth century this has changed, and it is now generally accepted, as was acknowledged at the time by his artistic colleagues, that of all the Hague school of painters Weissenbruch was most critical of his own work, while from the others potboilers came onto the market from time to time, scattered through their works of higher quality. "I am termed 'the sword without mercy'—and that's what I am," said Weissenbruch to Van Gogh. Incidentally, after the latter had broken with Anton Mauve, Weissenbruch consciously stimulated Van Gogh's powerful style of drawing.[1]

In the watercolors by Weissenbruch one sometimes sees the same magical suppleness as in the work of the much younger Breitner (1857–1923, see cats. 59–62). The main difference between the two is that Breitner occupied a position at the center of the cultural and social life of his time and attempted to depict its essence in his work. Also, Breitner was well informed about developments in French artistic circles and read contemporary French writers such as the Goncourt brothers and Baudelaire.[2] Weissenbruch, in contrast, was famous for the fact that he was a literary ignoramus and that he was reputed to have only one volume in his bookcase.[3] This "disengagement" can be clearly seen in his work. There is not a trace of literary reference; rather, his work emanates a general feeling of quietness, solitude, certainty, and melancholy. In the later work particularly there is scarcely a reference to human activity, and all that remains is the mood of a natural setting.

These free, almost abstract visions of nature were prized by collectors at the beginning of the twentieth century. An early example of this type of work, almost exalted above every human standard, is *Polder Landscape* from the Rotterdam collector Willem van der Vorm, which fits exactly in its atmosphere with the paintings done by the French Barbizon school artists also in Van der Vorm's collection.[4] The collector W. Palte, from whose legacy comes *Polder Landscape*,[5] had a decided preference for Barbizon school paintings. *Autumn Evening*,[6] which is inscribed with its title in French, was bought for the Boijmans Museum when Haverkorn van Rijsewijk was director. Haverkorn had a marked preference for works of a rather sketchy nature.

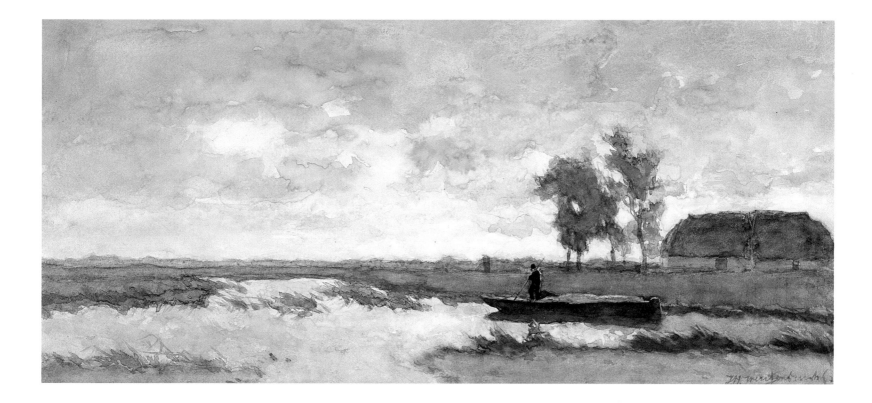

JOHANNES HENDRIK WEISSENBRUCH

The Hague 1824–1903 The Hague

41 *Fishing Smack on a Beach*

Watercolor, 438 x 551 mm
(17 1/4 x 21 3/4 in.)

Signed lower left with brush and brown paint: *J H Weissenbruch f*

Watermark: TURKEY MILL

Inv. MB 578 (VdV 1972/T10)

Provenance: W. van der Vorm, Rotterdam; on loan from the Willem van der Vorm Foundation, Rotterdam 1972

Literature: Hannema 1950, no. 113; Hannema 1958, no. 85; Hannema 1962, no. 90; De Boer 1960, no. 100; De Boer 1961, no. 92; Hefting 1963, 46, no. 132; Giltaij 1994, 266–67, no. 91

Of all these watercolors by Weissenbruch that can be loosely described as abstract, *Fishing Smack on a Beach*, the exhibited work, which also comes from the Willem van der Vorm Collection, is surely the pinnacle of simplicity and dramatic power. With its combination of these two features it forms a prime example of Weissenbruch's watercolors and goes a long way to explaining their enormous popularity among twentieth-century collectors.
SdB

1. Vincent van Gogh to Theo van Gogh, [The Hague] 13 February 1882; Van Gogh 1990, 305. Later Van Gogh mentions that he once said to Weissenbruch: "I see things as if they were pen drawings," to which Weissenbruch replied: "Then you must make pen drawings." Vincent van Gogh to Theo van Gogh [The Hague, 1 May 1882]; Van Gogh 1990, 549.
2. Compare Hefting 1970, 37 ff.
3. Dumas 1983, 285. The book in question was the famous Dutch novel *Camera Obscura*, by Hildebrand [Nicolaas Beets].
4. Compare Giltaij 1994.
5. Johannes Hendrik Weissenbruch, *Polder Landscape*, watercolor over black chalk, 223 x 319 mm (9 3/4 x 12 1/2 in.), signed lower right with brush and black paint: *J. H. Weissenbruch*. Museum Boijmans Van Beuningen, Rotterdam, inv. MB 530, provenance: W. Palte, Rotterdam; his legacy, 1943.
6. Johannes Hendrik Weissenbruch, *Autumn Evening*, watercolor, accents in bodycolor, 413 x 270 mm (16 1/4 x 10 5/8 in.), signed lower left with brush and gray paint: *JH. Weissenbruch*, verso: inscribed lower center in pencil: *Soir d'automne 10 4 64*. Museum Boijmans Van Beuningen, Rotterdam, inv. MB 529, provenance: acquired in 1899.

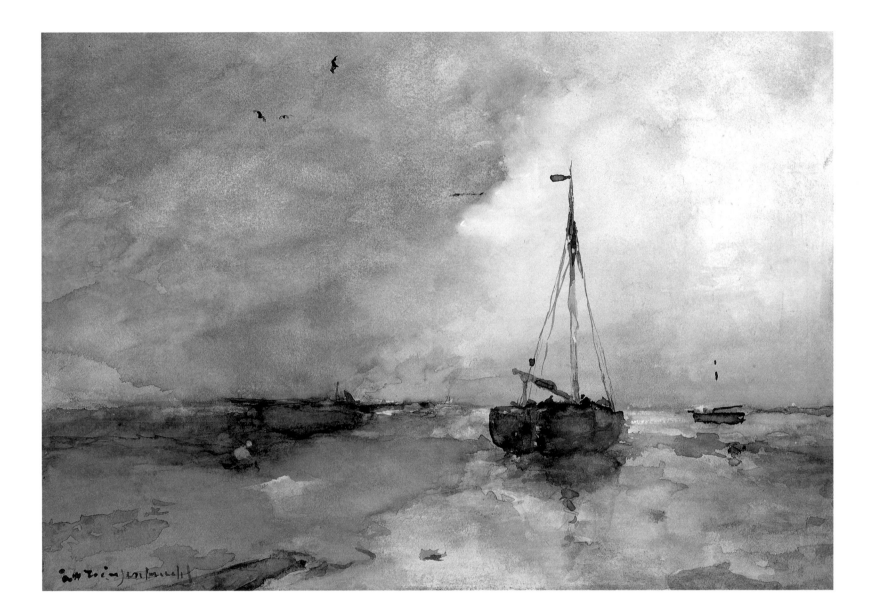

PAUL JOSEPH CONSTANTIN GABRIËL

Amsterdam 1828–1903 Scheveningen

42 Farmyard

1860s

Black and gray chalk, accents in red, stomped, on brown paper, 324 x 487 mm (12 3/4 x 19 1/8 in.)

Signed lower left in gray chalk: *Gabriel*

Inv. MB 536

Provenance: Gift of the artist, Scheveningen 1898

Literature: Haverkorn van Rijsewijk 1909, 347; De Gruyter 1965, 41, no. 23

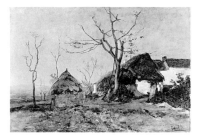

Fig. 1. Paul Joseph Constantin Gabriël, *La Hulpe*. Groninger Museum

It is only in the final phase of his career that Paul Gabriël, who lived and worked in Brussels between 1860 and 1884, is considered one of the Hague school of painters. In general, his work is more realistic, more true to nature, than that of his colleagues such as Jacob Maris (1837–99, see cat. 43), Anton Mauve (1838–88, see cats. 44–46), and J. H. Weissenbruch (1824–1903, compare cats. 38–41), artists who placed the emphasis in their work on their personal vision of the landscape.

The drawing here shows a farmyard, a fairly conventional subject, swiftly drawn in chalk, with an equally—for Gabriël—conventional composition. In his paintings he usually had quite striking "frames" for his pictures. This sketch is undated and bears no place name, but by comparing it with other work by Gabriël, including a watercolor in the Groninger Museum (fig. 1)[1] and a painted study in the Boijmans van Beuningen Museum,[2] it may be assumed that this is a work from Gabriël's Brussels period. Encouraged by his teacher in Brussels, Willem Roelofs (1822–97, see cat. 36), Gabriël spent much time in the 1860s and early 1870s working in the neighborhood of the Belgian capital. A fine example of his work from this period is the glowing painting *In Groenendael*, now in the Mesdag Museum, The Hague, and dated about 1863.[3] However, Gabriël went more often to La Hulpe, a spot at the edge of the wooded Zonienwoud and well known as an artists' center. Writing in 1887, the avant-garde Belgian magazine *L'Art Moderne* spoke in a derisive tone of the artists' colonies where liquor abounded, describing them as a "School of La Hulpe," and characterized the place as follows: "La Hulpe is the Barbizon of Belgium. Any Belgian school of outdoor painters you care to name has as it were rambled through La Hulpe."[4]

It is known that Roelofs, who had himself worked in La Hulpe, sent several of his pupils, including Gabriël, to work in the countryside. These artists included Jan Lokhorst and Carel Storm van 's Gravesande (1841–1924), the latter arriving in Brussels in the winter of 1868–69.[5] It is thought that these expeditions took place in La Hulpe, as evidenced by an etching by Storm van 's Gravesande bearing that title. However, toward the close of the 1860s Roelofs, Storm van 's Gravesande, and Gabriël all increasingly took up painting Dutch landscapes. "Didn't you like Belgium any more?" asked Louis de Haes much later of Gabriël when the latter had become one of the renowned Hague school of painters.[6] "No," replied Gabriël, "it didn't attract me very much—it does not have the refined atmosphere of Holland. It probably sounds odd that someone goes to live in Brussels in order to take a good look at the waters of Holland. But it works out as you see."

SdB

1. *La Hulpe*, watercolor, 490 x 730 mm (19 1/4 x 28 3/4 in.), Groninger Museum. Illustrated in De Haes 1893.
2. *Farmyard in a Row of Trees*, canvas, 39 x 62.5 cm (15 3/8 x 24 5/8 in.). Signed lower left: *Gabriel f.*, Museum Boijmans van Beuningen, inv. 2264. On the reverse is a note written by Gabriël ("Bruxelles 26 jan. 1878") in which he confirms that the painting is by him. Compare Ebbinge Wubben 1963, 46–47. This mentions a slightly smaller painting with exactly the same motif, signed: *Gabriel La Hulpe '69*, oil on panel, 32 x 41.5 cm (12 3/8 x 16 3/8 in.) that was auctioned with the contents of Gabriël's studio estate in Amsterdam (Fr. Muller), 14 June 1927, lot 24 (ill.).
3. Dumas 1983, 182.
4. *L'Art Moderne*, October 30, 1887 ("Un Barbizon belge"). Also, the nearby place of Tervuren (in Belgium) was frequently compared with the French Barbizon school in the Belgian press.
5. Compare De Bodt 1995(1), 154–56.
6. De Haes 1893, 228.

JACOB MARIS
The Hague 1837–1899 Karlsbad

43 *View of a City*

late 1870s[?]

Watercolor, accents in bodycolor,
180 x 393 mm (7 1/8 x 15 1/2 in.)

Signed lower left with brush and
gray paint: *J Maris*

Inv. MB 510

Provenance: W. A. Mees, Rotterdam;
J. P. van der Schilden, Rotterdam;
his legacy, 1925

Literature: Rotterdam 1899(1), 5,
no. 40; Baard 1923, 43, no. 513;
Wagner 1975, no. 49

Jacob Maris, regarded today as one of the foremost painters of the Hague school, had a difficult start, like his brother Matthijs (1839–1917, compare cats. 47 and 48). The oldest son of a printer, he was apprenticed at the age of twelve to J. A. B. Stroebel (1821–1905), a painter of The Hague, and in 1853 to Huib van Hove (1814–64). When tax debts forced the latter to flee to Antwerp, Maris went along as his assistant. Thanks to a grant that his brother Matthijs had obtained and the two youths shared, Jacob was able to study at the Antwerp Academy.

Crucial to Jacob Maris' development was a sojourn in Paris, where he went in 1865. At first he concentrated there on subjects with facile appeal, such as "Italian girls." By the time he returned to The Hague in 1871, he had painted his first landscapes, the genre that earned him the sobriquet of the "Rembrandt of the nineteenth century." Jacob Maris' landscapes were held in particularly high esteem as far afield as England, Scotland, and North America.

During his lifetime the work of Jacob Maris was considered somewhat inaccessible for the public at large. In his memoir *Au Jardin du passé*, the Dutch etcher Philippe Zilcken (1857–1930) declared that a series of twelve etchings of landscapes after works by Maris, which he had published in 1888 with Goupil, had not been a great success due to the fact that the time was not ripe.[1] In 1888 in the Dutch literary magazine *De Gids*, H. L. Berckenhoff offered two reasons to explain why Maris' work was not widely popular. First, his pieces did not appear to be finished; "The public does not look further than its nose—things must look like what they are."[2] Second, people did not like his work because of "the serious moments with which they confront you. . . . For example, the artist prefers to portray scenes of strife and conflict in nature. . . . Maris is the painter of *becoming* and he requires of the viewer that his eyes pierce through the mists."

Maris himself explained to Berckenhoff that the public only thought a drawing or painting was finished when in their view the sky was prettily painted and there was a nice composition of clouds charging across from left to right. But, objected the artist, "Where does the sky begin or end? In reality I have never been able to find the start or the finish. Things merge into each other."[3] These words of Maris could also be said to apply to the exhibited watercolor, which is a view of a city on a dull day. The sky, the houses, and the water are alike veiled by a gray mist. This hazy work also asks a degree of sensitivity from the viewer, not least because of its melancholy nature. The strong tonality, emphasized by tiny accents in white bodycolor, are typical of Maris' work in the second half of his career.

The watercolor is not identified either by place or by date. The swift sketchy nature of the work suggests a date at the end of the 1870s, possibly later. At this time Maris' watercolors were greatly prized for their "courageous" washes that did not diminish their "powerful tone," as the critic J. van Santen Kolff wrote in 1878.[4] It is not certain which place it represents, but the general mood of the drawing resembles Maris' Dordrecht work. The low square tower also suggests this city. But the art historian "Miss" Marius was probably right when in 1891, in connection with a cityscape by Jacob Maris in Amsterdam's Rijksmuseum, she remarked: "Jacob Maris did not paint that city canal from life—he hasn't done that for years."[5]

SdB

1. Zilcken 1930, 69.
2. Berckenhoff 1888, 483.
3. Ibid.
4. Van Santen Kolff 1878, 262.
5. Marius 1891. Cited in Dumas 1983, 74, 76, note 90.

ANTON (ANTHONIJ) MAUVE

Zaandam 1838–1888 Arnhem

44 Oxcart

early 1870s

Watercolor and bodycolor over black chalk, 280 x 440 mm (11 x 17 3/8 in.)

Signed lower right with brush and brown paint: *A Mauve*

Inv. MB 501

Provenance: Acquired from the art dealer E. J. van Wisselingh & Co., Amsterdam

Literature: Leeman 1988, no. 15

Anton Mauve is the first painter of the Hague school who has had a doctoral thesis (in the form of a monograph) written about him.[1] He was a superlative watercolor artist and had enormous esteem for this medium and for drawings. This is evidenced by his involvement with the Dutch Drawing Society, of which he was a founder member in 1876, together with H. W. Mesdag (1831–1915) and his great friend Willem Maris (1844–1910, see cat. 51). Until Mauve's death in 1888 he annually exhibited two or three of his watercolors at their shows. And in the years 1881–82 when Vincent van Gogh (1853–90, see cats. 52–56) was staying with Mauve in The Hague, the latter encouraged him to experiment with watercolors.

Mauve's watercolors were exceedingly popular, not only among painters but also with writers. This was because of their mixture of expert brushwork, the skillful manner in which the wash was applied, and a certain melancholy that they exuded. During the period when he was working in the unspoiled natural beauty of the Gooi district south of Amsterdam, Mauve got to know the painters belonging to the group known as the Tachtigers (from the 1880s) who were interested in new ideas about art. Even before he settled in the painters' community in the village of Laren in 1885, Mauve had been a regular guest at Ewijkshoeve, the country house of Willem Witsen (1860–1923, compare cats. 69 and 70).[2] And long after Mauve's death Dutch writers such as Hein Boeken, Frederik van Eeden, and Jan Veth wrote about him or were inspired by his silvery-gray interpretations of the heath and wooded landscape around Laren.[3]

There was a similar regard for Mauve's poetic and silvery tone in Belgian avant-garde circles connected with the group of artists known as Les Vingt (The Twenty). In Belgian magazines such as *La Jeune Belgique* and *L'Art Moderne*, Mauve received extremely laudatory criticism. Here too it was his watercolors that attracted greatest attention. In connection with the exhibition of the Dutch Drawing Society in 1884, a journalist in *L'Art Moderne* became quite ecstatic: "When Mauve paints a watercolor, then Poetry, the untamed virgin with firm breasts and harsh fragrance, brushes the paper with the tip of her wings and the work, simple as is all great art, is born, lives and breathes."[4]

It is striking how often Mauve's work—his portrayals of shepherds and cowherds, woodcutters and washerwomen—was compared in the foreign press with that of the artist Jean-François Millet (1814–75), who depicted the laborers living and working around the Barbizon Forest in France. Dutch critics paid special attention to the art-for-art's-sake aspect of Mauve's work. On his death, the artist and critic Veth characterized Mauve as a "dreamer of an utterly sensible sort, a kind of not-at-all mystic-minded and very Dutch Arcadian."[5]

Oxcart (cat. 44) probably dates from the early 1870s when Mauve regularly made drawings of this nature, in a bare and desolate landscape setting. The subject of a cart drawn by oxen had already attracted the artist in 1858, the year after he had left his teacher, P. F. van Os (1808–60).[6] In later versions of the theme, like this one in the Museum Boijmans Van Beuningen, Mauve used the "mixed" technique so characteristic of him, in which he combined chalk, watercolor, and bodycolor.

ANTON (ANTHONIJ) MAUVE

Zaandam 1838–1888 Arnhem

45 *Winter Landscape with a Flock of Sheep*

1851

Watercolor and bodycolor, 385 x 650 mm (15 1/8 x 15 5/8 in.)

Signed lower right with brush and gray paint: *A Mauve*; verso, stamp in the center in purple ink: *M. K. & CO W. C. No.2870 [number written in brown ink]*

Inv. MB 547

Provenance: J. P. van der Schilden, Rotterdam; his legacy, 1925

Literature: Leeman 1988, no. 53

In *Winter Landscape with a Flock of Sheep*, which has been given the date of 1881 by Mauve's biographer Engel, based on a preliminary study in the print room of the Rijksmuseum, Amsterdam (fig. 1), the balance of bodycolor and watercolor is almost reversed.[7] In particular the parts representing the snow consist almost entirely of suggestive, almost aggressive strokes of white.

Fig. 1. Anton Mauve, *Sketch for Shepherd with Sheep in the Snow.* Rijksprentenkabinet, Amsterdam

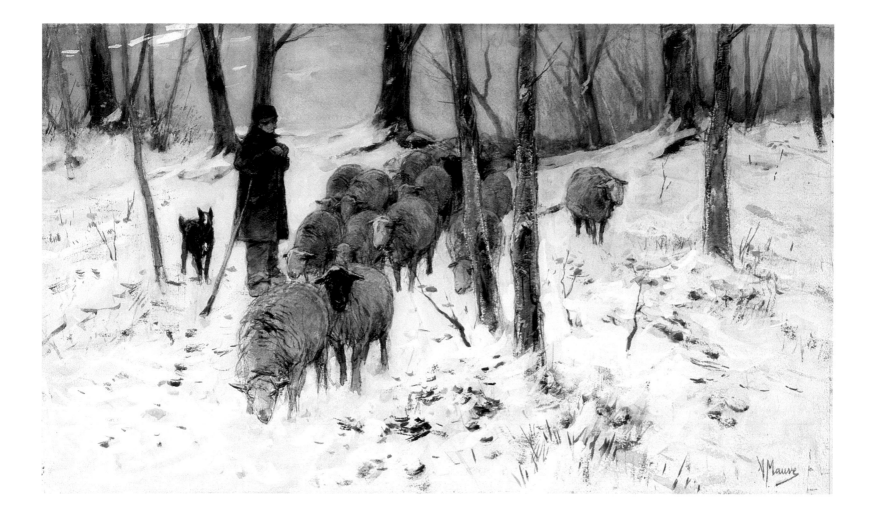

ANTON (ANTHONIJ) MAUVE

Zaandam 1838–1888 Arnhem

46 *Flock of Sheep*

1880s

Black and white chalk, stumped, on gray paper; 292 x 404 mm (11 1/2 x 15 7/8 in.)

Signed lower right in black chalk: *Atelier A Mauve.*; verso, *Studie van schapen*, black chalk

Inv. MB 526

Provenance: A. Mauve-Corbentus, The Hague; acquired in 1894

Literature: Leeman 1988, no. 71; Bionda 1991, 236, no. 97

Writing in 1882, Van Gogh said of Mauve, "I believe that every painting and every drawing of his contain a small portion of his very life."[8] Mauve suffered from severe depression and, toward the end of his life when he was living in Laren, he was under such pressure from art dealers, notably Arnold and Tripp who gave him many orders, that his painted work suffered as a result. However, this is certainly not true of most of the studies and quick sketches he made in his later years. A sketchbook sheet like that of the flock of sheep (verso of cat. 46, fig. 2), in black and white chalk, which comes from Mauve's studio estate, possesses enormous intensity and a visionary strength that seem scarcely to come from the same person as the Mauve whom Jan Veth characterized in 1896 as the artist of "delicate Dutch poetry of fields and flowers."[9]

SdB

Fig. 2. Anton Mauve, *Verso of Cat. 46, Flock of Sheep*. Museum Boijmans Van Beuningen, Rotterdam

1. Engel 1967.
2. Compare Van der Wiel 1988.
3. Brom 1959, 101–6. Compare also De Bodt 1997(2).
4. "Ninth Exhibition of Dutch Watercolorists in The Hague," *L'Art Moderne* (August 24, 1884), 277–28 [trans.]: "Quand Mauve fait une aquarelle, la poésie, vierge sauvage, aux seins durs, à l'âpre parfum, effleure le papier du boit de l'aile, et l'oeuvre, simple comme tout grand art, s'anime, vit, respire."
5. Veth 1905, 11.
6. Engel 1967, nos. 23 and 29a and b.
7. Engel 1967, no. 97b.
8. Vincent van Gogh to Theo van Gogh, The Hague, 26 January 1882; Van Gogh 1990, 499–500.
9. Veth 1905, 123.

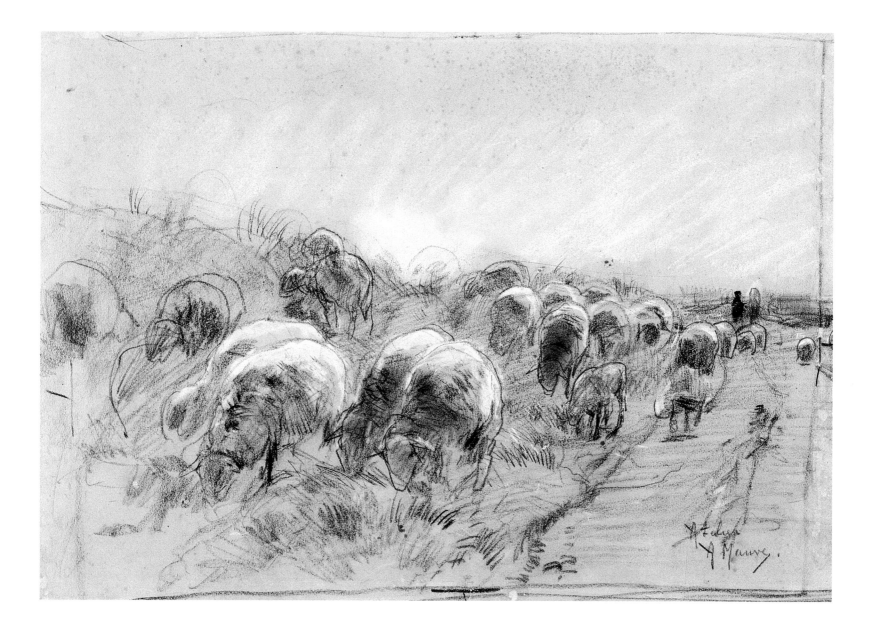

MATTHIJS MARIS

The Hague 1839–1917 London

47 Head of a Girl (Ecstasy)

1897–1906

Black chalk and charcoal, 500 x 340 mm (19 5/8 x 13 3/8 in.)

Inv. MB 558

Provenance: Acquired from the art dealer E. J. van Wisselingh, Amsterdam 1906, with support of the Vereniging Rembrandt (Rembrandt Society) and seventy-one citizens of Rotterdam

Literature: Haverkorn van Rijsewijk 1906; NRC 1906(1); NRC 1906(2); NRC 1906(3); NRC 1906(4); Haverkorn van Rijsewijk 1909, 335–36; Haverkorn van Rijsewijk 1911; Schmidt-Degener 1916, 161, no. 808; Schmidt-Degener 1921, 183, no. 808; Fridlander 1921, 15; Hannema 1927, 167, no. 808; Rotterdam 1930, 6–7; Van Gelder 1939, 54; Jaffé 1963, 99, no. 102; De Gruyter 1965, 68, no. 73; Wagner 1974, 76, no. 128; Blotkamp 1978, 150, no. 115; Imanse 1980, 63, no. 284; De Raad 1991, 122, no. 82; Stroo 1992, 2

Fig. 1. Matthijs Maris, *Head of a Girl ("Siska")*. Private Collection

Toward the end of April 1906, the director of the Boijmans Museum, Pieter Haverkorn van Rijsewijk, received a somewhat curious request from an elderly couple living in a working-class district of Rotterdam. They asked him if they might see the drawing by Matthijs Maris about which there had been such an intriguing account in the paper a few days before.[1] Haverkorn showed them the drawing. "'I don't see anything,' said the woman after a while. Her husband responded, 'What? Can't see anything? Look, there's a young lady, a beautiful woman, with her head bent backward. She's shrieking with pleasure.' And he went on, 'It is a person, but it looks like an angel—so beautiful. Can't you see?' And then his wife saw it too," reported Haverkorn.[2]

The drawing, *Head of a Girl*, which was exhibited in the Rotterdam Art Foundation shortly after this revealing discussion, had already been ordered by Haverkorn van Rijsewijk in about 1894 from Matthijs Maris in London. When the artist finally delivered the work in 1906, Haverkorn found it extremely difficult to raise the necessary six thousand guilders to pay for it. Meanwhile, the diligent director had invented a title for the drawing: *Ecstasy*.

Ecstasy, or rather *Head of a Girl*, is a late work by Matthijs Maris, which developed out of being worked over time after time. Maris usually worked in charcoal or chalk because he profoundly disliked color. Considering the large size of most of his drawings it is clear that he thought them to be at least as important as paintings. On the whole he found it easier to reach results in his drawings. The picture here is released as it were from nuances of tone flowing through one another. The open, grainy texture (which comes from using rough paper) produces a kind of hazy filter, behind which the figures are seen as if through a steamy window pane. In the Rotterdam drawing one can more or less make out the head, and the upper lip is clearly delineated. The girl is also clearly three-dimensional, which appears more so in indirect lighting. In a more diffuse light, by which Maris' later works always gain, it is clear that the girl is wearing a flower in her hair. The same flower is to be seen in a painting from 1890 (fig. 1)[3] that Haverkorn van Rijsewijk indicated as the immediate source of inspiration for the drawing he had bought.[4] He said it was

Fig. 2. Matthijs Maris, *Head of a Girl*. Rijksmuseum, Amsterdam

clearly the same woman, but it took Maris sixteen years to make a satisfactory image of what he had originally intended.[5] Although the painting, which was made at night, was not a copy from a posing model, the drawing corresponds even better to a comment made in 1905 when Maris explained to the critic Plasschaert that his models did not in fact exist. He had to "invent" them, as he did his landscapes.[6]

The very limited number of motifs that Maris used in those years indicates that his invention was not focused on the object. Apart from a couple of landscapes and a few larger figure pieces, most of what he drew were the heads of women similar to that in the Boijmans collection, with a few like that in the Rijksmuseum in Amsterdam (fig. 2)[7] in a posture that suggests Maris must have been looking in about 1900 for an equivalent in painting. At that time he continually stressed the problems connected with working out his concepts. There was no one, he said in 1907, who worked harder than he did, but also no one who produced less.[8]

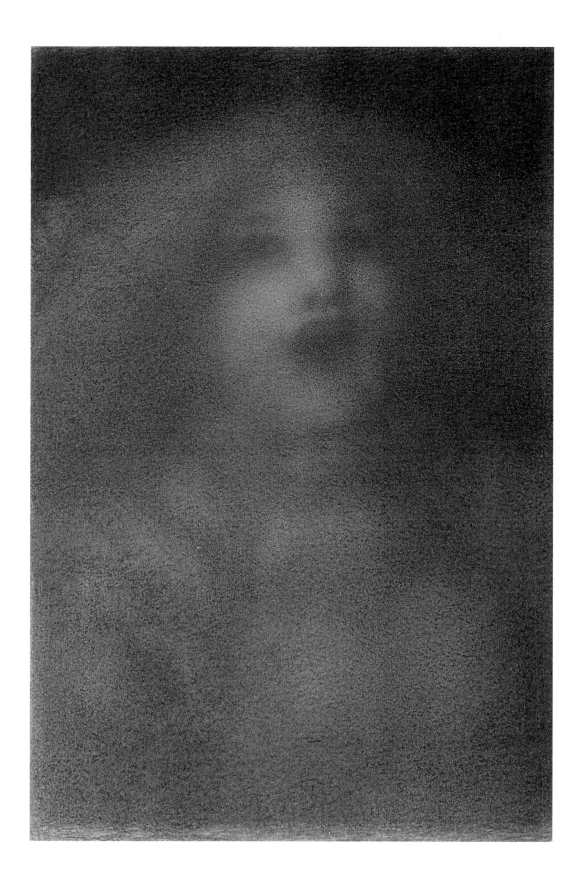

MATTHIJS MARIS

The Hague 1839–1917 London

Fig. 3. Matthijs Maris, *The Shepherdess*. Rijksmuseum, Amsterdam

He worked on the *Head of a Girl* on and off for about ten years, before, presumably because of an agreement he had made, he parted with it. He wrote that he had started on it in 1897, sometimes laying it aside for a year, sometimes longer. After he moved in 1906 he worked on it continually, again without any rapid results. "Don"t understand it," he declared afterward, "the lines are the same from the beginning. The filling-in is the bother—today it's black and tomorrow it's white—that's the way it goes. And if it's white I make it black and if it's black I make it white. I know this is what's going to happen, but I still carry on. I want it light and when it is light it does not express what I want, then there's no depth. & when it is dark it does not express either what I want. . . . They are so clever nowadays, up to all sorts of dodges, I *sd* like them to find out [how] to snapshot a thought."[9] Exactly what thought he had in mind, he leaves the viewer, as he generally did, to find out himself. He described it just once to W. J. G. van Meurs as a "spirit," but as a general description for something that was nonmaterial, not intended to be simply realistic.[10]

Haverkorn van Rijsewijk, who still planned to write a monograph on Maris, had an inkling of what the painter meant, and titled the drawing *Ecstasy*.[11] He could not have made a worse choice. Maris found the title far too pompous. In his final letter to him, Maris writes in great distress: "Wisselingh came around yesterday . . . I had sent him your newspaper cutting and said: this is settled. Extaze it is & extaze it shall be. I have nothing to say in the matter. . . . I know a chap here who always talks art & says 'when I have nice things around me, then I can ask more money,' applying the same to 'when I talk high the world will think something of me.' . . . fine speeches won't do, nor does a high title enhance the value of a thing. . . . so—what name shall we give it? You can't just call it algebra. But if it has to be listed in the catalogue, and can't be called *Head of a Girl*, why not simply call it 'Charcoal Drawing'? Extaze is utterly inappropriate."[12] Another suggested title, *Joyful Youth*, would also have been spurned by Maris as

absurd, was a suggestion from A. B. Zimmerman, burgomaster of Rotterdam, probably at the instigation of Haverkorn van Rijsewijk, since the burgomaster was related to Maris by marriage (his wife was a daughter of Jacob Maris), as yet one more attempt to solve the issue.

Very important to Maris were the frame and the passe-partout. He chose both with utmost care and colored the frame gray, "to widen it out," as he explained.[13] He strictly forbade Haverkorn to make any changes in this, as had been done with a landscape by him in the Stedelijk Museum in Amsterdam.[14] Haverkorn had wanted to replace the glass in front of the drawing as well as have it reproduced, but was not permitted by Maris to do so; the artist was worried that the drawing would suffer. Repeated attempts to allay his fears did not help; on a previous occasion it had its upper layer rubbed off so that it would be easier to reproduce. Nor would Maris agree to Haverkorn's request that he sign the drawing. "I didn't know where to put it [the signature] besides it looks so businesslike, & does not matter," he explained.[15] The director of the Boijmans was quite willing to do it himself, if Maris would have signed something for him to copy.[16]

Today, if you ask to look at the drawing by Maris, what you will see is in fact an amputated version: the original framework was removed long ago and is apparently lost. And to hold the drawing in one's hand and look at it is also not what Maris intended. He meant the work to hang fairly high so that the viewer looks up at it, in the same way as with his large painting *The Shepherdess* (fig. 3).[17] This picture still has its original frame and according to Maris was best seen hung in a stairway entrance. By way of final instruction in hanging the drawing, Haverkorn was told the following: "It is meant to be looked up to, like a statue. When looked down upon, or when on the same level with the eye, then it is out of proportion."[18] Haverkorn did as instructed, but with hindsight this was regrettable, since the work certainly suffered as a result in its too-bright location.

RB

1. NRC 1906(1).
2. Haverkorn van Rijsewijk 1906. On Haverkorn van Rijsewijk see also De Vries 1996.
3. *Head of a Girl ("Siska")*, 1890, oil on canvas, 38 x 30.5 cm (15 x 12 in.), private collection. Maris gave this painting to D. Croal Thompson, who later included it in color, under the title *Siska*, in his book on the Maris brothers. See Croal Thompson 1907, illustration M22.
4. Haverkorn van Rijsewijk 1911, 174-77.
5. "The same woman, yet another being! The painting lacks the pure, ethereal expression of the soul, that is stated in so masterly a manner in the drawing." Ibid., 176.
6. Letter from Maris to Albert Plasschaert, Netherlands Institute for Art History (RKD), The Hague, no. 7 (15 May 1905).
7. *Head of a Girl*, c. 1900, oil on canvas, 39 x 28 cm (15 3/8 x 11 in.), Rijksmuseum, Amsterdam.
8. Letter from Maris to W. J. G. van Meurs, Teylers Museum, Haarlem, no. 12 (September 30, 1907).
9. Letter from Maris to W. J. G. van Meurs, Teylers Museum, Haarlem, no. 53 (December 12, 1908). The printmaker Philippe Zilcken noticed the same thing on his visit to Maris in 1912. He saw that Maris was working on a couple of drawings of heads of girls (probably those of the children of Percy Westmacott, Burrell Collection, Glasgow) with a couple of sturdy clothes brushes beside him, "which he would use to brush away the charcoal drawing he had just made, and then begin again in exactly the same fashion." See Zilcken 1927, 37c.
10. Letter from Maris to W. J. G. van Meurs, Teylers Museum, Haarlem, no. 106 (31 August 1910). The term was partly suggested by an accompanying citation that said things spiritual or of the spirit could not be photographed. Maris used this in the first place to strengthen his objections to the plan of the Boijmans Museum to reproduce the *Meisjeskopje*. See also below.
11. On an old inventory of the drawing Haverkorn van Rijsewijk made a note of a citation from the German writer Jakob Wasserman (1873-1934), which was taken from *Sara Malcolm* (1906) and describes the mood the drawing suggested to him, which possibly suggested the title: [translated from German] "The decisive life of a human being does not take place in the real and tangible [world]. The most profound to which a mortal binds its soul, is mist and dreams."
12. Letter from Maris to Haverkorn van Rijsewijk, Rijksprentenkabinet, Amsterdam no. 14 (early May 1906). Earlier in the year Maris had already warned him: "I'll tell you beforehand not to put the spects of learning on your nose. Cleverness and skill you know well enough I had no inclination for, but you are under orders or commanded to let loose the reins of the imagination. And what isn't there, or what I didn't manage to express clearly—well, you have to envisage it, in spirit, no[t] supernatural but a human one. As you know I have no head for finances, you'll have to leave out that part of things. That's not why it was made, or an aim in making it." Letter from Maris to Haverkorn van Rijsewijk, Rijksprentenkabinet, no. 11 (spring 1906).
13. A short article in the Dutch newspaper *NRC* of April 21, 1906 (see note 1), refers to a drawing in "a gray frame and gray passepartout with a narrow white border." According to letter number 10 from Maris to Haverkorn van Rijsewijk (Rijksprentenkabinet, Amsterdam, October 1905) Maris had given his frame maker colored paper to stick onto some type of board; the frame maker produced a couple of specimens for a colored frame that Maris twice rejected because he did not like the color.
14. The original frame had been replaced with a gilded [!] one. He wrote to Haverkorn: "I am very sensitive about others handling my things. . . . The moment they got it, they put it in a new frame. It was like cutting off arms and legs, & say[ing] this is a human being." Maris to Haverkorn van Rijsewijk, Rijksprentenkabinet, Amsterdam, no. 12 (June 1906).
15. Maris to Haverkorn van Rijsewijk, Rijksprentenkabinet, Amsterdam, no. 14.
16. Letter from Maris to W. J. G. van Meurs, Teylers Museum, Haarlem, no. 98 (26 April 1909).
17. *The Shepherdess* ("a monumental conception of humanity"), 1888-98, oil on canvas, 200 x 135 cm (78 3/4 x 53 1/8 in.), Rijksmuseum, Amsterdam.
18. Maris to Haverkorn van Rijsewijk, Rijksprentenkabinet, Amsterdam, no. 14 (June 1906).

MATTHIJS MARIS
The Hague 1839–1917 London

48 *Portrait of Tine Lefèvre*

c. 1873

Black and colored chalk, brush and gray ink, gray washes, 150 x 127 mm (5 7/8 x 5 in.)

Verso: *Six Studies of a Cat* (fig. 1), in pencil

Inv. MB 497

Provenance: Acquired from the art dealer H. E. d'Audretsch, The Hague 1939

Literature: Van Regteren Altena 1958, 52, no. 140; Wagner 1974, 73, no. 103

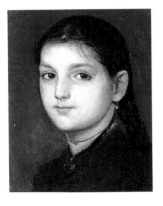

Fig. 1. Matthijs Maris, *Portrait of Tine Lefèvre*. Haags Gemeentemuseum, The Hague

All that the Museum Boijmans Van Beuningen owns by the painter Matthijs Maris are several sheets with studies of heads. This small number is mitigated by the fact that they were made at different times and vary in technique. While the previous drawing in this catalogue ("*Ecstasy*", cat. 47), which was by far the most important for Maris, was an ephemeral figure and not based on a model, these sheets, which really are observed studies done in a much smaller format, show that he was truly rooted in the nineteenth century and that reality was his starting point.

Throughout his career, Maris painted and drew portraits. His models were usually friends or family who posed for him at his request. He hardly ever accepted commissions except on a couple of occasions early in his career; the double portrait of the Westmacott children is one such picture.[1] In this and other later portraits, for instance that of Barye Swan, the young son of his friend the painter John Swan (1847–1910),[2] his strong personal approach prevented the picture from appearing too formal and too much like a product that had been paid for. Even among the early portraits there are few that appear emphatically posed. The portrait of his brother Jacob and one of Felix Moscheles for example, both dating from his time at the academy in Antwerp (1855–58), achieved their spontaneity because the sitters do not seem to have felt uncomfortable in his presence.[3] Another friend of his, Louis Sierig (1839–1905), behaved just as informally by sitting with a pipe in his mouth and wearing a painter's smock, presenting an uncompromising profile.[4] Even the artist's only known self-portrait, which was made when he was twenty years old, differs from the norm of the time by showing a tightly cropped view of the face, giving the eyes an extremely penetrating, almost intimate appearance.[5]

By far the most intriguing of the works at the Boijmans Museum is the exhibited chalk and watercolor portrait of a young girl. The sheet corresponds with a painted portrait from 1873 in the Gemeentemuseum, The Hague, showing Tine Lefèvre (fig. 1)[6] who lived next door to Maris in Paris. The girl also served as a model for his larger Paris figure pieces, among which was *Girl with Butterflies* from 1874 (Burrell Collection, Glasgow). There is also a painted preparatory study for the piece in The Hague (fig. 2)[7] in which the collar on the girl's dress and details such as the eyebrows and the shadow on the neck are closer to those in the drawing. These oil studies were probably done from life; the more worked-out painting in The Hague is derived from these studies, possibly with Leonardo's *Mona Lisa* in mind, a work that Maris

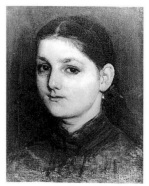

Fig. 2. Matthijs Maris, *Portrait of Tine Lefèvre*. Private Collection

Fig. 3. Matthijs Maris, *Head of a Girl*. Rijksmuseum Kröller-Müller, Otterlo

admired later in Paris. The Boijmans drawing is also not a study in the strict sense of the word, but rather a variation on it. It is an attempt to diminish portrait-like qualities by using experimental techniques as well as an attempt to take the characterization beyond pure representation, understood in the 1926 catalogue of the Barbizon House in London where the drawing was entitled *A Study in Tone*.[8] In the careful search for just the right line of the girl's cheek and nose, a veiling effect emerges that he further emphasized by lightly rubbing everything out with brush or stomper until the whole image seems coated in a mat, transparent layer of wax. Maris also strove for this effect when he was in Paris and, later, with his beautiful city scenes of Amsterdam. Later he regarded them as little eccentricities; memory filtered the image of reality and its coincidental, banal external appearance. In this respect the drawing is a beautiful example of the search that later led to more drastic elimination in London, where he elaborated on this head several times (fig. 3).[9]

RB

1. Compare cat. 47, note 9.
2. Haags Gemeentemuseum, The Hague.
3. Respectively in the collections of Pulchri Studio, The Hague, and the Foundation Hannema-De Stuers, Heino.
4. Rijksmuseum, Amsterdam.
5. In the collection of the Rijksmuseum Kröller-Müller, Otterlo.
6. *Portrait of Tine Lefèvre*, 1873, oil on canvas, 30 x 24 cm (11 7/8 x 9 1/2 in.), Haags Gemeentemuseum, The Hague.
7. *Portrait of Tine Lefèvre*, 1872, oil on canvas, 33 x 26.5 cm (13 x 10 3/8 in.), private collection.
8. London 1926, n.p., illustrated.
9. *Head of a Girl*, c. 1882-90, oil on canvas, 30.5 x 23 cm (12 x 9 in.), Rijksmuseum Kröller-Müller, Otterlo.

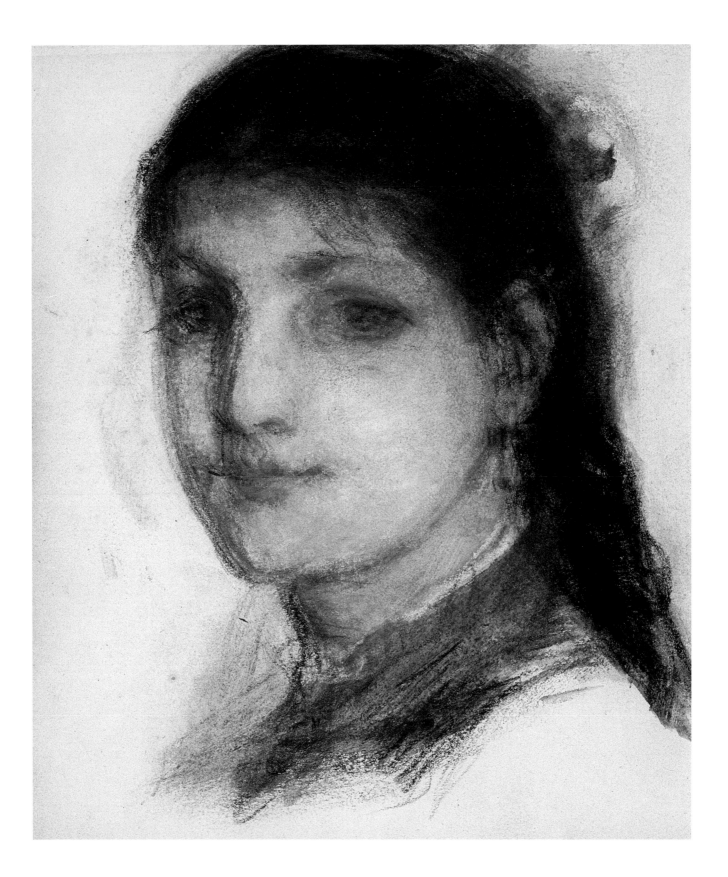

DAVID OYENS

Amsterdam 1842–1902 Brussels

49 *Portrait of Pieter Oyens*

1885

Watercolor, accents in bodycolor, over pencil, 285 x 205 mm (11 1/4 x 8 in.)

Signed and dated lower right in brush and black paint: *David Oyens 1885*

Inv. MB 576 (VdV 1972/T9)

Provenance: W. van der Vorm, Rotterdam; on loan from the Willem van der Vorm Foundation, Rotterdam 1972

Literature: Hannema 1950, no. 70; Hannema 1958, no. 55; Hannema 1962, no. 42; Giltaij 1994, 268–69, no. 92

In 1860 the banker's sons David (1842–1902) and Pieter Oyens (1842–94) left the Netherlands for Brussels to study at the studio of the Belgian painter Jean Portaels (1818–95), which was then highly fashionable. Their fellow students included Xavier Mellery (1845–1921), the Belgian symbolist who was later to achieve renown. The Oyens twins soon started to specialize in realistic, anecdotal interior pieces. These small, sketchy paintings achieved great success.[1]

Apart from brief intervals the Oyens brothers spent virtually their entire working lives in Brussels, inseparably sharing a studio. This is also where they set many of their paintings, which depict the corpulent twins themselves as the main subjects along with their frequently Italian- or Spanish-looking female models.

Since the twins were virtually identical and their work is also very similar, identifying the two brothers is sometimes far from easy. According to the much younger painter Frans Smissaert (1862–1944), whose teachers included Willem Roelofs (1822–97, see cat. 36), the Oyenses never painted themselves but only each other.[2] If he is right, the exhibited painting is a portrait of Pieter. It is one of the few genuinely posed portraits done by David, who usually "surprised" his models.

It was the brothers' virtuoso brushwork and naturalist vision that attracted press attention (they received both lavish praise and scathing criticism). They were also watercolorists, especially David, and both were involved from the outset in the exhibitions organized by the Hollandsche Teekenmaatschappij (Dutch drawing society). David did not start to exhibit until the late 1870s. These early exhibitions were with the Société Belge des Aquarellistes (Belgian society of watercolor artists) in the town where he lived. Although his watercolors are significantly more restrained than his works in oil, the former are not devoid of robust lines either.

SdB

1. For biographical details see Bionda 1991, 243. For the Oyens brothers' place in Belgian art see De Bodt 1995(1) and De Bodt 1995(2).
2. Frans Smissaert, "Herinneringen" (Recollections), manuscript kept in The Dutch Institute for Art History (RKD), The Hague. See De Bodt 1995(1), appendix VI.

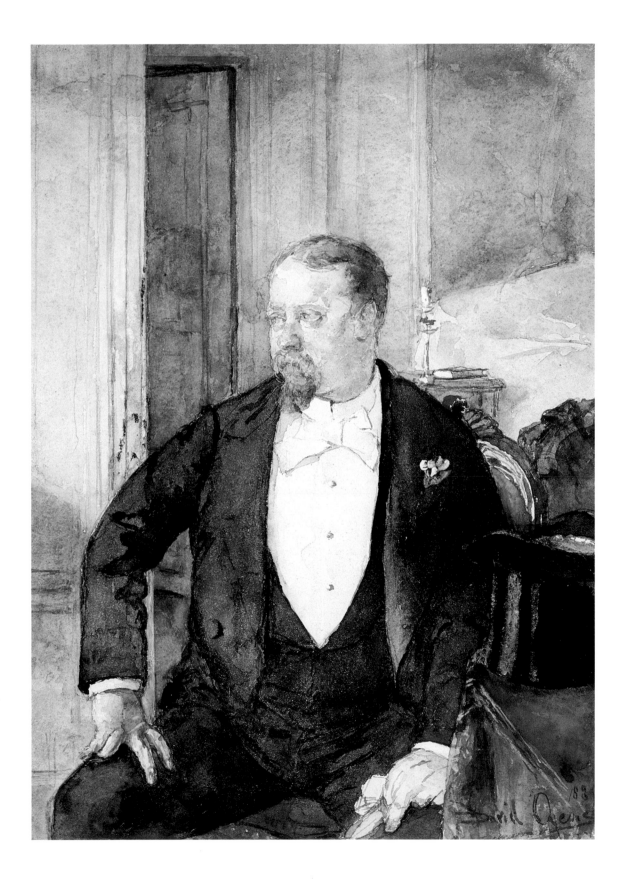

JOHANNES ALBERT NEUHUYS

Utrecht 1840–1914 Locarno

50 *Cradle with Blankets*

1885

Black chalk, stumped, 209 x 242 mm (8 1/4 x 9 5/8 in.)

Dated lower right in pencil: *1885*

Verso: *Woman at a Cradle*, black chalk, stumped (fig. 1)

Inv. MB 503

Provenance: Gift of the artist, The Hague 1898

Literature: Haverkorn van Rijsewijk 1909, 345–47

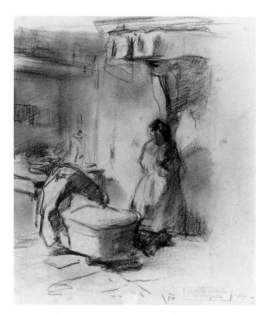

Fig. 1. Johannes Albert Neuhuys, *Woman at a Cradle*, verso of cat. 50. Museum Boijmans Van Beuningen, Rotterdam

Albert Neuhuys is known today as an important figure in the Hague school.[1] Together with the painters Jacob Maris (1837–99, cat. 43), Josef Israëls (1824–1911, compare cat. 37), and Bernhard Blommers (1845–1914), he played a major role in art circles in The Hague at the end of the nineteenth century. The artist moved to the city in 1876, specializing in interior scenes. Before, from 1872 onward, Neuhuys was often to be found in Laren where a number of artists such as Anton Mauve (1838–88, see cats. 44–46) and other art lovers and art dealers had established themselves. This group is sometimes referred to as the Laren school.[2] Neuhuys was strongly influenced in his choice of subject by French realism, the repercussions of which in the Netherlands were mainly found in the work of painters of the Hague school. Life on the farm and his own family proved a great source of inspiration.

Among Neuhuys' oeuvre, two pieces are known that can be connected to the chalk study of the *Cradle with Blankets* (cat. 50). One is a watercolor entitled *Playing with the Puss*,[3] and the other is a painting with the same title.[4] In the upper right-hand corner of the Rotterdam chalk drawing a small cat has been drawn with a few lines. The same cat is in the watercolor in the lower right-hand corner. The drawing bears such striking resemblances to the painting—for instance in the cradle, the table, and the floor—that it may be assumed to be a preparatory study. The drawing in black chalk is a hasty and not very detailed sketch. One may also assume that the artist was mainly concerned with composition. The watercolor in turn was probably copied after the painting; Neuhuys precisely reproduced many of his painting compositions in watercolor. Tradition has it that he did this in order to retain the memory of the oil paintings he had sold. However, it is more likely that his motives were commercial, for watercolors were more affordable than oils and were therefore more marketable.

MB

1. On Neuhuys, see Dumas 1983, Van Seumeren-Haerkens 1987, Van Rijn 1987, and Martin 1915.
2. Compare Heyting 1994, De Bodt 1997(2).
3. Whereabouts unknown. See Van Rijn 1987, fig. 12.
4. Whereabouts unknown. Auctioned in New York (Sotheby's), December 16, 1983.

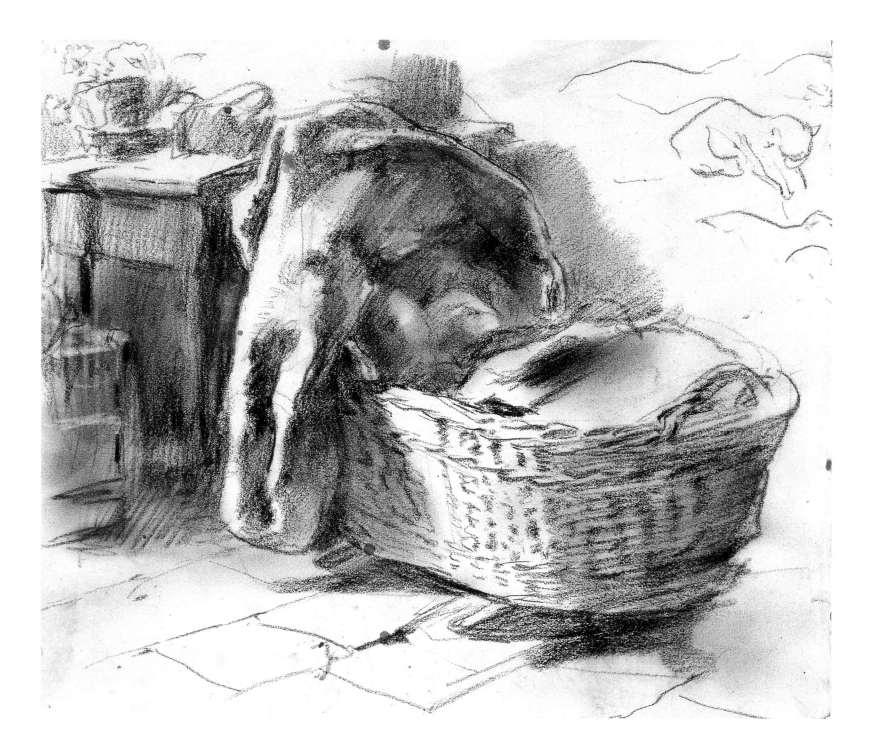

WILLEM MARIS

The Hague 1844–1910 The Hague

51 Landscape with Cows

Watercolor, 315 x 235 mm (12 3/8 x 9 1/4 in.)

Signed lower left with brush and brown paint: *Willem Maris f.*

Inv. MB 511

Provenance: Gift of the artist, The Hague, 1898

Literature: Haverkorn van Rijsewijk 1909, 345–47; Wagner 1975, no. 54

Willem Maris learned to paint at a young age from his older brothers Jacob (1837–99, compare cat. 43) and Matthijs (1839–1917, see cats. 47 and 48).[1] In a letter Willem once wrote: "Even before I was twelve years old I used to go into the meadows to draw cows in the morning before school and when I came home in the afternoon. My brothers who were four and six years older than myself were also there and not surprisingly I had my first lessons from them."[2] At the age of sixteen he drew a study of a recumbent cow,[3] an early work characterized by its exceptional accuracy. He precisely depicted the veins on the cow's head and the hair of its coat growing in different directions.

Maris' subjects did not vary much over the years. Apart from ducks, he mainly painted cows in boggy meadows or at the water's edge. According to a well-known anecdote, a famous Hague art dealer used to regularly call down the stairs to Maris' studio, "Haven't the cows turned into pigs yet?"[4]

If his preoccupation had been with detail in the early pieces, in *Landscape with Cows* even the cows become subsidiaries. Willem Maris saw them rather as "light catchers"[5] and often stated: "I do not paint cows, but effects of the light."[6] With his rapid brushstrokes he captured the effect of sunlight on the illuminated cow's back in the Boijmans drawing. This, together with the warm colors of the lush, green fields, makes this watercolor a successful depiction of summertime in Holland. The critic Johan Gram made a statement about Maris' paintings in 1880 that can also be applied to the Rotterdam watercolor: "In his canvases there is indeed space and atmosphere, distance and depth; one feels oneself outside, breathing in the fresh air as it were, and melting into the hazy distance. In the background, the cattle graze in the meadow and[,] standing a little away from the

drawing, the illusion of reality is really quite surprising."[7] Although generally speaking the critics praised Willem Maris' paintings, adverse comments were far from gentle. One critic, for example, declared that the representation of light upon the canvas did not appear "natural but theatrical."[8]

As an impressionist, Maris excelled mainly as a watercolorist. Together with Hendrik Willem Mesdag (1831–1915) and his friend Anton Mauve (1838–88, compare cats. 44–46), Maris was one of the founders of the Hollandsche Teekenmaatschappij (Dutch drawing society), where he regularly exhibited. Curiously, Maris, who advocated the most direct representation of nature possible, never wanted to live in the country. In an interview he stressed the fact that, as he saw it, a constant confrontation with nature led to imitation. He said the most beautiful views of nature are created in an ugly studio because when "[you] suddenly go out into the countryside you are more moved," more so than if he lived there all the time.[9]

JK

1. Willem Maris was originally called Wenzel Marris. He was named after his grandfather Wenzel Maresch (1779–1855), who came from Prague. The name Maresch changed from Marris to the more Dutch sounding Maris. Maris 1943, 11–13.
2. Letter from Willem Maris to D. Croal Thompson, 19 March 1910. Quoted from Dumas 1983, 58.
3. Willem Maris, *Recumbent Cow*, black chalk, stumped, accents in brush and black ink, 290 x 334 mm (11 3/8 x 13 1/8 in.); verso: *Study of a Tree*, pencil; inscribed lower right in pen and brown ink: *W M. 1858*; watermark: (H)ONIG. Museum Boijmans Van Beuningen, inv. MB 502; gift of the artist, The Hague, 1898.
4. Harms Tiepen 1910, 17.
5. Sillevis 1988, 198.
6. Hefting 1981, 35.
7. Sillevis 1988, 196.
8. De Raad 1991, 58.
9. Harms Tiepen 1910, 14.

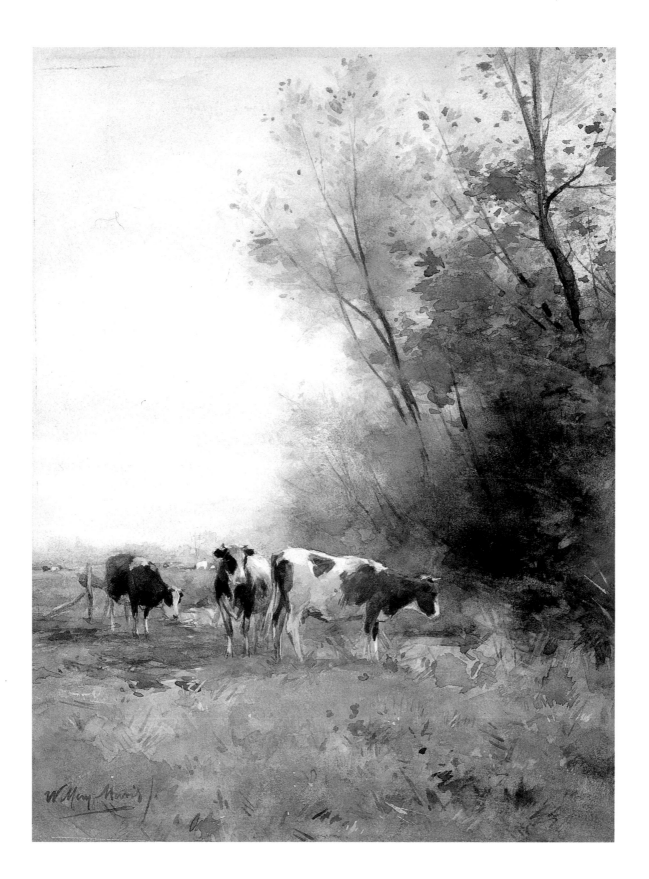

VINCENT VAN GOGH

Zundert 1853–1890 Auvers-sur-Oise

52 Farm in Brabant

1881

Pencil, black chalk, pen and brush in brown and black ink, brown and gray washes, spattered with black ink, surface scratched in places, 472 x 616 mm (18 5/8 x 24 1/4 in.)

Watermark: PL BAS

Inv. MB 549

Provenance: J. van Gogh-Bonger, Amsterdam; A. van Veen, Rotterdam, M. M. van Valkenburg, Rotterdam; gift of D. Hannema, Rotterdam 1922

Literature: Rotterdam 1922, 4; Hannema 1927, 164, no. 790; De la Faille 1928, no. 842, fig. 111; Munich 1961, no. 4; Longstreet 1963, n.p.; Van Gogh 1973, 233, no. 145; Hannema 1973, 99–100; Hulsker 1977, 14, no. 5; Van Uitert 1987, 133, no. 2; Van der Wolk 1990, 38, 56, no. 10

Vincent van Gogh was born in 1853 in Zundert in the Dutch province of Brabant, but did not begin his career as an artist until 1880 when he was living as preacher in the mining district of Borinage in Belgium. Before this time, his work in the art trade in The Hague, London, and Paris had kept him informed about developments in the art world, though he was unaware of impressionism for some time. He began drawing by copying a series of prints *Les Travaux des champs* by the painter of rural life Jean François Millet (1814–75), whom he admired enormously. After Van Gogh moved to Brussels, he practiced drawing from the figure as the classical art education system demanded at the time. When copying Millet's prints Van Gogh chose to work in pen, possibly to prepare himself for printmaking and a future as an illustrator. This was an ambition Van Gogh shared with George Breitner (1857–1923, see cats. 59–62), whom he had met in 1882 in The Hague. In Brussels he made contact with other artists. He found a friend in Anthon van Rappard (1858–92) with whom he afterward went drawing in Brabant. He also later kept up a correspondence with Van Rappard.[1]

Because Van Gogh was reliant on the financial support of his brother Theo he looked for a cheap way to live while working on his newly begun education. In the spring of 1881 he went to live with his parents in Etten, in the south of the Netherlands: "There I find plenty of material," he wrote. In May 1881, he announced to his brother: "When it does not rain I go outside almost every day, mostly into the heathland. I make studies which are rather large as thou hast already seen on your visit." He then listed a hut in the heathland, "het Heike," a shed with a moss roof, a mill, and trees in the churchyard. Furthermore he mentioned "woodcutters who are busy on a vast open space where a large pine wood has been felled." Van Gogh also drew carts, plows, harrows, and wheelbarrows.[2] In short, he studied life on the land.

As well as Van Rappard, the young draftsman Vincent looked to the *Traité d'aquarelle* by the

French painter A. Cassagne (1823–1907) for guidance. "Until now I have only drawn with a pencil highlighted or accented in pen, if need be with the reed pen which is broader," he wrote. He went on to sum up subjects that demanded extensive drawing, which were mainly workplaces.[3] At this time he liked to work on white Ingres paper because it was so suited to drawing with the pen. In July 1881 the supply of paper he had brought from Brussels had run out and he asked Theo to buy him some more.[4]

Because it was too warm to work on the heath in July, Van Gogh would have made the extensive pen drawing of the farm on the heath (cat. 52) in May or June. The drawing has been done with a great deal of effort and zeal but reveals little talent. Children play in front of an impoverished farm, a farmer's wife stands with a broom in her hand, and the farmer sows seed. Behind his head a church tower rises above the horizon.[5] A little farther to the front is a wheelbarrow, bundles of sticks lying on the ground, and a pile of peat. On the left of the foreground is a hole filled with water. Van Gogh apparently wanted to give an accurate picture of life on the farm in which plowing, sowing, and harvesting are endlessly repeated. This cyclical effect is emphasized by the evening mood suggested by a combination of gray pencil, black paint, and brown ink. It is an example of one of the poorest farms. There is no horse to be seen for pulling the plow; leaning against the house is only a spade.

The most striking thing about this drawing is the wealth of technique employed: pencil, pen and ink, and here and there some brushwork. In the foreground are spruce branches in black paint that emphasize the rugged nature of the terrain. The sky has been rubbed out and reworked. The drawing is almost as doggedly worked as the ground on which the farmer toils. Van Gogh applied similarly complicated technique in a number of copies he made of Millet's prints, one of which was *The Sower*. The prints in turn were graphic translations of paintings in which the tonal qualities had to be retained.

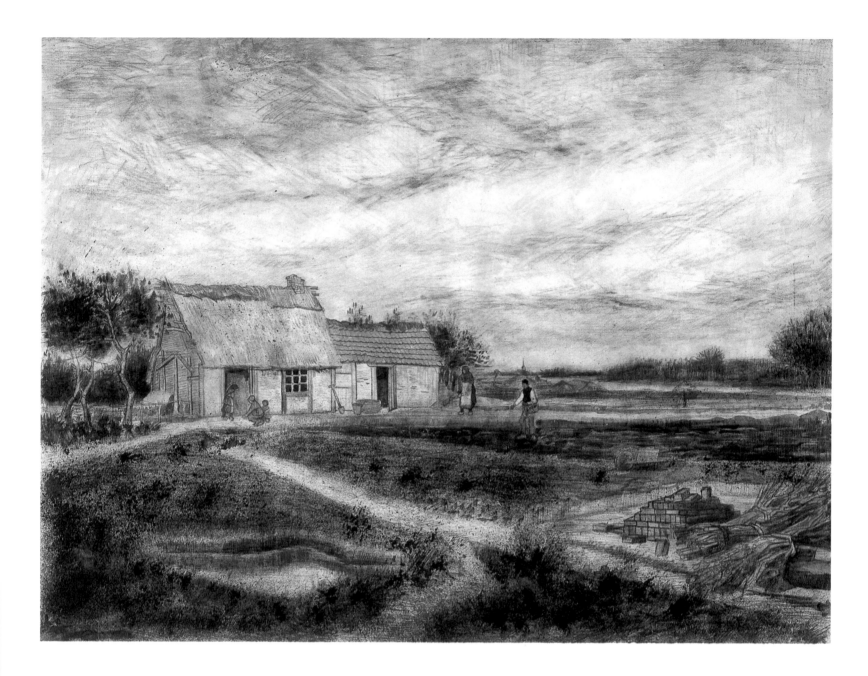

VINCENT VAN GOGH

Zundert 1853–1890 Auvers-sur-Oise

53 Orchard

1881

Pen and brown ink over black chalk, heightened in white body color, 254 x 317 mm (10 x 12 1/2 in.)

Inv. MB 1965/T2

Provenance: C. Mouwen, Jr., Breda; (auction Amsterdam 3.V.1904 no. 41); J. C. Meyers, The Hague; H. J. W. van den Boogaard, Rotterdam; (auction Dordrecht 3.XII.1912, no. 24); C. Vriesendorp, Dordrecht (auction Dordrecht 11 13.V.1937, no. 581, repr.); the art dealer d'Audretsch, The Hague; mejuffrouw S. M. C. Kronenburg, Wassenaar; bequeathed to the Boijmans Van Beuningen Museum, 1965

Literature: Rotterdam 1965, 21; Rotterdam 1967, 2–7; De la Faille, 1970, no. 902 a; Wagner 1973, pl. II, 18; Hulsker 1977, cat. 10

Fig. 1. Vincent van Gogh, *Two Figures in an Orchard*. Van Gogh Museum, Amsterdam

Orchard, done with equal care as *Farm in Brabant*, shows a rural village scene with a secluded house in the background. In the foreground a path runs through various kinds of trees planted in neat rows. Under a large fruit tree on the right is a slatted structure that may have served some domestic purpose or other. The simple composition is defined by a horizontal band formed by a fence with a light horizontal strip of ground in front of it and by the vertical tree trunks. The spatial structure is also simple, on the right closed off by the sawn trunk and crown. Depth is suggested by the path leading to the right at a slant.

Heavy, dark accents draw the eye farther back into the picture. The tonal values in this drawing, which is laid down in a few chalked lines, are of supreme importance, emphasized by the sky, which is heightened with white paint. The hatched treetops and branches thus convey the effect of a large area of tonal gradations. There is also a suggestion of leaves in the hatching.

Technique and style place this drawing in Van Gogh's early period in Etten, in 1881, although the time he spent in Drenthe in 1883 has also been suggested.[6] The heightening of the sky with white paint could bear this out, as could the kind of paper that the artist used.

Van Gogh was to repeat the garden and orchard theme several times in drawings and paintings. In October 1882 he enclosed in a letter a little watercolor sketch of two figures in an orchard[7] (fig. 1).[8] Here, too, the composition is closed off at the back with a horizontal, again a fence, behind which a farmhouse can be discerned. The sketch is a depiction of spring, one of a series of seasons, but a spring drawn in the autumn. The painstaking pen drawing of the orchard looks as if it was done directly from nature, however, and this favors a dating in 1881, in Etten.

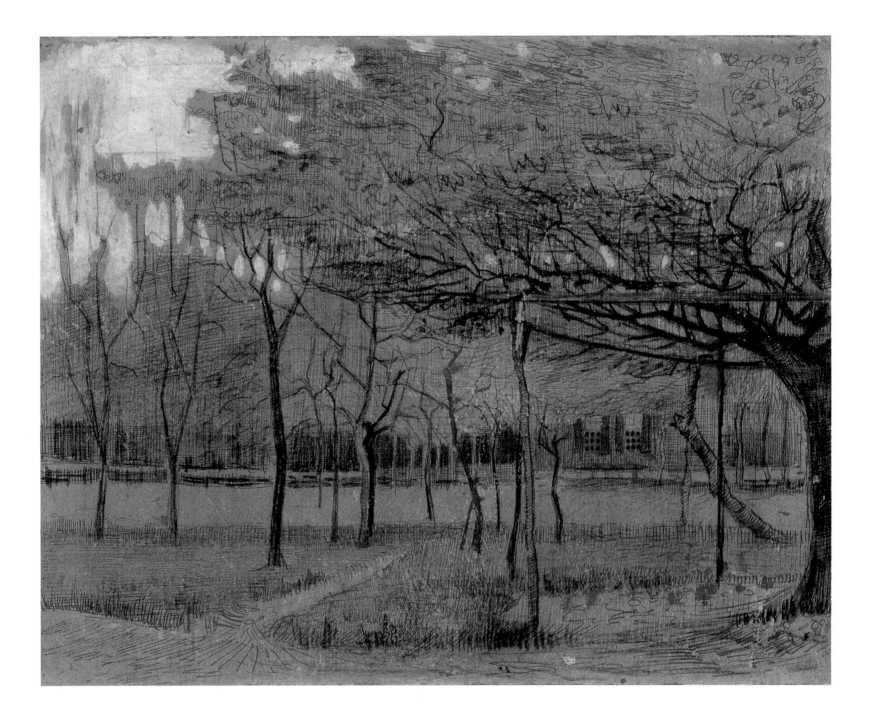

VINCENT VAN GOGH

Zundert 1853 · 1890 Auvers-sur-Oise

54 The Seamstress

1881–82

Pencil and black chalk, stumped, brush and black paint, gray washes, one highlight in white body color, 532 x 376 mm (21 x 14 7/8 in.)

Signed lower left in pencil: *Vincent*

Watermark: circle with scrollwork, illegible

Inv. MB 1949/T6

Provenance: H. P. Bremmer, The Hague; the art dealer J. Hageraats, The Hague; acquired in 1940 by the art dealer Huinck & Scherjon, Amsterdam; their gift, Amsterdam 1949

Literature: Vanbeselaere 1937, 104, nos. 1025–26; Rotterdam 1949, 4; Haverkamp Begemann 1950, 58–61, no. 6; Longstreet 1963, n.p.; De la Faille 1970, no. F1025; Van Gogh 1973, 154, no. 277; Hulsker 1977, 84, no. 346; Pickvance 1985, 60–62, no. 15; Van der Wolk 1990, 89, no. 37

For the painter of farmers, or "painter of the people" that Van Gogh wanted to be, the subject of the seamstress was an obvious choice. His letters demonstrate what kind of associations this raised for him because he referred to a poem by Thomas Hood, *The Song of the Shirt*, which was published in the Christmas edition of *Punch* in 1843. This is a sad verse about an overworked woman, stitching away in "poverty, hunger and dirt." This theme was dealt with by several artists and writers, always with the same social implications.[9] In 1881 Van Gogh was looking for the poem he had obviously read somewhere before; at the beginning of April 1882 he wrote, "There is a poem, by Tom Hood I think, in which he tells the story of a grand lady who cannot sleep at night because during the day, when she went out to buy a new dress, she saw the poor seamstress pale, consumptive, emaciated working in an airless room."[10]

The poem by Hood was apparently what gave Van Gogh the idea to take up the theme of the seamstress, one popular also among artists in the seventeenth century. He drew various seamstresses. One of the earliest examples was made at the end of 1881 in Etten,[11] where a farmer's wife posed for him. In The Hague it was Clasine (Sien) Hoornik, the woman with whom he was living at that time, who was his model. Sewing referred to a typical female, domestic virtuousness that in this case was relevant because Vincent wanted to help "the woman," as he often called her in his letters, onto the right path.[12] She had been forced at times to earn her keep by prostitution, and that is how Van Gogh met her. She was also a good model.

The expressiveness of the Rotterdam piece (cat. 54) was created by Sien's attentive attitude and the gesture of the hands. The black dress dominates the white cloth in the drawing; the gray background provides the mid-tones. This is a painterly way of working that was particularly effective in the areas depicting mass; contours and details were added

later. The tones have been executed in pencil, chalk, and watered-down ink, the contours and details in pen and pencil, most strikingly in the hands, the face, and the dark seam running along Sien's sleeve. The thread is depicted in white paint. On April 1, 1883, Van Gogh wrote that he had drawn a seamstress in mountain crayon. "Also made with an eye on clair-obscure," explained Vincent.[13]

From the signature on the lower left it is evident that the drawing must have been trimmed at a later date. The cropping and the style of drawing indicate that this is a second version. A slightly larger one is in the Kröller-Müller Museum at Otterlo, which has been drawn in a less finished manner.[14] Apparently Vincent felt it worthwhile to make the drawing once more. He was planning to make a series showing working people and, because he already had a few, "the desire to make them better was not as much an idea . . . but more a tedious labor." He gave the example of the French Lhermitte (1844-1925) who "knows the tough, strong worker's body through and through and who grabs his motifs from the heart of the people."[15]

EvU

1. See Brouwer 1974.
2. Van Gogh 1990, 372, letter 166 [145].
3. Van Gogh 1990, 372, letter 167 [146].
4. Van Gogh 1990, 374, letter 168 [147].
5. According to some art historians the church tower in this case lends a religious connotation to the sower; compare Kódera 1990, 29.
6. See A. Tellegen, "Vincent van Goghs appelboomgaard te Zweelo," Rotterdam 1967, 2-7.
7. Van Gogh 1958, letter 236. Also see Van Heugten 1996, 155-59, cat. 41.
8. Van Gogh museum, inv. d 277 V/1971.
9. Compare Treuherz 1987. Also see Redgrave, 24-26, in which the painting *The Seamstress* by the Victorian painter Richard Redgrave and the poem by Hood are discussed.
10. Van Gogh 1990, 528, letter 214 [185].
11. De la Faille 1970, nos. 869, 886, 887, and 1216.
12. Zemel 1987.
13. Van Gogh 1990, 867, letter 335 [227].
14. De la Faille 1970, no. 1026.
15. Van Gogh 1990, 867, letter 335 [227].

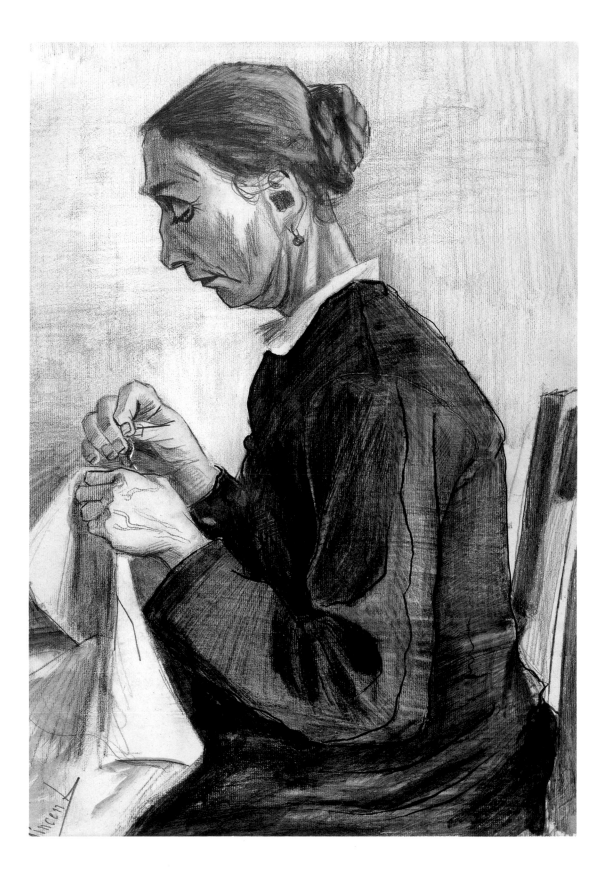

VINCENT VAN GOGH

Zundert 1853-1890 Auvers-sur-Oise

55 Woman Planting Beets

1885

Black chalk, 522 x 435 mm (20 1/2 x 17 1/8 in.)

Inv. MB 744

Provenance: Gift of J. Hidde Nijland, Dordrecht

Literature: Jaarverslag Museum Boijmans van Beuningen, 1899, 7; Vanbeselaere 1937, 271, 394–95, 412; Longstreet 1963; Martini 1963, fig. 2; De La Faille, 1970, no. 1270; Hulsker 1977, cat. 821

In the summer of 1885 Van Gogh hoped that his *Potato Eaters* would bring him the commercial success he sought in Paris as a painter of peasants. The results were disappointing, and Vincent diligently started to make studies of male and female peasants in the fields, planting beets, lifting potatoes, mowing, and binding sheaves. He intended to send his figure studies to the Paris art dealer Serret to demonstrate that he was far from indifferent to the ensemble of a figure and the form,[1] an implicit response to the criticism prompted by his figures in *The Potato Eaters*. In June 1885 he wrote that he was drawing figures every day and had surely done a hundred. He was seeking something different from his old drawings and endeavoring to capture the character of the peasants, especially the local ones.[2]

The impressive drawing of a woman planting beets comes from a series of studies Vincent made in the countryside near Nuenen in Brabant in the summer of 1885.[3] The woman's stance echoes that of *The Gleaners* by Jean–François Millet (1814–75), which Van Gogh greatly admired, as well as Millet's *Angelus* with its religious charge.[4] This Millet stance is frequently observed in Van Gogh's work. In August 1884 he even devised a harvest scene with a gleaner to decorate the dining room of an acquaintance who had originally envisaged compositions with saints.[5]

To Van Gogh, scenes from rural life referred just as much to more elevated themes as the lives of the saints.

Van Gogh did not aspire to the correct life drawings of the academies; what he wanted was the expression of the characteristic. His brother Theo sent him a catalogue of work by Jean-François Raffaëlli. It included an "étude des mouvements de l'art moderne et du beau caractériste." Vincent found the reproduced drawings superb and the essay interesting, although he did not agree with everything it said.[6] Be that as it may, Vincent felt strengthened in his resolve by Raffaëlli. "Artists want character. Well, so will the public."[7] In order to express *le beau caractériste*, in Raffaëlli's opinion, one should not cling to the past and certainly not to bourgeois academic standards. Van Gogh will surely have read these sentiments with approval.[8]

A striking feature of this drawing is the emphasis on the woman's too-large hands. Her head is hidden by the contours of her bent body, and the face is not academically correct either, being only half drawn. A variant of this pose, probably made shortly before or after, is found in a related drawing,[9] with a caption, not authentic, *"Planteuse de betteraves, Juin,"* that also appears on the study shown here.

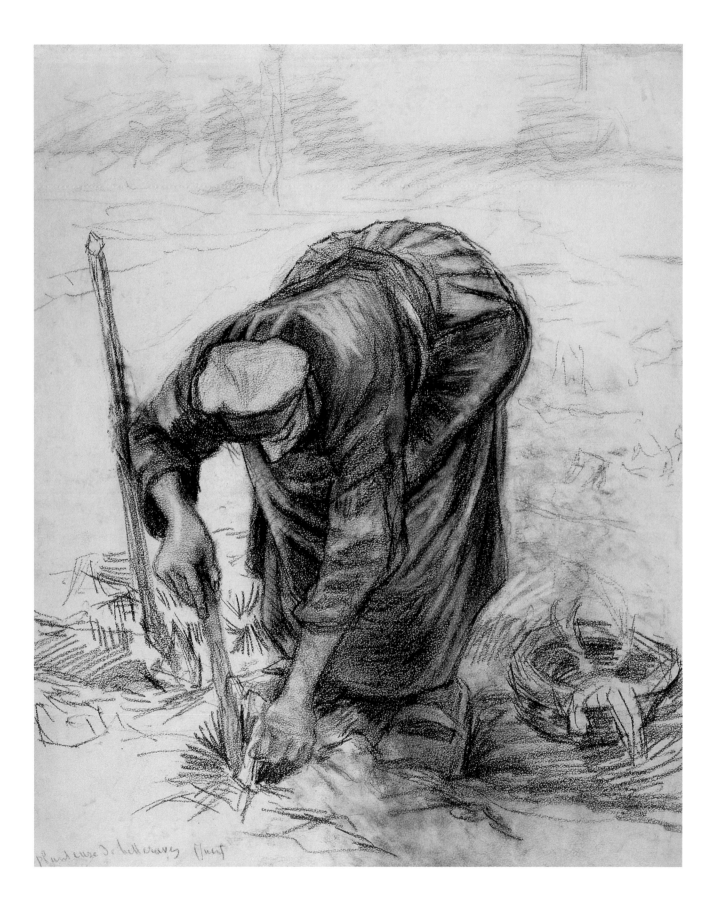

planteuse de betteraves (Vincent)

153

VINCENT VAN GOGH

Zundert 1853–1890 Auvers-sur-Oise

56 *The Rhône at Arles*

c. 1888

Brush, reed pen, and brown [originally purple] aniline ink, 395 x 610 mm (15 1/2 x 24 in.)

Signed and inscribed lower left with brush and brown ink: *Borde Du Rhône Vincent*

Watermark: PL BAS, oval with the letters: AL

Inv. MB 555

Provenance: Van Gogh's family in Brabant; P. F. Fentener van Vlissingen, Helmond; the art dealer E. J. van Wisselingh & Co., Amsterdam; gift of H. van Beek and H. Nijgh, Rotterdam 1929

Literature: Rotterdam 1929, 7; Haverkamp Begemann 1950, 55–61, no. 6; Nuremberg 1956, no. 64; Hammacher 1956(2), no. 116; Haverkamp Begemann 1957, 70, no. 81; Longstreet 1963, n.p.; De la Faille 1970, no. F1472a; Millard 1974, 161, no. 2; Pickvance 1984, 62, no. 20; Van der Wolk 1990, 251, no. 177; De Jonge 1992, 93, no. 55

Vincent wrote *"Bords du Rhône"* under the reed pen drawing *The Rhône at Arles* (cat. 56), which shows a view of Arles seen from the river in the setting sun. In the center a dark boat is moored and two horses are being watered. In the foreground are a small patch of stony ground and tufts of grass. The high side of the quay stretches from left to right and into the distance. Above it are houses, trees, towers, and chimneys. It is a panoramic view with a strong topographical character familiar to Van Gogh not only from the European tradition, but also from Japanese prints. Quick drawing with the reed pen over a pencil sketch creates a Japanese impression; the originally purple ink has now faded to a pale brown. Van Gogh wrote at the beginning of April 1888 that he needed to draw a great deal and in the manner of Japanese prints. He saw Provence, where he moved in February of that year, as an equivalent of Japan, a belief he worked out in a number of pieces.

In the second half of April he actively set about drawing with a reed pen cut like a goose-feather quill. This produced a very fine line and was a technique he had already tried in Holland. In Arles he was able to obtain better quality reed. Vincent probably made this drawing in May. Dating from the same period, and also subtitled, are his drawings *Verger de Provence* and *Vue d'Arles*. These drawings are all done in the best topographical tradition, and one

may assume he was planning a series like the earlier city scenes that he had made in The Hague.[10]

Vincent used a perspective frame for these south-of-France drawings. In this too he fell back on experiments he had carried out in The Hague. He now claimed that the perspective frame had a future, even if it differed from its earlier use in the time of Dürer.[11] In September 1888 Vincent went out at night to the same piece of land in the river pictured in *The Rhône at Arles*. There he painted the starry sky above Arles and the reflections of the lights along the quay in the water of the Rhône with a pony in the foreground. The sober topography has given way to a deeper sentiment.[12]

EvU

1. Van Gogh 1958, Letter 413, July 1885.
2. Van Gogh 1958, Letter 414.
3. Van Heugten 1997, cats. 180–92, 222–43.
4. See Van Tilborgh 1988. Publication accompanying the eponymous exhibition.
5. Van Gogh 1958, Letter 456.
6. Van Gogh 1958, Letter 416.
7. Ibid.
8. *Catalogue illustré des oeuvres de Jean-François Raffalli [sic] Exposées 28 bis, avenue de l'Opéra suivi d'une étude des mouvements de l'art moderne et du Beau Caractériste* (Paris, 1884).
9. De la Faille 1970, no. 127a.
10. De la Faille 1970, nos. 1414 and 1416.
11. Van Gogh 1990, 1494, letter 587 [469].
12. De la Faille 1970, no. 1515 (drawing) and no. 474 (painting).

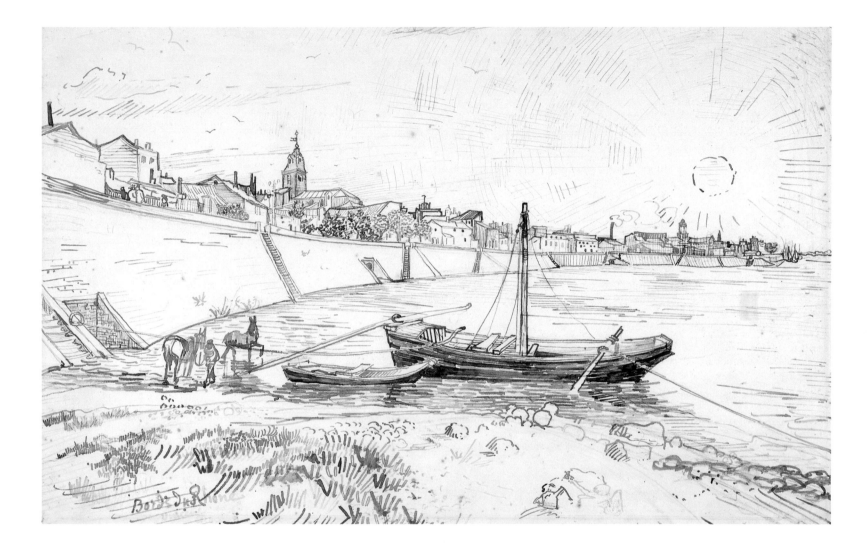

Bords du Rhône

JACOBUS VAN LOOY

Haarlem 1860–1923 Haarlem

57 *Blacksmith's Forge*

c. 1890–93

Black chalk, gray washes, stomped, accents in red chalk

445 x 555 mm (17 1/2 x 21 5/8 in.)

Signed lower left in black chalk: *Jac v Looy*

Watermark: Van Gelder & Zo . . .

Inv. MB 1994/T12

Provenance: Kunsthandel Glerum, The Hague, purchased in 1992

R. Bionda, Purmerend; acquired in 1994

Fig. 1. Jacobus van Looy, *Village Scene*. Frans Hals Museum, Haarlem

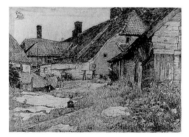

Fig. 2. Jacobus van Looy, *Farmyard, Oirschot*. Private Collection

"From there [the Trappist monastery Achelse Kluis] the next day to Schaft, worked a bit and from there on to Bergeik, via Borkel, in wonderful sunshine. Stayed the night in the house of a friendly taverner's wife and worked for a while this morning before coming here, not far, just two and a half hours: more or less. It was so pleasant this evening, I had a drink on the doorstep with the sweet, rustic countryside, irritating sun still shining on the houses, velocipedists in front of the doors, their cycles propped against the trees. I thought of Pieter de Hoogh's small country house . . . which hangs in the museum."

In this letter of October 12, 1890, to an unknown person in Amsterdam and possibly never sent, the writer and painter Jacobus van Looy recounts his journey from Amsterdam through Brabant between October 6 and 22, 1890.[1] He arrived on October 6 in Den Bosch where he visited his friends the painter Antoon Derkinderen (1859–1935) and the composer Alphons Diepenbrock. By train and on foot he then traveled through a number of villages in central and western Brabant, ending his journey with a four-day house party at the home of the writer Lodewijk van Deyssel, who at that time was living in Bergen op Zoom. On the way he sketched and drew landscapes and village scenes, particularly in the villages of Valkenswaard, Schaft, and Oirschot.[2] In the Jacobus van Looy Foundation Collection in Haarlem's Frans Hals Museum there are six sketches of Oirschot. Among others is a village scene of a farm with a view of a church tower (fig. 1). There are also five sheets containing drawings of the nave and tower of the Catholic church of Saint Peter. In 1891 he developed these preparatory studies into a painting, now in the Frans Hals Museum, of the distinctive solid church tower. In a private collection there is a worked-out drawing in black and red chalk of a farmyard also in Oirschot (fig. 2), but this is dated July 1893 when Van Looy was looking for somewhere new to live and considered moving there. The plan did not come to fruition and Soest, which was more accessible from Amsterdam, became his new home.

It is so far not known which village is pictured in the drawing in the Museum Boijmans Van Beuningen. It is dominated by a farm-like building with a road or a yard with cart tracks in the foreground and is completed with sky and clouds done in light, gray washes. The tiled roof and the yard in the foreground are stomped. The dominant tone of the black chalk composition is dark but has a single color accent in red-brown chalk and a few highlights on the cart tracks created by using a rubber eraser to reveal the white of the paper.

The building is probably a craft workshop with a house built under one roof in typical Brabant farmhouse style. Van Looy speaks of "green country villages with farms with rounded roofs."[3] The house is at the back on the left, and the rest of the building is made up of a forge where horses are shod and cart wheels are provided with metal tires. In the center, in front of the building, a special stable has been built onto the house where the horses are shod. Leaning against the stable and the outside wall are several wheels and hoops. These hoops are the iron bands that the blacksmith fits red-hot around the wheel rims, cooling them very suddenly in cold water so that they contract to fit firmly around the wheel. Inside the forge another wheel can just be seen through the open door. On the left of the yard are a couple of wheelbarrows that are probably in need of new hoops. This is very likely the drawing entitled *Smederij* (smithy) that Van Looy showed as a member of the Dutch Etching Club in 1893 as cat. no. 86 at the club's sixth exhibition at Arti et Amicitiae in Amsterdam.

Van Looy undoubtedly felt some affection for the motif of a workshop with cartwheels since he began his career as an apprentice carriage painter in Haarlem. At that time he took evening lessons in the fine art of painting from D. J. H. Joosten (1818–82) and H. J. Scholten (1824–1907). This was in preparation for studying at the Rijksacademie in Amsterdam under August Allebé (1838–1927).

CW

1. See Will 1982, 91–95. The letter is in the Jacobus van Looy Foundation Archive in the Frans Hals Museum, Haarlem.
2. In the former collection of Dr. J. A. van Dongen, exhibited in 1961 in the print room of the Rijksmuseum, there was a watercolor by Van Looy of a barn at Valkenswaard.
3. See Van der Wiel 1985. Here Rein van der Wiel published a number of letters from Van Looy to Betsy van Vloten, the fiancée of his best friend Willem Witsen, in which he gave an extensive account of his hike through Brabant. These letters are in the Manuscript Department of the University Library in Amsterdam, shelf mark Archief Elizabeth van Vloten XXX A46.

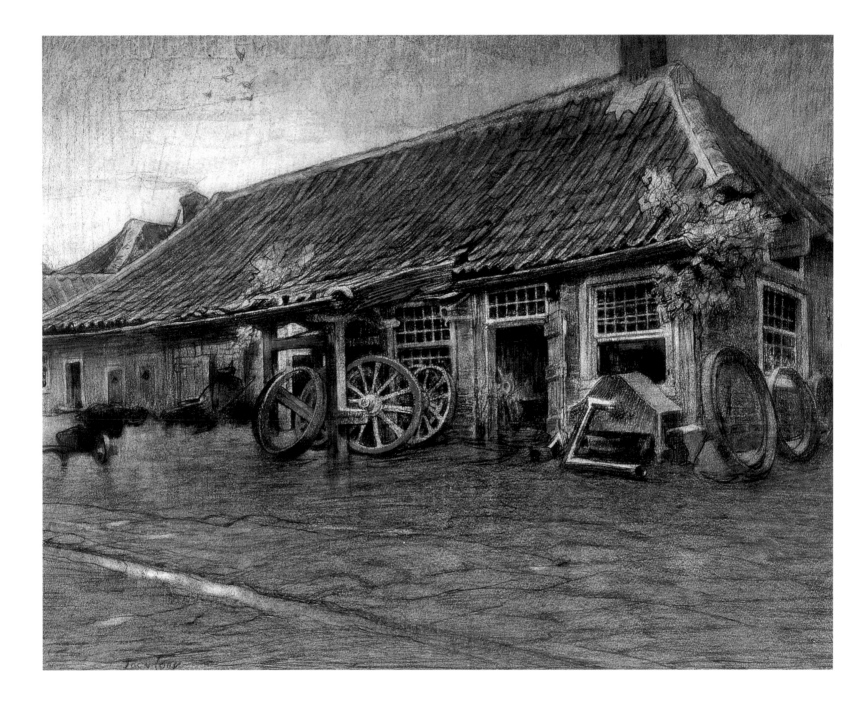

SUZE (SUSANNE) ROBERTSON

The Hague 1855–1922 The Hague

58 Head of an Old Woman Asleep

Black ink over black chalk, stumped, 332 x 419 mm (13 1/8 x 16 1/2 in.)

Signed lower left in black chalk: *Suze Robertson*; verso, inscribed lower center in pencil in a later handwriting: *Suze Robertson tekening. Geschenk N. N. 1922*

Watermark: MONT GOLFIER A St MARCEL

Inv. MB 509

Provenance: Anonymous gift, 1922

Suze Robertson is one of the artists

Fig. 1. Käthe Kollwitz, *Mother with Child*. Museum Boijmans Van Beuningen, Rotterdam

of the last decade of the nineteenth century who possessed a very modern outlook but who only came to be acknowledged much later. The art historian A. M. Hammacher (himself born in 1897) in his book on Amsterdam impressionism (1941) called her "one of the belatedly recognized, premature transition figures who were to be found in several countries in Europe during the nineteenth century and who, despite large differences in position and technique, spiritually had much in common."[1] Hammacher sees "spiritual" affinities in "the feeling for the truly tragic in life. . . . Their design is heavy; light and shade come to mean something other than day and night."[2] Suze Robertson worked during the transition between impressionism and expressionism. In this respect her work can be compared with that of Paula Modersohn-Becker (1876–1907), Jacob Smits (1855–1928), and sometimes even of Van Gogh (1853–90, see cats. 52–56). There are considerable affinities also between the work of Robertson and of Käthe Kollwitz (1867–1944).

In the 1890s Suze Robertson regularly worked in the villages of Dongen and Leur in Brabant, and in summer she frequented places such as Laren and Blaricum in the Gooi region.[3] The work she did there, using local inhabitants as models, displays an affinity with Vincent van Gogh. A study of an old woman at a table with a coffeepot[4] from the Museum Boijmans Van Beuningen is an example of this realistic, unidealized portrayal of poor peasants. But whereas Vincent's figures became a prototype of his ideas about rural life, the figure of this woman impresses by virtue of her simplicity without any direct moralizing intention. This is a characteristic trait of practically all of Suze Robertson's figural work. Because of its confident character and robust, monumental rendering, her work was often labeled "unfeminine" or "masculine."[5]

In her later artistic development, expression and concentrated form came to play an increasingly important role. Robertson turned her attention more and more to what she herself called the "inner process." In the period around World War I, contrasts

between light and shade became more pronounced. Robertson now painted fewer and fewer canvases, producing large drawings instead. The head of an old woman asleep (cat. 58) is a fine example of the eloquence, form, and vision that characterize Robertson's mature work: it is a full-fledged, complete work. The artist used chalk soaked in oil, with which she obtained strong contrasts and a variety of tonal values.[6] A dramatic effect is produced by the dark tones of the face. The woman's tragic mien is accentuated by the composition: attention is focused on the closed eyes and furrowed face.

This head of a tired old woman reflects Robertson's mature expression of her somber view of life and the exacting existence of a female artist. With this drawing she leaned toward expressionism, displaying a strong affinity with the work of Kollwitz (fig. 1),[7] although Robertson's sense of commitment is more personal than political. Hammacher's statement "light and shade come to mean something other than and night" is particularly appropriate to this work.

MdB-S

1. Hammacher 1941, 73. On Suze Robertson see also Bionda 1991, 252–57.
2. Hammacher 1941, 76.
3. Wagner 1984, 10–19, compare also Heyting 1994, 22.
4. Suze Robertson, *Old Woman at a Table with a Coffeepot*, black chalk, stumped, on cardboard; 572 x 379 mm (22 1/2 x 15 3/4 in.); signed lower left in black chalk: *Suze Robertson*. Museum Boijmans Van Beuningen, inv. MB 583; provenance unknown, acquired before 1940.
5. "How masculine is this woman's vision of poverty!" wrote A. de Meester-Obreen, in the foreword to the exhibition of Suze Robertson and her daughter Sara Bisschop. See Smithuis 1993, 104.
6. The heavy application of oil-soaked chalk to emphasize certain points of expression in the face has resulted in a high concentration of oil, which has led to a shiny effect on the surface. Restoration is not possible.
7. Käthe Kollwitz, *Mother with Child*, black chalk, Museum Boijmans Van Beuningen, Rotterdam, inv. MB 587.

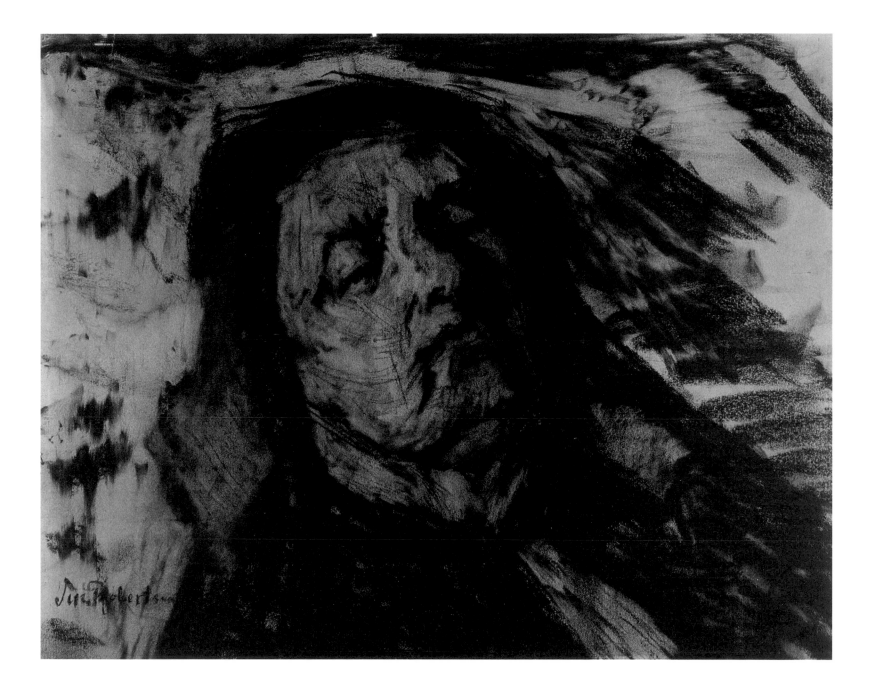

GEORGE HENDRIK BREITNER

Rotterdam 1857–1923 Amsterdam

59 Military Inspection

c. 1881

Watercolor with accents in white bodycolor, 510 x 643 mm (20 1/8 x 25 3/8 in.)

Signed lower right in black paint: *G H Breitner*

Watermark: illegible

Inv. MB 548

Provenance: A. J. Domela Nieuwenhuis, Munich/Rotterdam; acquired in 1923

Literature: Hannema 1927, 161, no. 777; Hefting 1983, 20, no. 5

Breitner was born on September 12, 1857, in Rotterdam, the son of a grain importer.[1] The young Breitner worked for a short time in the family business before he turned entirely to art, for which he had early shown a great propensity. He took lessons in Rotterdam and then, on the recommendation of Charles Rochussen (1814–94, see cats. 28 and 29), enrolled at the art academy in The Hague. Shortly thereafter he gained his certificate that qualified him to become a drawing instructor. Indeed, for a short time Breitner did teach in Leiden (1878–79) and in Rotterdam (1882–83), but without great success. One of his pupils in Leiden was the artist Floris Verster (1861–1927, cat. 71), who recalled that during the lessons Breitner would draw horses, soldiers, and cannons on loose sheets of paper that the students were not allowed to see. In his early period Breitner was excessively fond of the military genre.[2]

Breitner remained at the academy until 1880. He then joined the group of young artists attached to the Hague school and in the same year worked on the panoramic painting that the artist Willem Mesdag (1831–1915) was preparing. In 1882 Breitner and Van Gogh (1853–90, cats. 52–56) worked together making drawings in The Hague. Van Gogh described Breitner as a "highly proficient" draftsman.[3] The two men also shared a great admiration for French novelists including Flaubert, the Goncourt brothers, and Zola. Like Van Gogh, Breitner wanted to become "a painter of the people" in the sense of the writer Jules Michelet, whom they both greatly esteemed. In his Amsterdam years Breitner would realize this ambition.

Like many lads, the young Breitner would draw battle after battle and sea-fight upon sea-fight, basing them on drawings he found in illustrated magazines. But in his case the habit did not die out with childhood, and in 1881 he went to Brabant in the southern Netherlands to attend military exercises there. For him this proved a rich source of paintings and watercolors. In December 1881 he wrote to his patron A. P. van Stolk, telling about a number of drawings that he had submitted for a competition organized by Pulchri Studio, the artists' society in The Hague. Breitner explained, "Of course [my drawings] are of soldiers and of course people again say my work resembles that of [the French painter] Neuville. Although the man never sees a spot of color."[4] The artist-critic Jan Veth (1864–1925) once quoted an anonymous critic about Breitner's inspiration sources: "[he] is clearly besotted with Detaille and Neuville and frequently produces very colorful cleverly washed pieces featuring horsemen."[5] Breitner's reaction to this sort of remark was resigned: "the press declared that it was quite simply a copy of a French military piece—ah well, thank heavens such remarks don't upset me too much."[6] Just as well, because the critics were quite right.

The art historian Paul Hefting has quite rightly likened Breitner's *Military Inspection* to the painting *Rencontre d'un officier blessé* (Encounter with a wounded officer) by Alphonse de Neuville (1835–85). Indeed, Breitner himself described his work that he submitted for a viewing at the Amsterdam artists' society Arti et Amicitiae as representing "an officer mounted on a white horse speaking to a trumpeter."[7] While De Neuville adopted a dramatic tone with his wounded officer, it looks as if Breitner, with his unintelligent, bandy-legged trumpeter, is seeking a comic effect. Unlike France, the Netherlands had not seen any battles fought on its territory for many years, and wounded officers were a completely unfamiliar phenomenon. This kind of thigh-slapping humor gives his large watercolor the nature of an old-fashioned illustration despite the freedom of its execution. The military inspection takes place during a thaw. The dappled white of the horse forms a point of rest in the composition while the road, on which there are still remains of snow, suggests a forceful movement. The group of horsemen, the trumpeter, and the cannon that is just being pulled away form a slightly semicircular frieze across the line of vision. This is a tried and tested method of composing a scene. As is usually the case, Breitner has combined a broad, painterly treatment, whereby he also used white bodycolor, with finely-drawn details. The slender legs of the horses, faces, and parts of the cannon are rendered with great accuracy.

Breitner was a virtuosic watercolorist, and this made a deep impression on his fellow artists in The Hague who saw him at work on the evenings organized by the artists' society Pulchri Studio. In her famous study of Dutch nineteenth-century art, "Miss" Marius discusses this. Breitner would begin a watercolor on a pad that he held fast between his ankles, so that he could gain a certain distance, with "the color dripping in accurate values of the tones he had painted." It was again the tones that mattered. The onlookers saw "out of the wetness soaked with color, the white of an apron, the blue of a soldier's uniform, emerging, and cried out with tremendous appreciation 'who can paint like him?'" The appreciation was for the sensitive use of color. Jan Veth also provided early testimony to the blotchy, suggestive method of working. His reporter referred to work dealing with military horsemen and furthermore "a number of blotches that are supposed to represent a flower market, one daub that is meant to be a drunkard leaning against a wall, in which, if you look carefully, you can undoubtedly detect the figure."[8] Both these descriptions sound as if the writer is familiar with the methods of Edouard Manet (1832–83) and the later French impressionists in their manner of depicting a figure as a silhouette in one tone. In French the word used is *tache*, a mark or blot. Manet was preoccupied

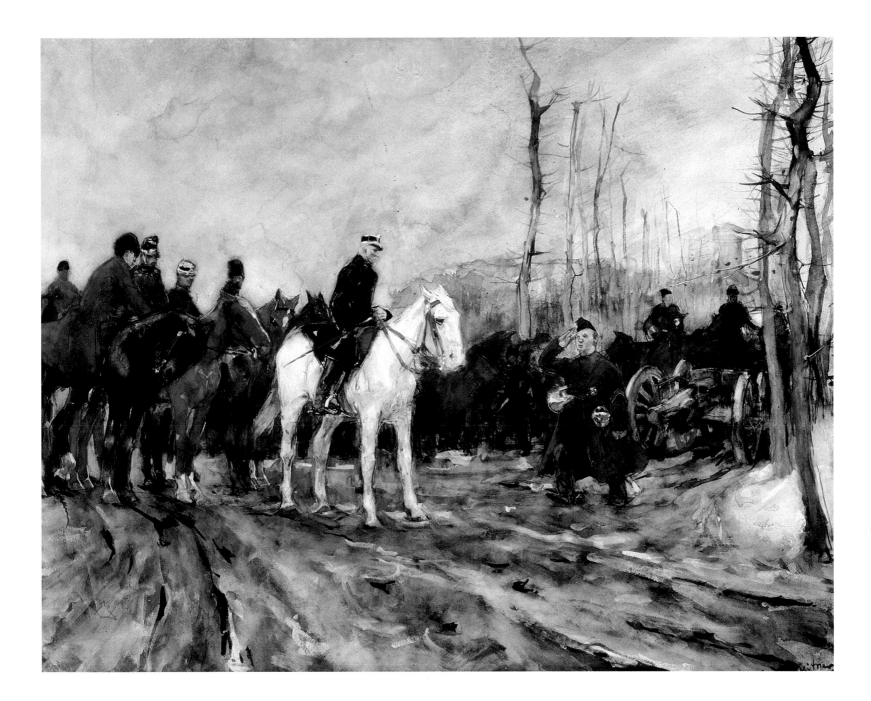

GEORGE HENDRIK BREITNER

Rotterdam 1857–1923 Amsterdam

60 Flower Market

c. 1889

Watercolor over black chalk, 442 x 333 mm (17 3/8 x 13 in.)

Signed lower left in blue paint: *G. H. Breitner*, verso, lower right in pencil: *Atel. G. H. Breitner*, with *Hidde Nijland* written underneath

Inv. MB 537

Provenance: J. Hidde Nijland, Dordrecht; gift of A. Veder-van Hoboken, Rotterdam 1929

Literature: Rotterdam 1929, 7; Bol 1955, 29, no. 180; Hammacher 1956(1), no. 52; Hefting 1970, no. 133; Hefting 1983, 22, no. 16

by "the mark that the movement of a silhouette makes in the air." These painters were called *tachistes*, artists who made small marks or blots.[9]

The watercolor of the woman in black and two children standing in front of a flower stall (cat. 60) is a masterpiece in this *tachiste* style. Veth's reporter mentioned the flower market as one of Breitner's subjects. In this watercolor too Breitner combined large, blotchy areas, with the wash removed in sections, for example where the flowers are, with detailed parts that he applied with a pen and thinned paint. In this way the woman, dressed perhaps in mourning, acquires a delicacy that turns this work into a sophisticated piece reminiscent of fashion prints that the poet Charles Baudelaire had strongly recommended for the study of "the painter of modern life."[10] Since the woman's dress has not one but

two bustles and in view of the style of her bonnet, it would seem that this watercolor was made about 1889. The identity of the lady in black remains a mystery.

The broader way of watercolor painting, emphasizing the values of color tones, produced criticism from the older generation. One of their spokesmen, the writer J. A. Alberdingk Thijm, declared in 1881 that: "Painters avoid the expression 'watercolor drawing'—they prefer to use the term 'aquarelle'; probably because they sense that the drawing has been lost along the way." Drawing was equated more and more often with literature. Modern painters like Breitner were only busy "seeking color effects" according to Thijm.[11] And it is true that in Breitner's later work there is a great difference between his watercolors and his drawings, which increasingly acquired the nature of brief jottings in swift lines.

GEORGE HENDRIK BREITNER

Rotterdam 1857–1923 Amsterdam

61 Recumbent Nude

c. 1890

Black chalk, 445 x 604 mm (17 1/2 x 23 7/8 in.)

Signed lower right in black chalk: *G. H. B.* and traces of rubbed-out annotations: . . . *101*; inscribed twice in the center in black chalk: *binnenkant*; verso, *Study of Horses and Horseman*, black chalk

Watermark: DG, countermark: PL BAS

Inv. MB 1966/T8

Provenance: M. E. Mak van Waay, Amsterdam; acquired in 1966

Literature: Hefting 1983, 28, no. 77; Bergsma 1994, 111, no. 38

The rapid sketch of a recumbent nude (cat. 61), consisting of one or at most two curved lines with a suggestion of light and shade, must have been made when Breitner was living in Amsterdam, possibly shortly before 1890. There is a photograph showing a slightly different pose.[12] In the drawing the thighs are pulled up more than in the photograph so that the pelvis is tipped and the buttocks stick out in a pronounced fashion. The light falls from the left. The model's right thigh catches the most light, and the rest of her body and face are in shadow. The overall shape is an oval in which the body is contained. Breitner wrote the word *binnenkant* (inside) on the right and left of the legs, probably meaning that the inside of the cloth (perhaps a kind of cape) apparently had a different color on its reverse. There is a piece of drapery that Breitner used in several of his paintings, possibly the same one. The drawing has traces of rubbed-out scribbles, words, and numbers and fits into a series Breitner made of daring nude studies in the tradition of Manet and Edgar Degas (1834–1917) and the new art of photography.

GEORGE HENDRIK BREITNER

Rotterdam 1857–1923 Amsterdam

62 Seated Woman in a Kimono

c. 1890

Black chalk, 440 x 238 mm (17 3/8 x 9 3/8 in.)

Signed lower right in black chalk: *G. H. B*; verso, *Studies of Women Wearing Hats*, black and colored chalk

Inv. MB 585

Provenance: Acquired from the art dealer Frans Buffa & Zonen, Amsterdam 1942

Literature: Hefting 1983, 28, no. 73

Breitner's drawings of girls dressed in kimonos must have been made during the 1890s in Amsterdam. One shows a standing girl in a kimono[13] looking into a small mirror at her reflection as she adjusts the belt at her back. In a moment she will sit down on a small stool, looking straight at the artist as in cat. 62. The reflection in the exhibited work shows her face in profile. It is a composition that painters have used through the centuries but none the less effective for that. Apart from this drawing there are others, as well as photographs, that reveal Breitner's working methods.[14] Like the French sculptor Auguste Rodin (1840–1917), Breitner asked his model to walk around naturally, picking things up and so forth, fastening a belt, doing her hair, putting on an earring. The latter attitude is the subject of one of Breitner's well-known paintings in the Boijmans Museum, and he also made a painting showing a nude in front of a mirror. It seems as if Breitner made many studies of his models as they moved in a relaxed manner, thereby accumulating ideas for his paintings. These sketches should not be regarded as preliminary studies as such. Breitner finally chose the earring-fastening rather than the belt-adjusting motif because the former movement is far more elegant and, more important still, it creates a long slim silhouette, almost an abstract *tache*. The fact that Breitner's work, with the kimono and the slim silhouette, echoed the fashionable Japanese prints of the time is no coincidence.

EvU

1. The artistic development of the young artist was profoundly influenced by the grain merchant and art collector A. P. van Stolk. Between the years 1877 and 1883 Van Stolk acted as patron for the young George. The letters that Breitner wrote to his patron form an important source of information about his development as an artist; compare Breitner 1970.
2. The most authoritative article is still that by Jan Veth, "Breitners jeugd" (Breitner's youth), the last versions in Veth 1908. See also for Breitner Hefting 1970 and Bergsma 1994.
3. "From time to time these days I go out drawing with Breitner, a young painter who is studying with Rochussen in the same way as I am with Mauve," wrote Vincent van Gogh on February 13, 1882, referring to the artists from whom they received advice. "He draws very skillfully and very differently from how I do, and we often make sketches together—types we see in the public soup kitchens or in a waiting room and so forth. He sometimes comes and visits me at the studio to look at wood engravings, and I also visit him." Van Gogh 1990, 502, letter 203 [174].
4. Breitner 1970, 26, letter 18.
5. Veth 1908, 189, and Hefting 1970, 141.
6. Breitner 1970, 26 and 71, letter 17.
7. Hefting 1970, 133, cites Breitner's letter to the secretary of Arti dated 1885.
8. Marius 1920, 198–99; Veth 1908, 194.
9. Camille Lemonnier (1878), cited in Riout 1989, 205. With regard to the word *tache*, the Frenchman Félix Bracquemond wrote: "This mode of viewing color and tonal values is again the reason why 'ton local' is expressed by 'tache,' or blotch; hence the epithet 'tachiste' given to painters who make use of this method." And he goes on to say that examples of this style can be found in Persian, Chinese, and Japanese art; Bracquemond 1885, 42.
10. Baudelaire's *Le Peintre de la vie moderne* first appeared in 1863. In the chapter entitled "Le croquis de moeurs" (a sketch of customs), Baudelaire said: "But in trivial life, in the daily metamorphosis of external things, there is a rapid movement that demands of the artist an equal speed of execution," and this is relevant to this watercolor by Breitner. Baudelaire 1962, 457.
11. Cited from Brom 1927, 73. Thijm's remark dates from 1888.
12. See Tineke Ruiter, "Foto's als schetsboek en geheugensteun" (Photographs as sketchbooks and mnemonics), in Bergsma 1994, 193 and 204.
13. George Hendrik Breitner, *Girl in a Kimono before a Mirror*, black chalk, 435 x 280 mm (17 1/8 x 11 in.); verso: *Woman with Her Hands on Her Back*, black chalk; watermark: MBM. Museum Boijmans Van Beuningen, Rotterdam, inv. MB 1954/T3; provenance: private collection, Haarlem; the art dealer Frans Buffa & Zonen, Amsterdam; Paul Brandt, Amsterdam; his auction, Amsterdam, 5–8 april 1954, lot 270.
14. See Weerdenburg 1994, 128–29. Underneath the painting *Meisjes in de sneeuw* (girls in the snow) Breitner originally painted a seated nude seen from the back, in front of a mirror; there is a similar drawing as well. The photographs by Breitner have so far not been published in a complete or thorough version. See Osterholt 1974 and Hefting 1989. In his book on Breitner, A. van Schendel reproduced a drawing of a girl in a kimono, seen in profile. She holds a ginger pot, and her profile is reflected behind her in a mirror; compare Van Schendel 1939.

HENDRIK JOHANNES HAVERMAN

Amsterdam 1857–1928 The Hague

63 *Portrait of Jacob Maris*

1898

Black chalk, accents in colored chalk, brush and black paint, accents in white bodycolor, 510 x 498 mm (20 1/8 x 19 5/8 in.)

Signed and dated right in black chalk and brush with black paint: *1898 H. J. Haverman.*

Inv. MB 552

Provenance: Acquired in 1899

Literature: Marius 1902, 11; Haverkorn van Rijsewijk 1909, 327; Schmidt-Degener 1916, 158, no. 788; Schmidt-Degener 1921, 180, no. 788; Bolten 1967, 73, no. 37; Bionda 1991, 224

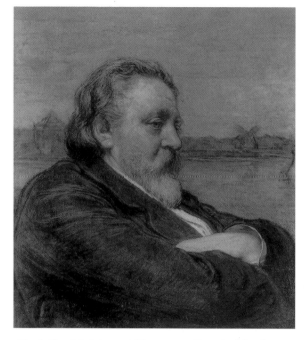

Fig. 1. Hendrik Johannes Haverman, *Portrait of Jacob Maris*. Gemeentemuseum, The Hague

Like many of the artists in the group known as the Schilders van Tachtig (painters of the 1880s), Haverman studied at the Rijksacademie in Amsterdam under August Allebé (1838–1927). Although he also painted nudes and intimate tableaux of mothers with their children, Haverman became renowned in the nineteenth century for his portraits. Together with Jan Veth (1864–1925), his contemporaries saw him as a representative of the new approach to portraiture in which a good likeness of the sitter was no longer considered sufficient. The painter had to try to analyze the character of the subject and allow this to emerge from the portrait.[1] Like Veth, Haverman painted and drew many portraits of famous contemporaries.

The drawing exhibited here pictures the artist Jacob Maris (1837–99, compare cat. 43), a celebrated Dutch painter at the end of the nineteenth century. It was painted in 1898 according to the inscription. The portrait was done on the same brown paper and in black chalk with accents in colored chalk. Haverman used white bodycolor mainly to emphasize the face, which he worked on in detail. This treatment of the face contrasts with the rest of the body, which is drawn in a more sketchy manner. The artist is pictured seated with his arms crossed. The background, a painting by the subject, remains vague. Veth and Haverman "view the background of the figure as a factor that has more to do with the imagination than with reality," explained a contemporary critic.[2] In emulation of his younger colleague Veth, who transferred his portraits to the lithographic stone for publication in *De Amsterdammer* and *De Kroniek*, Haverman published most of his portraits in magazines also.[3]

The chalk drawing of the portrait of Maris is a precise preparatory study for the painting that hangs in the Gemeentemuseum in The Hague (fig. 1).[4] Haverman made only slight changes to the painting in the background, removing the mooring post but keeping the haystack and windmill. He also "zoomed in" on the figure of Maris, leaving only the head and crossed arms visible. In this way the robust figure of the painter appears even more substantial against the background. Haverman felt great admiration for the artist: "Jacob Maris is so exceptional that one can learn as much from him as one can learn from all great artists."[5] Haverman painted Maris' portrait three times, twice with him standing before his easel.[6] However, these pictures lack the imposing nature of the portrait in the Gemeentemuseum in The Hague and the drawing in the Museum Boijmans Van Beuningen.

MdH

1. De Boer 1918, 364.
2. H. de Boer, see De Boer 1918, loc. cit.
3. This type of reproduction was often published as a lithograph, sometimes as a wood engraving. The results of the latter technique, according to contemporary opinion as well, tended to be less successful. On seeing a portrait of Lodewijk van Deyssel by Haverman in *Woord en Beeld*, Veth wrote: "The modest chalk drawing (to which the poorly executed wood engraving does scant justice) is a triumph." Veth 1905, 161.
4. *Portrait of Jacob Maris*, oil on canvas, Gemeentemuseum, The Hague, inv. 6–1941.
5. See De Boer 1918, 362.
6. *Portrait of Jacob Maris*, 1897, gouache, Musée des Beaux-Arts de Montreal; a portrait of Jacob Maris, seated before a canvas with brush and palette in his hand, whereabouts unknown, illustrated in the 1903 catalogue of the art dealer J. C. Schüller in The Hague.

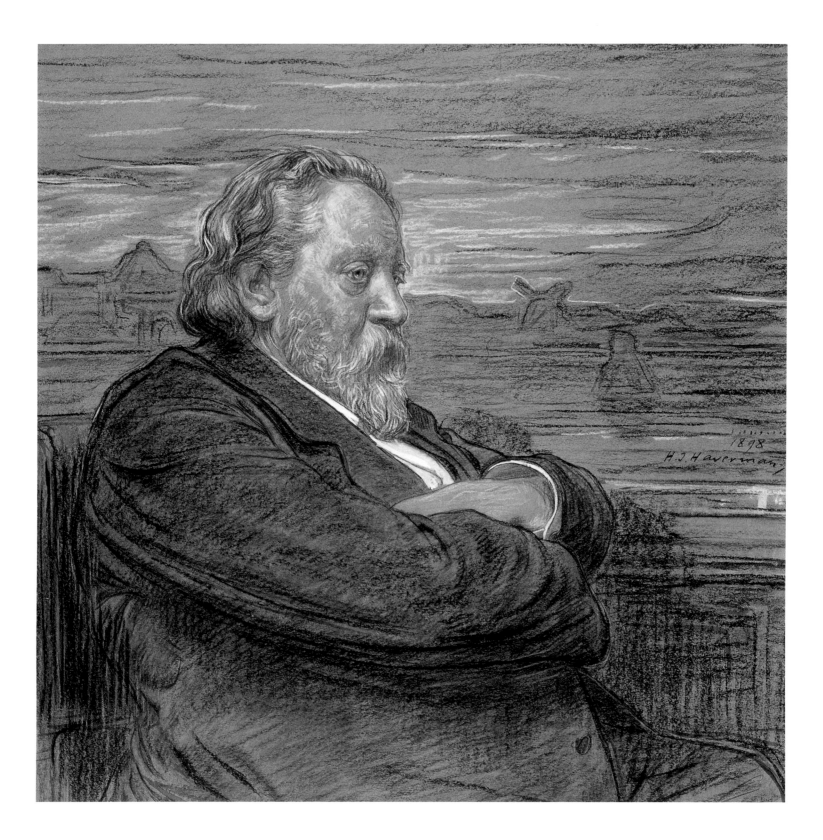

JOHANNES THEODORUS TOOROP

Poerworedjo 1858–1928 The Hague

64 The Strike (Thirst for Justice)

1899

Black chalk, stumped, accents in light blue, red, and white chalk on cardboard, 633 x 764 mm (24 7/8 x 30 1/8 in.)

Signed lower right in black chalk: *J. tH. Toorop 1899*; verso, inscribed in black chalk: *Werkstaken*

Inv. MB 564

Provenance: Oppenheim collection; the art dealer J. H. de Bois, Haarlem (1913–26); Kleykamp collection, The Hague; his auction, The Hague, June 2, 1931, lot 34; gift of several Rotterdam citizens, Rotterdam 1931

Literature: Molkenboer 1918, 5–48; Plasschaert 1925, 38, no. 21; De Boer 1926, 18–19, no. 12; Van Gelder 1928, 34, no. 51; Knipping 1929, 25–26; Rotterdam 1931, 8, 15; Hannema 1931–32, 22, no. 55; Utrecht 1941, 13, no. 68; Mertens 1969, 157–206, no. 12; Heijbroek 1993, 138

Jan Toorop made his most important symbolist works in the 1890s, culminating in *Sphinx* of 1897. He alternated the linear style he used in *Sphinx* with a naturalistic way of working. This found its expression in his pencil and chalk portraits, which were often exceptionally precise and aesthetically refined. It is also to be seen in his more direct, realistic scenes such as *The Strike*, in which the lines are far coarser. This drawing, also known as *Thirst for Justice*, is dated 1899 and has been drawn in forceful black chalk lines heightened with a few color accents. A large group of workers fills the whole picture surface like a frieze. In the center standing with legs astride is presumably the strike leader who has demonstratively dug his spade, a traditional symbol for work, into the ground in front of him. The drawing style— heavy wooden lines, almost diagrammatic faces, and strikingly large, gesticulating hands—was also used by Toorop later in his life.

The drawing was often printed and written about in early studies of Toorop, an artist with Socialist leanings before he converted to Catholicism in 1905. One could ask why this drawing was so successful. In 1917 the Catholic historian Gerard Brom wrote that Toorop made this drawing in response to a rebellion provoked by the eviction of a poor man from his house.[1] "This work, as a curse might do, ended the respectful mood of works like [Toorop's earlier] 'Respect à la mort,' and Toorop today does not disown that early period, only the rebellious middle years." Here Brom referred to the time of Toorop's acquaintance with the Dutch writer Herman Heyermans with whom in around 1900 he fought for better conditions for the poor fisher folk of Katwijk, a village on the coast north of The Hague. Brom concluded: "In the meantime Socialism could no longer satisfy Toorop, who by then had more or less grown out of his revolutionary beliefs." Twelve years later, in 1929, in a book commemorating Jan Toorop, the writer Jan Nieuwenhuis suggested that Toorop's social conscience had found its apotheosis in the drawing *Thirst for Justice*. He admired it because it emanated a pure and indomitable conviction that the cause was just.[2]

Nieuwenhuis could speak of an apotheosis because Toorop had sided with poor farmers and other workers much earlier in his career. Thus his work from the earlier Machelen period already gives an impression of where his social sympathies lay. He had tried the strike as a subject in two pointillist paintings called *Before the Strike* and *After the Strike*, which might have been made after a job action that took place in the industrial town of Charleroi in Belgium in 1886. However, the strike pieces are very different from one another. While the two earlier Machelen paintings emanate a sense of intimacy and melancholy, the exhibited drawing displays the resolution of a group of workers who have laid down their tools.

It is not probable that the drawing in the Boijmans Museum should be seen as an eye-witness report of the strike; the composition is far too deliberate for this. The alternation of men and women in the group cannot be coincidental, and even less so the foreman's short red jacket. Toorop said himself that he had built up *Thirst for Justice* around a single central figure, like hungry wolves around the leader of the pack.[3] In fact, he probably seized upon this demonstration in order to once again display his sense of social commitment, deliberately choosing a realistic way of working for this purpose. After this he did not draw any more of these provocative scenes. The drawing's provenance also tells us that this strike scene was difficult to sell.[4] With hindsight, one can see why. The combination of a naturalistic style with exaggerated expressiveness is far from happy; nor, at the beginning of the twentieth century, would it have been regarded as particularly modern, even less so when taking the socialist iconography into account. This is why Toorop came to regret this scene by 1917, as Brom has clearly stated, but by then Catholicism had become a more reliable and lucrative alternative. The fact that this drawing is nevertheless often written about and admired is thanks to Toorop's mainly Catholic biographers. The drawing, they felt, was preeminently suitable for expressing their admiration of Toorop. It served as proof of the "masterly and impressive way" with which Jan Toorop had caught the "soul" of the common people.[5]

IG

1. Brom 1916–17. A shorter version of this essay has been published in 1918 in the periodical *Wendingen*. Brom's article is repeated almost word for word by J. B. Knipping, in Knipping 1947, 25–26.
2. Nieuwenhuis 1929, 6.
3. Brom 1916–17, 503.
4. Heijbroek 1993, 138. From 1913 on De Bois repeatedly put this drawing up for sale; he had to keep it in stock until 1926.
5. Knipping 1947, 26.

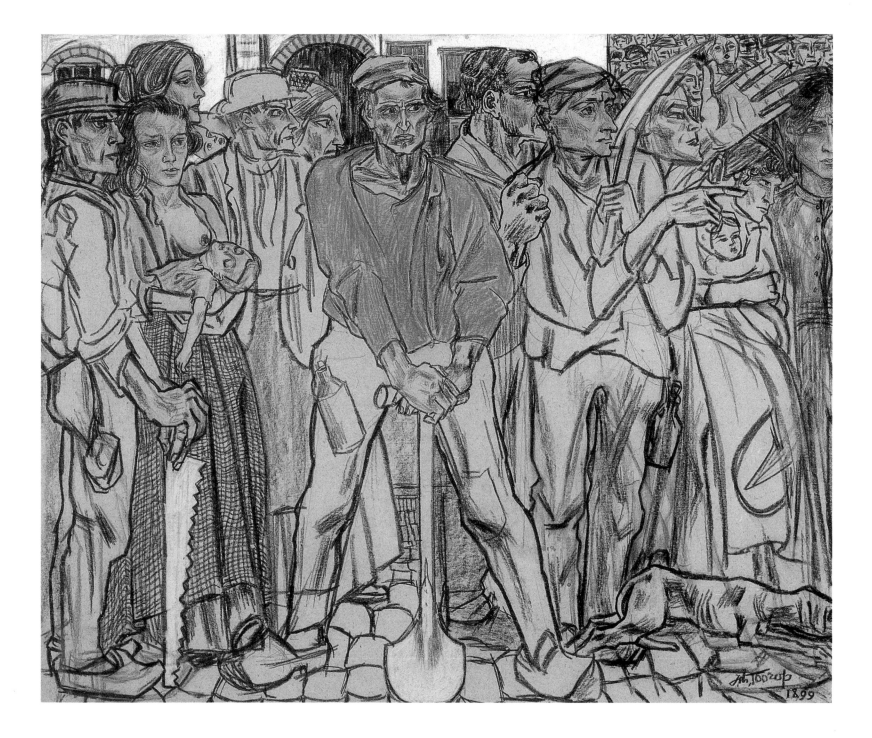

JOHANNES THEODORUS TOOROP

Poerworedjo 1858–1928 The Hague

65 *Faith in God*

1907

Black and colored chalk and pencil, 579 x 435 mm (22 3/4 x 17 1/8 in.)

Signed and dated at the right of the center in pencil: *JTh Toorop 07*; pinholes in the four corners; verso, signed lower right in pencil: *J. Toorop*

Inv. MB 557

Provenance: E. Flersheim, Frankfurt; gift of W. der Vorm and H. van Beek, Rotterdam 1943

Literature: Viola 1909, no. 82; De Boer 1911, 125; Viola 1912, 16, no. 18; Plasschaert 1925, 16 and 47, no. 15; De Boer 1926, 57, no. 28; Knipping 1929, 25; Van de Oudendijk Pieterse 1929, 6–7; Loosjes-Terpstra 1959, 78; Van Daalen 1962, 11, no. 18; Hefting 1988, 141, no. 102; Van Vloten 1994, 82, no. 45, and 122, no. 81

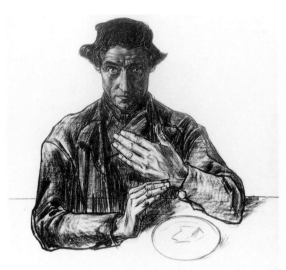

Fig. 1. Johannes Theodorus Toorop, *Simon Zelotes*. Stedelijk Museum, Amsterdam

To the day he died, Toorop did much work that bears witness to his Catholic inclinations. This is true of the drawing *Faith in God* (1907). A Zeeland farmer, depicted frontally, is looking upward to a point beyond the picture with no outward display of emotion. The Domburg farmer Pieter Provoost (Pier van Jille) had served as a model for this drawing. In his treatment of the background the artist has emphasized the depth of Provoost's faith. In front of a mullion window is the head of the farmer drawn slightly off-center, while to the right the resolute Westkapelle lighthouse emerges as a symbol of faith, bringing light into the darkness. According to information gathered at the time it was built, the lighthouse had special symbolic significance for Toorop because the tower stood close to the spot where Saint Willibrord had landed: "where they have fought for the faith with the cross on their banners."[1] For the series of

Fig. 2. Johannes Theodorus Toorop, *Christmas Triptych* (detail). Whereabouts unknown

Apostles' heads, drawn in black chalk (compare *Simon Zelotes* (fig. 1), and also for his *Christmas Triptych* (fig. 2, 1908, also called *The Word Becomes Flesh*), well-known in Catholic circles, Toorop turned again to Zeeland farmers as models.[2] Once again, these were grave, very naturally rendered portraits that were possibly made less convincing by the emphatic gestures of the men, which seem more theatrical than persuasive.

Toorop found the style of composition for *Faith in God* in early Renaissance portraiture, where people are depicted in a similar way in front of a window gravely staring out to a point beyond. The very detailed style of drawing using fine contour lines, which clearly release the head from the background, is also fifteenth-century in style. Finally, the church tower in the distance is reminiscent of Jan van Eyck's (c. 1390–1441) famous painting *Saint Barbara*.[3]

IG

1. Van Daalen 1962, W18. It is interesting to note that the drawing was already reproduced on the cover of an exhibition catalogue on Jan Toorop and other artists working in Zeeland in 1912. This notwithstanding the fact that *Faith in God* was not even exhibited on this occasion; see Van Vloten 1994, 122, fig. 81.
2. Concerning the triptych, of which the present location is unknown, see Van Vloten 1994, 134–35, fig. 93. On the right side of the painting, Pier van Jille is again portrayed. The drawing of Simon is in the Stedelijk Museum, Amsterdam.
3. In the collection of the Koninklijk Museum voor Schone Kunsten, Antwerp (inv. 410).

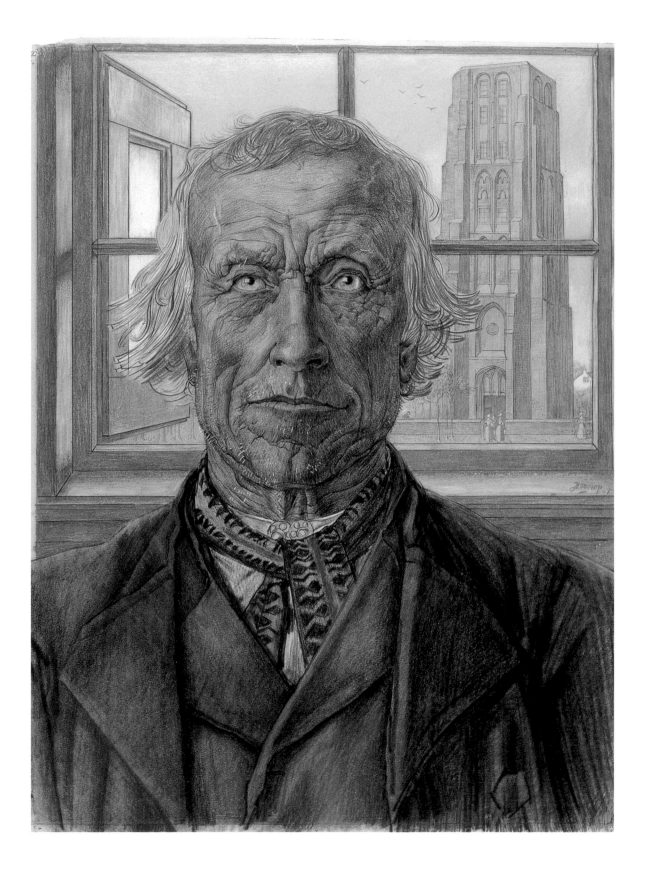

WILLEM BASTIAAN THOLEN

Amsterdam 1860–1931 The Hague

66 *View of Roofs*

Watercolor, 253 x 470 mm (10 x 18 1/2 in.)

Four pinholes in the corners; signed lower right with brush and brown paint: *WB. Tholen*.

Inv. MB 562

Provenance: A. J. Domela Nieuwenhuis, Munich/Rotterdam; acquired in 1923

Literature: Hannema 1927, 173, no. 846; De Jong 1993, 93, no. 117

Willem Tholen studied under August Allebé (1838–1927) at the Rijksacademie in Amsterdam in the mid-1870s. Among his contemporaries were Piet Meiners (1857–1903), Willem Witsen (1860–1923, compare cats. 69 and 70), and Anthon van Rappard (1858–92).[1] He therefore belonged to the generation of artists who, on one hand, developed in the wake of the Hague school and, on the other, were in very close contact with the Dutch movement of the 1880s. Tholen's solidarity with the Hague school can be seen in work from as late as the 1890s, for example in his famous painting *The Skaters in The Hague Wood* (1891), in which Jacob (1837–99, see cat. 43) and Willem Maris (1844–1910, see cat. 51) and J. H. Weissenbruch (1824–1903, compare cats. 38–41) are clearly portrayed.[2] He got to know the group of painters known as the Tachtigers (artists of the 1880s) at Ewijkshoeve, the country residence of Willem Witsen, where Tholen, like his friend Meiners, spent many months.[3]

In Tholen's early paintings from the beginning of the 1880s, when he was based in his birthplace of Kampen in the north of the Netherlands, the influence of the Hague school painter Paul Gabriël (1828–1903, cat. 42) is particularly visible. Tholen spent the summer of 1879 working with Gabriël. Later, undoubtedly under the influence of friends such as Witsen and Jan Veth (1864–1925), with whom he founded the Netherlands Etching Club, Tholen's work gained an almost graphic character with strong contrasts between light and shade. The specific, somewhat theatrical lighting can be seen in both the drawings exhibited here. The rather dreamy, undated drawing *View of Roofs* is one of Tholen's favorite themes, the *doorkijkjes* (through-views), which he painted all his life. The window frame is often drawn in or painted right up against the picture frame. He is clearly concerned here with the fall of light on the various forms and volumes rather than topographical exactitude.

174

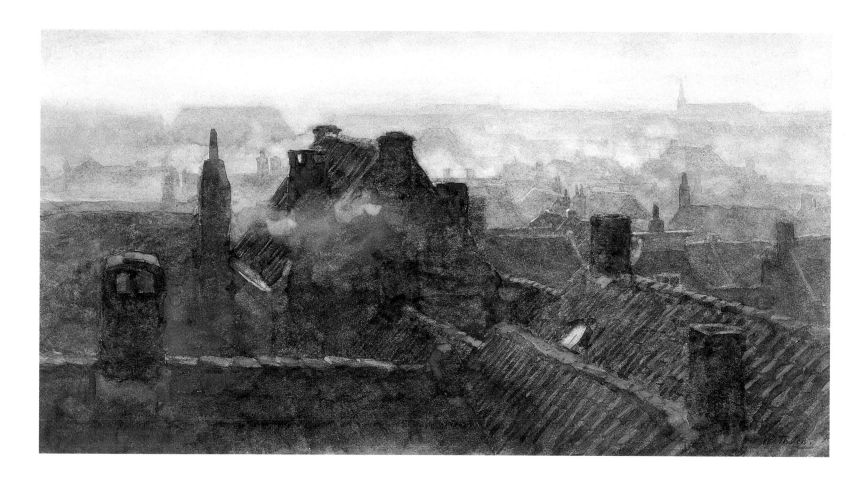

WILLEM BASTIAAN THOLEN

Amsterdam 1860–1931 The Hague

67 Making Paper

Black chalk, accents in blue chalk, gray washes, accents in watercolor, 496 x 648 mm (19 1/2 x 25 1/2 in.)

Signed lower left with brush and black paint: *Tholen*

Inv. MB 551

Provenance: G. Knuttel, The Hague; acquired in 1937

Literature: Rotterdam 1937, 6-7

In the chalk drawing *Making Paper*, Tholen's search for clarity is even more apparent. The large white surfaces of the paper, with which the men in the paper mill are working and which determine the composition of the drawing, are literally depicted by Tholen's own white paper, which has been left unpainted in places. *Making Paper* is one of a large series of pieces in various techniques that Tholen made in a paper mill at Vaassen near Apeldoorn between 1898 and 1907.[4] Tholen's lyrical biographer, G. Knuttel, Jr., described them in 1927 as follows: "The pure portrayal has become a poem, full of the tenderness of hesitatingly falling light in which rubbish and rags are transformed into beautiful bouquets of color."[5]

SdB

1. For biographical details see Bionda 1991, 271, and De Jong 1993, 142–43.
2. Haags Gemeentemuseum, The Hague. Also see De Jong 1993, 68.
3. Compare Van der Wiel 1988.
4. This series is in the collection of the Boijmans Museum. The drawings were published separately in 1958, see Schulte 1958.
5. G. Knuttel, Jr., in *Catalogus tentoonstelling van tekeningen* (January 1927), 27. Cited in De Jong 1993, 88–89. See also Knuttel 1944.

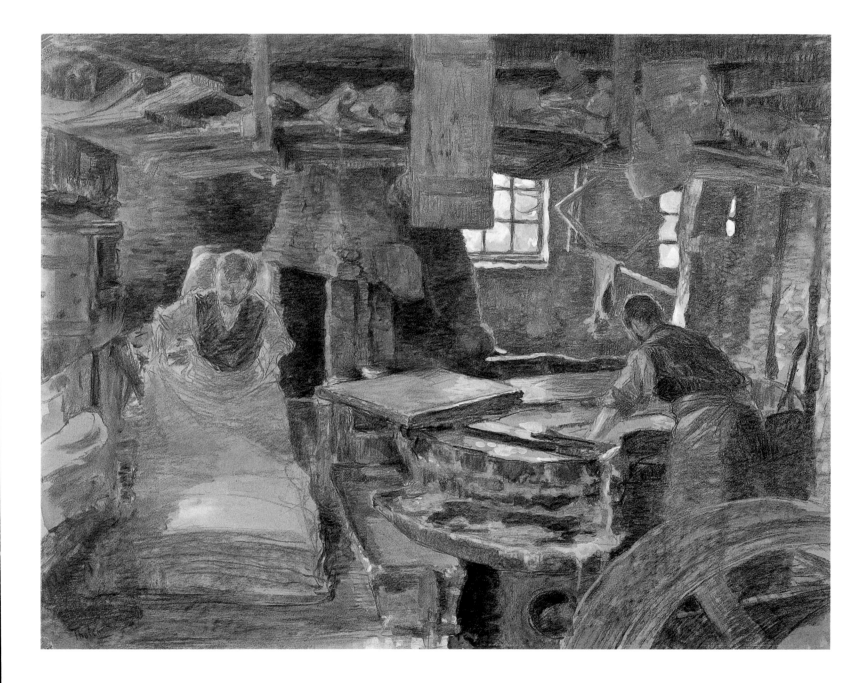

JOHAN EDUARD KARSEN

Amsterdam 1860–1941 Amsterdam

68 The Deserted House (Self-portrait)

c. 1890

Black chalk, gray washes, stomped, 428 x 316 mm (16 7/8 x 12 3/8 in.)

Signed lower right in black chalk: *J. Ed. Karsen*

Inv. MB 1994/T11

Provenance: R. Bionda, Purmerend, acquired in 1994

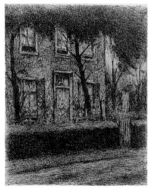

Fig. 1. Johan Eduard Karsen, *The Deserted House.* Museum Boijmans Van Beuningen, Rotterdam

"The drawing by Karsen leaves me with a sense of all the mournful beauty of a cold October evening. Karsen is an emotional artist. His art is a highly individual art of moods." So wrote Willem Witsen (1860–1923, compare cats. 69 and 70), and although this comment was not made about the Rotterdam drawing, it might well have been.[1] In black chalk Karsen has drawn this somber house looming up behind a hedge and trees. It appears to have been done on a dark day or at dusk. The house, rather than being inviting, gives the impression of being closed and deserted.

Like much of Karsen's work, the sheet is not dated.[2] However, in an etching entitled *The Deserted House* that was published in the fifth album of *De Nederlands Etsclub* (The Netherlands etching club, fig. 1),[3] Karsen portrayed the identical scene in 1890 and probably made both in the same year. There is also an undated painting in the same dark shades of *The Deserted House*.[4] The exhibited drawing was probably not a preparatory study for the painting, because the drawing is so highly finished that it was more likely intended as a work of art in its own right, possibly even made from the finished painting.

Karsen liked to paint houses and city scenes, particularly in Amsterdam where he lived and work. It is possible that he was somewhat influenced by his father, Kaspar Karsen (1810–96, see cat. 25), who specialized in cityscapes.[5] Where Karsen senior chose full daylight for his romantic city scenes, Eduard preferred dusk or dark, misty days. He depicted the busy sections of Amsterdam, such as Het Spui, in the lonely silence of morning or late evening.[6] He had an aversion to the modern "progress" of the city. At the age of sixty-four he spoke out against the mutilation of this city on the river IJ and the excesses of modern life that go hand in hand with haste and speed.[7] He did not portray reality, but rather the city of his imagination; in the words of Albert Verwey, "He preferred to dream about reality."[8]

The dreamy, miserable, mysterious atmosphere in the artist's work is often connected with the personal tragedy in Karsen's life that took place around 1890. His extreme reaction to his unrequited love for the artist Saar de Swart (1861–1951) was to be a turning point in his work and the reason for his isolated existence thereafter.[9] The matter-of-fact critic A. C. Loffelt saw things in a very different light in 1895: "There is nothing mysterious about the obscure shadows of Karsen's character; we see too many opaque layers of paint and varnish."[10] However, most of his contemporaries, both painters and critics, were impressed by Karsen's "mysterious" paintings. Matthijs Maris (1839–1917, see cats. 47 and 48) was full of praise for his work.[11] Maris felt a particular bond with Karsen, which is not especially surprising, as their work was a far cry from the realist paintings of the Hague and Amsterdam schools. Maris lived in England, and his work showed affinities with symbolist painting, a movement at the end of the nineteenth century that reacted against the realistic representation of reality, preferring to depict a more dreamlike world of fantasy and magic. Although Karsen cannot be said to be a symbolist, his painting, etching, and drawing of the deserted house have substantial symbolist content. Karsen called this drawing a self-portrait, a dark, closed image of how he saw himself.[12] The portrayal of a particular frame of mind, sorrow, and loneliness through the image of a house was regularly used by the symbolists, as in the work of the Belgian painter Fernand Khnopff.[13]

MdH

1. Verberchem [Willem Witsen] 1888, 428.
2. Compare Hammacher 1947, 85.
3. For "Nederlandse Etsclub" see Giltaij 1976.
4. *The Deserted House*, oil on canvas, private collection. Also see Hammacher 1947, 78.
5. On Karsen senior, see Bokhoven 1976; De Bodt and Sellink 1994, 200–2.
6. Compare *Het Spui*, Rijksmuseum, Amsterdam, inv. A 2581.
7. See Hammacher 1947, 27.
8. Albert Verwey, quoted in Bokhoven 1976, 6. Karsen, after completing a commission to paint a house, was criticized by his patron, who said that the house next to his in the painting did not correspond with reality. Karsen could not bring himself to paint the modern building next to the client's house. Anecdote described in the newspaper *Algemeen Handelsblad* of 1939, press documentation Eduard Karsen, National Institute for Art History, The Hague (RKD).
9. Much has been written about this affair. See Karsen 1986.
10. Loffelt 1895(1), written in response to an exhibition of paintings by Karsen at the art dealer E. J. van Wisselingh & Co. in Amsterdam.
11. Hammacher 1947, 72–73.
12. Hammacher 1947, 78.
13. For Khnopff, see Draguet 1995.

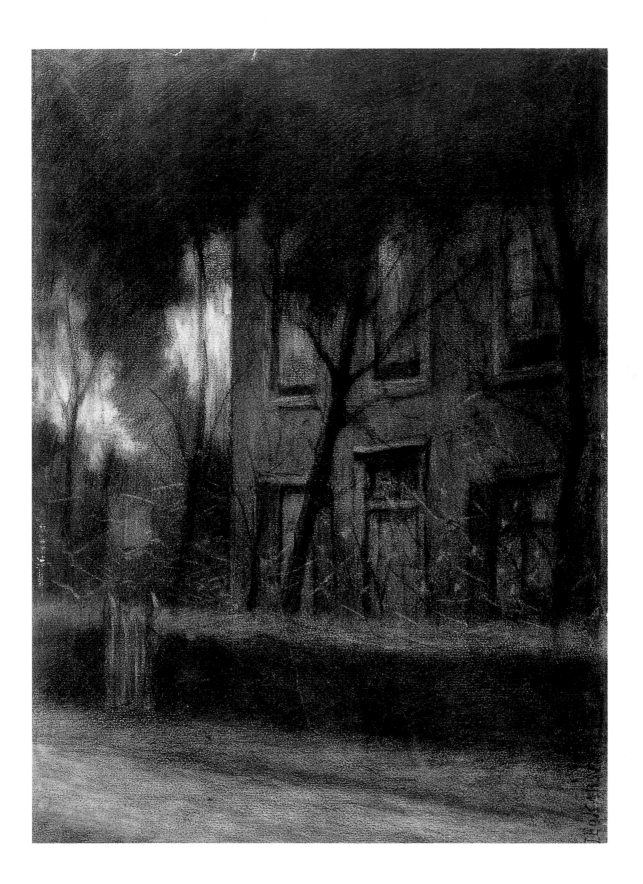

WILLEM ARNOLD WITSEN

Amsterdam 1860–1923 Amsterdam

69 *View of the Leuvehaven, Rotterdam*

c. 1897

Watercolor, 450 x 570 mm (17 3/4 x 22 1/2 in.)

Signed lower left with brush and brown paint: *WITSEN*

Inv. MB 554

Provenance: Acquired from the art dealer E. J. van Wisselingh & Co., Amsterdam 1897

Literature: Haverkorn van Rijsewijk 1909, 324; Schmidt-Degener 1916, 168, no. 860; Schmidt-Degener 1921, 191, no. 862; Hannema 1927, 176, no. 862

Willem Witsen came from a well-to-do and art-loving Amsterdam family[1] and had the good fortune to be able to devote himself to art from a young age without financial worries. He became a pupil at the Rijksacademie in Amsterdam where, under the watchful eye of the popular teacher August Allebé (1838–1927), a talented and critical generation of young artists was educated. Many of this group were to become famous as the Schilders van Tachtig (painters of the 1880s).

Witsen turned out to be a versatile artist. He quickly made a name for himself as a painter, draftsman, and etcher of subjects taken from rural life, portraits, and especially city scenes. He also wrote art criticism under a pseudonym for a number of magazines. Witsen's amiable personality and financial independence made him a central figure in the Amsterdam and thus Dutch art world at the end of the nineteenth century. As such he was involved with the founding of the artists' society *Sint Lucas*, the literary society *Flanor*, and the magazine *De Nieuwe Gids*. Witsen was a personal friend of most of the painters and writers who influenced art around the turn of the century. Wherever possible Witsen supported his friends by making available to them studios in Amsterdam, at the Oosterpark, and at his family's country home Ewijkshoeve near Den Dolder.[2]

Witsen's city scenes are without a doubt his most important works. During a three-year stay in London, the artist became fascinated with the city as a subject: "there is always so much to observe."[3] Unlike Breitner (1857–1923, see cats. 59–62), with whom he shared a studio for some time, Isaac Israëls (1865–1934, see cats. 77–79), or the French impressionists, Witsen was little interested by the dynamic movement of life in the big city. Human figures are either absent from his paintings or present merely as extras in the scenery. He emphasized the quiet aspects of the city: the canals, houses, bridges, and ships in rain, mist, or snow. He documented Amsterdam in particular in numerous etchings, watercolors, and paintings[4]; however, on his many journeys, other cities also attracted Witsen's attention: London, San Francisco, Venice, and, closer to home, Dordrecht and Rotterdam.[5]

As well as a splendid collection of prints, the Museum Boijmans Van Beuningen also possesses various drawings by Witsen. Together with a couple of early black chalk figure studies, the print room has two large detailed watercolors of views of Dordrecht and Rotterdam in its collection. As early as 1897 the museum's then director, P. Haverkorn van Rijsewijk, acquired *View of the Leuvehaven, Rotterdam*, possibly made in the same year, from the Amsterdam art dealer E. J. Wisselingh, the permanent agent for Witsen's work. The watercolor *Voortstraathaven, Dordrecht* (Harbor of Dordrecht) was acquired fairly recently from a private collection.

Although very different in atmosphere—the one a more panoramic view of Rotterdam painted in somber tones, the other a detailed Dordrecht picture with its, for Witsen, unusually sunny and fresh colors—both sheets are typical of Witsen's work. Witsen had a great preference for compositions featuring canals, harbors, and channels in the foreground, leading the viewer's eye to the urban buildings in the background. The absence of people in his work and the often somber weather increase the melancholic character of Witsen's pieces.

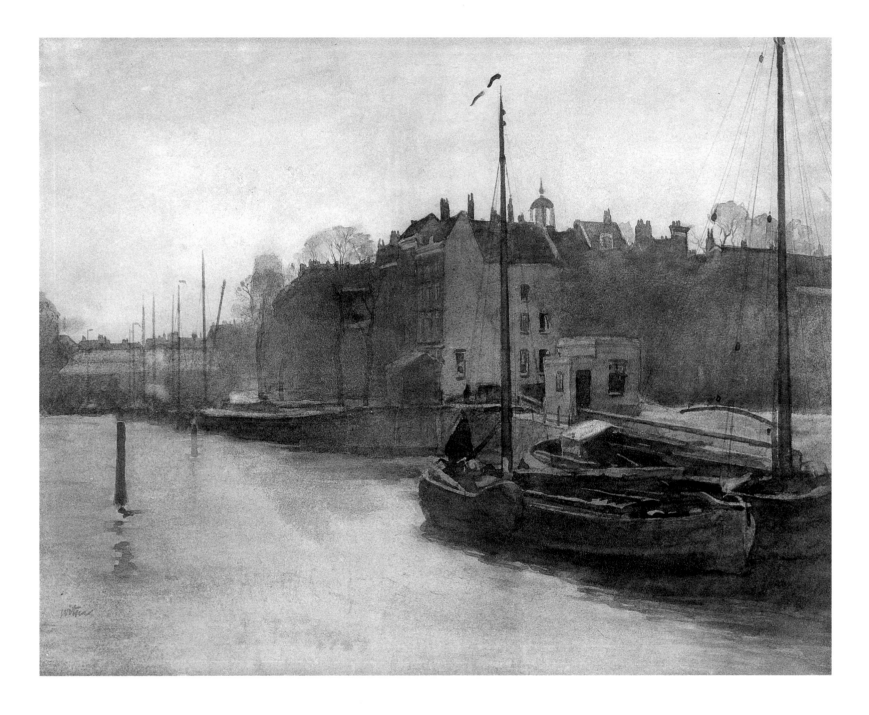

WILLEM ARNOLD WITSEN

Amsterdam 1860–1923 Amsterdam

70 *Voortstraathaven, Dordrecht*

Watercolor over black chalk, 517 x 714 mm (20 3/8 x 28 1/8 in.)

Signed lower right with brush and brown paint: *WITSEN*

Inv. MB 1994/T8

Provenance: Auction Amsterdam (F. Muller/Mensing), April 16, 1929, lot 177; the art dealer De Kool, Dordrecht 1991, R. Bionda, Purmerend; acquired in 1994

Literature: Tableau 1991, 120

In the picture of the Voortstraathaven especially, the position of the viewpoint is strikingly low. The low horizon may be explained by the influence of photography, much admired by Witsen, or by the possibility that this view of Dordrecht houses was painted from a studio on a barge.[6]

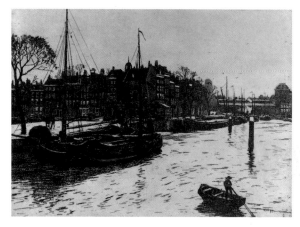

Fig. 1. Willem Arnold Witsen, *View of the Leuvehaven, Rotterdam.* Museum Boijmans Van Beuningen, Rotterdam

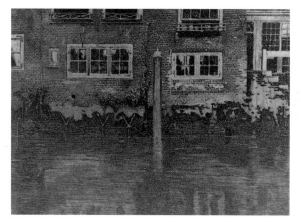

Fig. 2. Willem Arnold Witsen, *Voortstraathaven, Dordrecht.* Museum Boijmans Van Beuningen, Rotterdam

Witsen habitually made etchings and watercolors, as well as paintings, of views he considered successful. This does not help to clarify the exact order in which the works were made. In some cases, for instance in various views of Amsterdam, it seems Witsen first made an etching in his barge studio and from there developed a watercolor and a painting that he then put up for sale.[7] He more often seems to have worked in his studio from preparatory drawings made on the spot.[8] There are etched versions of both Rotterdam watercolors (figs. 1 and 2). Unfortunately, it is not possible to tell how the prints and drawings relate to each other. In any case, it seems that Witsen made these two very large, worked-out watercolors in the comfort of his studio.[9]

MS

1. For a biographical summary, with a short literature entry, see Bionda 1991, 326. For a summary of Witsen's oeuvre, see also Van Harpen 1924 (published the year after the artist's death), De Groot 1977(2), and Sellink 1991.
2. Compare Vergeer 1985 and Van der Wiel 1988.
3. See Heijbroek 1988.
4. See De Groot 1990.
5. For London, see Heijbroek 1988; for Witsen's stay in America, compare Heijbroek 1985.
6. Whistler and Storm van 's Gravesande had already drawn views of Dordrecht from a barge in 1884. Around 1900 Witsen worked in Dordrecht, and it is known for certain that Witsen made use of a studio on a barge from 1910 on in Amsterdam; see De Groot 1990. The influence of photography seemed to limit itself to a more general preference for unusually low or high view points and the unusual framing of a composition. Compare Hekking 1985, 108–10, and Heijbroek 1986.
7. Compare De Groot 1990, 358.
8. The latter seems mostly to have happened when Witsen traveled abroad, for instance to London, Venice, and San Francisco. See Heijbroek 1985, 127, and Heijbroek 1988, 75–78.
9. For the two etchings, see Boon 1948, 27, no. 82 (Rotterdam) and no. 94 (Dordrecht); Van Wisselingh 1933, 27, no. 426 (Dordrecht) and 29, no. 452 (Rotterdam). What is striking in the view of the Leuvehaven is that the watercolor and the etching/aquatint are mirror images of each other, which would suggest that the drawing precedes the print. According to Boon (loc. cit.), in the year the museum bought the watercolor, 1897, Witsen first made an etched version that was not published until 1907 in an altered form. Witsen's series of nine prints of views of the Voortstraathaven was put on the market by Van Wisselingh in 1900. However, various watercolors were drawn in 1898; see Amsterdam 1933, 14, nos. 48–50. The last number probably concerns the drawing shown here of the houses in the Voortstraathaven.

FLORIS HENDRIK VERSTER VAN WULVERHORST (FLORIS VERSTER)

Leiden 1861–1927 Leiden

71 Decorative Gourds

1895–1900

Wax crayon over pencil, highlighted with white bodycolor, on cardboard, 340 x 558 mm (13 3/8 x 21 7/8 in.)

Signed and dated lower left in pencil: *Floris Verster 95.*

Inv. MB 541

Provenance: Presented to the museum by the Rotterdam Art Circle, 1904

Literature: Rotterdam 1899(1), 9, no. 69; Plasschaert 1902, 118–19; Rotterdam 1904, 9; Haverkorn van Rijsewijk 1909, 318; Schmidt–Degener 1916, 167, no. 854; Schmidt-Degener 1921, 190, no. 854; Hannema 1927, 175, no. 857; Verwey 1927, no. 51; Scherjon 1928, 68, no. 101; Hammacher 1937, no. 12; Leiden 1952, no. 26; De Gruyter 1961(2), 22, no. 27; Verwey 1970, 38, no. 77; De Haan 1971, no. 48; Huizinga 1977, 11, no. 8; Montens 1986, 16, no. 25

Floris Verster spent most of his life and career in Leiden. It was there that he studied between 1878 and 1879 at the society Ars Aemula Naturae from George Hendrik Breitner (1857–1923, compare cats. 59–62), his senior by four years. After several years at the Hague academy and six months at the Brussels academy he returned to Groenoord, a country estate near Leiden. He suffered increasingly from depression and drowned himself in the river there in 1927.

It was not easy for Floris Verster to keep up with the rapid developments in modern art and to find his own place within its complexity.[1] The wax crayon drawing with gourds belongs to a series of about twenty-five pieces, which came into being between 1895 and 1900 and are traditionally seen as a transition from a somewhat rough impressionistic style to his later more subtle form of realism. This explanation originates from his friend, the poet Albert Verwey, who wrote an introduction for the memorial exhibition in 1927 in his birthplace and home town of Leiden. "With his disciplined use of wax crayons, he has, over the years, created a new form of art." After this rigorous training he once again returned to painting.

The composition with gourds is dominated by a large fruit in the middle section that points its stalk at the onlooker. A fine network of lines springs from this point. The other smaller pumpkins are grouped around it, the light orange ones in front, flanked left and right by green ones. They fill the entire picture surface excluding the lower edge, where they are mysteriously reflected in the pane of glass on which they are lying. One can imagine the artist standing in the room in front of the sideboard where the decorative gourds are displayed.

The flawless technique of these and similar drawings goes hand in hand with a refined style in the Japanese idiom. Verster worked patiently and methodically and in all probability completed the page from left to right. The light also runs from dark (left) to light (right). The piece of paper was cut off rather carelessly by Verster and then framed; at the bottom edge there are still some flakes of primer traceable to the frame. The color scheme is also typical of Verster and, together with the fine play of lines and positioning on the paper, creates a somewhat alienating effect despite the realistic rendering. One striking element is the great unity of color shown in the fruit. The effect is decoratively abstract. A similar work in this respect is the abstract plant composition that Henry van de Velde (1863–1957) drew in chalk in 1893.[2] Van de Velde's composition is dominated by a light orange pumpkinlike form with a spiraling leaf and stalklike forms—in brief, the same decorative theme, but realized in a more abstract way that was more modern.

EvU

1. See the recent number of *Kunstschrift* devoted to Floris Verster: Haveman 1995 and Bionda 1991, 300–312.
2. Kröller-Müller Museum, Otterlo. See Canning 1987–88, 225–26.

WILHELMUS HENDRIKUS PETRUS JOHANNES (WILLEM) DE ZWART

The Hague 1862–1931 The Hague

72 *The Boy Model*

after 1894

Red chalk, accents in watercolor over black chalk, 275 x 379 mm (10 3/4 x 15 in.)

Signed lower left with red chalk: *W de Zwart . . .*; verso, vague, unrecognizable imprint from a drawing

Inv. MB 531

Provenance: Gift of A. Vles, Rotterdam 1930

Literature: Rotterdam 1930, 7; Bionda 1984, 49

Willem de Zwart is often regarded as one of the "young masters" of the Hague school,[1] which suggests that De Zwart's work was strongly influenced by the school. But although he studied with Jacob Maris (1837–99, see cat. 43), his work is closer to the "Amsterdam impressionism" of his friend George Hendrik Breitner (1857–1923, see cats. 59–62). Around 1885 he made an exceptional number of drawings: "Hundreds . . . from his early years, in chalk, charcoal, pastel, or watercolor; all kinds of people at work; sketches of landscapes, farmyards with trees, and cattle, tracks with tall trees and distant views of towns, all set down on paper with forceful lines, nimbly and true to life."[2]

De Zwart often wandered through the landscape to draw. In this period he was beginning to make a name for himself. He illustrated two books, won a bronze medal in Chicago for his prints, and signed a contract with the art dealer E. J. Wisselingh & Co., which obliged him to supply a number of paintings in return for regular payments.[3]

Around 1890, De Zwart lived on Beeklaan in The Hague, a street at that time right on the edge of the city.[4] Other painters were also attracted to this peaceful district, such as artists as Jan Toorop (1858–1928, see cats. 64 and 65) and Breitner; however, the latter had left by the time De Zwart went to live there.[5]

The rural character of the Beeklaan that De Zwart was so fond of was soon spoiled by the encroachment of the suburbs of the city. He left in 1894 for Soest, near the Gooi district.[6] Here his work underwent a great change, becoming more colorful: "Remarkable for the contrast in atmosphere. The Hague, gray in mood caused by the sea and the damp rising off the polders, quite the opposite to the colorful green of the woods and meadows. . . . It was as if he had left everything . . . behind in The Hague."[7]

As well as landscapes and village scenes, De Zwart drew the farming folk of the region, capturing their gestures as they bargained at the local meat markets. He had harbored a fascination for working from the model even before he left The Hague in 1894 and made powerful chalk drawings of ordinary people.[8]

The red chalk drawing *The Boy Model* shows us that De Zwart worked from models in his studio. The boy is sitting cross-legged on a raised platform opposite a woman reading. Behind them are two canvases and frames. Although it is possible that De Zwart hired the two models, they could also have been members of his family posing for this intimate scene. A few color accents have been added in watercolor. De Zwart also did this sometimes in his studies of farmers from the Gooi region. The characteristic way of drawing and the use of watercolor indicate also that this piece must have been made after 1894.

De Zwart's powerful and expressive style was praised during his lifetime and after his death. One critic saw "an undeniable raw strength," and another compared his way of drawing with that of Vincent van Gogh (1853–90, cats. 52–56).[9] In 1937 the Hague art dealer d'Audretsch organized an exhibition of a number of De Zwart's drawings. "His most ordinary sketches are absolutely superb," one critic wrote, "where this forceful, flexible way of drawing, with the unerring lines, smudges, and dots is clearly recognizable as that of Willem de Zwart, who spontaneously and without any discernible mannerism made a work of art from everything he saw."[10]

MdH

1. Compare Marius 1920, 202–4, and De Gruyter 1968–69, 73–81. Both place De Zwart within the Hague school. Also see Bionda 1984 and Bionda 1991, 334–39, for the biographical details on the artist's life and work.
2. De Meester-Obreen 1909, 150.
3. See Bionda 1984, 30, and De Gruyter 1968–69, 75.
4. "It was in that time still very primitive and, although there were houses along the Loosduinschen weg, they were few and far between on the Beeklaan. It was completely outside the city with dunes immediately beyond." See Marius 1910, 21.
5. On the popularity of the Gooi region, see Koenraads 1969 and Heyting 1994.
6. Marius 1910, 23.
7. See, for these etchings, catalogue nos. 78–81 in Bionda 1984, 93–111.
8. Bionda 1984, 25.
9. Steenhoff 1908 and Plasschaert 1909, 252.
10. Veth 1937.

THEODOOR VAN HOYTEMA

The Hague 1863 1917 The Hague

73 Swans with Laburnum and Irises

c. 1896

Colored chalk, pen and black ink, 640 x 478 mm (25 1/4 x 18 7/8 in.)

Signed lower right with pen and black ink: *TvH[in ligature]oytema*

Inv. MB 550

Provenance: Unknown, acquired before 1940

Literature: De Groot 1977(1), 44, no. T 19; Van Dam 1991, 47, no. 59

Fig. 1. Theodoor van Hoytema, *Ex Libris with Two Owls* (verso, cat. 73). Museum Boijmans Van Beuningen, Rotterdam

Fig. 2. Theodoor van Hoytema, *Chrysanthemums*. Rijksprentenkabinet, Rijksmuseum, Amsterdam

Theo van Hoytema has become best known for his lithographs and animal drawings. In Holland his calendars are extremely popular. His love of nature became apparent when he was very young. As his oldest sister remembered: "Already as a young child, outdoor life, birds, and flowers were his greatest source of joy. Drawing too was his life and passion."[1] After working in a bank for a short time, he found a job, through his uncle, as a draftsman at the Zoological Museum in Leiden where he made many accurate drawings of animals from life. Here he built up a basic knowledge of their anatomy that was to become useful to him later in his career.[2] Although Hoytema drew many different kinds of animals, his favorites were birds. He had his first success with comical bird illustrations for the book *How the Birds Found a King* of 1892 and the fairy tale *The Ugly Duckling* by Hans Christian Andersen of 1893.[3]

Van Hoytema probably made the drawing *Swans with Laburnum and Irises* in 1896. On the back of the sheet was his own "ex libris" sticker from 1896 showing two owls on a branch (fig. 1).[4] The Rotterdam sheet shows three elegant swans swimming beneath the golden flowers of a laburnum tree along a bank where blue irises grow. Hoytema was clearly influenced by Art Nouveau in this painting. He chose two motifs that were very popular because of their elegant forms, the swan and the iris.[5] The composition of the hanging flowers is strongly reminiscent of Japanese prints.[6]

The drawing of the swans is highly detailed and carefully colored. When one compares this to other drawings and preparatory studies by Van Hoytema, one is struck by the sketchy way he usually drew. Only one other drawing by Van Hoytema with so much detail is known, a pen drawing of chrysanthemums in brown ink with colored chalk (fig. 2)[7] in Amsterdam that is close to the Rotterdam sheet in style and technique. It is possible that the Rotterdam sheet was intended as a presentation drawing. In the 1890s, Van Hoytema made many decorative designs for furniture and murals. In 1894 he was commissioned to make a series of murals for the now demolished club hall in Gorinchem, among which he painted a number of large peacocks on the wall (fig. 3).[8] Several similarities exist between the peacocks in Gorinchem and the swans on the Rotterdam sheet. Both birds, which are pictured under trees, are worked out in detail and with great attention to their plumage and surrounding flora.

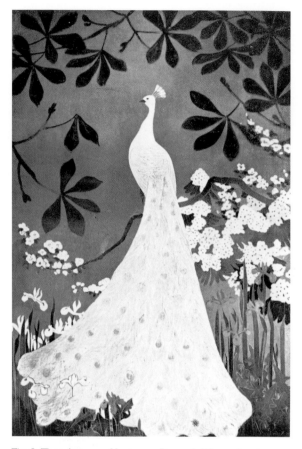

Fig. 3. Theodoor van Hoytema, *Peacock*. Whereabouts unknown

Shortly after these peacocks were completed, Van Hoytema was commissioned to make a large number of murals inside one of the ships belonging to Fop Smit & Co.[9] He decorated this ship, the *Merwede*, with a series of fifty panels showing birds and flowers symbolizing the seasons of the year.[10] The ladies' lounge was decorated with "summer and spring attire of colorful butterflies, white swans and attractive cranes."[11] The drawing shown here may well have been a preparatory study or a presentation drawing for one of the paintings on the *Merwede*. Considering the similarities in style and technique it is possible that the drawing in the Rijksprentenkabinet in Amsterdam was also a study for the same project. Unfortunately the panels for the ship have not survived.[12]

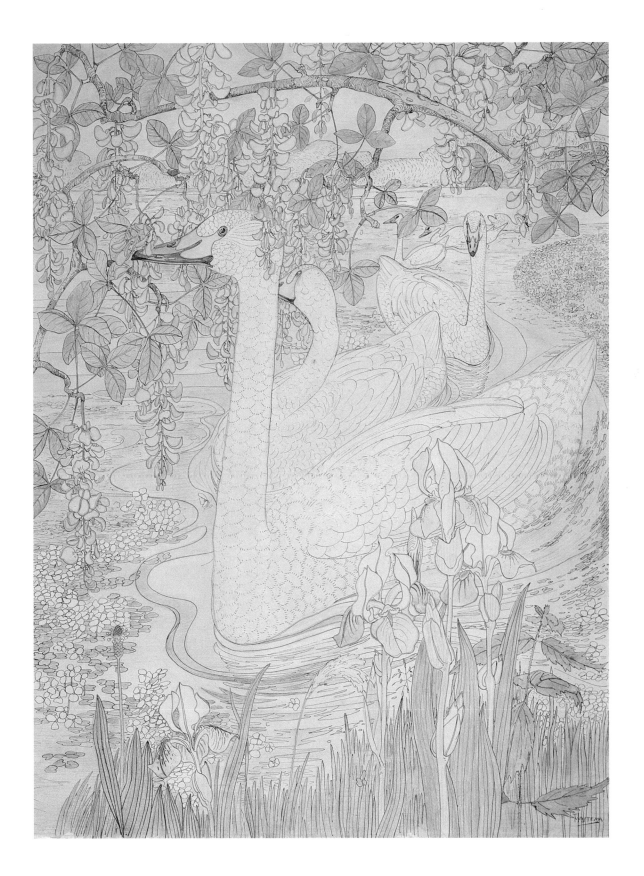

THEODOOR VAN HOYTEMA

The Hague 1863–1917 The Hague

74 Black Cockerel

after 1896

Watercolor, 291 x 226 mm (11 1/2 x 8 7/8 in.)

Signed lower right with brush and gray paint: *TH[in ligature]*

Inv. MB 543

Provenance: Unknown, acquired before 1940

The quick sketch of the black cockerel is not dated, but appears to have been made later than *Swans with Laburnum and Irises*. Van Hoytema continued making studies from nature throughout his life. For many years he went to the Amsterdam zoo, Artis, to record exotic animals in his sketchbook.[13] However, the subjects he drew most were Dutch birds, mainly ducks and chickens, for which he kept a special sketchbook.[14] Van Hoytema drew these animals in extremely diverse media ranging from pencil and red and black chalk to pen and black ink and watercolor. Most of these drawings were preparatory studies or sketches for his own use. The sheet with the cockerel shown here was probably intended to be sold, as it is clearly signed on the lower right with a Japanese-looking monogram *TM*.

MdH

1. Letter from Bep Hoytema, quoted in Knuttel 1953, 9.
2. The Gemeentemuseum in The Hague has in its collection many anatomical studies by Van Hoytema from this period.
3. Van Hoytema 1892 and Van Hoytema 1893. See also Veth 1905, 62–63 and 73–76.
4. Theo van Hoytema, *Ex Libris with Two Owls*, lithograph. See also: De Groot 1977(1), 17, no. 53.
5. See, among others, Hofstätter 1965 and Wichmann 1984.

6. See under Wichmann 1980. Exhibitions of Japanese prints were regularly organized in the Netherlands, for instance in 1899 in Leiden in the Rijks Ethnographisch Museum' compare De Vries 1899.
7. *Chrysanthemums*, pen and brown ink and colored chalk, Rijksprentenkabinet, Rijksmuseum, Amsterdam, inv. 49:531. See the collection of drawings in Museum Boijmans Van Beuningen, Rotterdam, Rijksprentenkabinet, Rijksmuseum, Amsterdam, and in particular the Gemeentemuseum, The Hague, where many of Hoytema's drawings and sketchbooks have ended up.
8. For the illustration, see De Vries 1909, 4–5; further, see Knuttel 1953, 14, and De Vries 1909, 7.
9. The company Fop Smit & Co. was based in Rotterdam and transported passengers and cargo along the big rivers in the Netherlands. The owner of the company sat on the board of Boijmans Museum from 1886 to 1892.
10. The ships belonging to the firm F. Smit & Co. also sailed the river Lek. They were therefore also known as "Lek boats." See also *De Kroniek, algemeen weekblad* III (1897), 90–91, De Vries 1909, 7–8, Knuttel 1939, 365, Knuttel 1953, 14, and Gans 1966, 53.
11. De Vries 1909, 7–8.
12. None of the paintings for the Lek boat have been preserved. The fifty panels of birds and flowers, which were painted on linen in swift, even paintwork, symbolizing the Four Seasons, have been separated. Many have probably been lost, while others have probably begun new lives as "paintings." See, for quote, Knuttel 1953, 14.
13. See Knuttel 1953, 19.
14. Sketchbook cover *Chickens and Ducks*, Gemeentemuseum The Hague, no inv., but is stored with drawings of ducks and chickens.

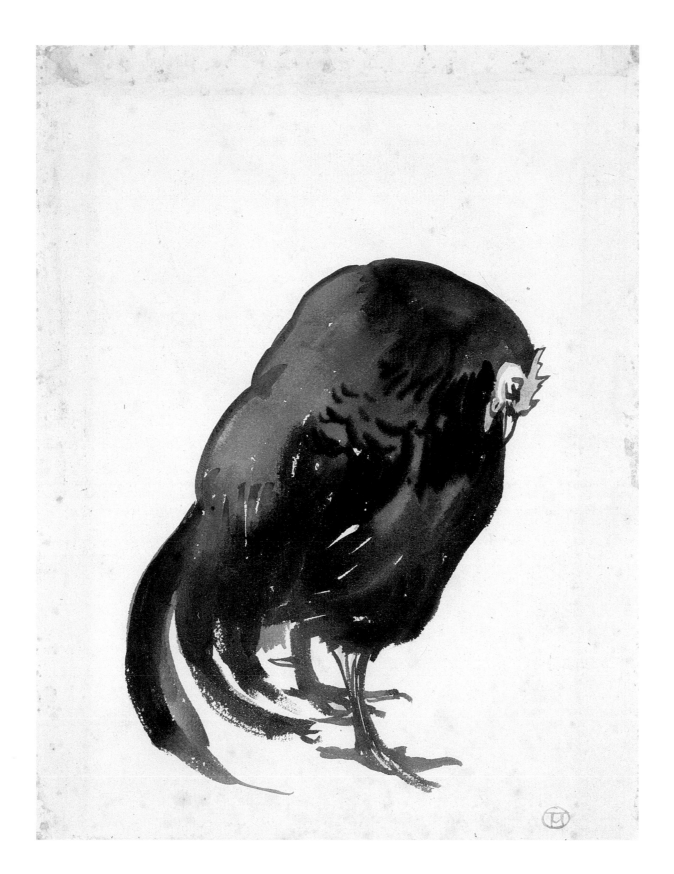

THEODOOR VAN HOYTEMA

The Hague 1863 1917 The Hague

75 The Village of Heeze

1899

Black and colored chalk, 316 x 480 mm (12 1/2 x 18 7/8 in.)

Signed lower right in a circle in blue chalk: *TH[in ligature]*; inscribed and dated lower center in blue and brown chalk: *Het. Dorp. Heeze. in. N. B. Geteekend voor het Vrouwtje 4. nov 1899 TH.* (The village of Heeze in North Brabant drawn for my wife 4 November 1899)

Watermark: PL BAS

Inv. MB 540

Provenance: Widow of the artist, The Hague; her legacy, 1927

Literature: Rotterdam 1927, 5

Theo van Hoytema was first and foremost an artist in the applied arts. His lithographs and book illustrations and the preparatory drawings for these developed out of left-wing sympathies. He was a member of the SDAP, the precursor of the Dutch Labor Party, and it was therefore appropriate for him to produce non-elitist art that could be distributed on a wide scale.[1] The painter-writer Jan Veth (1864–1925) more than once emphasized the refreshing, cheering influence that he experienced in Hoytema's work, and called it a "good antidote" to the anxious, gloomy attitudes of some people. "They are outstandingly healthy works that inspire *joie de vivre*, they are a delight to have in your house, in the study, or in the long passage through which you walk many times a day; and yet he is not considered an artist of whom it is thought prestigious to own a single piece. In fact, in such a passageway one could hang a whole series of Hoytemas, so that one would not go blind gazing at the single one, and could constantly rehang them or change them around, in which way their refreshing influence would continue to delight you."[2]

Van Hoytema's prints have been well known since the artist R. N. Roland Holst (1868–1938), who was also committed to the education of the masses, arranged for the Rijksprentenkabinet in Amsterdam to buy all Hoytema's printed work for the occasion of the artist's fiftieth birthday in 1913. Where the independent work of Hoytema is concerned, the situation is somewhat different. In particular, the landscapes he made on his journeys through the Netherlands are less accessible and vary greatly in character. The writer and art fancier G. Knuttel, Jr., who published a monograph on Van Hoytema in 1953, owned a semi-symbolist, extremely abstract moonlit scene in oil from 1891 that radiated a strange, alien atmosphere. The landscapes Van Hoytema made during the 1890s near Hilversum, where he was then living, and in the village of Heeze in Brabant,[3] were more direct and very modern in interpretation. Their colors are bright and clearly influenced by Art Nouveau. In particular, *Farmland with Vegetables and Cabbages*, which shows a farmer plowing and a woman on the right wearing a white hat, reveals a Japanese influence in the composition and stylized execution of line.

The colored landscape drawing exhibited here is inscribed in a very decorative manner. The words have been written along the edge in a border as if it were a book or calendar illustration. However, this was not the case, judging from the very personal dedication "drawn for ny wife." The village of Heeze depicted here was at that time an artists' haunt where, from about 1880 until well into the twentieth century, Dutch artists such as Suze Robertson (1855–1922, see cat. 58), August Allebé (1838–1927), and Arthur Briët (1867–1939) came to paint Brabant farmhouses and farmers.[4] However, Van Hoytema did exactly the opposite. He did not go looking for picturesque poverty but brought with him a refreshing view, modern form, and used anything but earthy colors.

The *vrouwtje* (little wife) in question, for whom the drawing was made, was called Tine. Her stormy relationship with Van Hoytema has been described a number of times by his contemporaries, not least by Aegidius W. Timmerman (1858–1941). This witty chronicler of the "Beweging van Tachtig en Negentig" (movement of the 1880s and 1990s) in his book *Tim's Herinneringen* (Tim's memoirs) recounts how Van Hoytema rescued her from a job in a so-called "café with female service" and how she ended up with the painter enjoying a very artistic lifestyle. According to Timmerman it would seem that Van Hoytema had a love-hate relationship with the "blushing Tine," and he described in equal detail both sides of her behavior, the cursing and the consolation.[5] Timmerman also wrote a roman à clef about the marriage of Theo and Tine called *Leo en Gerda*, which was first serialized in the literary magazine *De Nieuwe Gids* in 1909.[6]

Although the couple had separated long before Van Hoytema's early death, Tine carefully preserved the drawing that was dedicated to her until she donated it, together with the other two drawings, to the Boijmans Museum in 1927.

SdB

1. Tibbe 1994, 155.
2. Jan Veth, "Veiling van werk door Th. van Hoytema" (auction of work by Theo van Hoytema), [1900], in Veth 1905, 202–3.
3. Theodoor van Hoytema, *Farmland with Vegetables and Cabbage*, black and colored chalk; 152 x 226 mm (6 x 8 7/8 in.), signed lower right in pencil: *TvH[in ligature]oytema.* Museum Boijmans Van Beuningen, Rotterdam, inv. MB 521, provenance: widow of the artist, The Hague; her legacy, 1927; Theodoor van Hoytema, *Farmland with Vegetables*, black and colored chalk, pencil; 142 x 211 mm (5 5/8 x 8 1/4 in.), signed lower right in pencil: *TvH[in ligature]oytema.* Museum Boijmans Van Beuningen, Rotterdam, inv. MB 520, provenance: widow of the artist, The Hague; her legacy, 1927.
4. Van Laarhoven 1985–86. With thanks to Bernard Vermet.
5. Timmerman 1983, 229–39.
6. An altered version of *Leo en Gerda* was published in 1911.

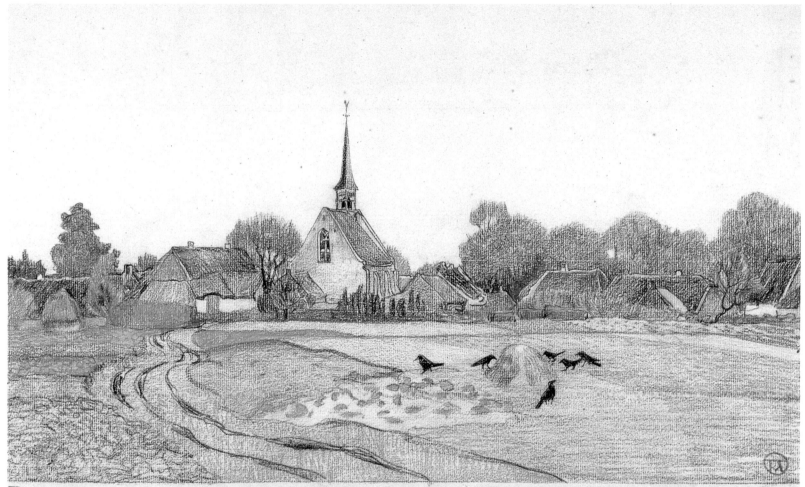

DET. DORP. HEEZE. IN. N. B. GETEEKEND VOOR HET VROUWTJE 4. NOV 1899 TT.

PIETER FLORENTIUS NICOLAAS JACOBUS (FLORIS) ARNTZENIUS

Surabaya 1864–1925 The Hague

76 Demolition

c. 1912

Watercolor and bodycolor, 672 x 1000 mm (26 1/2 x 39 3/8 in.)

Signed lower right in brush and brown paint: *FL. Arntzenius*

Inv. MB 561

Provenance: Acquired in 1920

Literature: Rotterdam 1920, 3; Schmidt-Degener 1921, 176, no. 767; Hannema 1927, 159, no. 766; Wagner 1969, 17-18, no. 100

Floris Arntzenius was born in Surabaya and moved to Amsterdam as a young boy in about 1875. Recommended by August Allebé (1838–1927), director of the Rijksacademie in Amsterdam, to whom he showed his work, Arntzenius went on to study under Johan Nachtweh (1857–1941). A year later, in 1883, he was admitted to the Rijksacademie.[1] His fellow students included George Breitner (1857–1923, cats. 59–62), Isaac Israëls (1865–1934, cats. 77–79), Jacobus van Looy (1860–1923, cat. 57), and Willem Witsen (1860–1923, cats. 69 and 70).[2]

Arntzenius stayed in Amsterdam for five years. After finishing at the Rijksacademie, he went to Antwerp to study under Charles Verlat (1824–1890) at the academy there. He trained in drawing and painting from life. Verlat's considerable influence on his pupils can be clearly seen in Arntzenius' work from the years that followed this period in Antwerp. Strong contrasts between light and shade, together with a very dark earthy paint in these works, which critics mockingly called "sirop d"Anvers," can be traced back to Verlat. In 1890 Arntzenius returned to Amsterdam for two years. He was a member of the artists' society Arti et Amicitiae and submitted work for various members' exhibitions. He moved to The Hague in 1892 and became a member of the Pulchri Studio.[3]

In The Hague, Arntzenius produced the work most characteristic of his oeuvre. The city was an important source of inspiration, and the artist was often nicknamed "the street painter." The relative peace offered by The Hague compared to the hustle and bustle of Amsterdam generated numerous cityscapes. Arntzenius' fascination for the city in different weather conditions and the busyness of every-day urban affairs give a good picture of life in The Hague at the end of the nineteenth century. His paintings do not provide realistic representations of the city, but rather impressions of it often based on watercolor or oil sketches that he made from life. A loose, free brushstroke is also characteristic of his watercolors.

Arntzenius preferred the center of the city, in particular the Lange Voorhout. Like many artists at this time Arntzenius rented a "window," a room with a view alongside one or other of the canals or streets, in his case the Spuistraat, in order to be able to spend more time studying and painting a part of the city.[4] Building sites and suburbs held no charm for him, and therefore the subject of the watercolor *Demolition* occupies an exceptional position in Arntzenius' oeuvre.[5] The watercolor gives an impression of redevelopment work in the city. The drawing is in horizontal format and in dark hues that give it a rather somber appearances. The neighborhood shown was in District VII in The Hague. This district, which was situated between the Pletterijkade and Central Station, was partially redeveloped in 1912,[6] clearly around the time of this watercolor.

MB

1. From *Stamboek I der leerlingen aan de Rijksacademie van Beeldende Kunsten te Amsterdam* (records of the pupils at the art academy in Amsterdam) of the period between 25 November 1870 and 25 February 1893, it appears on p. 44a that Arntzenius was not an exceptional pupil. Alongside his student number (216) is the comment: "over het algemeen ijver vrij goed maar aanleg gering . . ." (generally quite diligent but possessing little talent).
2. Arntzenius was very impressed by Breitner and his impressionist way of working.
3. In 1896 he was accepted as a member of the Hollandse Teekenmaatschappij (The Holland Drawing Society).
4. Compare Welling 1992.
5. Another painting of a similar subject is known: *Redevelopment*, see Welling 1992, 34. There are also two paintings entitled *Steam Engine in an Excavated Hole*, pictured in Welling 1992, 33–34.
6. Wagner 1969, 17–18.

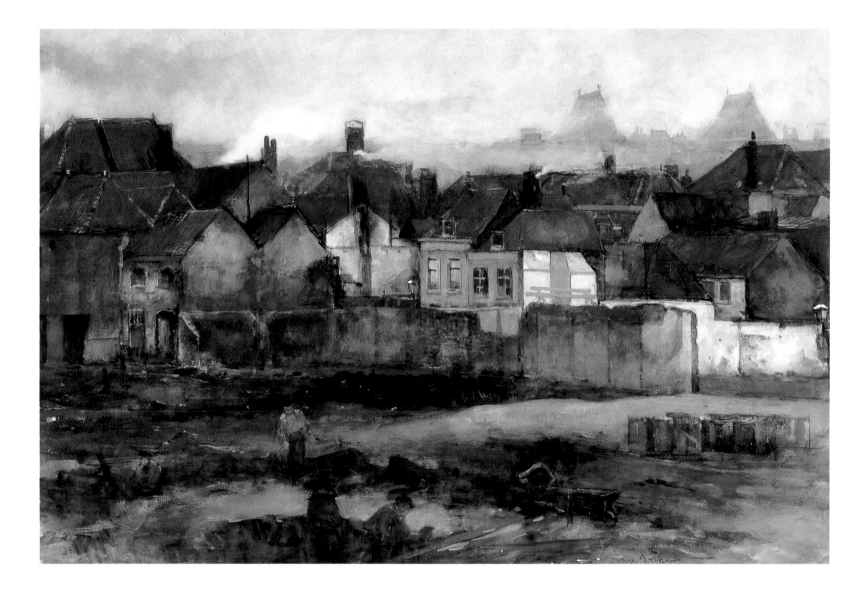

ISAAC ISRAËLS

Amsterdam 1865–1934 The Hague

77 *Two Servant Girls from Amsterdam*

1892

Black chalk, 445 x 275 mm
(17 1/2 x 10 7/8 in.)

Signed and dated lower right in black chalk: *Isaac Israels '92*; verso, vague counterproof of an unidentified drawing in black chalk, dated lower left in pencil: *1892*

Watermark: Coat-of-arms with fleur-de-lis

Inv. MB 534

Provenance: Gift of the artist, Amsterdam 1898

Literature: Haverkorn van Rijsewijk 1909, 347–48; Bremmer 1923–24, 46–47, no. 47

Isaac Israëls was something of a child prodigy. He was one of the two children of the painter Josef Israëls (1824–1911, see cat. 37) who, at the close of the nineteenth century, was the most celebrated contemporary artist in the Netherlands. Isaac grew up in a predominately artistic environment where it was taken for granted that art and literature were of primary importance.[1] When he was thirteen years old he was accepted at Haagse Tekenacademie (The Hague drawing academy), where he studied for two years. Fellow pupils at that time were George Breitner (1857–1923, see cats. 59–62), Floris Verster (1861–1927, see cat. 71), and another child wonder, Marius Bauer (1867–1932, see cat. 80). After Isaac's successful debut in 1881 at the Exhibition for Work of Living Masters in The Hague, everything looked as if the young artist was launched upon a brilliant career as painter of portraits and large-scale military figure pieces, executed in a realistic manner inspired by the Hague school.

But, like the somewhat older Breitner, whose artistic development ran parallel to that of Israëls for a long time, the young painter wanted to move in another direction. In 1887 Israëls settled in Amsterdam. Influenced by French impressionists such as Edouard Manet, Edgar Degas, and Jean-François Raffaëlli and by French naturalist writers such as Zola and Huysmans, a group of young Dutch artists, who were labeled the Amsterdam impressionists, concentrated on portraying fashionable life in the great city.[2] The writer Frans Erens and the artist Israëls wandered day and night through the streets of Amsterdam, both in search of inspiration for their work. Between 1888 and 1894 Israëls made very few paintings but all the more drawings. He filled sketchbook after sketchbook with visual jottings, mostly in black chalk, illustrating the city's street- and nightlife.[3] The swiftly executed chalk drawing from 1892, showing two women walking arm in arm down the street (cat. 77), is a fine example of this work. Characteristic of this type of drawing by Israëls are the swift lines. There is a light suggestion of detail in the drawing of the upper body of the woman at the right, otherwise only the outlines of the women are set down. This method of production is very similar to that of Breitner's chalk drawings (compare cats. 61–62).

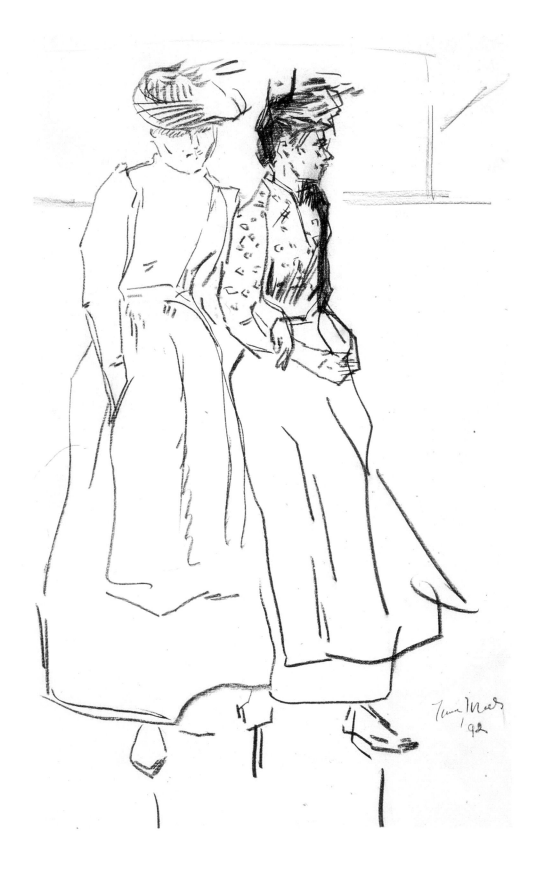

197

ISAAC ISRAËLS

Amsterdam 1865–1934 The Hague

78 *Servant Girl beside a Canal*

c. 1890–95

Black and colored chalk, stumped, 225 x 303 mm (8 7/8 x 11 7/8 in.)

Signed lower right in black chalk: *Isaac Israels*

Inv. MB 1963/T13

Provenance: Gift of the widow G. Hoppen, Rotterdam 1963

The remarkably attractive pastel showing a servant girl walking along a canal in Amsterdam (cat. 78) must date from the first half of the 1890s. After first working chiefly in black chalk and watercolor, around 1893 Israëls began recording street life more often in pastel. The Rotterdam sheet consists of lively contours in black chalk with considerable stumping in the colored areas, that is lines rubbed away with either the thumb or a leather "stump." Not only is the result painterly, but because of the somewhat vague, rubbed-away lines, it excellently produces the sense of movement and activity in a city.[4]

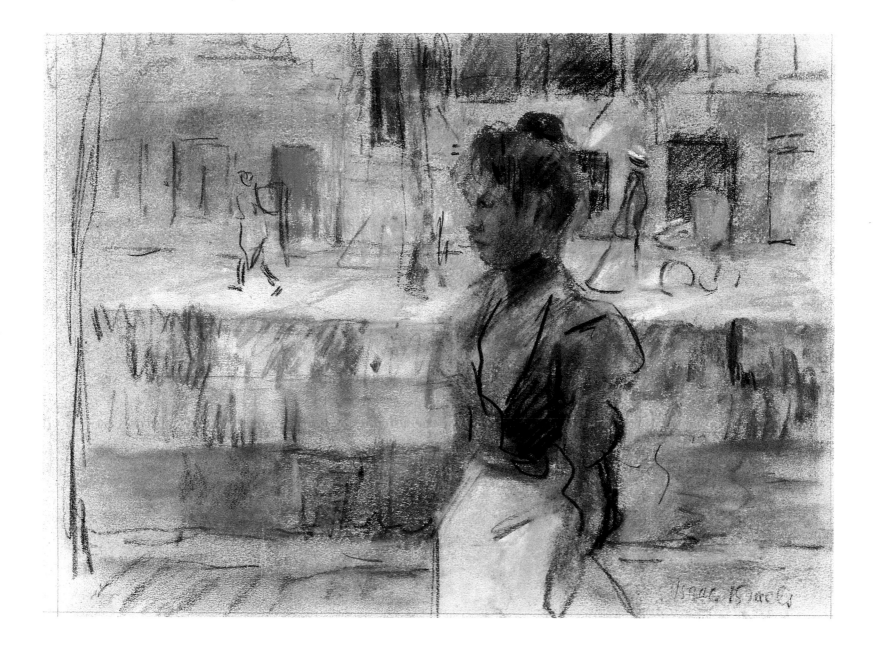

199

ISAAC ISRAËLS

Amsterdam 1865–1934 The Hague

79 *Lying in the Park*

c. 1895

Watercolor, 355 x 510 mm
(14 x 20 1/8 in.)

Signed lower right in brush and
brown paint: *Isaac Israels*; verso,
Lady with a Hat, watercolor

Inv. MB 1963/T14

Provenance: Gift of the widow G.
Hoppen, Rotterdam 1963

The watercolor showing workmen taking time off for a nap in their wheelbarrows (cat. 79) was probably also made around 1895. The clear palette and suggestion of summer sun, created by leaving the paper almost uncolored, are close in style to the watercolor drawings that Israëls made in Amsterdam's Oosterpark. This park lay directly opposite Israëls' studio and was opened in 1894.[5] It is amusing to imagine that the dozing workmen had been employed in laying out the park, though this is by no means certain.

MS

1. For a biographical study of Israëls, see Bionda 1991, 181, Welling 1991, vii–xxv, and especially Anna Wagner's standard work on the painter, Wagner 1985.
2. Compare the somewhat outdated handbook Hammacher 1941 and the introduction by Richard Bionda and Carel Blotkamp in Bionda 1991, 10–12.
3. After the death of the painter, hundreds of complete sketchbooks were found in his studio. In 1935 these were largely distributed among the various Dutch art museums, which included the Museum Boijmans Van Beuningen, the latter receiving about sixty sketchbooks. Throughout his life Israëls sketched indefatigably. The sketchbooks, which can be seen as separate from all the sketches that were scattered far and wide during Israëls' lifetime, can be dated beginning in the early 1880s until his death in 1934. See Wagner 1961.
4. The pastels most resembling this one from the period 1893–95 are, for example, *Meisjes van de Munt* (Private Collection), *De hoedenwinkel van Mars op de Nieuwendijk* (Private Collection), and *Stormweer aan het Kastanjeplein* (Rijksmuseum, Amsterdam). See Wagner 1985, figs. 31–32, Welling 1991, 109, and Bionda 1991, 192, no. 66. From 1894 on Israëls, with official permission from the city council, began to paint outside in the street.
5. Compare, for example, Wagner 1985, 42, fig. 39, and Welling 1991, 119.

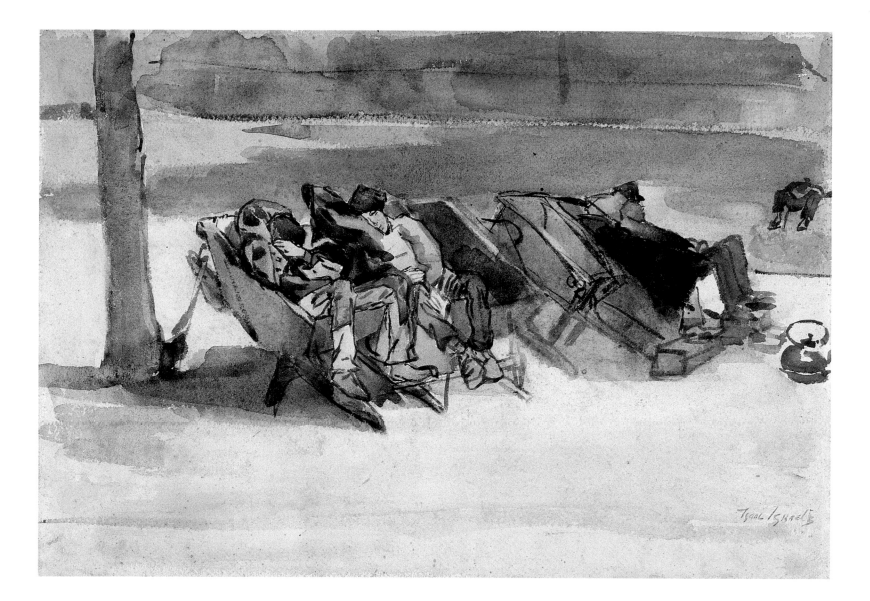

MARIUS ALEXANDER JACQUES BAUER

The Hague 1867–1932 Amsterdam

80 Procession of Elephants before a Temple

after 1897

Watercolor with accents in body color, 805 x 595 mm (31 3/4 x 23 3/8 in.)

Signed lower left with brush and black ink: *MBAUER*

Inv. MB 1940/T3

Provenance: W. Palte, his legacy, Rotterdam 1940

Literature: Rotterdam 1940, 5

Fig. 2. Marius Bauer, *Entrance to the Friday Mosque at Delhi,* 1899. Museum Boijmans Van Beuningen, Rotterdam

Marius Bauer is considered an outstanding representative of the Dutch Orientalist school.[1] Eastern depictions and topography were popular for a long time, and the genre continued to play a role in modern art right up to the time of painters such as Pierre-Auguste Renoir (1841–1919), Henri Matisse (1869–1954), and Paul Klee (1879–1940).[2] Marius Bauer was not one of the great pioneers. In his style and views he fitted in with the highly atmospheric naturalism of the Hague school. In 1888 the Amsterdam art dealer E. J. van Wisselingh sponsored Bauer's journey to the Near East, to Constantinople. Van Wisselingh must have had a keen eye for Bauer's artistic and commercial talents, spurred on by the fact that the artist was a skilful etcher and could distribute prints of his eastern scenes.

On his very first visit to the Near East in 1888, Bauer was struck by the fairy-tale atmosphere, which confirmed the descriptions in *A Thousand and One Nights*. To his friend and colleague Philippe Zilcken (1857–1930) he wrote: "one keeps on imagining that Aladdin with his train of slaves is about to emerge from one of those little doors, or that a team of gorgeously attired eunuchs will drive one away and empty the streets because Princess Badura is approaching on her litter."[3] Many such journeys were to follow. In Russia Bauer attended the coronation of Tsar Nicholas II in 1896; he also traveled to Egypt and Israel and as far afield as India and Indonesia.

In addition to countless drawings, Bauer brought back numerous souvenirs from his trips. Not only did he transform his studio and house into a veritable oriental palace, he also used the artefacts and especially the costumes in the tableaux vivants with which he entertained friends and colleagues at evening parties in Pulchri Studio, the Hague artists' society. It was rumored in the newspapers that Bauer had actually brought back a small, live elephant from India, which he kept in the garden, beside his studio.

The drawing exhibited here was made during or after Bauer's trip to India in 1897–99. Through the dark gate the entrance to the Friday Mosque in Delhi can be seen. Caught in the sunlight is a festive procession of what is probably a prince and his retinue, seated on elephants. Both the procession of elephants and the mosque inspired Bauer to make several watercolors, paintings, and especially etchings (figs. 1 and 2).[4] He also used the theme of a royal procession with caparisoned elephants for the title-page illustration of the French translation of *A Thousand*

Fig. 1. Marius Bauer, *Elephants at Hyderabad,* 1899. Museum Boijmans Van Beuningen

and One Nights. Bauer illustrated this private edition for his own pleasure with some 3,000 drawings. He later sold the book to an enthusiast because there was no room for new drawings in the sixteen-volume edition.[5]

Procession of Elephants Before a Temple displays the characteristic traits of Bauer's watercolor style. He laid down his sketch-like drawings in a few harmonizing tints, dispensing with a preliminary study in pencil or black chalk. Bauer applied his watercolors directly, in the "wet-into-wet" technique. He often gave strong colors a wash to attain a more subdued effect. The drawing was then enlivened with the occasional accent, often watercolor mixed with body color. This technique enhanced the unreal, magical atmosphere of Bauer's watercolors. Unlike most nineteenth-century orientalists, including the Frenchman Horace Vernet (1789–1863) and the Dutch artist Willem de Famars Testas (1834–96), Bauer conveyed a less realistic impression of the East. The prevailing mood of his scenes is one of a charming fairy-tale.

EvU/MdH

1. De Leeuw 1985, 10–36, and especially 26–29; Bionda 1991, 119–22 (with bibliography on Bauer).
2. Compare Stevens 1984.
3. Letter to Phillipe Zilcken cited in De Vries, Jr., 1944, 20.
4. *Entrance to the Friday Mosque at Delhi*, 1899, etching, and *Elephants at Hyderabad*, 1899, etching.
5. *Fragments des Mille nuits et Une nuit avec des illustrations de M. A. J. Bauer*, limited black-and-white edition no. 93, formerly owned by J. G. J. Bierens de Haan, Wassenaar 1927 (Library of the Boijmans Van Beuningen Museum, Rotterdam). The original is kept in the Kröller Müller Museum, Otterlo.

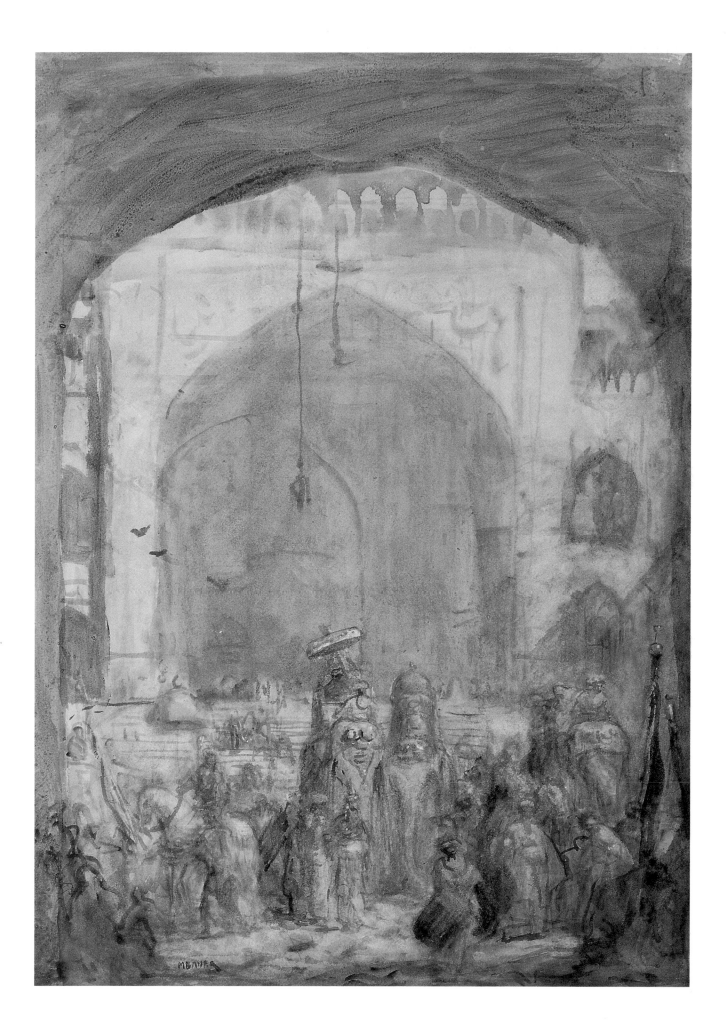

BIBLIOGRAPHY

About 1855
About, E. *Voyage à travers l'Exposition des Beaux-Arts (peinture et sculpture)*. Paris, 1855

Algemeen Handelsblad
Algemeen Handelsblad of 1939, press documentation Eduard Karsen, National Institute for Art History, The Hague (RKD)

Amsterdam 1863
Teekeningen: Hollandsche en Vlaamsche school. Exh. cat. Museum Fodor. Amsterdam, 1863

Amsterdam 1932
Tentoonstelling van schilderijen door Vincent van Gogh, J.B. Jongkind, Floris Verster. Exh. cat. Huinck & Scherjon. Amsterdam, 1932

Amsterdam 1933
Willem Witsen. Exh. cat. E. J. van Wisselingh. Amsterdam, 1933

Andree 1968
Andree, R. *Die Gemälde des 19. Jarhhunderts mit Ausnahme der Düsseldorfer Schule*, vol. 1. Exh. cat. Kunstmuseum Düsseldorf, 1968

L'Art Moderne 1884
Review of "Neuvième Exposition des Aquarellistes Hollandais à la Haye." *L'Art Moderne* (August 24, 1884), 277–78

L'Art Moderne 1887
"Un Barbizon belge." *L'Art Moderne* (October 30, 1887)

B. 1813
B. "Brief over de tentoonstelling van 1813." *Algemeene Konst-en Letterbode* (1813), 2:297-304

B. 1818
B. "Brief wegens de tentoonstelling der kunstwerken van nog in leven zijnde Nederlandsche meesters te Amsterdam 1818." *Algemeene Konst- en Letterbode* (1818), 2:342-47, 355-59

Baard 1923
Baard, C. W. H. *Tentoonstelling van Nederlandsche beeldende kunsten*. Exh. cat. Stedelijk Museum. Amsterdam, 1923

Bachmann 1982
Bachmann, F. *Aert van der Neer, 1603/4-1677*. Bremen, 1982

Bastet 1989
Bastet, F. *Met Carel Vosmaer op reis*. Amsterdam, 1989

Baudelaire 1863
Baudelaire, C. *Le peintre de la vie moderne*. Paris. 1863

Baudelaire 1962
Baudelaire, C. *Curiosités esthétiques*. Paris, 1962

Baudelaire 1965
Baudelaire, C. *Art in Paris 1845–1862: Salons and Other Exhibitions*. Translated and edited by J. Mayne. London, 1965

Bauer
Bauer, M. *Brieven van Marius Bauer, 1888–1931*. Amsterdam/Mechelen, n.d.

Berckenhoff 1888
Berckenhoff, H. L. "De Gebroeders Maris." *De Gids* (1888), 4:469–501

Van den Bergh 1852
Van den Bergh, S. J. "Aan Johannes Bosboom." *Kunstkronijk* (1852), 13–14

Bergsma 1994
Bergsma, R., et al. *George Hendrik Breitner, 1857–1923: schilderijen tekeningen foto's*. Bussum, 1994

Bergvelt 1975
Bergvelt, E. *J. A. Knip, een neo-classicist uit Tilburg*. Exh. cat. La Barrique. Tilburg, 1975

Bergvelt 1976
Bergvelt, E. "J. A. Knip (1777–1847), de werkwijze van een 19de-eeuwse landschapschilder in relatie tot de kunsttheorie in Holland en Frankrijk omstreeks 1800." *Nederlands Kunsthistorisch Jaarboek* 28 (1977): 11–73

Bergvelt 1977
Bergvelt, E. *J. A. Knip 1777–1847*. Exh. cat. Noordbrabants Museum. Den Bosch, 1977

Bergvelt 1984(1)
Bergvelt, E., et al. *Reizen naar Rome, Italië als leerschool voor Nederlandse kunstenaars omstreeks 1800*. Exh. cat. Teylers Museum. Haarlem, 1984

Bergvelt 1984(2)
Bergvelt, E. "Nationale, levende en 19de-eeuwse meesters: Rijksmusea en eigentijdse kunst (1800–1848)." *Nederlands Kunsthistorisch Jaarboek* 35 (1984):77–151

Bilders 1876
Bilders, A. G. *Brieven en dagboek*. Leiden, 1876

Bille 1961
Bille, C. *De tempel der kunst of het Kabinet van den Heer Braamcamp*, 2 vols. Amsterdam, 1961

Bionda 1984
Bionda, R. *Willem de Zwart, 1862–1931*. Haarlem, 1984

Bionda 1991
Bionda, R., et al. *De schilders van Tachtig: Nederlandse schilderkunst 1880–1895*. Exh. cat. Rijksmuseum Vincent van Gogh. Amsterdam, 1991

Blotkamp 1978
Blotkamp, C., et al. *Kunstenaren der idee: symbolistische tendenzen in Nederland, ca. 1880–1930*. The Hague, 1978

De Bodt 1981(1)
De Bodt, S. "Hendrik Willem Mesdag en Brussel." *Oud Holland* 95 (1981), 59–87

De Bodt 1981(2)
De Bodt, S., and M. van Delft. "Het Panorama Mesdag." *Antiek* 16 (1981):145–47

De Bodt 1985
De Bodt, S. "Schetsboeken van H. W. Mesdag." *Jong Holland* 1 (1985):36–45

De Bodt 1988
De Bodt, S. Folder accompanying the exhibition *Nederlandse schilderkunst, 1850–1900*. Museum Boymans-van Beuningen, Rotterdam, 1988

De Bodt 1990
De Bodt, S. "Pulchri Studio: het imago van een kunstenaarsvereniging in de negentiende eeuw." *De Negentiende Eeuw, documentatieblad Werkgroep 19e eeuw* 14 (1990):25–40

De Bodt 1995(1)
De Bodt, S. *Halverwege Parijs: Willem Roelofs en de Nederlandse schilderskolonie 1840–1890*. Brussels/Amsterdam (UvA), 1995

De Bodt 1995(2)
De Bodt, S. *Brussel kunstenaarskolonie. Nederlandse schilders 1850–1890*. Brussels, Ghent, 1995/ *Bruxelles, Colonie d'artistes. Peintres Hollandais 1850–1890*. Brussels, Ghent 1995

De Bodt 1997(1)
De Bodt, S. *De Haagse School in Drenthe*. Drents Museum Zwolle/Assen, 1997

De Bodt 1997(2)
De Bodt, S. *Anton Mauve en de Haagse School*. Publicaties van Openbaar Kunstbezit, no. 4. The Hague 1997.

De Bodt & Sellink 1994
De Bodt, S., M. Sellink, et al. *Nederlandse tekeningen uit de negentiende eeuw 1 (1800–1850): keuze uit de verzameling van het prentenkabinet*. Exh. cat. Museum Boijmans van Beuningen. Rotterdam, 1994

De Bodt & Sellink 1995
De Bodt, S., M. Sellink, et al. *Nederlandse tekeningen uit de negentiende eeuw 2 (1850-1900): keuze uit de verzameling van het prentenkabinet*. Exh. cat. Museum Boijmans van Beuningen. Rotterdam, 1995

De Boer 1911
De Boer, J. "Jan Toorop." *Onze Kunst* 19 (1911):119-26

De Boer 1918
De Boer, H. "H. J. Haverman." *Elsevier's Geïllustreerd Maand-schrift* 228 (1918):360-73

De Boer 1926
De Boer, J. *Jan Toorop*. Amsterdam, 1926

De Boer 1960
De Boer, R. G., et al. *Jan en Johan Hendrik Weissenbruch: schilderijen, aquarellen, grafiek*. Exh. cat. Singer Museum. Laren, 1960

De Boer 1961
De Boer, R. G., et al. *Jan en Johan Weissenbruch*. Exh. cat. De Beyerd. Breda, 1961

Bokhoven 1976
Bokhoven, J., et al. *De verstilde wereld van Karsper en Eduard Karsen*. Exh. cat. Stedelijk Museum, Schiedam, 1976

Bol 1955
Bol, L. J. *Boom, bloem en plant: Nederlandse meesters uit vijf eeuwen*. Exh. cat. Dordrechts Museum. Dordrecht, 1955

Bol 1956
Bol, L. J. *De gebroeders Van Strij*. Exh. cat. Dordrechts Museum. Dordrecht, 1956

Bol 1991
Bol, L. J. *Aert Schouman, Ingenious Painter and Draughtsman*. Doornspijk, 1991

Bolten 1967
Bolten, J. *Dutch Drawings If the Collection of Dr. C. Hofstede de Groot*. Utrecht, 1967

Boon 1948
Boon, K. G. "Witsen's etstechniek." Published with a list of Wit-sen's engravings in Hammacher, A. M., et al., *Witsen en zijn vriendenkring*. Amsterdam (1948)

Van Borssum Buisman 1972
Van Borssum Buisman, J. H., et al. *Wybrand Hendriks 1744–1831*. Exh. cat. Teylers Museum. Haarlem, 1972

Bosboom 1917
Bosboom, J. "Een en ander betrekkelijk mijn loopbaan als schilder (1881)." *Catalogus der Eere-tentoonstelling ter herdenk-ing van Johannes Bosboom*. Exh. cat. Pulchri Studio. The Hague, 1917

Bosboom 1946
Bosboom, J. *Een en ander betrekkelijk mijne loopbaan als schilder* [1891], annotated by A. Glavimans. Rotterdam/Antwerp, 1946

Van Boven 1988
Van Boven, M., and S. Segal. *Gerard & Cornelis van Spaen-donck: twee Brabantse bloemenschilders in Parijs*. Second edi-tion, The Hague, 1988

Bracquemond 1885
Bracquemond, F. *Du Dessin et de la couleur*. Paris, 1885

Bredius 1936
Bredius, A. "De schilder Hendrik Voogd en zijn maecenas." *Medelingen van het Nederlandsch historisch instituut te Rome*, tweede reeks, deel 6, 111–18. The Hague, 1936

Breitner 1970
Breitner, G. H. *G. H. Breitner: brieven aan A. P. van Stolk met enkele brieven van A. P. van Stolk aan G. H. Breitner en van G. H. Breitner aan Mej. van Stolk*. Compiled and annotated by P. H. Hefting. Utrecht, 1970

Bremmer 1923–24
Bremmer. H. P. "Isaac Israëls." *Beeldende Kunst* 11 (1923–24):46–47

Ten Brink 1891
Ten Brink, J. "David Bles." *Elsevier's Geïllustreerd Maandschrift* 2 (1891):317–32. Reprinted in M. Rooses. *Het schildersboek*, 1:45–59 (Amsterdam, 1898)

Brom 1916–17
Brom, G. "Toorop." *De Beiaard* (1916–17), 481–510

Brom 1927
Brom, G. *Hollandsche schilders en schrijvers in de vorige eeuw*. Rotterdam, 1927

Brom 1959
Brom, G. *Schilderkunst en litteratuur in de 19e eeuw*. Amster-dam/Antwerp, 1959

Broos 1989
Broos, B. "Improving and Finishing Old Master Drawings: An Art in Itself." *Hoogsteder-Naumann Mercury* 8 (1989):34–55

Brouwer 1974
Brouwer, J., et al. *Anthon van Rappard, Companion and Corre-spondent of Vincent van Gogh: His Life and All His Works*. Am-sterdam/Maarssen, 1974

Busch 1994
Busch, W. "Die Ordnung im flüchtigen: Wolkenstudien der Goethezeit." In Schulze, S., et al. *Goethe und die Kunst*. Exh. cat. Schirn Kunsthalle. Frankfurt, 1994, 519–70

Canning 1987–88
Canning, S. M., and J. F. Buyck. *Henry van de Velde (1863–1957): schilderijen en tekeningen*. Exh. cat. Koninklijk Museum voor Schone Kunsten. Antwerp, 1987–88

Chong 1988
Chong, A., et al. *Meesterlijk vee: Nederlandse veeschilders 1600–1900*. Exh. cat. Dordrechts Museum. Dordrecht, 1988

Churchill 1935
Churchill, W. A. *Watermarks in Paper*. Amsterdam, 1935

Colmjon 1950
Colmjon, G. *De Haagse School: de vernieuwing van onze schilderkunst sinds het midden der negentiende eeuw*. Rijswijk, 1950

Croal Thomson 1907
Croal Thomson, D. *The brothers Maris (James, Matthew, William)*. London, etc. 1907 (special summer number of *The Studio*)

Van Daalen 1962
[Van Daalen, P.] *Jan Toorop in Zeeland, 1898–1923*. Exh. cat. Zeeuws Museum. Middelburg, 1962

Van Dam 1991
Van Dam, J. D., et al. *Imitation and Inspiration 1680–1991: Japanese Influence on Dutch art*. Exh. cat. Suntory Museum of Art. Tokyo, 1991

Van Delft 1980
Van Delft, M. "Kunstbeschouwingen bij Pulchri Studio 1847–1917." Jaarboek *Die Haghe* (1980), 147–68

Dekkers 1994
Dekkers, D. *Jozef Israëls, een succesvol schilder van het vissers-genre*. Ph.D. dissertation, University of Amsterdam. The Hague, 1994

Draguet 1995
Draguet, M. *Khnopff 1858–1921*. Brussels, 1995

Drost 1944
[Drost, A. C. A., and D. Hannema]. *Catalogus van aquarellen en teekeningen uit het legaat van Montauban van Swijndregt*. Exh. cat. Museum Boymans. Rotterdam, 1944

Dumas 1983
Dumas, C., et al. *De Haagse School, Hollandse meesters van de 19de eeuw*. Exh. cat. Haags Gemeentemuseum. The Hague, 1983

Ebbinge Wubben 1963
Ebbinge Wubben, J. C. *Catalogus schilderijen na 1800*. Exh. cat. Museum Boymans-van Beuningen. Rotterdam, 1963

Van Eijnden/Van der Willigen 1816–40
Van Eijnden, R., and A. van der Willigen. *Geschiedenis der vaderlandsche schilderkunst, sedert de helft der XVIII eeuw*. 4 vols. Haarlem, 1816–40

Elink Sterk 1826
Elink Sterk, A., Jr., ed. *Aanteekeningen van C. Kruseman, Betrekkelijk deszelfs Kunstreis en verblijf in Italië*. The Hague, 1826

Emants 1985
Emants, M. *Aantekeningen*. Compiled and annotated by N. Maas and P. H. Dubois. Nederlands Letterkundig Museum en Documentatiecentrum. The Hague, 1985

Engel 1967
Engel, E. P. *Anton Mauve (1838–1888): bronnenverkenning en analyse van zijn oeuvre*. Ph.D. dissertation, Rijksuniversiteit Utrecht, 1967

Esmeyer 1977
Esmeyer, A. C. "Cloudscapes in Theory and Practice." *Simiolus* 9 (1977):123–48

Ewals 1980
Ewals, L. J. I., and J. J. Heij. *Ary Scheffer, tekeningen, aquarellen en olieverfschetsen*. Exh. cat. Dordrechts Museum. Dordrecht, 1980

Ewals 1987
Ewals, L. J. I. *Ary Scheffer, sa vie et son oeuvre*. Ph.D. dissertation, Katholieke Universiteit Nijmegen, 1987

Ewals 1995
Ewals, L. *Ary Scheffer 1795–1858, Gevierd Romanticus*. Exh. cat. Dordrechts Museum. Dordrecht, 1995

De la Faille 1928
De la Faille, J. B. *L'oeuvre de Vincent van Gogh: catalogue raisonné*. Volume 4. Paris/Brussels 1928

De la Faille 1970
De la Faille, J. B. *The Works of Vincent van Gogh: His Paintings and Drawings*. Amsterdam, 1970

Fridlander 1921
Fridlander, E. D. *Matthew Maris*. London/Boston, 1921

"G" 1893
"G." "De Hollandsche Teeken-maatschappij" (The Dutch Drawing Society). *De Nederlandsche Spectator* 1893

Gans 1966
Gans, L. *Nieuwe kunst: de Nederlandse bijdrage tot de Art Nouveau: dekoratieve kunst, kunstnijverheid en architectuur rond 1900*. Utrecht, 1966

De Geest 1989
De Geest, T. *Vier historische opstellen*. Assen, 1989

Van Gelder 1928
Van Gelder, H. E., et al. *Eere-tentoonstelling Jan Toorop*. Exh. cat. Pulchri Studio. The Hague, 1928

Van Gelder 1939
Van Gelder, H. E. *Matthijs Maris*. Amsterdam, 1939

Van Gelder 1947
Van Gelder, H. E. *Honderd jaar Haagsche schilderkunst in Pulchri Studio*. Amsterdam, 1947

Van Gelder 1950
Van Gelder, H. E. "Een kunstzinnige familie: het nageslacht van Andreas van Hove." *Die Haghe* (1950), 11–24

Gerards 1989
Gerards, I., and E. van Uitert. "Jan Toorop, Een 'fabuleuse bevattelijkheid': het symbolische scheppen." *Jong Holland* 5 (1989):2–17

Gerards 1994
Gerards, I., and E. van Uitert. *In de lijn van Jan Toorop: Symbolisme in de kunst* (publikatie bij Openbaar Kunstbezit, no. 2). The Hague, 1994

Gerlagh 1995
Gerlagh, B., and J. F. Heijbroek. "De Atlas Amsterdam." *Voor Nederland bewaard. De Verzameling van het Koninklijk Oudheidkundig Genootschap in het Rijksmuseum*. Baarn, 1995

Giltaij 1976
Giltaij, J. "De Nederlandsche Etsclub (1885–1896)." *Nederlands Kunsthistorisch Jaarboek* 27 (1976):91–125

Giltaij 1994
Giltaij, J., et al. *De verzameling van de Stichting Willem van der Vorm*. Exh. cat. Museum Boymans-van Beuningen. Rotterdam, 1994

Van Gogh 1958
Van Gogh, V. *The Complete Letters of Vincent van Gogh*. New York/London, 1958

Van Gogh 1973
Van Gogh, V. *Vincent van Gogh: verzamelde brieven*. Compiled and edited by J. van Gogh-Bonger and V. W. van Gogh. Four volumes. Amsterdam/Antwerp, 1973

Van Gogh 1990
Van Gogh, V. *De brieven van Vincent van Gogh*. Compiled and edited by H. van Crimpen and M. Berends-Albert. The Hague, 1990

Gorissen 1962
Gorissen, F. *B. C. Koekkoek 1803-1862: Werkverzeichnis der Gemälde*. Düsseldorf, 1962

Grant 1954
Grant, H. M. *Jan van Huysum 1682-1749, Including a Catalogue Raisonné of the Artist's Fruit and Flower Paintings*. Leigh-on-Sea, 1954

Van Grijzenhout 1992
Van Grijzenhout, F., and H. van Veen (red). *De Gouden Eeuw in perspectief*. Nijmegen, 1992

De Groot 1977(1)
De Groot, I. M. *De grafiek van Theo van Hoytema*. Exh. cat. Rijksprentenkabinet, Rijksmuseum. Amsterdam, 1977

De Groot 1977(2)
De Groot, I. M. Folder accompanying the exhibition *Willem Witsen (1860-1923) als tekenaar en etser* (folder Rijksprentenkabinet no. 15). Rijksprentenkabinet, Rijksmuseum. Amsterdam, 1977

De Groot 1989
De Groot, J. M., et al. *Een onsterfelijk zeeschilder: J. C. Schotel 1787-1838*. Exh. cat. Dordrechts Museum. Dordrecht, 1989

De Groot 1990
De Groot, I. M. "Willem Witsen en zijn drijvend atelier." *Bulletin van het Rijksmuseum* 38 (1990):345–67

De Gruyter 1961(1)
De Gruyter, W. J. *Catalogus Jozef Israëls*. Exh. cat. Museum voor stad en ommelanden. Groningen, 1961

De Gruyter 1961(2)
De Gruyter, W. J., and J. N. van Wessem. *Floris Verster*. Exh. cat. Stedelijk Museum De Lakenhal. Leiden, 1961

De Gruyter 1965
De Gruyter, W. J. *Meesters van de Haagse School*. Exh. cat. Haags Gemeentemuseum. The Hague, 1965

De Gruyter 1968–69
De Gruyter, W. J. *De Haagse School*. Two volumes. Rotterdam, 1968–69

"H." 1865
"H." "Exposition des aquarellistes." *Journal des Beaux-Arts et de la Littérature* (May 12, 1865)

De Haan 1971
De Haan, P. I., and J. N van Wessem. *Floris Verster, 1861-1927: schilderijen, aquarellen, waskrijt, tekeningen, grafiek*. Exh. cat. De Waag. Nijmegen, 1971

De Haes 1893
De Haes, L. "P. J. C. Gabriel." *Elsevier's Geïllustreerd Maandschrift* 3 (1893):453–73 (reprinted in M. Rooses. *Het schildersboek* [Amsterdam, 1890] 1:212-36)

Halbertsma 1997
Halbertsma et al. *Charles Rochussen 1814–1894. Een veelzijdig kunstenaar*. Rotterdam/Zwolle, 1997

Hammacher 1937
Hammacher, A. M. *Floris Verster (1861–1927)*. Exh. cat. Huinck en Scherjon. Amsterdam, 1937

Hammacher 1941
Hammacher, A. M. *Amsterdamsche impressionisten en hun kring*. Amsterdam, 1941

Hammacher 1947
Hammacher, A. M. *Eduard Karsen en zijn vader Kaspar*. The Hague, 1947

Hammacher 1956(1)
Hammacher, A. M., et al. *Breitner*. Exh. cat. Stedelijk Van Abbe Museum. Eindhoven, 1956

Hammacher 1956(2)
Hammacher, A. M., et al. *Vincent van Gogh, 1853–1890*. Exh. cat. Haus der Kunst. Munich, 1956

Hannema 1927
Hannema, D. *Geïllustreerde catalogus der schilderijen. teekeningen en beeldhouwwerken*. Exh. cat. Museum Boymans. Rotterdam, 1927

Hannema 1931–32
Hannema, D. *Kersttentoonstelling in het Museum Boymans*. Exh. cat. Museum Boymans. Rotterdam, 1931–32

Hannema 1950
Hannema, D. *Beschrijvende catalogus van de schilderijen uit de kunstverzameling Stichting Willem van der Vorm*. Rotterdam, 1950

Hannema 1958
Hannema, D. *Catalogus van de schilderijen uit de kunstverzameling Stichting Willem van der Vorm, Westersingel 66, Rotterdam*. Rotterdam, 1958

Hannema 1961
Hannema, D. *Oude tekeningen uit de verzameling Victor de Stuers*. Exh. cat. Almelo. De Waag, 1961

Hannema 1962
Hannema, D. *Beschrijvende catalogus van de schilderijen uit de kunstverzameling Stichting Willem van der Vorm, Westersingel 66. Rotterdam*. Rotterdam, 1962

Hannema 1973
Hannema, D. *Flitsen uit mijn leven als verzamelaar en museumdirecteur*. Rotterdam, 1973

Harms Tiepen 1910
Harms Tiepen, C. *Willem Maris' herinneringen*. The Hague, 1910

Van Harpen 1924
Van Harpen, N. *Willem Witsen*. Amsterdam, 1924

Haskell 1976
Haskell, F. *Rediscoveries in Art : Some Aspects of Taste, Fashion and Collecting in England and France*. London. 1976

Van Hattum 1983
Van Hattum, M. *Lezingen en verhandelingen in "Concordia et Libertate" (1769–1806) en "Felix Meritis" (Dep. Letterk. (1779–1808, 1810–1832, 1865–1873)*. Amstelveen, 1983 (private press)

Haveman 1995
Haveman, M., et al. "Floris Verster." Monographic issue of *Kunstschrift* 39 (1995):6–47

Haverkamp Begemann 1950
Haverkamp Begemann, E. "Vroege tekeningen van Breitner en Van Gogh." *Bulletin Museum Boymans* 1 (1950):58–61

Haverkamp Begemann 1957
Haverkamp Begemann, E. *Vijf eeuwen tekenkunst: tekeningen van Europese meesters in het Museum Boymans te Rotterdam*. Museum Boymans-van Beuningen, Rotterdam

Haverkorn van Rijsewijk 1906
Haverkorn van Rijsewijk, P. "Thijs Maris" [letter to the editor]. *Nieuwe Rotterdamse Courant* (April 28, 1906)

Haverkorn van Rijsewijk 1909
Haverkorn van Rijsewijk, P. *Het Museum-Boymans te Rotterdam*. The Hague/Amsterdam [1909]

Haverkorn van Rijsewijk 1911
Haverkorn van Rijsewijk, P. "De 'Extase' van Matthijs Maris." *Rotterdamsch Jaarboekje* 9 (1911):174–77

Heawood 1950
Heawood, E. *Watermarks, Mainly of the 17th and 18th Centuries* (Monumenta Chartae Papyrraceae I). Hilversum, 1950

Hecht 1980
Hecht, P. "Candlelight and Dirty Fingers, or Royal Virtue in Disguise: Some Thoughts on Weyerman and Godfried Schalken." *Simiolus* 11 (1980):23–38

Hefting 1948
Hefting, V. *Johan Barthold Jongkind, 1819–1891*. Exh. cat. Haags Gemeentemuseum. The Hague, 1948

Hefting 1963
Hefting, V. *L'aquarelle neérlandaise*. Exh. cat. Institut Neérlandais. Paris, 1963

Hefting 1970
Hefting, P. H. *G. H. Breitner in zijn Haagse tijd*. Utrecht, 1970

Hefting 1971(1)
Hefting, V. *Aquarelles de Jongkind*. Exh. cat. Institut Néerlandais. Paris, 1971

Hefting 1971(2)
Hefting, V. *[J. B. Jongkind]*. Exh. cat. Rijksmuseum Twenthe. Enschede, 1971

Hefting 1975
Hefting, V. *Jongkind*. Paris, 1975

Hefting 1981
Hefting, V. *Schilders in Oosterbeek, 1840–1870*. Zutphen, 1981

Hefting 1982
Hefting, V. *Jongkind*. Odakyu Grand Gallery. Tokyo, 1982

Hefting 1983
Hefting, P. *G. H. Breitner 1857–1923, aquarellen en tekeningen*. Exh. cat. Singer Museum. Laren, 1983

Hefting 1988
Hefting, V. *Jan Toorop*. Exh. cat. Metropolitan Teien Art Museum. Tokyo, 1988

Hefting 1989
Hefting, P. *De foto's van Breitner*. The Hague, 1989

Heij 1989
Heij, J. J., et al. *Een vereeniging van ernstige kunstenaars: 150 jaar Maatschappij Arti et Amicitiae 1839–1989*. Amsterdam, 1989

Heijbroek 1985
Heijbroek, J. F. "Willem Witsen in Amerika." In J. F. Heijbroek et al. *Geen schepsel wordt vergeten: liber amicorum J. W. Schulte Nordholt*. Amsterdam/Zutphen 1985, 121–42

Heijbroek 1986
Heijbroek, J. F. "Werken naar foto's, een terreinverkenning: Nederlandse kunstenaars en de fotografie in het Rijksmuseum." *Bulletin van het Rijksmuseum* 34 (1986):220–36

Heijbroek 1988
Heijbroek, J. F. "Impressies uit de 'reuzestad': het verblijf van Willem Witsen in Londen (1888–1891)." In F. W. Kuijper et al. *Liber amicorum A. G. van der Steur*. Haarlem 1988, 61–97

Heijbroek 1989
Heijbroek, J. F., et al. *De verzameling van mr. Carel Vosmaer (1826–1888)*. Exh. cat. Rijksprentenkabinet, Rijksmuseum. Amsterdam, 1989

Heijbroek 1993
Heijbroek, J. F., and E. Wouthuysen. *Kunst, kennis en commercie: de kunsthandelaar J.H. de Bois (1878–1946)*. Amsterdam/Antwerp, 1993

Hekking 1985
Hekking, S. "Dat is weer de groote kwestie van voelen en niet voelen: het dilemma van de fotografie tussen 1880 en 1900." In P. J. A. Winkels et al. *Ten tijde van de Tachtigers: rondom de Nieuwe Gids, 1880–1895*. The Hague, 1985, 103–16

Heldring 1948
Heldring, E. *De verzameling van de vereeniging tot het vormen van eene openbare Verzameling van Hedendaagsche Kunst te Amsterdam*. Exh. cat. Stedelijk Museum. Amsterdam, 1948

Heugten 1996
Van Heugten, S. *Vincent van Gogh Drawings. Volume 1, The Early Years 1880–1883*. Van Gogh Museum. Amsterdam/Bussum, 1996

Heugten 1997
Van Heugten, S. *Vincent van Gogh Drawings. Volume 2, Nuenen 1883–1885*. Van Gogh Museum. Amsterdam/Bussum, 1997

Heyting 1994
Heyting, L. *De wereld in een dorp: schilders, schrijvers en wereldverbeteraars in Laren en Blaricum, 1880–1920*. Amsterdam, 1994

Hoenderdos 1974
Hoenderdos, P. *Ary Scheffer, Sir Lawrence Alma-Tadema, Charles Rochussen of de vergankelijkheid van de roem*. Exh. cat. Lijnbaancentrum. Rotterdam, 1974

Hofstätter 1965
Hofstätter, H. H. *Symbolismus und die Kunst der Jahrhundertwende*. Cologne, 1965

Hofstede de Groot 1907–28
Hofstede de Groot, C. *Beschreibendes und kritisches Verzeichnis der Werke der hervorragendsten holländischen Maler des XVII. Jahrhunderts*. Ten vols. Esslingen/Stuttgart/Paris, 1907–28

Hoogenboom 1982
Hoogenboom, A., and L. van Tilborgh. *Tekenen destijds: Utrechts tekenonderwijs in de 18e en 19e eeuw*. Utrecht, 1982

Hoogenboom 1993
Hoogenboom, A. *De stand des kunstenaars: de positie van kunstschilders in Nederland in de eerste helft van de negentiende eeuw*. Leiden, 1993

Van Hoytema 1892
Van Hoytema, T. *Hoe de vogels aan een koning kwamen*. Amsterdam, 1892

Van Hoytema 1893
Van Hoytema, T. *Het leelijke jonge eendje*. After the Tales of H. C. Andersen. Amsterdam, 1893

Hubert 1909
Hubert, H. J. *De etsen van Jozef Israëls, een catalogus*. Amsterdam, 1909

Huizinga 1977
Huizinga, P. J. *Floris Verster*. Exh. cat. Stichting Fraeylemaborg. Slochteren, 1977

Hulsker 1977
Hulsker, J. *Van Gogh en zijn weg: al zijn tekeningen en schilderijen in hun samenhang en ontwikkeling*. Amsterdam, 1977

Ihle 1960
Ihle, B. L. D. *Bloemen, vogels en insecten: tekeningen en aquarellen van Hollandse meesters uit de jaren 1650 tot 1850 uit eigen bezit* (catalogue Print Room no. 15). Exh. cat. Museum Boymans-van Beuningen. Rotterdam, 1960

Imanse 1980
Imanse, G., et al. *Van Gogh bis Cobra, Holländische Malerei 1880–1950*. Exh. cat. Wurttembergischer Kunstverein. Stuttgart, 1980

Immerzeel 1842–43
Immerzeel, J. *De levens en werken der Hollandsche en Vlaamsche kunstschilders, beeldhouwers, graveurs en bouwmeesters, van het begin der vijftiende eeuw tot heden*. Three vols. Amsterdam, 1842–43

Jaffé 1963
Jaffé, H. L. C., et al. *Nationale herdenking 1813–1963: 150 jaar Nederlandse kunst*. Exh. cat. Stedelijk Museum. Amsterdam, 1963

Jansen 1986
Jansen, G., L. van Tilborgh, et al. *Op zoek naar de Gouden Eeuw: Nederlandse schilderkunst 1800–1850*. Exh. cat. Frans Halsmuseum. Haarlem, 1986

Jansen 1987
Jansen, G. Folder accompanying the exhibition *Nederlandse schilderkunst, 1800–1850*. Museum Boymans-van Beuningen. Rotterdam, 1987

Jeltes 1910
Jeltes, H. F. W. *Uit het Leven van een kunstenaarspaar: brieven van Johannes Bosboom*. Amsterdam, 1910

Jeltes 1911
Jeltes, H. F. W. *Willem Roelofs: bizonderheden betreffende zijn leven en werk*. Amsterdam, 1911

Jeltes 1925
Jeltes, H. F. W. "Brieven van Willem Roelofs aan Mr. P. Ver-Loren van Themaat." *Oud Holland* 42 (1925):86–96, 131–40

Joly 1857
Joly, V. *Les Beaux-Arts en Belgique de 1848 à 1857*. Brussels/Leipzig, 1857

De Jong 1993
De Jong, A. *Willem Bastiaan Tholen, 1860–1931*. Exh. cat. Museum het Catharina Gasthuis. Gouda, 1993

De Jonge 1992
De Jonge, P. *Impressionisme: een schone kijk*. Exh. cat. Museum Boymans-van Beuningen. Rotterdam, 1992

Karsen 1986
Karsen, E. *Een droom en een scheidsgerecht*. Annotated by R. van der Wiel. Amsterdam, 1986

Van de Kasteele 1810
Van de Kasteele, R.P. *Redevoering over het aangename en nuttige van de beoefening der Teekenkunde*. The Hague, 1810 (lecture held during prize-winning festivities in the "Academie-zaal" of the Pictura Society, The Hague, May 3, 1810)

Knip 1819
Knip, J. A. "Levensbeschrijving, door hemzelf opgesteld in 1819. . . ." As published in Bergvelt 1977, 189–95

Knip 1840(1)
Knip, J.A. "Levensbeschrijving, door hemzelf opgesteld rond 1840. . . ." As published in Bergvelt 1977, 196–97

Knip 1840(2)
Knip, J. A. "Levensbeschrijving van N. F. Knip en J. A. Knip, door henzelf opgesteld rond 1840. . . ." As published in Bergvelt 1977, 198–202

Knipping 1929
Knipping, J. B. *Jan Toorop Herdenking: 32 reproducties met artikelen van Alb. Plasschaert*. Amsterdam, 1929

Knipping 1947
Knipping, J. B. *Jan Toorop*. Amsterdam, 1947

Knoef 1943
Knoef, J. *Tusschen Rococo en Romantiek*. The Hague, 1943

Knoef 1947
Knoef, J. *Van Romantiek tot Realisme*. The Hague, 1947

Knolle 1984
Knolle, P. Review of Th. Laurentius et al. "Cornelis Ploos van Amstel." *Oud Holland* 98 (1984):45

Knolle 1986–1987
Knolle, P. "Dilletanten en hun rol in de 18de eeuwse Noordnederlandse tekenacademies." *Leids Kunsthistorisch Jaarboek* 5–6, Leiden (1986–1987):289–301

Knuttel 1939
Knuttel, G. "Th. van Hoytema." *Elsevier's Geïllustreerd Maandschrift* 49 (1939), 361–73

Knuttel 1944
Knuttel, G. *W. B. Tholen*. The Hague, 1944

Knuttel 1953
Knuttel, G. *Theo van Hoytema*. The Hague, 1953

Kódera 1990
Kódera, T. *The Hague Vincent van Gogh: Christianity versus Nature*. Amsterdam/Philadelphia, 1990

Koekkoek 1841
Koekkoek, B. C. *Herinneringen en mededeelingen van eenen landschapschilder* [Amsterdam, 1841]. Reprint Schiedam, 1982

Koenraads 1969
Koenraads, J. P. *Gooise schilders*. Amsterdam, 1969

Kolks 1991
Kolks, Z., and P. Thoben. ". . . onbedorven schilderachtige toestanden. . . ." Exh. cat. Rijksmuseum Twenthe. Enschede, 1991

Kramm 1857–64
Kramm, C. *De levens en werken der Hollandsche en Vlaamsche kunstschilders, beeldhouwers, graveurs en bouwmeesters, van den vroegsten tot op onzen tijd*. Six vols. Amsterdam, 1857–64

Kunstkronijk 1846
Kunstkronijk 7 (1846)

Kunstkronijk 1850
Kunstkronijk 11 (1850)

Kunstkronijk 1857
Kunstkronijk 18 (1857)

Kunstkronijk 1861
"De tentoonstelling in Arti et Amicitiae te Amsterdam."
Kunstkronijk (1861), 21 ff.

Kunstkronijk 1871
Kunstkronijk 33 (1871)

Kunstkronijk 1874
Kunstkronijk 46 (1874)

Kunstschrift 1995
Kunstschrift 39 (1995), over Floris Verster, 6–43, 46

L.
F. Lugt. *Les marques de collections de dessins et d'estampes.*
Vol. 1, Amsterdam, 1921; supplement, The Hague, 1956

Laanstra 1992
Laanstra, W., and S. Ooms. *Johan Hendrik Weissenbruch,
1824–1903.* Amsterdam, 1992

Van Laarhoven 1985–86
Van Laarhoven, J., et al. *". . . toch wilde ik in Heeze werken":
zeventig jaar schilderkunst in en rond een Brabants dorp.* Exh.
cat. Gemeentemuseum Helmond. Helmond, 1985–86

Lamme 1852
[Lamme, A. J.]. *Catalogus van teekeningen in het Museum te
Rotterdam gesticht door Mr. F. J. O. Boymans.* Exh. cat. Museum
Boymans. Rotterdam, 1852

Lamme 1869
[Lamme, A. J.]. *Beschrijving der teekeningen in het Museum te
Rotterdam gesticht door Mr. F. J. O. Boymans.* Exh. cat. Museum
Boymans. Rotterdam, 1864

Lamme 1869
[Lamme, A. J.]. *Catalogus van teekeingen in het Museum te Rot-
terdam gesticht door Mr. F. J. O. Boymans.* Exh. cat. Museum
Boymans. Rotterdam, 1869

Leeman 1988
Leeman, F. "Mauve's aquarellen." *Bulletin Rijksmuseum Vincent
van Gogh* 2 (1988): n.p.

Leeman 1996
Leeman, F., H. Pennock, et al. *Museum Mesdag: Catalogue of
Paintings and Drawings.* Zwolle, 1996

De Leeuw 1983
De Leeuw, R. "Introduction." *The Hague School Dutch Masters
of the 19th Century.* Grand Palais/Royal Academy/Gemeente-
museum. Paris, London, The Hague, 1983

De Leeuw 1984
De Leeuw, R., et al. *Herinneringen aan Italië: kunst en toerisme
in de 18de eeuw.* Exh. cat. Noordbrabants Museum. Den Bosch,
1984

De Leeuw 1985
De Leeuw, R. "Nederlandse oriëntalisten." *Jong Holland* 1
(1985):10–36

Leiden 1952
[E. P.]. *Floris Verster.* Exh. cat. Stedelijk Museum De Lakenhal.
Leiden, 1952

Lockspeiser 1973
Lockspeiser, E. *Music and Painting. A Study in Comparative
Ideas from Turner to Schoenberg.* London, 1973

Loffelt 1895(1)
Loffelt, A. C. "Karsens tentoonstelling in de zaal van Wis-
selingh." *Nieuws van de Dag.* November 23, 1895

Loffelt 1895(2)
Loffelt, A. C. "Johannes Warnardus Bilders, 1811–1898." *El-
sevier's Geïllustreerd Maandschrift* 5 (1895):225–58

London 1926
Barbizon House: Record of 1925. Exh. cat. Barbizon House. Lon-
don, 1926

Longstreet 1963
Longstreet, S. *The Drawings of Van Gogh.* Los Angeles, 1963

Loosjes-Terpstra 1959
Loosjes-Terpstra, A. B. *Moderne kunst in Nederland 1900–1914.*
Utrecht, 1959

Luijten 1990
Luijten, G., and A. W. F. M. Meij. *Van Pisanello tot Cézanne:
keuze uit de verzameling tekeningen in het Museum Boymans-
ban Beuningen.* Museum Boymans-van Beuningen. Rotterdam,
1990

Van Luttervelt 1984
Van Luttervelt, R. "De kwekelingen van Koning Lodewijk." *Pu-
blicaties van het genootschap van Napoleontische studiën* 13
(1961):561–72

Maas 1989
Maas, N., et al. *De literaire wereld van Carel Vosmaer: een docu-
mentaire.* The Hague, 1989

Maaskamp 1827
Maaskamp, E. *Handleiding voor jonge kunstenaars, in het teeke-
nen van landschappen naar de natuur. . . .* Amsterdam, 1827

Maris 1943
Maris, M. H. W. E. *De geschiedenis van een schildersgeslacht.*
Gouda, 1943

Marius 1891
Marius, G. H. "Jakob Maris." *Elsevier's Geïllustreerd Maandschrift*
2 (1891):1–13

Marius 1902
Marius, G. H. "Een studie over Jacob Maris." *Onze Kunst* 1
(1902):9–16

Marius 1910
Marius, G. H. "Willem de Zwart." *Onze Kunst* 9 (1910):13–28

Marius 1917
Marius, G. H., and W. Martin. *Johannes Bosboom.* The Hague,
1917

Marius 1920
Marius, G. H. *De Hollandsche schilderkunst in de negentiende
eeuw.* The Hague, 1920

Martin 1915
Martin, W. *Albert Neuhuys, zijn leven en zijn kunst.* Amsterdam,
1915

Martini 1963
Martini, A. *Van Gogh I Maestri del Colore.* Milan, 1963

Martens 1994
Martens, C. Folder accompanying the exhibition *Jan Stolker
(1724–1785): een herontdekte bundel tekeningen.* Museum Boij-
mans van Beuningen. Rotterdam, 1994

De Meester-Obreen 1909
De Meester-Obreen, A. "Willem de Zwart." *Elsevier's Geïllus-
treerd Maandschrift* 19 (1909):145–56

Meij 1978
Meij, A. W. F. M. "Een landschap in de omgeving van Rotter-
dam door J. B. Jongkind." In *Boymans bijdragen: opstellen van
medewerkers en oud-medewerkers van het Museum Boymans-
van Beuningen voor J. C. Ebbinge Wubben.* Museum Boymans-
van Beuningen. Rotterdam, 1978, 171–76

Meij 1993
Meij, A. W. F. M. "Een Italiaans landschap door Abraham Teer-
link." In Giltaij 1993, 86–93

Menalda 1995
Menalda, M., et al. *Een kunstkast gaat open. Tekeningen uit de
verzameling Teding van Berkhourst.* Exh. cat. Teylers Museum.
Haarlem/Zwolle 1995

Meppen 1848
Meppen, K. N. "De lof der Teekenkunst." Lecture held during the prize-winning festivities at the Teeken-Instituut van de Maatschappij tot Nut van 't Algemeen in The Hague, May 27, 1846, published in *Kunstkronijk* 9 (1848):25–26

Mertens 1969
Mertens, Ph. "De brieven van Jan Toorop aan Octave Maus." *Bulletin Koninklijke Musea voor Schone Kunsten van België* 18 (1969):157–206

Ter Meulen 1893
Ter Meulen, F. P. "Herinneringen." *Elsevier's Geïllustreerd Maandschrift* 3 (1893):557–74

Millard 1974
Millard, C. W. "A chronology for Van Gogh's drawings of 1888." *Master Drawings* 12 (1974):161

Molkenboer 1918
Molkenboer, B. H., et al. "Toorop's vergeestelijking." *Wendingen* (1918):5–48

Monnier 1985
Monnier, G. *Musée du Louvre, Cabinet des dessins Musée d'Orsay Pastels du XIXe siècle*. Paris, 1985

Montens 1986
Montens, A., et al. *Floris Verster, 1861–1927*. Exh. cat. Stedelijk Museum De Lakenhal. Leiden, 1986

Mosler 1995
Mosler, M. *Dirk Hannema, de geboren verzamelaar*. Rotterdam, 1995

Mras 1966
Mras, G. P. *Eugène Delacroix's Theory of Art*. Princeton, New Jersey, 1966

Munich 1961
[H. K. R.]. *Zeichnungen und Aquarelle, Vincent van Gogh*. Exh. cat. Munich, 1961

Nederlandsche Spectator 1865
[Necrologie Gerard Bilders]. *De Nederlandsche Spectator* (1865):160

Nieuwenhuis 1929
Nieuwenhuis, J. *Jan Toorop herdenking*. Amsterdam, 1929

Niemeijer 1961
Niemeijer, J. W. "Portretten door P.G. van Os." *Oud Holland* 76 (1961):114–15

Niemeijer 1977
Niemeijer, J. W. "De betekenis van Drenthe voor de vernieuwing in de landschaps-schilderkunst omstreeks 1800." *Nieuwe Drentse Volksalmanak* 94 (1977):69–97

Niemeijer 1990–91
Niemeijer, J. W. *Hollandse aquarellen uit de 18de eeuw in het Rijksprentenkabinet*. Exh. cat. Rijksprentenkabinet. Amsterdam, 1990–91

Nochlin 1971
Nochlin, L. *Realism*. Harmondsworth, 1971

Nollert 1994
Nollert, A., et al. *Barend Cornelis Koekkoek: seine Familie, seine Schule und das Haus Koekoek in Kleve*. Exh. cat. Museum Haus Koekkoek. Kleef, 1994

Nollert 1997
Nollert, A. *Barend Cornelis Koekkoek (1803–1862): Prins der Landschapschilders*. Exh. cat. Dordrechts Museum, Museum Haus Koekkoek. Dordrecht/Kleef, 1997

NRC 1906(1)
"Een Thijs Maris." *Nieuwe Rotterdamse Courant*.(April 12, 1906)

NRC 1906(2)
"De Thijs Maris." *Nieuwe Rotterdamse Courant*.(May 1, 1906)

NRC 1906(3)
[Rubriek Tijdschriften]. *Nieuwe Rotterdamse Courant*. (June 28, 1906)

NRC 1906(4)
"De teekening van M. Maris. Extase." *Nieuwe Rotterdamse Courant* (July 4, 1906)

Nuremberg 1956
Vincent. Exh. cat. Fränischen Galerie. Nuremberg, 1956

Osterholt 1974
Osterholt, A. B. *Breitner en zijn foto's*. Amsterdam, 1974

Onze Kunst 1904
Onze Kunst 3 (1904):44

Van de Oudendijk Pieterse 1929
Van de Oudendijk Pieterse, F. "Nabetrachting over de Eeretentoonstelling Jan Toorop in Pulchri Studio Den Haag." *Maandblad van Beeldende Kunsten* (1929):6–7

Parijs 1884
Catalogue illustré des oevres de Jean-François Raffaëlli Exposées 28 bis, avenue de l'Opéra suivi d'une étude des mouvements de l'art moderne et du Beau Caractériste. Paris, 1884

Paris 1972
Les sources d'inspiration de Vincent van Gogh. Institut Neérlandais. Paris, 1972

Pickvance 1974/75
Pickvance, R. *English Influences on Vincent van Gogh*. Exh. cat. University Art Gallery. Nottingham, 1974/75

Pickvance 1984
Pickvance, R., et al. *Van Gogh in Arles*. Exh. cat. Metropolitan Museum of Art. New York, 1984

Pickvance 1985
Pickvance, R., et al. *Vincent van Gogh*. Exh. cat. National Museum of Western Art. Tokyo, 1985

Plasschaert 1902
Plasschaert, A. "Floris Verster." *Onze Kunst* 1 (1902):118–19

Plasschaert 1909
Plasschaert, A. *XIXde eeuwsche Hollandsche schilderkunst*. Amsterdam [1909]

Plasschaert 1925
Plasschaert, A. *Jan Toorop*. Amsterdam, 1925

Plomp 1993
Plomp, M. "Enkele bewerkingen door Wybrand Hendriks (1744–1831) van Hollandse 17de-eeuwse voorbeelden." *Delineavit et sculpsit* 9 (1993):22–32

Prout 1833
Prout, S. *Facsimiles of Sketches Made in Flanders and Germany*. n.p. 1833

De Raad 1991
De Raad, J., et al. *Maris: een kunstenaarsfamilie*. Exh. cat. Singer Museum. Laren, 1991

Redgrave
Redgrave, R., and G. F. Watts. *The First Victorian Social Realists*. n.p., n.d.

Van Regteren Altena 1958
Van Regteren Altena, J. Q. *Dutch Drawings: Masterpieces of Five Centuries*. Exh. cat. National Gallery of Art. Washington, 1958

Te Rijdt 1994
Te Rijdt, R. J. A. *Nederlandse figuurstudies 1700–1850*. Folder Rijksprentenkabinet no. 25. Exh. cat. Rijksprentenkabinet. Amsterdam, 1994

Van Rijn 1987
Van Rijn, J. *Rijkdom der eenvoud: Albert Neuhuys. 1844–1914*. Exh. cat. Jacques van Rijn. Maastricht, 1987

Riout 1989
Riout, D. *Les écrivains devant l'impressionisme*. Paris, 1989

Roelofs 1919
Roelofs, W. E., Jr. *De practijk van het schilderen: wenken aan collega's door een kunstschilder*. Amsterdam, 1919

Rosen 1984
Rosen, C., and Henri Zerner. "Rediscoveries of the Past and the Modern Tradition." In *Romanticism and Realism: The Mythology of Nineteenth Century Art*. London, 1984

Rosenberg 1993
Rosenberg, Y., and K. Tsukasa. *The Mythology of Vincent van Gogh*. Tokyo, Amsterdam, 1993

Rotterdam 1899(1)
September tentoonstelling: schilderijen en teekeningen. Exh. cat. Rotterdamsche Kunstkring. Rotterdam, 1899

Rotterdam 1899(2)
Jaarverslag 1899 (annual report 1899). Museum Boymans. Rotterdam, 1899

Rotterdam 1904
Jaarverslag 1904 (annual report 1904). Museum Boymans. Rotterdam, 1904

Rotterdam 1916
Jaarverslag 1916 (annual report 1916). Museum Boymans. Rotterdam, 1916

Rotterdam 1920
Jaarverslag 1920 (annual report 1920). Museum Boymans. Rotterdam, 1920

Rotterdam 1922
Jaarverslag 1922 (annual report 1922). Museum Boymans. Rotterdam, 1922

Rotterdam 1925
Jaarverslag 1925 (annual report 1925). Museum Boymans. Rotterdam, 1925

Rotterdam 1927
Jaarverslag 1927 (annual report 1927). Museum Boymans. Rotterdam, 1927

Rotterdam 1929
Jaarverslag 1929 (annual report 1929). Museum Boymans. Rotterdam, 1929

Rotterdam 1930
Jaarverslag 1930 (annual report 1930). Museum Boymans. Rotterdam, 1930

Rotterdam 1931
Jaarverslag 1931 (annual report 1931). Museum Boymans. Rotterdam, 1931

Rotterdam 1933
Jaarverslag 1933 (annual report 1933). Museum Boymans. Rotterdam, 1933

Rotterdam 1935
Jaarverslag 1935 (annual report 1935). Museum Boymans. Rotterdam, 1935

Rotterdam 1937
Jaarverslag 1937 (annual report 1937). Museum Boymans. Rotterdam, 1937

Rotterdam 1940
Jaarverslag 1940 (annual report 1940). Museum Boymans. Rotterdam, 1940

Rotterdam 1943
Jaarverslag 1943 (annual report 1943). Museum Boymans. Rotterdam, 1943

Rotterdam 1949
Jaarverslag 1949 (annual report 1949). Museum Boymans. Rotterdam, 1949

Rotterdam 1965
Bulletin Museum Boijmans. Museum Boymans. Rotterdam, 1965

Rotterdam 1967
Bulletin Museum Boijmans. Museum Boymans. Rotterdam, 1967

Rotterdam 1977
Jaarverslag 1977 (annual report 1977). Museum Boymans-van Beuningen. Rotterdam, 1977

Rotterdam 1982
Jaarverslag 1982. Dienst Gemeentelijke Musea. Rotterdam 1983

De Ruiter 1994
De Ruiter, T. "Foto's als schetsboek en geheugensteun." In *George Hendrik Breitner, 1857–1923: schilderijen tekeningen foto's*. Bussum, 1994

Van Santen Kolff 1878
Van Santen Kolff, J. "Indrukken van de derde tentoonstelling der Hollandsche Teekenmaatschappij." *De Nederlandsche Spectator* (1878):261–63

Scharf 1974
Scharf, A. "The Dilemma of Realism." *Art and Photography*. Harmondsworth, 1974

Scheen 1952
Scheen, P. A. *Tentoonstelling van schilderijen en tekeningen door W. J. J. Nuyen*. Exh. cat. Panorama Mesdag. The Hague, 1952

Scheen 1981
Scheen, P. A. *Lexicon Nederlandse beeldende kunstenaars 1750– 1850*. The Hague, 1981

Van Schendel 1939
Van Schendel, A. *Breitner*. Amsterdam, 1939

Van Schendel 1975
Van Schendel, E. *Museum Mesdag: Nederlandse negentiendeeeuwse schilderijen, tekeningen en grafiek*. The Hague, 1975

Scherjon 1928
Scherjon, W., et al. *Floris Verster, volledige geïllustreerde catalogus van zijn schilderijen*. Utrecht, 1928

Schmidt-Degener 1916
Schmidt-Degener, F. *Catalogus van schilderijen en teekeningen tentoongesteld in het Museum Boymans*. Exh. cat. Museum Boymans. Rotterdam, 1916

Schmidt-Degener 1921
Schmidt-Degener, F. *Catalogus van schilderijen en teekeningen tentoongesteld in het Museum Boymans*. Exh. cat. Museum Boymans. Rotterdam, 1921

Schotel 1840
Schotel, G. D. J. *Leven van den zeeschilder J. C. Schotel*. Haarlem, 1840

Schulte 1958
Schulte, T. *Bilder aus alten Papiermühlen von Wilhelm Bastian Tholen*. Mainz, 1958

Sellink 1991
Sellink, M. Folder accompanying the exhibition *Willem Witsen, grafiek*. Museum Boymans-van Beuningen. Rotterdam, 1991

Sellink 1993
Sellink, M. "'Die grijze kop vol vuur en stoute denkings kragt': Johann Bernhard Scheffers portret van Dirk Langendijk." In Giltay 1993, 94–101

Segal 1982
Segal, S. *Een bloemrijk verleden: overzicht van de Noord- en Zuidnederlandse bloemschilderkunst, 1600-heden*. Exh. cat. Noordbrabants Museum. Den Bosch, 1982

Van Seumeren-Haerkens 1987
Van Seumeren-Haerkens, M. *Albert Neuhuys (1844–1914): schilderijen, aquarellen en tekeningen*. Exh. cat. Singer Museum. Laren, 1987

Sillevis 1977
Sillevis, J., et al. *Wijnand Nuyen, 1813–1839: romantische werken*. Exh. cat. Haags Gemeentemuseum. The Hague, 1977

Sillevis 1985
Sillevis, J. *Dutch Watercolours of the 19th Century from the Printroom of the Rijksmuseum Amsterdam*. Exh. cat. Rijksprentenkabinet. Amsterdam, 1985

Sillevis 1988
Sillevis, J., et al. *De Haagse School: de collectie van Haags Gemeentemuseum*. Exh. cat. Haagse Gemeentemuseum. The Hague, 1988

Sillevis 1991
Sillevis, J., and E. Stades-Visscher. *Jongkind, een Hollander in Frankrijk*. Exh. cat. Slot Zeist. Zeist, 1991

Smithuis 1993
Smithuis, Mariette. *Suze Robertson en de positie van de vrouwelijke kunstenaar rond 1900*. Unpublished Ph.D. thesis. Rijksuniversiteit Utrecht. 1993

Steenhoff 1908
Steenhoff, W. "W. de Zwart." *De Groene* (November 8, 1908)

Stevens 1984
Stevens, M. A., et al. *The Orientalists, Delacroix to Matisse: European Painters in North Africa and the Near East*. Exh. cat. Royal Academy of Art. London, 1984

Stroo 1992
Stroo, M. "Onze leden verwachten dit niet van ons: de Vereniging Rembrandt en de moderne kunst." *Bulletin van het Nationaal Fonds Kunstbehoud Vereniging Rembrandt* 2 (1992): no. 3, 2–9

Tableau 1991
Review of the exhibition *Willem Witsen* (De Kool, Dordrecht). *Tableau* 14 (November 1991), 120

Tellegen 1967
Tellegen, A. In *Bulletin Museum Boijmans van Beuningen*. 1967, 2–7

Van Thiel 1976
Van Thiel, P. J. J., et al. *Alle schilderijen van het Rijksmuseum te Amsterdam*. Exh. cat. Rijksmuseum. Amsterdam, 1976

Thieme/Becker
Thieme, U., F. Becker, et al. *Allgemeines Lexicon der bildenden Künstler von der Antike bis zur Gegenwart*. Thirty-seven volumes. Leipzig, 1907–50

Tholen 1914
Tholen, W. B. *Notulen Hollandsche Teekenmaatschappij 1876–1901*. [The Hague], 1914

Thomson 1826
Thomson, J. *Le Stagioni, tradotta di Patrizio Muschi di Siena*. Florence, 1826

Thomson 1981
Thomson, J. *The Seasons*. Ed. J. Sambrook. Oxford, 1981

Thoré-Burger 1893
Burger, W. [Theophile Thoré]. *Les Salons, études de critique et d'esthétique*. Three volumes. Brussels, 1893

Thorn Prikker 1980
Thorn Prikker, J. *Brieven van Johan Prikker aan Henri Borel en anderen*. Bijeengebracht en toegelicht door J. M. Joosten. Nieuwkoop, 1980

Tibbe 1994
Tibbe, L. *R. N. Roland Holst: arbeid en schoonheid vereend, opvattingen over Gemeenschapskunst*. Ph.D. dissertation, Free University of Amsterdam, 1994

Van Tilborgh 1984
Van Tilborgh, L. "Dutch Romanticism: A Provincial Affair." *Simiolus* 14 (1984):179–88

Van Tilborgh 1986
Van Tilborgh, L., and G. Jansen (red). *Op zoek naar de Gouden Eeuw: Nederlandse schilderkunst 1800–1850*. Zwolle, 1986

Van Tilborgh 1988
Van Tilborgh, L. "Hetzelfde maar dan ander: Van Gogh en zijn leermeester Millet." In *Van Gogh & Millet*. Zwolle, 1988

Timmerman 1983
Timmerman, A. E. *Tim's herinneringen*. Compiled and annotated by H. G. M. Prick. Amsterdam, 1983

Treuherz 1987
Treuherz, J., et al. *Hard Times: Social Realism in Victorian Art*. Exh. cat. City Art Galleries/Riijksmuseum Vincent van Gogh. London, Manchester, Amsterdam, 1987

Van Uitert 1987
Van Uitert, E. "Vincent van Gogh, boerenschilder." In *Van Gogh in Brabant: Schilderijen en tekeningen uit Etten en Nuenen*. Noordbrabants Museum. Zwolle and s'-Hertogenbosch, 1987

Van Uitert 1993
Van Uitert, E. "Some Artists with Whom Vincent van Gogh Identified." In *The Mythology of Vincent van Gogh*. Tokyo, Amsterdam, 1993

Utrecht 1941
Tentoonstelling van werken van Jan Toorop. Exh. cat. Centraal Museum. Utrecht, 1941

Vanbeselaere 1937
Vanbeselaere, W. *De Hollandsche periode (1880–1885) in het werk van Vincent van Gogh (1853–1890)*. Antwerp, 1937

Veen 1997
Van Veen, A., R. Bergsma, et al. *G. H. Breitner. Fotograaf en schilder van het Amsterdamse stadsgezicht*. Gemeentearchief. Bussum/Amsterdam, 1997

Verberchem 1888
Verberchem [Willem Witsen], [untitled]. *De Nieuwe Gids* 3 (1888):428

Vergeer 1985
Vergeer, C. *Willem Witsen en zijn vriendenkring*. Amsterdam/Brussels, 1985

Verhaeren 1882
Verhaeren, E. "Exposition des aquarellistes." *Journal des Beaux-Arts et de la Littérature* (April 30, 1882)

Verwey 1927
Verwey, A. *Catalogus van werken door Floris Verster*. Exh. cat. Stedelijk Museum De Lakenhal. Leiden, 1927

Verwey 1970
Verwey, K., and P. I. de Haan. *Floris Verster*. Exh. cat. Singer Museum. Laren, 1970

Veth 1905
Veth, J. *Hollandsche teekenaars van dezen tijd*. Amsterdam, 1905

Veth 1908
Veth, J. *Portretstudies en silhouetten*. Amsterdam, 1908

Veth 1937
Veth, C. "Teekeningen van Breitner en De Zwart: beide meesters overleefden hun talent." *Hollandia Water* (October 27, 1937)

Viola 1909
Viola, M. *Jan Toorop*. Exh. cat. Larensche Kunsthandel. Amsterdam, 1909

Viola 1912
Viola, M. *Jan Toorop*. Exh. cat. Kunstzalen Unger & Van Mens. Rotterdam, 1912

Van Vloten 1994
Van Vloten, F., et al. *Reünie op 't duin: Mondriaan en tijdgenoten in Zeeland*. Exh. cat. Zeeuws Museum. Middelburg, 1994

Vosmaer 1881–85
Vosmaer, C. *Onze hedendaagsche schilders*. Series. The Hague/Amsterdam, 1881–85

Vosmaer 1893
Vosmaer, C. *Amazone*. Fifth edition, with illustrations by C. Rochussen. The Hague, 1893

Vreugdenhil 1936–55
Vreugdenhil, A., with additions by J. van der Sluijs. *Nederlandsche oorlogsschepen 1572–1950*. Manuscript. Scheepvaartmuseum, Amsterdam, compiled 1936–55

De Vries 1816
[De Vries, J.], "Beschouwing van de tentoonstelling der kunstwerken van levende Nederlandsche meesters, in october 1816, te Amsterdam." *Vaderlandsche letteroefeningen* 2 (1816):760–81

De Vries 1818
[De Vries, J.]. "Gesprek, over de tentoonstelling, te Amsterdam, van de kunstwerken van nog in leven zijnde Nederlandsche meesters, in den jare 1818." *Vaderlandsche letteroefeningen* 2 (1818):706–17, 766–76

De Vries 1899
De Vries, R. W. P. "Tentoonstelling van Japansche Kunst I en II." *De Amsterdammer, weekblad voor Nederland* (August 27, 1899, September 3, 1899).

De Vries 1909
De Vries, R. W. P., Jr. "Theo van Hoytema." *Elsevier's Geïllustreerd Maandschrift* 19 (1909):1–11

De Vries 1944
De Vries, R. W. P., Jr. *M. A. J. Bauer*. Amsterdam, 1944

De Vries 1996
De Vries, J., E. van Uitert, S. de Bodt. *Pieter Haverkorn van Rijsewijk 1839–1919. Dominee, journalist en museumdirecteur*. Amsterdam, 1996

Wagner 1961
Wagner, A. "Enkele schetsboeken van Isaac Israëls." *Bulletin Museum Boymans-van Beuningen* 12 (1961):38–65

Wagner 1969
Wagner, A. *Floris Arntzenius 1864–1925: het Haagse leven van gisteren*. Exh. cat. Haags Gemeentemuseum. The Hague, 1969

Wagner 1974
Wagner, A. *Matthijs Maris*. Exh. cat. Haags Gemeentemuseum. The Hague, 1974

Wagner 1975
Wagner, A. *17 schilders in hun Haagse tijd*. Exh. cat. Slot Zeist. Zeist, 1975

Wagner 1984
Wagner, A., and H. Henkels. *Suze Robertson*. Exh. cat. Haags Gemeentemuseum. The Hague, 1984

Wagner 1985
Wagner, A. *Isaac Israëls*. Second, revised edition. Venlo, 1985

Wap 1839
Wap, J. J. F. *Mijne reis naar Rome*. Volume 2. Breda, 1839

Weerdenburg 1994
Weerdenburg, S. "George Hendrik Breitner, restauratie en onderzoek." *Bulletin van het Stedelijk Museum* (1994):128–29

Welling 1991
Welling, D. *Isaac Israëls: The Sunny World of a Hague Cosmopolitan*. The Hague, 1991

Welling 1992
Welling, D. *Floris Arntzenius*. The Hague, 1992

De Werd 1983
De Werd, G. *Barend Cornelis Koekkoek 1803–1862: Zeichnungen*. Exh. cat. Städtisches Museum Haus Koekkoek. Kleve, 1983

Wichmann 1980
Wichmann, S. *Japonismus*. Herrsching, 1980

Wichmann 1984
Wichmann, S. *Jugendstil floral funktional in Deutschland und Osterreich und den Einflußgebeiten*. Munich, 1984

Van der Wiel 1985
Van der Wiel, R. "Brabant, october 1890. Lieve Betsy." *Het Oog in 't Zeil* 3 (1985), no. 1

Van der Wiel 1988
Van der Wiel, R. *Ewijkshoeve, tuin van Tachtig*. Amsterdam, 1988

Will 1982
Will, C., and P. Winkels. *Jacobus van Looy, schilder van huis uit, schrijver door toevallige omstandigheden*. The Hague, 1982

Van der Willigen 1811–13
Van der Willigen, A. *Aantekeningen op eene reize van Parijs naar Napels, door het Tirolsche en van daar door Zwitserland en langs den Rhijn terug naar Holland*. Four vols. Haarlem, 1811–13

Van Wisselingh 1933
Van Wisselingh, E. J. *Het etswerk van Willem Witsen*. Amsterdam [1933]

WNT
De Vries, M., et al. *Woordenboek der Nederlandsche taal*. Series. The Hague/Leiden 1882—

Van der Wolk 1990
Van der Wolk, J., et al. *Vincent van Gogh, tekeningen*. Exh. cat. Rijksmuseum Kröller-Müller. Otterlo, 1990

Wright 1980
Wright, C. *Paintings in Dutch Museums: An Index of Oil Paintings in Public Collections in The Netherlands by Artists Born before 1870*. Amsterdam, 1980

X. 1835
X. "Beoordeelend overzigt der voornaamste kunstwerken op de tentoonstelling, te 's Gravenhage in 1835." *Algemeene Konst- en Letterbode* (1835):328–34

Zemel 1987
Zedmel, C. "Sorrowing Women, Rescuing Men: Van Gogh's Images of Women and Family." *Art History* 10 (1987):351–68

Zilcken 1893
Zilcken, P. *Peintres Hollandais modernes*. Amsterdam, 1893

Zilcken 1927
Zilcken, P. *Herinneringen van een Hollandsche schilder der negentiende eeuw 1887–1927*. Typescript. 1927. Rijksbureau voor Kunsthistorische Documentatie. The Hague

Zilcken 1930
Zilcken, P. *Au jardin du Passé*. Paris/The Hague, 1930

INDEX OF ARTISTS IN THE EXHIBITION

215

The Princeton Review®

Cracking the
GMAT®

2014 Edition

Geoff Martz and Adam Robinson

PrincetonReview.com

Random House, Inc. New York

The Princeton Review, Inc.
111 Speen Street, Suite 550
Framingham, MA 01701
E-mail: editorialsupport@review.com

Terms of Service: The Princeton Review Online Companion
Tools ("Online Companion Tools") for the *Cracking* book series
and *11 Practice Tests for the SAT & PSAT* are available for the
two most recent editions of each book title. Online Companion
Tools may be activated only once per eligible book purchased.
Activation of Online Companion Tools more than once per book
is in direct violation of these Terms of Service and may result in
discontinuation of access to Online Companion Tools services.

ISBN: 978-0-307-94565-5
ISSN: 1549-263X

GMAT is a registered trademark of the Graduate
Management Admission Council, which does not
sponsor or endorse this product.

The Princeton Review is not affiliated with Princeton University.

Editor: Meave Shelton
Production Artist: Maurice Kessler
Production Editor: Jim Melloan

Printed in the United States on partially recycled paper.

10 9 8 7 6 5 4 3 2 1

2014 Edition

Editorial
Rob Franek, Senior VP, Publisher
Mary Beth Garrick, Director of Production
Selena Coppock, Senior Editor
Calvin Cato, Editor
Kristen O'Toole, Editor
Meave Shelton, Editor

Random House Publishing Team
Tom Russell, Publisher
Nicole Benhabib, Publishing Director
Ellen L. Reed, Production Manager
Alison Stoltzfus, Managing Editor